W9-CLA-551

THE WORLD ATLAS OF STREET ART AND GRAFFITI

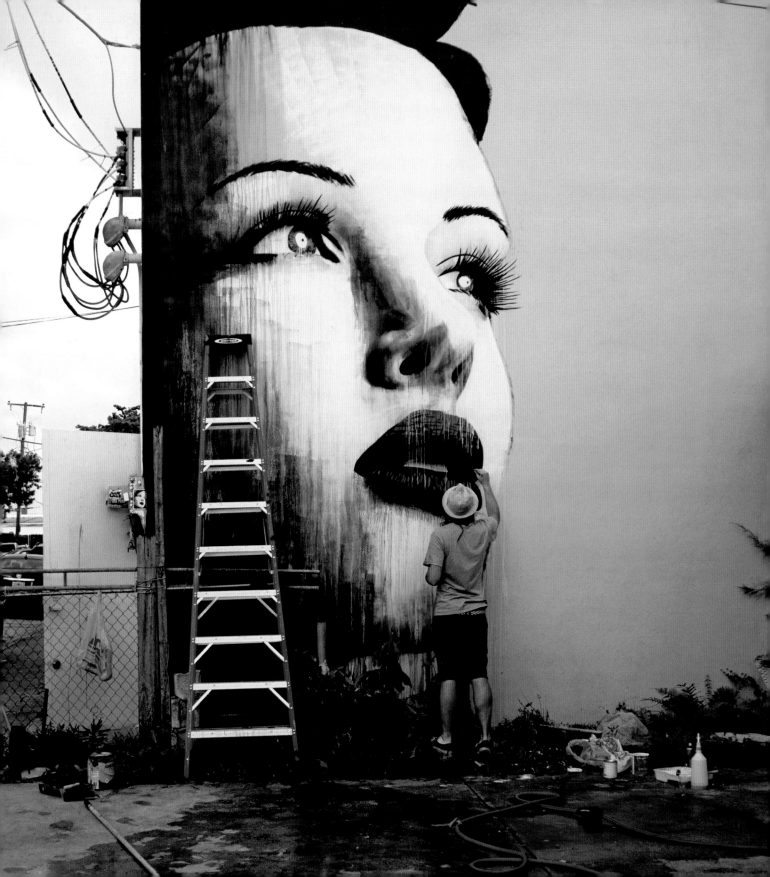

THE WORLD ATLAS OF STREET ART AND GRAFFITI

RAFAEL SCHACTER

FOREWORD BY
JOHN FEKNER

YALE UNIVERSITY PRESS, NEW HAVEN

NORTH AMERICA

LATIN AMERICA

CONTENTS

FOREWORD
BY JOHN FEKNER

The year was 1968. It was around eleven at night. New York City's Gorman Park, known as "85th Street," was locked and closed. This is where I played handball during the day but, more importantly, where I would prowl at night. The thought never crossed my mind as I climbed over the playground's chain-link fence with a few co-conspirators, armed with brushes, rollers, and two gallons of white paint, that what I was about to do would one day be considered art. It was trespassing and illegal, and a rush. It was a lot more fun than sitting in an art school class painting a still life. My heart was pounding in the light of the following day; two crudely painted large words "Itchycoo Park" emblazoned high up on the park house wall.

It is an honor to be part of *A World Atlas of Street Art and Graffiti*, a book featuring Independent Public Art created by artists working across the globe today. Author Rafael Schacter has chosen 113 artists from twenty-five different countries whose works are monumental creations of defiant joy that inspire, engage, and, at times, provoke the viewer. The artists showcased within these pages demonstrate a resolute vision. There is a strong connection to the community-based mural movement of the late 1960s and 1970s in Chicago, New York, Los Angeles, and San Francisco, as well as the mural movements in Mexico, Portugal, and further abroad. On the cover of Robert Sommer's 1975 book *Street Art* there is a wonderful image of a mural depicting people of all cultures and races with the inscription "Free Territory Revolution." These concepts continue to be embraced and manifested in the works produced by the artists in this book.

Why do artists choose to work directly in the environment? Perhaps striving to be at the center is no longer sustainable. Why aim for the center, if the center is dead? The bull's-eye has moved outside as seen by the activities of groups such as the Occupy movement, Change.org, and other grassroots organizations. Some of these artists' works evoke the imagery that flourished on the streets of New York City during the 1970s and 1980s. Most importantly, these new artists have created an ideology that is the opposite to the graffiti and street art commercialization of the mid-1980s, as well as the mass-produced, post-street art shown in some galleries today.

For nearly a half century, streetwise teenagers have boldly proclaimed their identity with a territorial mark on a wall, using a crayon, chalk, a marker, or spray paint. Growing up in their neighborhoods, they know every shortcut, hideout, and alleyway like the back of their hand. Once their mark is up and seen, they are part of the hood. History has shown that the young always bring something new and unconventional to the arts. Working outdoors allows this new breed an unbridled freedom to experiment with form, color, and gesture on a large scale. Over the course of a few nights, they infuse a site with personal energy, vivid stories, and "a sense of place." The ingenuity in the work they create reflects a new and unique zeitgeist. This is not art made solely for an attentive art public, but for an entire public at large.

Every artist in this book originates from a distant place they call home: a big city, a small town, or a rural village, each a special location that remains deep within his or her own heart. No matter where these artists journey in following their muse, they readily adapt to the shifting and ephemeral nature of working outdoors. For the first time in history, artists who are creating art away from the major centers of art and culture are no longer at a disadvantage. The internet has increased accessibility through the proliferation of blogs and social media, which has fueled hordes of dedicated fan bases using cell phones and cameras to instantly record, document, and post their interpretations of life, culture, and art online. Some artists utilize cameras to record an entire installation. Working on their laptops while on the run, artists can create a new work by combining any media and special effects to create a time-lapse, hand-painted rotoscope and stop-motion animation video free to all across the digital realm.

The view from high up on a boom lift provides a unique perspective, where an artist can observe, reflect upon, and question the status quo. The fact remains that these extraordinary individuals who hang off the sides of buildings or swing from beneath a bridge are not simply full of whimsy. By creating intriguing works of experimental intervention, these artists are redefining the concept of public art in the twenty-first century.

Art in unexpected places: anywhere, anytime, any place, and *everyone*. Always remember that open space is the place! There is no conversation if we blindly ignore new challenges. Now, as a reader, it's your move.

1

INTRODUCTION

The story of graffiti and street art presents us with an unimaginably vast arena. Both in terms of space, through its all pervasive global reach, as well as time, through its status as a practice that is as old as human culture itself, the act of writing upon walls (also known as parietal writing) is an equally ubiquitous and elemental act, one linked to the primal human desire to decorate, adorn, and physically shape the material environment. Although its modern archetype only emerged in the late 1960s, Independent Public Art—an umbrella term first coined by the theorist Javier Abarca and one that will be used throughout this book— has itself now multiplied and spread, moving from its birthplace on the East Coast of the United States to countless destinations around the world. As quite possibly the most common popular art form in existence today, this contemporary aesthetic practice has taken numerous different physical forms (from apparently "vandalistic" tagging to ostensibly "artistic" muralism), absorbed variant local influences (from the Italian tradition of Arte Povera to the *pixação* of Brazil), occurred in multifarious environments (from the densely populated city to the isolated desert), and been produced by disparate individuals (of every nationality, religion, and culture). Indeed, there are as many different motivations, styles, and approaches within this artistic arena as there are practitioners themselves— a "street art" for every street artist, a "graffiti" for every graffiti writer.

Bringing these diverse practices together into one cohesive unit, *A World Atlas of Street Art and Graffiti* constitutes the most in-depth and authoritative account of this contemporary art form and provides the definitive biographical guide to the most original and inventive artists working in Independent Public Art today. The book profiles 113 individual

 1 Filippo Minelli, Tudela, Spain, 2011

or collective practitioners from twenty-five different countries, and includes sixteen city profiles written by experts from those regions. As an "atlas," we have also included twelve individually created city maps by a select group from the artists profiled. Rather than simply featuring a group of "traditional" maps, however, the maps shown are psycho-geographic representations of the city, maps that can more perspicuously account for the deeply ephemeral nature of the art discussed. The book incorporates a huge range of practices—including actions that have often been described as graffiti or street art, yet also embracing works that extend beyond these traditional designations. Accompanied by stunning illustrations, the book explores works that emerge via every conceivable form of artistic medium; it examines styles from traditional graffiti to sculptural intervention, from poster art to performance art, and from geometrical abstraction to photo-realistic figuration. In examining this wide-ranging collection of artists, however, the book resists the urge toward the sensationalism that these artists' work is so often (and sadly) subjected. Giving what are often highly conceptual works the thorough analysis they deserve, the book focuses on issues such as formal style, key influences, and artistic development, bringing the vitally important social, political, and ethical dimensions of these artists' cultural production to the fore. Illuminating the most significant figures, works, and themes to have emerged within contemporary Independent Public Art, *A World Atlas of Street Art and Graffiti* therefore offers a global survey of the most exciting international art being produced today and provides a definitive review of this most contentious, committed, and clandestine of contemporary art forms.

The individual artists profiled in the book were selected according to three separate criteria: Those chosen were practitioners currently operating within the field of Independent Public Art today; they were fully active, working outside in the unrestricted, communal areas of the environment; and their work was emblematic of a certain form of street art or graffiti, the artist in question being a prime exemplar of his or her particular style. These parameters ensured that the text remained both relevant and contemporaneous (as well as avoiding unnecessary repetition of artists of similar styles). This criteria also meant that we excluded works that occur in the private world of the gallery or the auction house, works that are institutionally commissioned, and the so-called latrinalia (markings made on lavatory or restroom walls) and gang graffiti that work within a more purely literal style. While these may all be worthy topics of study, it is simply contemporary artists who independently produce art in the public realm that we have chosen to feature here.

The individual city profiles—three from North America, three from Latin America, four from northern Europe, three from southern Europe,

and three from the rest of the world—were determined through another set of criteria: Locations had to contain a critical mass of artists; be of equal historical and contemporary importance; and to have produced a distinct variety of Independent Public Art. As such, the global scope of work shown in *A World Atlas of Street Art and Graffiti* has materialized from various aesthetic lineages. Although the common point of foundation for the majority of the work featured is the spray can art that so famously burgeoned in New York City, other equally important movements, such as the aforementioned Italian Arte Povera and Brazilian *pixação*, American pop art and land art, the political stencils of Argentina, the Dutch De Stijl movement, and Mexican muralism, have also exerted an immense influence on the artists profiled. The city profiles provide the historical context for the art that is produced in these locations today, detailing the surrounding influences that enabled the growth of the artists who emerged from these particular sites, including the work of pivotal figures such as Banksy and Barry McGee. Demonstrating the enormous breadth and scope of this global movement, the book presents a body of work not linked through any specific formal aesthetic or conceptual standpoint, but through its physical status in the heart of the public sphere, its status as an art form intoxicated with the potential that this location bestows.

As a form of popular art with a total lack of middle ground—works are either immediately destroyed or reverently protected, practitioners are either fined and imprisoned or idolized and adored (often both at the same time)—it is the strength of feeling that these artworks engender that is so enrapturing. Exploring work that is both consensual (outward-looking and community embracing) and agonistic (inward-looking, with more subculturally centered aspirations) in its approach, this volume brings together a group of diverse practices that are combined through their commitment to the public sphere whatever the cost in time, money, and risk—a commitment to working for pleasure not gain, a commitment to the belief that working in the public sphere is the only honest form of practice. The artists featured in this book are therefore those for whom the city is a medium not merely a canvas, a site for play and performance not merely advertisement and ego. By giving these artists the visual and textual attention they deserve, I hope this book not only gives a taste of the conceptual and material beauty of these practices, but also acts as a springboard for readers to delve deeper into the work of each artist. As an art form that is so often treated with disdain—whether through condemnation by the police and judiciary or through its treatment as a second-class artistic citizen by academics and publishers alike—*A World Atlas of Street Art and Graffiti* demonstrates the enormous vibrancy of this popular form of global contemporary art, a practice of image-making that remains untethered by the restraints of the white cube.

NORTH AMERICA

NEW YORK SAN FRANCISCO LOS ANGELES

SWOON REYES AUGUSTINE KOFIE KATSU REVOK SEVER KR REMIO MARK JENKINS JETSONORAMA BNE SHEPARD FAIREY EVAN ROTH GESO JURNE MOMO NOV YORK CALEB NEELON ESPO FAILE HOW & NOSM RON ENGLISH THE READER EL MAC JIEM

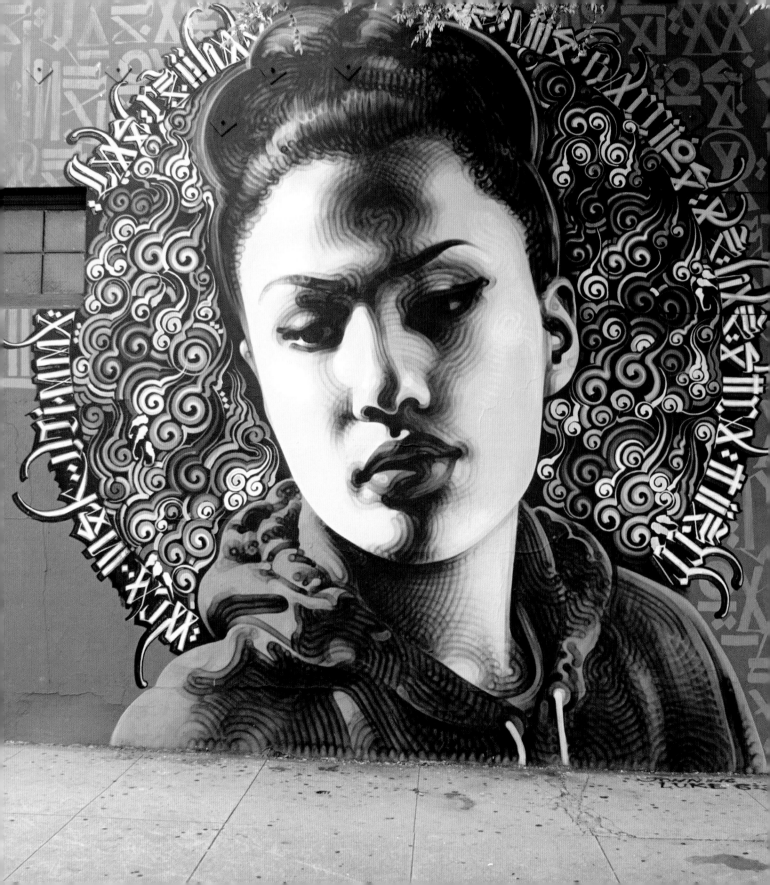

1 *La Reina de Thaitown* by El Mac, Los Angeles, USA, 2010 (background by Retna)

As the birthplace of modern graffiti, North America has had a pivotal and enduring influence on Independent Public Art. It remains a key place of pilgrimage for adherents of illicit art today, with graffiti artists in particular being drawn to New York as a location they must visit and where, if possible, paint. The region has continually pushed at the boundaries of graffiti since its inception in the late 1960s; its "fifteen-year head start on the rest of the world," as Caleb Neelon defines it (see pp.16–17), has led to many aesthetic innovations in Independent Public Art emerging from within its borders. North America has also been at the forefront of graffiti's somewhat precarious flirtations with the art market (preceding the boom of the early 2000s by around twenty years) and at the vanguard of the metamorphosis from classical graffiti to what is now commonly known as "street art." Furthermore, the region has produced a wealth of artists whose formal and conceptual developments are still being digested by many today.

Of the three cities individually profiled, New York's connection to what has often been termed as "spray can art" is as inexorably linked as it is to being the home of iconic landmarks like the Statue of Liberty and the Empire State Building. It has consistently produced and nurtured leading artists in the Independent Public Art world since its genesis, and the contemporary stylistic advances made in this great metropolis match its historical ones. Although artists as diverse as Blade, Cost and Revs, Dondi, and Reas stand on a significant pedestal, their work lionized and incessantly pored over since it was first produced, present-day practitioners, such as Espo (see pp.18–21), Faile (see pp.22–5), Katsu (see pp.28–9), and Swoon (see pp.40–3), have continued to produce an equally heterogeneous and pioneering form of work, one that has not lost the grit, panache, and authenticity for which this city's inhabitants are so renowned. A place in which coarseness and elegance are often intertwined, the physical harshness of the city interposed with its cultural refinement, New York remains one of the world's most important sites for Independent Public Art.

San Francisco (or the Bay Area generally, to be more precise) has had a quite different trajectory to New York. As a more laid-back, typically West Coast location it has produced its own distinctive form of Independent Public Art. Its most famous son, Barry McGee (or Twist) is probably the most accomplished and respected artist to have emerged from the graffiti underground in the whole of North America (if not the world). He is also one of the first artists from the region to move from a textually based graffiti practice into a more iconic or figurative sphere. Influenced strongly by (and also a member) of what has been termed the Mission School—a San Franciscan art movement with a classical American folk aesthetic at its core (including the hobo and surf cultures), McGee has in turn influenced the next generation of artists about the vast potential of graffiti. Like New York, San Francisco and the Bay Area has also acted as a fulcrum attracting artists from all over the country, particularly in the 1990s when the city's graffiti scene thrived through the influx and influence of new residents. However, what the city has always been renowned for is its spirit of innovation. From KR's drips (see pp.68–9) to BNE's stickers (see pp.60–1), from McGee's figurative icons to Jurne's textual figuration (see pp.64–7), it is a city that has stretched the scope and horizons of the urban arts.

The last of the three cities profiled, Los Angeles, has also developed its own unique character. Although the MSK/AWR collective dominates the scene today, with members such as Revok (see pp.82–3), Rime, and Retna all global graffiti superstars, the city's *cholo* gang style of graffiti writing must be considered a crucial part of its historical background. As a genuinely local aesthetic whose gothic script has now become legendary, this Latino influence has affected the city's artists as much as its constant sun, an environmental factor whose impact can be seen in the vivid colors that many of the local artists have employed. While the city has provided the stage for numerous groundbreaking moments in street art—Saber's infamous piece on the bank of the Los Angeles River in 1997 perhaps being its most legendary—its status as the entertainment capital of the world has also pulled many practitioners into its orbit, establishing it as a location of key importance in terms of the market as well as the aesthetic itself.

While all three cities have evolved their individual and contrasting styles—the grittiness of New York, the deep colors of Los Angeles, the folk-infused, innovative nature of the Bay Area (bearing in mind the danger of generalization)—there are a number of artists included in this chapter who have emerged from outside these three locations: They include, from the East Coast, artists Caleb Neelon (see pp.50–3) and Mark Jenkins (Cambridge and Washington, DC respectively; see pp.44–5); from the Southwest (in what is the most rural location featured), Jetsonorama (Arizona; see pp.56–7); from Canada, Remio and Jiem (although neither artist was actually born within its borders; see pp.92–3 and pp.90–1); and finally, The Reader (see pp.54–5), whose itinerant lifestyle leaves the allocation of one site in particular impossible. There are, of course, thousands of other artists from thousands of other sites all over North America—from Chicago and Miami, to Seattle and Detroit—whose work and efforts also make up the body and soul of this aesthetic arena. What remains clear about the practitioners featured in this chapter in particular, however, is the way they have taken up the North American mantle and embraced its status as both the fountainhead and the creative breeding ground of Independent Public Art. From the hacktivism of Evan Roth (see pp.46–9) to the vandalism of BNE, from MOMO's abstract compositions (see pp.30–3) to Sever's sardonic, satirical graffiti (see pp.84–5), these artists illustrate the enormous heterogeneity and creativity of contemporary Independent Public Art.

NEW YORK

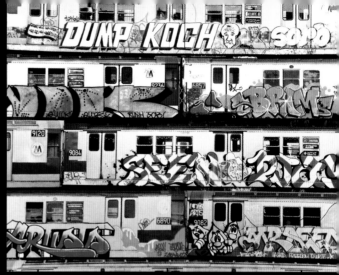

At the end of the tumultuous 1960s, few in New York City thought of writing their names—real or invented, along with maybe a street number—as a form of social protest, or as an art, but it certainly was a lot of fun. By the time *The New York Times* caught up with a Greek kid from Washington Heights who wrote TAKI 183 everywhere he went in his midtown Manhattan delivery job, the game was on. The next round of young writers discovered that they could enter the storage yards and layups for the subway system and write on dozens of cars in one go, letting the transit system do the work of spreading their names across the city. From there, writers such as Stay High 149, Phase 2, SUPER KOOL 223, and dozens more turned the name into art, as the real test began: Make your name stand out from the rest with color, design, and style.

New York City, thanks to its graffiti writers in the 1970s, had a fifteen-year head start on the rest of the world in terms of art in the

streets. No other city in the world had such a cascade of rebellious artwork, and because its center was the subway system, it was not restricted to one or two neighborhoods. Street artists in the 1970s who did work in specific neighborhoods, such as Gordon Matta-Clark's cut buildings in the South Bronx, for example, had to rely on their own photo-documentation to really get the word out about their ephemeral works. Subway graffiti writers of the 1970s, such as Blade and Lee, makers of equally ephemeral works, at least had their paintings roll in splendor up and down the elevated tracks of the Bronx and Brooklyn a few times for the entire city to see.

By 1979, when Lee had his first solo show at an Italian gallery, there were signs that the art world of commerce and investment was sniffing around the graffiti movement. By the early 1980s, two artists who operated on graffiti's periphery but who were not themselves graffiti writers except in the loosest of senses, Keith Haring (see image 2) and Jean-Michel Basquiat (see image 3), had gained the art world's approval. Graffiti writers, among them Crash, DAZE, Dondi, Futura, who painted both subways and canvases, began careers as gallery artists, showing in cities around the world and hand-delivering the graffiti movement to new cities.

More than anything, however, what introduced graffiti to the world was a book and a film in 1984. *Subway Art* by photographers Henry Chalfant (see image 1) and Martha Cooper captured subway graffiti masterpieces at their most glorious. As did *Style Wars*, a film by Chalfant and Tony Silver, which added motion and encapsulated the characters of artists, including Seen, Case 2, CAP, Dondi, and Iz the Wiz, as they spoke about what they did. By the end of 1984, the movement was global.

By the late 1980s, however, New York had nearly won its war against it. The stock market crash of 1987, along with the AIDS and crack epidemics, took their tolls from multiple angles of the New York art scene. The

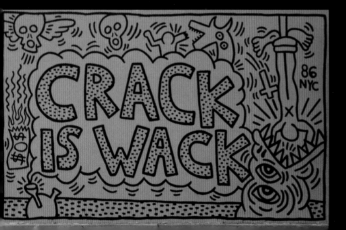

1 *We Drenched the City with Our Names*, Henry Chalfant, 'Art in the Streets,' Museum of Contemporary Art,
Los Angeles, 2011 2 *Crack Is Wack*, Keith Haring, 1986 3 Samo (Jean-Michel Basquiat), *c.* 1979
4 JA 5 Revs, 2009

subway system, which had fought graffiti in varying degrees of
effectiveness since it began, finally had a system that worked. By 1989,
the subways were officially clean and, despite the efforts of writers
such as VEN, REAS, and SENTO to keep them painted, any graffiti from
then on only made it to the world's eye with the artist's photograph.

Yet graffiti from the time of TAKI 183, even before it migrated to the
trains, had developed in the streets. With the trains presenting a less
appealing option, graffiti moved back to the streets, this time with tactical
planning to saturate the city by writers such as JA (see image 4), VFR, JOZ,
and EASY. By the early 1990s, a writing duo had emerged who stripped
graffiti down to its most effective elements and added in new media—
handbills, sculpture, and murals—as they saw fit. By 1994, the Cost and
Revs (see image 5) partnership in New York had rekindled the interest of
the downtown art world in the street, and had given the movement that
would later be known as street art the legs it needed to run wild.

A Philadelphia transplant and frequent Revs collaborator in the late
1990s, Espo (see pp.18–21) had by 1999 begun painting the ubiquitous store
grates of New York into the giant block letters of his name. Using oil paints

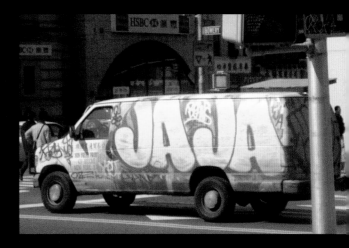

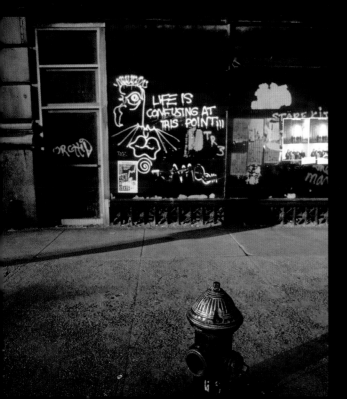

and his gift of the gab to undertake the unsanctioned improvements in
broad daylight, Espo was soon drawn to the city's sign painting tradition
and began meshing it into his artwork. Former Rhode Island School of Design
student Shepard Fairey (see pp.86–9) made dozens of visits to downtown
Manhattan, and inspired by Cost and Revs, took his own postering style
worldwide. Longtime New York and New Jersey artist Ron English (see
pp.38–9) continued his hundreds and hundreds of billboard takeovers.

After the September 11 attacks in 2001, the popular appeal of street
art in New York and around the world took off. In New York especially,
the works by transplant artists such as Swoon (see pp.40–3), Faile (see
pp.22–5), MOMO (see pp.30–1), and hundreds of others, whether graffiti
writers or street artists, all seemed to indicate a simple message of
survival and a thriving culture that would not be held in fear. **CN**

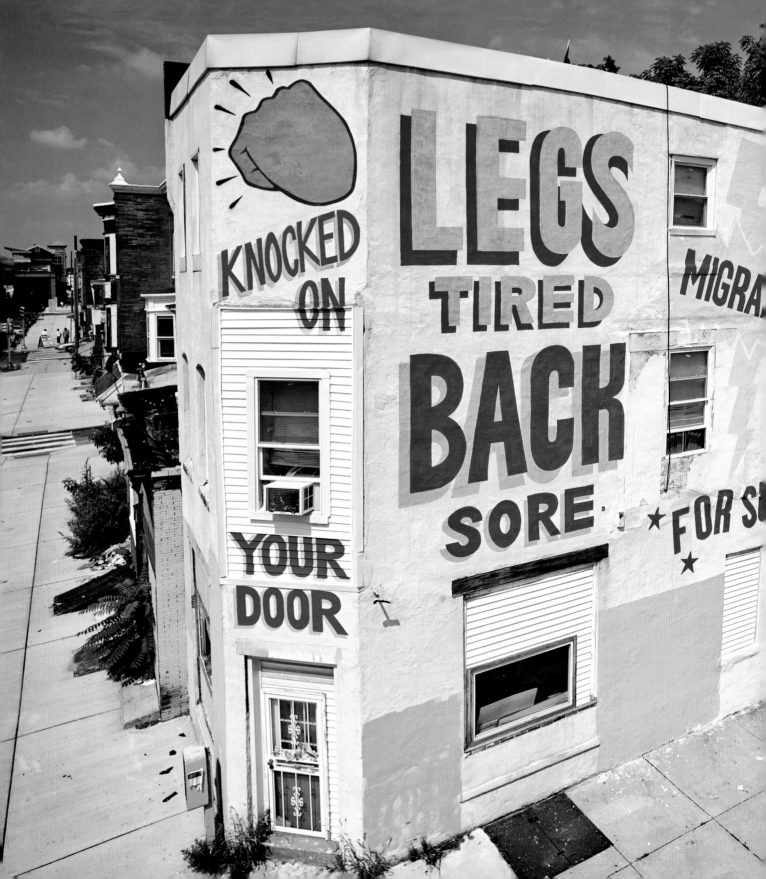

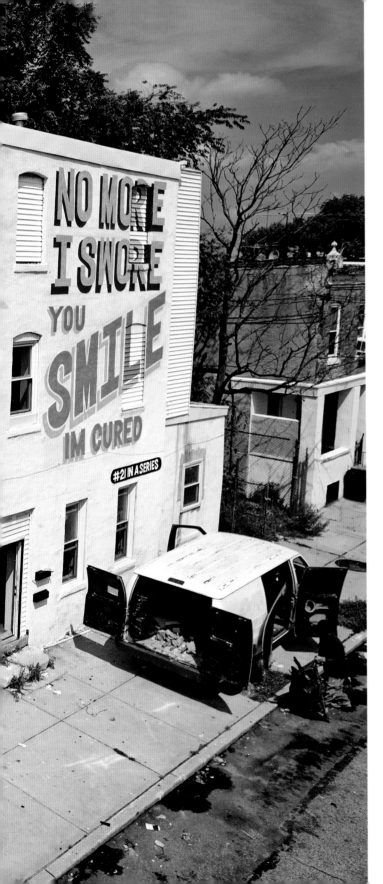

NEW YORK
BORN 1968, Philadelphia, USA MEDIUM Spray paint, installation
STYLE Emotional advertising THEMES Community, love, vitality
INFLUENCES Vernacular art, street signage, typography, advertising

ESPO
STEVE POWERS

Espo, perhaps more famously known as Steve Powers, is an artist, sign painter, and self-confessed raconteur based in New York City. Having made the journey from graffiti writer to Fulbright scholar, Powers has progressed from traditional illicit work to highly conceptual installations, from classical sign painting to visionary community projects, utilizing an endearingly impudent, witty style regardless of the medium or theme he chooses. With a mastery of wordplay and typography intertwined in his search for the perfect triad of candor, clarity, and creativity, Powers forms an aesthetic that disrupts the fine line between artist and artisan, between art and advertising, and celebrates the beauty and sincerity of the vernacular within each project he undertakes.

Born and raised in West Philadelphia, Powers first remembers painting at about the age of three or four, when he says he mashed crayons over every wall "from three feet down" in his family home. Although his artistic instincts were set from an early age, his entrance into graffiti came admittedly late, however. He first began to tag around his neighborhood when he was sixteen and it satisfied, as he puts it, his need for "line, color, [and] adventure." Powers immediately understood graffiti as a compromise of crimes, a practice that contained the allure of the illicit yet which could produce a highly refined aesthetic, a world away from the staid still lifes he was being instructed in at his art classes. While his growing love of graffiti pushed him toward Philadelphia's University of the Arts, at the same time Powers was founding, writing, and editing the legendary *On the Go* magazine, a pioneering graffiti and hip-hop publication that he ran between 1988 and 1996. He continued to experiment with his graffiti, however, and by 1997, after deciding to focus on his artwork more seriously, Powers initiated his groundbreaking *Exterior Surface Painting Outreach* project (an inversely formed acronym of his graffiti name), which represented a radical new approach in both formal and conceptual terms. Working on the already graffitied surfaces of shop front shutters, and taking on the guise of a public employee (working openly during the day and providing his believably bureaucratic acronym if questioned), Powers painted huge blocks of either white or silver on top of the existing graffiti, subsequently marking out his name in the negative space through a

1 *Knocked On Your Door*, 5027 Market Street, Philadelphia, USA, 2009

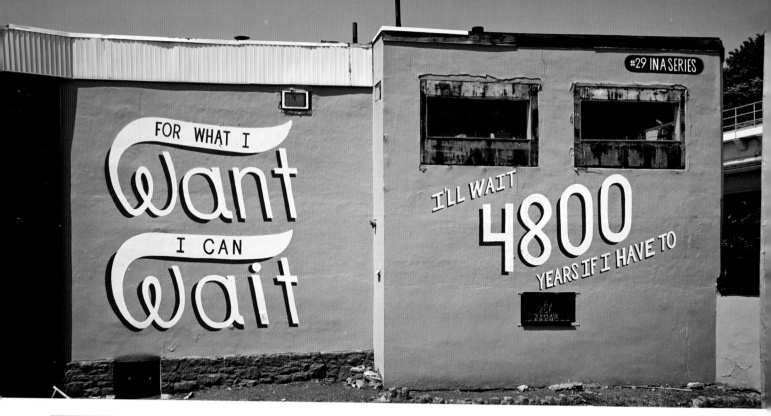

1 *Want and Wait*, 4800 Market Street, Philadelphia, USA, 2009
2 *Your Everafter*, 6100 Market Street, Philadelphia, USA, 2009
3 *Hold Tight*, 16 N. 51st Street (left) and *Home Now*, 5101 Market Street (right), Philadelphia, USA, 2009 4 *Saboteur*, Philadelphia, USA, 2010

sparing and delicate use of black (in a classic figure/ground reversal). After racking up more than seventy of these designs in New York City, he was eventually arrested for this work in 1999. However, the project marked the beginning of Powers's search for a way of rechanneling his graffiti skills, fueled by his urge to communicate in a distinctive and inventive way as he moved away from strictly illegal work.

By the beginning of the new century, with the release of his book *The Art of Getting Over* (1999), which featured some of the most infamous graffiti writers from the 1990s, as well as his exhibition "Indelible Market" and installation *Street Market* (2000) produced with Barry McGee and Todd James, Powers had shown his ability to use the skills and knowledge he gained on the street to produce truly groundbreaking projects giving perhaps the clearest taste of the American graffiti movement in the final decade of the twentieth century. However, it was his project *The Dreamland Artist Club* in 2004 that fused together all his various inspirations and took his work in the direction that he is now famous for. Inspired by Margaret Kilgallen's sign-painting work in the Tenderloin area of San Francisco, and noting the dilapidated state of many of the store signs in the Coney Island district of south Brooklyn, Powers set about

reforming these once illustrious signs. He even repainted the official New York landmark—the Coney Island Cyclone—and invited a whole range of artists and friends to help complete the project. Recognizing the integral connection between traditional hand-painted advertising and graffiti—their similar iconographic clarity and equivalent obsession with fonts, colors, and public locations—Powers used this connection to build an oeuvre around what he terms "emotional advertising," a form of publicity concerned "with the actual business of living" and therefore separate from the mendacious effects of brute capitalism. He went on to produce related work as part of his Fulbright scholarship in Dublin and Belfast, as well as the series *A Love Letter For You* completed back in West Philadelphia (see images 1–4 and image 1, pp.18–19), which moved people through their intimacy and purity. Taking inspiration from both the origins and the originator of modern graffiti practice, therefore, from the messages of love that Philadelphian artist Cornbread scrawled across the walls of the city, Powers desires a reinstitution of this original message in his projects: Using "class, style, and panache" to advertise "strength, life, and vitality," he has created a graceful, poignant, affective form of graffiti, an aesthetic of love that perfectly synthesizes both word and image.

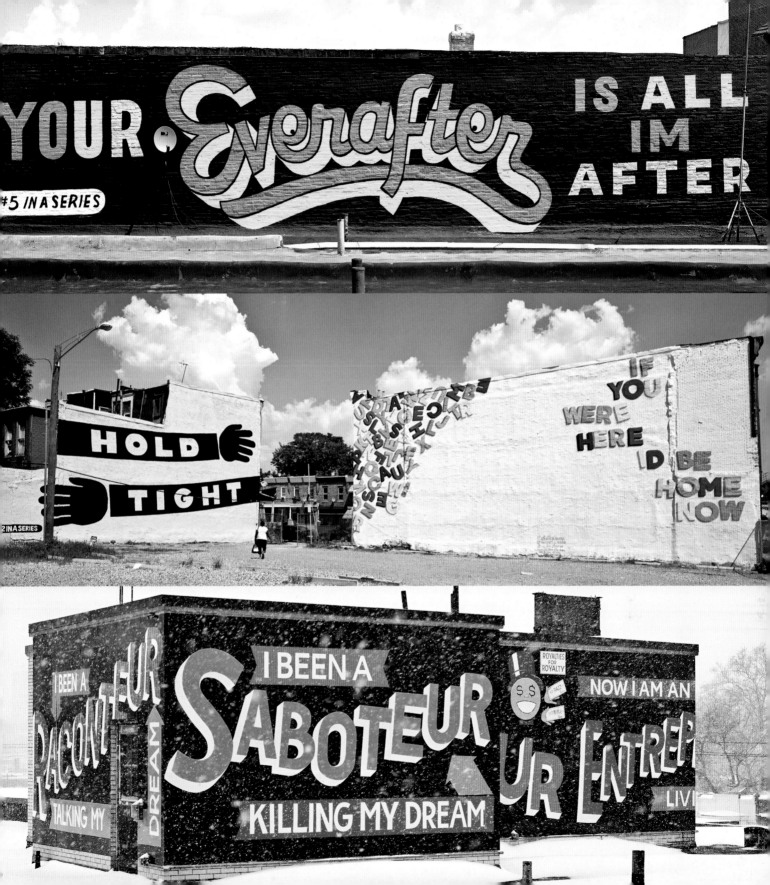

NEW YORK
BORN 1975 (McNeil), 1976 (Miller) MEDIUM Posters, wheat paste, sculpture
STYLE Collagist, overlaid printmaking THEMES Ephemera, nostalgia, religion,
popular culture INFLUENCES Street sign typography, vintage advertising

FAILE

Although they originated neither the wheat paste nor the stencil art
movements within Independent Public Art, Faile—a collective comprising
the artists Patrick McNeil and Patrick Miller—have taken this means of
practice to unprecedented heights, creating a multi-layered, collagist
style of production that now stands as an archetypal model for this kind
of artistic approach. Through their appropriation of found imagery, their
densely overlaid printmaking and the inclusion of whimsical, often poetic
phrases in their work, they have fashioned a pop-infused, dirty aesthetic
that presents a poignant reminder of the past, a vehicle through which
to reawaken a certain type of collective cultural consciousness. With
more recent projects, Faile have moved away from using paper and paint
in favor of more unconventional sculptural mediums, but the street still
remains the key location for their practice: Whether working on two- or
three-dimensional forms, this is the site in which their work most fully
comes to life.

Both of the Patricks had become New York residents by the late 1990s
(McNeil having moved there to attend college in 1996 while Miller
remained in Minneapolis to study) and witnessed the burgeoning street
art scene in the city, becoming hugely influenced by work from artists
such as Bast and Shepard Fairey (see pp.86–9). In 2000, they met Aiko
Nakagawa (now producing solo work under the name Lady Aiko), who
would work alongside them for five years. The three artists felt the urge
to contribute to the nascent street-art discourse around them and utilized
their printing skills to develop their first project, a set of large-format,
monochromatic, screen-printed female nudes.

The group had originally adopted the name Alife (taken from an early
work of Miller's), a term expressing the way they were, in their own
words, "starting something new, something that had a beginning." The
decision to change their name to Faile came about not only because they
became aware of the existence of a New York clothing company with
the same name, but through the idea that, as McNeil revealed in 2007,
"you could Faile to succeed," that there was a "growth process where you
could create the most from what you were given and move forward from
there." They employed numerous different images within their early
work—street sign typography and magazine-style cut-outs being the

1 Brooklyn, New York, USA, 2011
2 Berlin, Germany, 2004

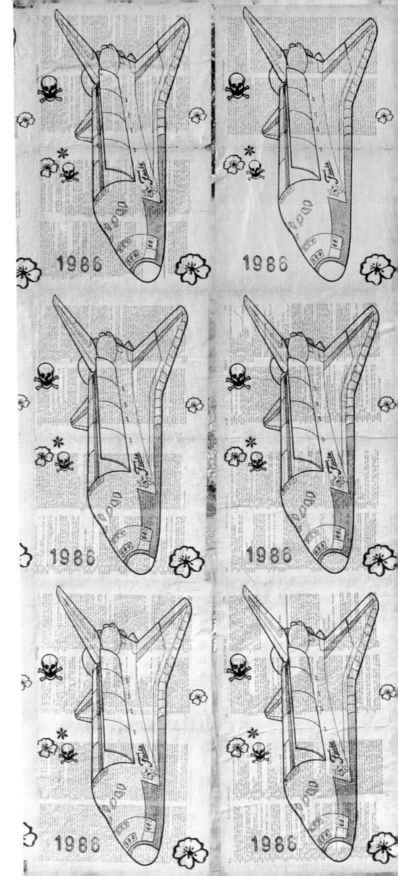

1 *Prayer Wheels*, Brooklyn, New York, USA, 2009
2–4 *Temple*, Lisbon, Portugal, 2010

most common motifs. But it was their use of the iconic image of the Space Shuttle *Challenger*—displayed alongside the year of its tragic destruction (1986)—in what became almost a secondary signature for Faile, that was to define the collective's nascent output, an image that represented something more than just a well-designed graphic or self-aggrandizing advertisement (see image 2, p.23). Faile's use of the *Challenger* was intended to provoke a secondary reaction in the viewer (aside from the primary recognition of the Space Shuttle itself), to provide a reaction that would, they hoped, "allow the viewer to travel, to go to a time and place through an image." Through their use of strange, twentieth-century ephemera, through taking some lost image and "tying a little piece of that back into something that's happening today," Faile were attempting to develop a sense of perpetuity within their work, a palimpsestic layering made up not just of images but of time itself. This paradoxical pairing of the transient and perennial, the modern and the historical, converging in a singular object, has subsequently become a key motif throughout Faile's projects, a way of embedding a sense of density into their work, and producing an artifact that cannot be fixed to any particular time or space.

Faile enjoyed enormous success with this earlier style, which worked equally well in the street or the gallery, on posters or canvas. Their more recent work, however, has moved into outwardly quite different— although conceptually comparable—terrain. With both *Prayer Wheels* and the groundbreaking installation *Temple* (see images 2–4) in Lisbon, Faile have embarked on a more rigorous investigation of the space between the sacred and profane—by taking popular religion, rather than popular culture, as a starting point. *Prayer Wheels* (see image 1) took a Buddhist object of invocation and incorporated many of Faile's classic images into it, metaphorically animating their work with the energy of this popular religious object. *Temple* went several steps further, however, forming a full-scale prototype of a "ruined" (in fact, just half-built) Baroque chapel in a central square in Lisbon. With its hand-made tiles, carved reliefs, spectacular ironwork, and mosaics, all undertaken in Faile's inimitable style—although in far more muted colors than is typical of their usual approach—*Temple* followed on from many of the key themes and practices in the two Patricks' work, such as overlayering, cryptic traces of imagery, and the merging of ephemeral and perpetual elements, while taking the physicality of their medium, its basic materiality, to an almost unimaginable magnitude.

Reintegrating the past and the present in one moment, returning popular visual culture to the space of the streets, *Temple* acts as a signpost for Faile's oeuvre as a whole. It is the architectural embodiment, or perhaps consequence, of their earliest aesthetic convictions.

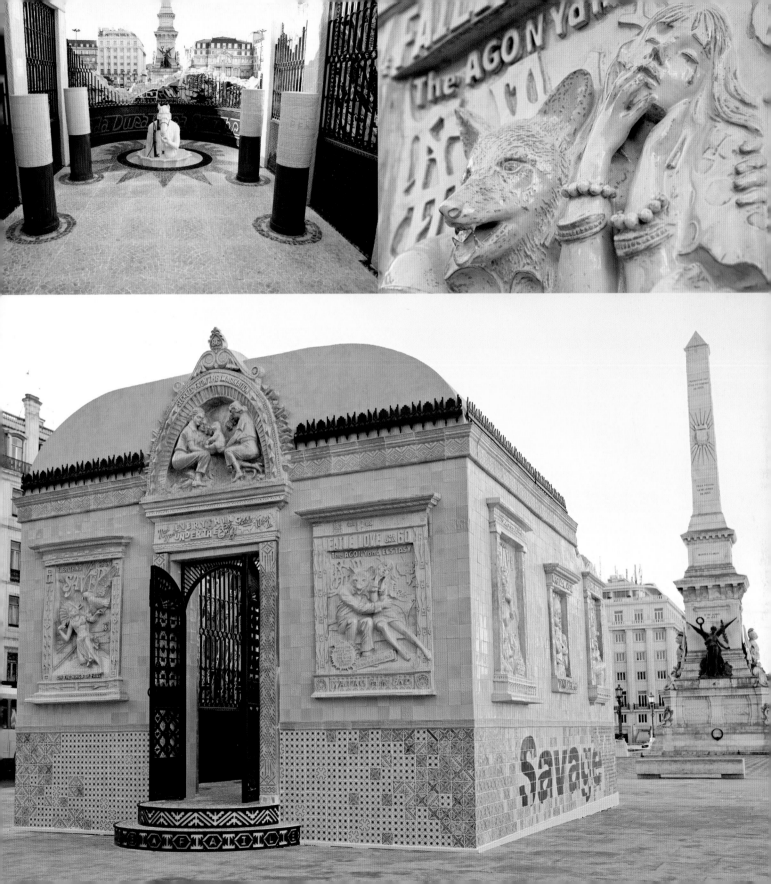

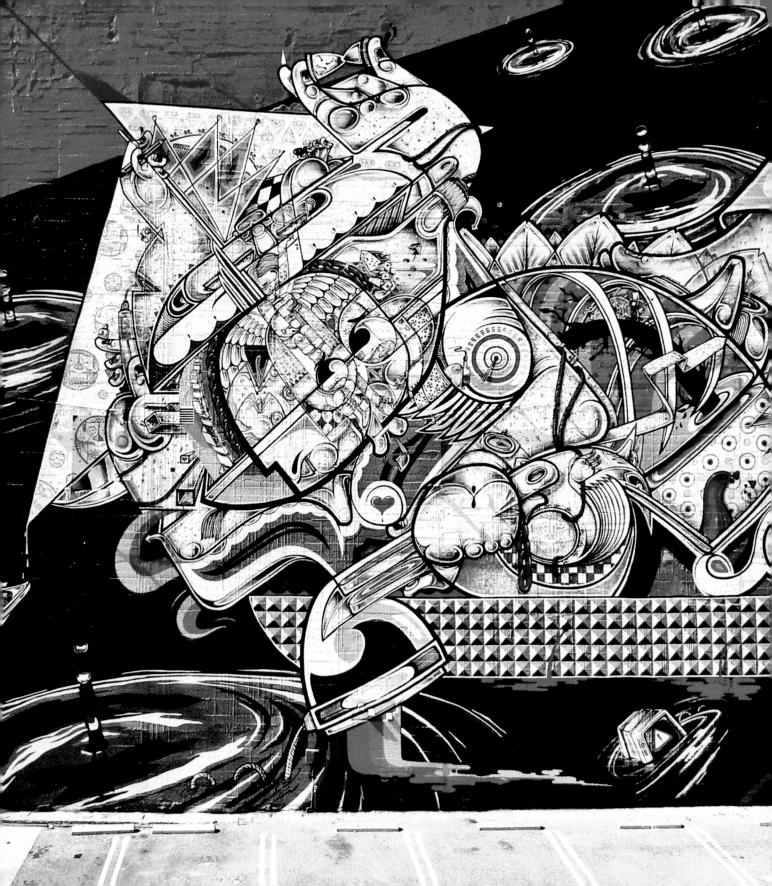

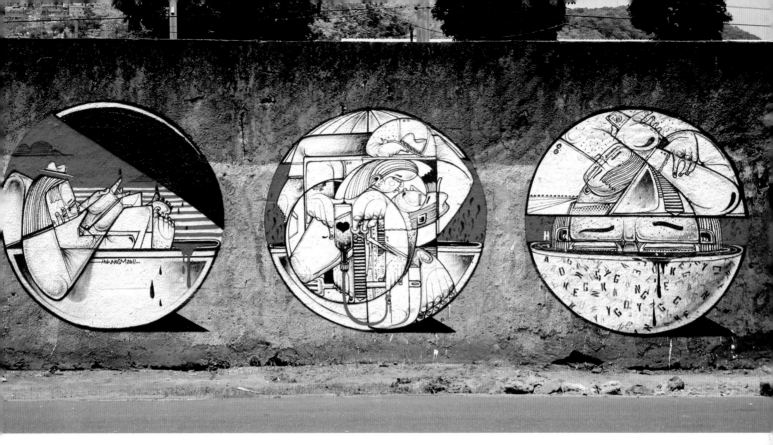

NEW YORK

BORN San Sebastián, Spain **MEDIUM** Spray paint
STYLE Symbolic figurative graffiti, minimal palette (black, white, red)
THEMES Allegory **INFLUENCES** TATS CRU **CREW** TATS CRU

1 *Heartship*, Los Angeles, USA, 2012
2 *Dot, Dot, Dot*, Rio de Janeiro, Brazil, 2011

HOW & NOSM

Born in San Sebastián, raised in Düsseldorf, and now residents of New York for the best part of fifteen years, the transatlantic twins Raoul and Davide Perre (perhaps better known as How & Nosm) have movement in their blood, a traveling spirit that has taken their work to more than sixty countries around the globe. Although originally the duo worked in more of a classic graffiti tradition, their recent work has marked a development toward a figurative, symbolic technique, a delicate and highly refined aesthetic incorporating a multitude of embedded messages. Using only a minimal palette (white, black, and red), they have created a uniquely personal style that is still in the process of expansion—both literally, as it moves onto an ever-more impressive scale, and figuratively, with an increasingly allegorical tone and broader narrative scope.

Growing up in a small suburb of Düsseldorf, a town with "no entertainment besides crime," the two were introduced to graffiti at an early age. They were raised on welfare, and tagging was one of the few

free activities available, as well as a way to step outside the poverty and drug abuse that surrounded them. The duo continued to learn and develop throughout their teens, spending time painting all over Europe between 1990 and 1997—the year they arrived in the Bronx, with the offer of free accommodation through a friend. There, they met up with the legendary TATS CRU and soon became part of the collective themselves.

The move to New York had become permanent by 1999. The style for which they are now best known came later, however, a reinvention that they now view as a way to maintain their motivation and keep themselves inspired after more than twenty years of working with lettering. This shift of approach gave How & Nosm a space that they could comfortably call their own, but also helped them to rekindle their passion, driving them on to hone and perfect their new style. By rejecting polychromy in favor of imagery characterized by elaborate patterns and minimal color, they created a platform on which their combined skills could shine to the utmost. It was an aesthetic deeply indebted to, but radically divergent from, its graffiti roots, one that has enabled them to push the form into spaces hitherto unexplored.

BORN Unknown MEDIUM Spray paint, stickers, video, fire extinguishers
STYLE Conceptual vandalism THEMES Destruction, pseudo-advertisements,
digital vandalism CREW Big Time Mafia (BTM)

KATSU

Katsu is a vandal, a conceptual vandal. He is not an artist, an illustrator, or a designer. He is, in his own words, a graffiti writer who seeks to "strategically execute systematic vandalism," to destroy, hack, and subvert the urban environment. A member of the famed Big Time Mafia (BTM), Katsu's work is not about appropriation, adaption, détournement, or decoration; his aesthetic is purely concerned with destruction and damage; it is an aesthetic formed to "promote crimes and disrupt the look of the city."

Katsu is probably most infamous for his adoption of the ultimate vandalistic tool—the customized fire extinguisher. Unknown in the graffiti world until only a few years ago, the fire extinguisher—due to the high-pressure discharge of the unit as well as its innate portability—has enabled him to create mammoth pieces up to around 30 feet (9 m) in height that can take possession of an entire building. Aside from producing hundreds of these huge tags all over New York City and beyond, most notoriously, Katsu used this method of production on the entrance wall of the Museum of Contemporary Art in Los Angeles (MOCA) the night before the opening of the hugely influential "Art in the Streets" exhibition in 2011 (see image 1). The piece was, he says, an attempt to "test [curator] Jeffrey Deitch's motives"; his interrogation of the exhibition's validity and authenticity was directly and unambiguously answered, however, when his tag was immediately removed by the museum. Out of respect, many artists, including the Brazilian twins Os Gêmeos (see pp.120–3), refused to paint over its erased shadow thereby implicitly validating Katsu's actions.

As well as using the highly destructive fire extinguisher technique to produce his graffiti moniker, Katsu also utilizes it for the production of his figurative icon—the single stroke skull. Produced in one, fluid, unbroken movement (and seeming to contain the word "tag" hidden within it), the skull symbol also features on the thousands of printed stickers Katsu employs within his practice (see image 4). It is a technique that, like the extinguisher, follows his principle of producing works that "take the least amount of effort and [have] the maximum impact." Appearing all over Manhattan and beyond, Katsu's stickers (see image 5), along with his recent range of pseudo-advertisements for Nike and New York's Museum of Modern Art (MoMA)—featuring famous icons such as Steve Jobs, Bill Murray, Jay-Z, Morrissey, Damien Hirst, and Kurt Cobain—attempt to reach the most amount of people in the minimum amount of time, promoting his destructive brand in any way he can.

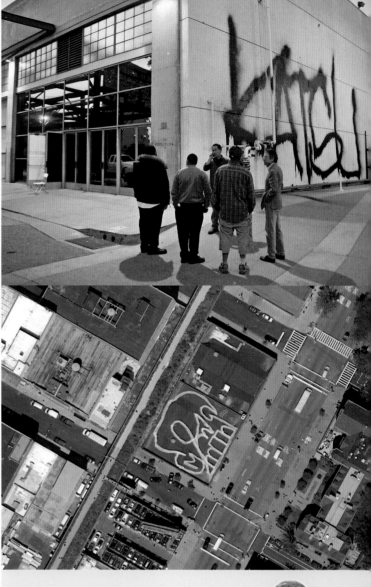

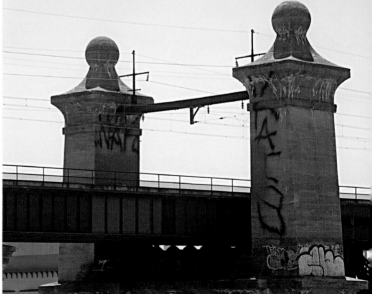

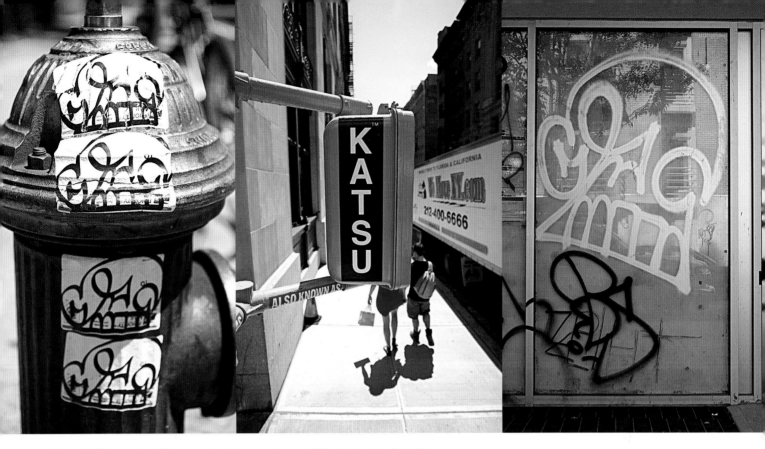

1 *Real Graffiti*, Los Angeles, USA, 2011 2 *Powers of Katsu*, Chelsea, New York, USA, 2009
3 *Welcome to HELLsgate*, New York, USA, 2009 4 East Village, New York, USA, 2012
5 Soho, New York, USA, 2012 6 Brooklyn, New York, USA, 2012

Following this approach, Katsu has also taken advantage of a variety of digital media tools to enhance his work. These include tools such as his (sometimes doctored) videos (featuring Katsu tagging the White House or a Picasso work, for example); smartphone applications (such as FatTag and FatTag Deluxe); and thermoplastic sculptures (produced with geek graffiti doyen Evan Roth, see pp.46–9). Forming what he labels "conceptual graffiti"—a "lethal" combination of graffiti and digital technology—for him this practice must always work alongside "actual vandalism" to remain authentic, however. His film *The Powers of Katsu* (the title of which references Charles and Ray Eames's classic 1977 film *Powers of Ten*) follows this ideal exactly as a project that merges his illicit and conceptual practices in one: Reproducing his skull tag from the scale of ⅟₂₀ of an inch (a needle onto a grain of rice) increased to 120 feet (36.5 m)—using a fire extinguisher on a New York rooftop—and an image visible from Google Earth (see image 2), the legality of the practice remains irrelevant to its status as a task done, an experiment in scale that necessitated its completion.

For Katsu, therefore, graffiti is purely about reputation and recognition; it is about getting his name out to as many people as possible, promoting himself, his tag, and his icon, as the means and ends of his practice. While his work may be self-consciously conceptual, therefore, taking manifold and increasingly innovative forms, the basic hypothesis is simple: To be "up," to take his name and image as far as it can possibly go. Rather than "fading colors" or "blowing on lines to prevent them from dripping," rather than fantasizing about painting trains that will never be seen outside of a photograph, Katsu is on the streets producing work in which mass takes precedence and in which quality *is* quantity.

Wholeheartedly embracing fame (going directly against the highly self-conscious rejection of celebrity that many artists adopt), he turns graffiti "into a game in which the objective is to gain 'FT's' or 'FameTokens' in the most effective ways possible." For him it is a game in which "placing my name in people's lives, and in unique ways, is the main objective." Katsu therefore actively wants his work to be hated and despised by the public, but at the same time he wants it to be loved by genuine graffiti writers: He wants to conquer space solely with the use of ink, to invade and occupy the city by any means possible.

NEW YORK

BORN San Francisco, USA **MEDIUM** Spray paint, acrylic paint, paper, wood
STYLE Non-figurative graffiti, collage, sculpture, installations
THEMES Randomness, uncertainty, shapes, kinesis

MOMO

1 Lisbon, Portugal, 2011
2 *PLAF—Autonomous Mechanisms*, East River State Park, New York, USA, 2008

MOMO's instantly recognizable, vibrant, non-representational aesthetic is perhaps a counterpoint to the non-figurative graffiti of the Italian artist 108 (see pp.334–7). In contrast to 108's instinctive approach to abstraction, MOMO's works are highly manipulated; he utilizes the infinite possibilities of collage in his constant search for novel—although not necessarily visually perfect—forms. Whether working with kinetic sculptures or silk-screened posters, spandex, or spray paint, MOMO's experiments with shapes, form, and color investigate two- and three-dimensional spaces, destruction and construction, movement and quietude.

Although he has lived in New York for six years (his longest stretch in any one location), MOMO can be considered an archetypal American nomad, embodying the deep strain of wanderlust entrenched within his San Franciscan heritage. He has traveled all over the United States and lived in Jamaica, Spain, and numerous other locations. MOMO can be seen as an outside artist in the more literal sense of the term, one whose work is deeply indebted to a life al fresco. Having initially worked in a highly representational manner, his first taste of graffiti came through painting freight trains in Montana (following the classic hobo tradition). He went on to paint El Greco-inspired images of local men while living in Andalucía (similar to, if less monumental than, the work of Jorge Rodríguez-Gerada), ending his naturalistic period on his return to the States wheatpasting life-size (or larger) images of mischievous children all over New Orleans.

With the move to New York complete, abstraction started to dominate MOMO's work, which also betrayed the influence of contemporary European artists such as Eltono (see pp.280–3), Filippo Minelli (see pp.340–3), and Zosen (see pp.312–13). He went on to produce a poster parodying the cover of *The New Yorker* (in 2005) and, the following year, created both the world's largest tag—in the form of a thin, eight-mile- (13-km)

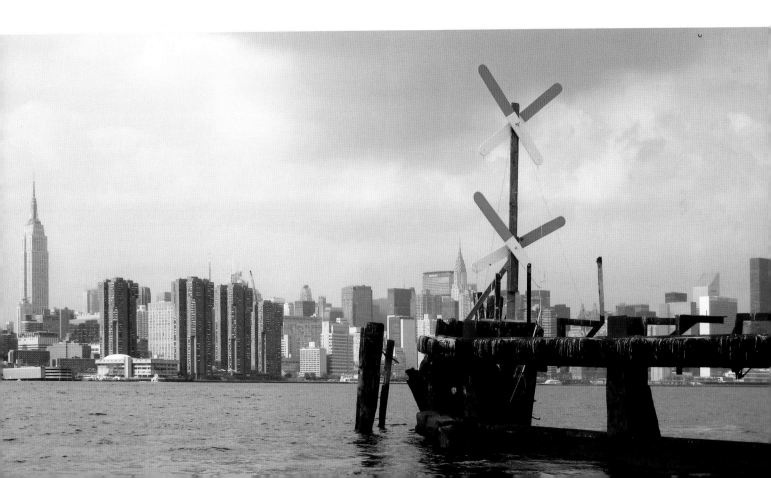

1 Manhattan, New York, USA, 2009 2 Brooklyn, New York, USA, 2009 3 Manhattan, New York, USA, 2009 4 New Orleans, USA, 2010 5 London, UK, 2008 6 La Coruña, Spain, 2010

long trail of paint across Manhattan's streets (see map pp.34–5)—as well as a totem pole in the East River, in collaboration with Marie Lorenz and the aforementioned Zosen. These works suggest that he was developing a more conceptual dynamic, yet it was his switch to collage that introduced what we now understand as the MOMO aesthetic. Producing these new works entirely in situ, armed only with a knife and sheafs of colored paper, MOMO would arrange and rearrange his materials in an effort to discover their full potential. He has since described each of his collages as an "experiment for intellectual delight," adding "I try to set up uncertain compositions that break with the surroundings [and] feel unstable." Employing a set palette of shapes, the collages interacted with the forms and structures around them, their physical status changing as they competed with, or imitated, their environment.

His next major project, the MOMO Maker, took the concept of collage to an entirely new level. Having built a computer program using gifs and free code, MOMO created a means of generating patterns in which the computer itself rearranged and restructured the different shapes and colors it was given, creating (literally) millions of variations from only a handful of original elements in never-ending compositional modularity, which you can see in action on his website (see http://MOMOshowpalace.com). He then transferred a selection of the results (including both successful and non-successful outcomes) into physical form. "Using the computer as inspiration and guide," he reveals, he still wound up with "the same mess of surprises" he had produced manually. He created sculptures, paintings, and large-scale murals from the patterns generated, but his series of silk-screened posters proved to be the most visually arresting end product of the MOMO Maker—not only because of the designs themselves, but also due to his innovative choice of site. Using a customized bike and roller, MOMO designed posters to fit the second-story "sidewalk sheds" so prevalent in New York City—a space ignored by graffiti artists and advertising companies alike—pasting up more than 400 street posters out of the thousands of possible designs produced (see images 1–3).

Since the Maker, MOMO's work has continued to intensify and mutate. In the project PLAF, completed with Eltono in 2008, the pair illegally installed seven kinetic sculptures in New York's East River (see image 2, p.31); focusing on materiality and uncertainty, the sculptures used the wind and the tide to affect the movement of these artworks on water. In projects conducted with Melissa Brown (2008) and Piet Dieleman (2011), MOMO incorporated elements of destruction and construction in which each artist took turns to paint over the other's work. The one constant in MOMO's diverse practice, however, remains his perpetual search for another way to experiment with form, driven by his boundless curiosity and his desire to take every combination to its ultimate state.

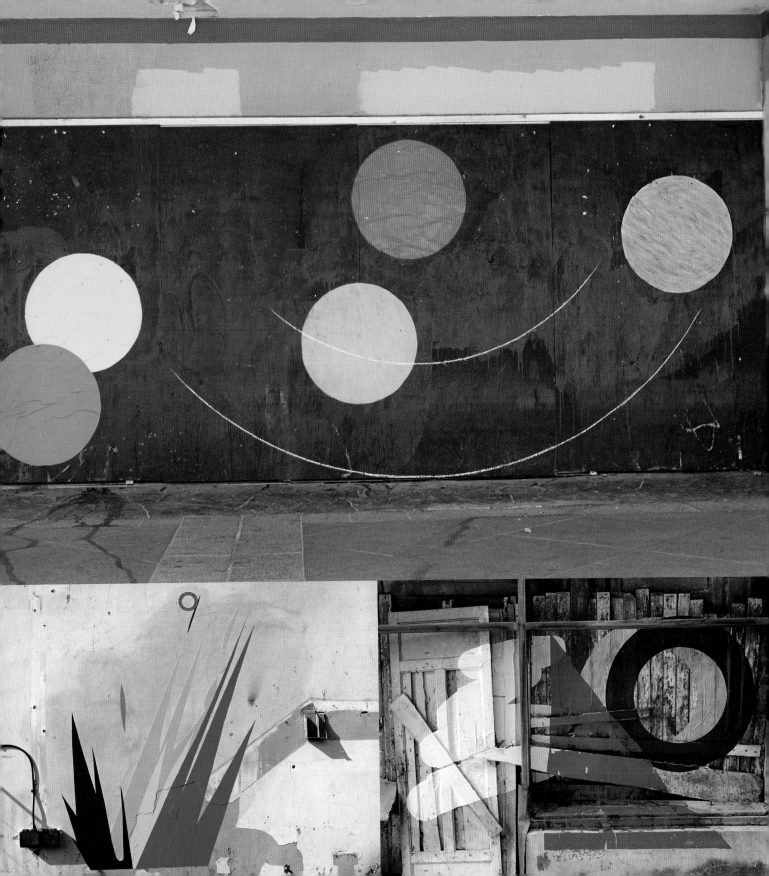

NEW YORK

BY MOMO

visible to the human eye; it is only truly accessible through physically shadowing its entire, complex, circuitous journey. It is a journey which, thanks to the modernist urban grid design of Manhattan, spells out each letter of his name in a single continuous movement (or one-liner): MOMO.

The map was produced in mid-2006, over two long nights spent cycling around the city; MOMO, being the DIY King of New York (see pp.30–3), fixed a five-gallon bucket of paint to the back of his pushbike along with a mechanism he constructed that slowly dropped paint while the bike was moving, tracing the journey that he navigated. The map can therefore be understood, just like every tag one encounters in the street, as a physical residue of a complex movement, denoting a past action, a past gesture. MOMO's map represents an experimental, innovative response to the world of graffiti, an artistic creation working on both microscopic and monumental scales. It can be regarded as a material deposit of an expedition, a map representing two nights as lived by the artist. It is a form of cartographic self-representation, a map of MOMO's passage from the East to Hudson Rivers, a clandestine, yet immense tag.

MOMO's almost imperceptible map is so diaphanous and unobtrusive that thousands, if not hundreds of thousands of people, have trampled upon it without ever being aware of its existence. It is a topographical survey traceable solely through a thin, but particularly long drip of paint, a now faded orange and pink rivulet that flows for more than 8 miles (13 km) through Manhattan. It is almost certainly one of the longest tags in the world, so long that in its entirety it is not even

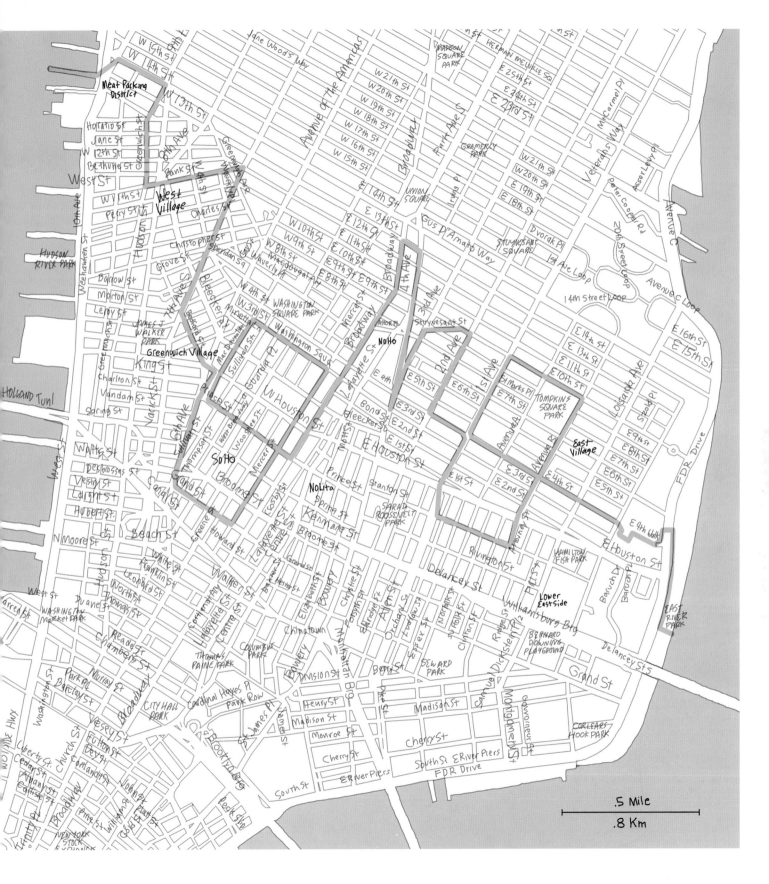

NEW YORK

BORN Unknown MEDIUM Spray paint, literature
STYLE Graffiti writing, writing about graffiti THEMES Obsession,
societal-political critique, philosophy INFLUENCES Revs

NOV YORK
AKA DUMAR BROWN AKA NOV

A writer of both raw, rugged graffiti and gritty, often grotesque novels,
Nov York aka Dumar Brown aka Nov is a Brooklynite who is totally
consumed with the culture of graffiti and possessed by the power of
the pen. He has laid his Nov York pseudonym to rest since the completion
of his first novel (an inspirational text entitled *Nov York: Written by a
Slave*), however, Nov continues to work illegally on the streets, although
he leaves these new projects almost entirely unattributed, allowing only
those "with a built in Rosetta Stone" to decipher their origins. Doing this
enables him to pursue writing in its more conventional terms; he has
therefore tried to liberate himself from the ego within his graffiti, painting
so that he can think more clearly, and later reflect and explore these works
through the means of fiction and intertextual academic writing. Although
his work on the streets continues unabated (although not to the extreme
extent it did during the 1990s), Nov's various short stories, scripts, and

novels now take precedence in his life, fulfilling his need to communicate
the mania, the love, the hatred—as he puts it, the "terrible obsession"—
he has with graffiti, to everyone and anyone who will listen.

Although most of Nov's public work remains hidden, camouflaged and
concealed through his desire for anonymity, some of his work does slip
through the gaps and is recognizable as his through its unmistakable
presence. The majority of this work continues to demonstrate the
same rough aesthetic he became renowned for and the wickedly
anti-establishment attitudes he has so strongly proclaimed. Having
grown up in the desegregated landscape of Brooklyn and spent years
teaching English in the unimaginably tough environment of the United
States Prison Industrial Complex, Nov is quick to regale against the ills
of modern America—against organized religion, the dangers of blind
patriotism, and the misdeeds of the police—using graffiti "as a tool of
dissension" and his words as a "sophisticated rant." While much of his
output functions through this provocative approach, Nov also tries to flip
this powerfully negative energy, working to advocate some of the more
poetic principles of graffiti practice through being a diligent student of its
history as well as being a dedicated student of a more academically

1 *Nazca Lines*, Brooklyn, New York, USA, 2012

critical language. Producing works that seek to expose the common ground that capitalism has tried to hide, Nov's contemporary graffiti writing intertwines with his literary activities, attempting to present the genius of graffiti in the language of those who so often demean it as a "low" art. His work *Nazca Lines* (produced with Gorey and Deoed, see image 1), which Nov eloquently writes about below, stands as an example of this component of his work. At one level it is a tribute to the ancient Peruvian geoglyphs that bear this name; on another it is an image with a raft of meanings that viewers may or may not instantly discern. Whether they are party to the various layers of significance or not, one explanation at least emerges from Nov's text:

"Why do you keep doing that?" is the question that the uninitiated continually ask the Graffiti Writer. "It's for God," I answer. Using the limited vocabulary intrinsic to written language in order to answer the question makes one seem illogical. That one must describe their bond with the divine using laymen's terminology is the actual error. I always felt the best answer was without words, more of a dance starting on the floor & rising with hands waving in the air, conjuring spirits & helping them up to the heavens, aka

"That's why I write graffiti." As I've grown older, in order to survive, I've had to accept society's authority & answer questions with complete sentences. But I won't relinquish my spirit.

Looking at the Nazca Lines and meditating on them & their creators I grow strong. When they were making these huge images, I envision their contemporaries could have looked at the lines on the floor & these "artists" wasting their time with this action that seemingly has no value & I hear them saying "Why do you keep doing that?" The Artist, sensing the cynicism in the questioner's voice might have done a dance starting on the floor & rising with hands waving in the air, conjuring spirits & helping them to the heavens, & then they would have responded "It's for God."

If it weren't for the advent of the flying machine, modern man might never have known about this ancient civilization or their intimacy with God, not that it would have mattered to the creators of the work. Maybe in a thousand years they'll have another machine that will show the people of that age the wonder that is graffiti. Maybe the dance will be felt and people still won't get simple answers to one-sided questions. Maybe nothing will happen & no one will ever talk about graffiti or the Nazca Lines again, but God will know for whom it was done.

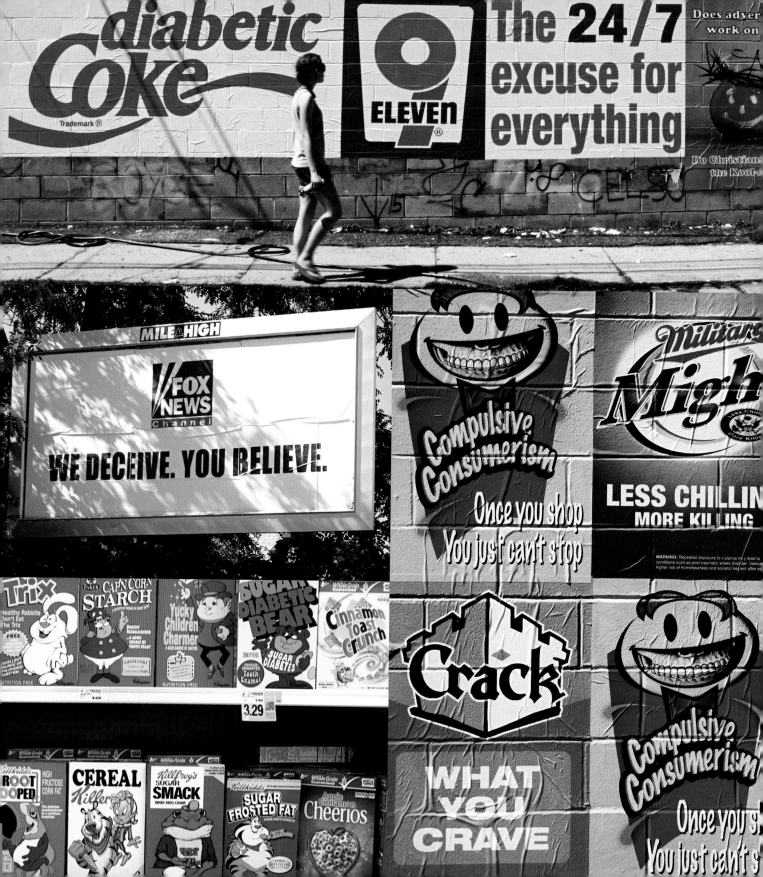

NEW YORK

BORN 1966, Dallas, Texas, USA **MEDIUM** Billboards, sculptures, murals
STYLE Culture jamming **THEMES** Consumer culture, activism, popular culture,
high/low culture **INFLUENCES** Subvertising, agitprop

1 Queens, New York, USA, 2011 2 Denver,
USA, 2008 3 Beacon, New York, 2012
4 Queens, New York, USA, 2011
5 Detroit, USA, 2011

RON ENGLISH

A street artist before street art existed, Ron English has been a chief architect of the culture-jamming movement since the 1980s. Agitation, reappropriation, and revolt are essential to his work. Famed for a very particular form of aesthetic expropriation—one that commandeers both space (billboard takeovers) and imagery (iconoclastic reformation of popular icons), English practices an impudently witty, defiant, yet always sanguine form of cultural bricolage. Deconstructing the boundaries between advertising and aesthetics, activism and art, pop culture and high culture, he uses his work to stage a willful rejection of modern US culture, a highly contemporary style of agitprop termed "Popaganda."

After studying photography at University of North Texas, English became intrigued by the possibilities of billboards in about 1980. Noticing the plethora of them that lay scattered across the region, he began to use these sites as huge canvases. By around 1984, however, having honed his skills as a painter of scale, English saw the potential of focusing on the companies that used the billboards and inverting the power of this media against itself. He began setting the advertisements through a mutant mirror, a Popagandist looking glass that could uncover the true intentions of these companies. Most notoriously, he worked on Camel cigarette ads, in which he comically recast the Old Joe character and displayed messages such as "The Cancer Kids" and "Camel Juniors." Whether depicting Ronald McDonald as morbidly obese or Mickey Mouse stuck in a credit card mousetrap (just two of his motifs), English uses popular culture to introduce important social and political themes into the public and visual landscape, using this iconography as a tool to slyly comment on society. Adopting the classic methods of détournement and the modern ideals of subvertising, he takes on everything that is dear to America including capitalism, the state, and organized religion. Acting like a "dogmatic propagandist with a built-in sense of humor," as English himself describes it, he forms a socially aware, aesthetically rich style of public art.

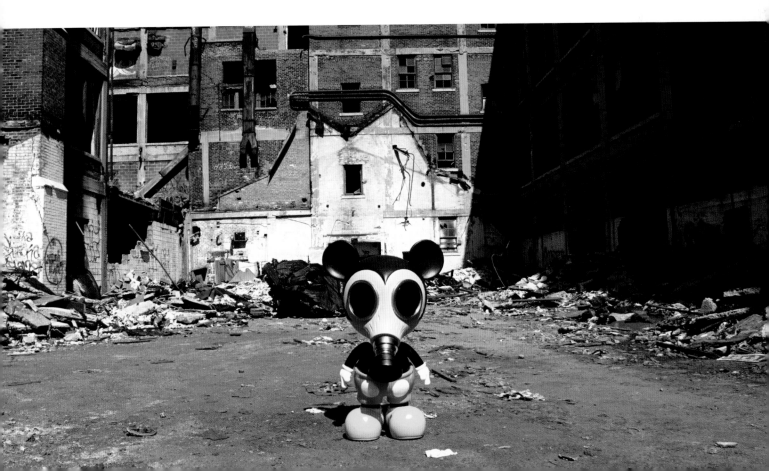

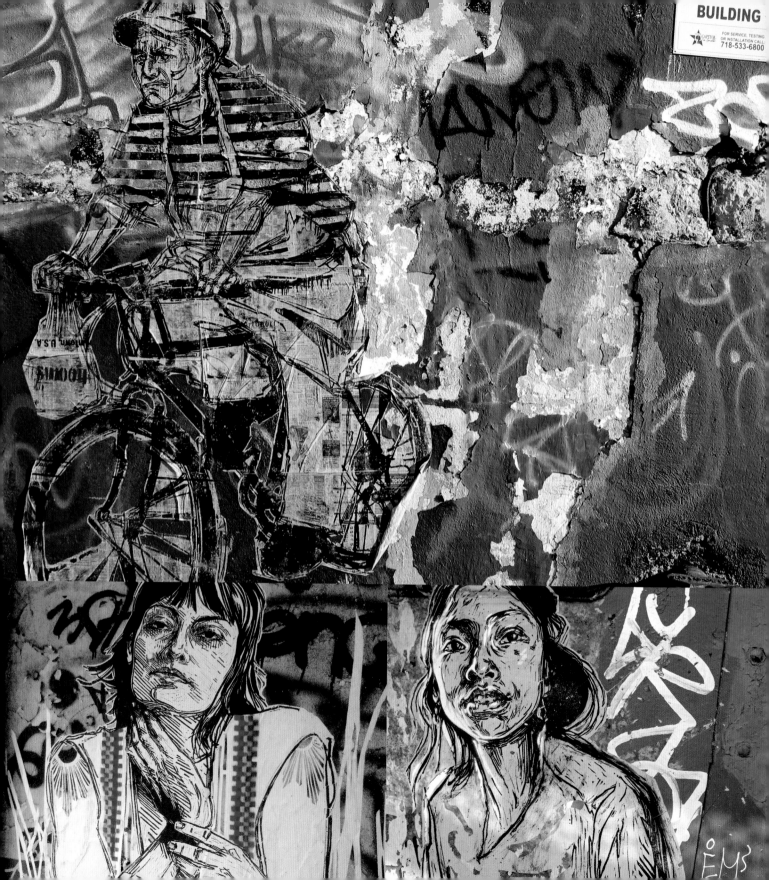

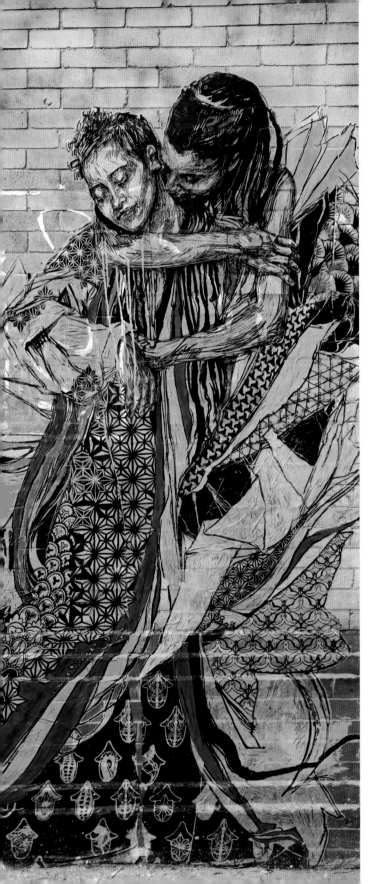

BORN 1978, Connecticut, USA MEDIUM Wheat paste, installation
STYLE Street art, performance THEMES Portraiture, fragility, community
INFLUENCES Gordon Matta-Clark

SWOON

Although she is most famous for her life-size, diaphanous, wheat paste portraiture, Swoon's artistic practice is highly diverse, encompassing a heterogenous series of works bound by her love of community and her desire to carefully examine the "relationship of people to their built environment." A trained printmaker from a classical art background, since deciding to move her practice from the studio onto the streets, her work has become increasingly experimental and elaborate. Her desire to intervene in the urban landscape has seen her work evolve into projects that she herself could never have previously imagined. Moving from woodcuts and immersive installations, to flotillas and Superadobe earthbag constructions, Swoon manages to keep the threads of her artistic journey tightly interconnected by following an ideal of art that has persisted since she first began to paste on the street. She was driven by a desire to create a form of art that, as she puts it, "participated in the world, that sought context within our daily lives, and that was not dependent solely upon art institutions," ideals that she has undoubtedly realized within her practice to date.

Swoon was raised in Daytona Beach, Florida, but moved to New York to study at the Pratt Institute; she has been based since 1998 in Brooklyn, where she produced her first wheatpasted pieces. Her images, which often depict family and friends, are pasted onto the nooks and crevices of abandoned buildings, and attempt to maintain a close dialogue with the city—both with its walls and its inhabitants. Her arrival on the scene brought an intensity and femininity to the streets of New York that had rarely been seen before. Her delicately cut stencils had time engraved on their very surfaces; each one took around a week to physically produce and the thin recycled paper they were made from became yellowed and cracked, intentionally decaying so that each image had an unmistakable life cycle of its own. Apart from enjoying the "experience of becoming part of the fabric of the city," one of the principal reasons that kept Swoon working on the streets was the "stories that emerge" from the interactions she has with the people living there.

Although she has moved on from her original wheatpasted images to hugely successful and engaging gallery-based installations, it is her flotillas or floating art performances that most clearly express

1	4	
2	3	

1 *Bicycle Boy*, Brooklyn, New York, USA, 2005
2 *Irina*, Paris, France, 2007
3 *Helena*, Gowanus, Brooklyn, New York, USA, 2007
4 *Alixa and Naima*, Brooklyn, USA, 2008

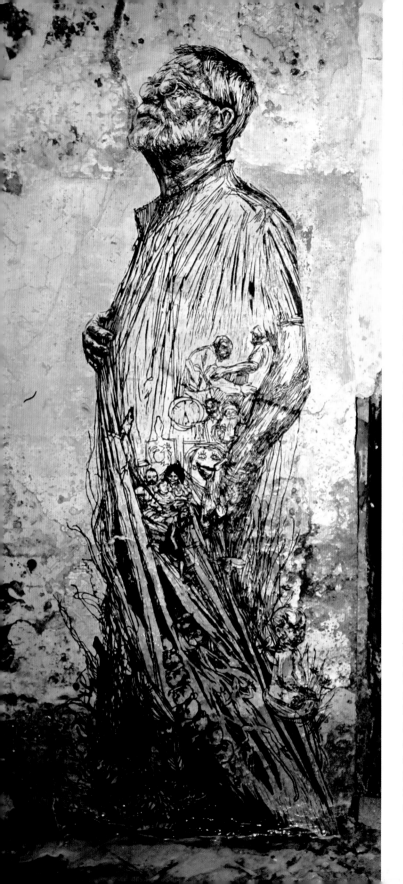

1 *Milton*, Italy, 2010
2-4 *Swimming Cities of Switchback Sea*, Hudson River, New York, USA, 2008

the next developments in her oeuvre, most famously the *Swimming Cities of Switchback Sea* (2008, see images 2–4) and the *Swimming Cities of Serenissima* (2009). Beginning in 2006 with the *Miss Rockaway Armada*, these flotillas, which are constructed entirely from recycled and reclaimed materials, have been navigated by Swoon and her crew down the Mississippi River, across the Hudson River and, in her most ambitious project to date, from Slovenia to Venice along the Adriatic Sea—docking at Certosa Island during the 2009 Venice Biennale where they performed their show "The Clutchess of Cuckoo" on a nightly, entirely informal basis.

Although the rafts were incredible objects in themselves, possessing a primitive-futuristic, postapocalyptic yet strangely organic aesthetic, what remained key about the raft ventures for Swoon herself was the fact that they were "intentional communities" that were entirely "collectively built and run" by a group of artists. As such, the projects intentionally blurred the boundary between art and life, acting as an experiment in sustainable living and communitarianism as much as a visual and performative display for the public: "Once I learned how to dream big with groups of like-minded people, I found that when a group gets together and decides to make something happen, what emerges is more than the sum of its parts. Things [that] seem impossible start to become a matter of believing in them enough to figure out, piece by piece, what it takes to make them happen. It's a kind of magic, which gets generated, and what you are able to believe in grows, because what you are able to do has grown."

Just as the street posters led on to the flotillas, therefore, the flotillas progressed quite naturally to Swoon's latest series of projects, the most significant and exceptional of which is entitled the *Knobit Project*. Taking place in earthquake-devastated Haiti, and working alongside a much larger group of artists, builders, architects, and engineers, the project utilized the work of the inspirational Iranian-American architect Nader Khalili to build a Superadobe construction—a domed, curvilinear building (reminiscent of a giant beehive) that needed simply dirt, clay, and water to be constructed. Forming both a community center and a hurricane shelter, the Superadobe project followed the ethical imperative that Swoon sets herself throughout all her work—the attempt to find a new way of interacting with the environment and a new relationship with the resources available to us. More recently, together with the collective New Orleans Airlift, Swoon constructed a musical house entitled *Dithyrambalina* in New Orleans. Her experimentation with her surroundings has therefore continued to develop, allowing the creative energy that emerged with her wheatpasted images to flow onward. Interweaving her work with both the human and physical environment, Swoon remains inspired by people, nature, and the city as her artistic exploration expands into ever new and exciting territory.

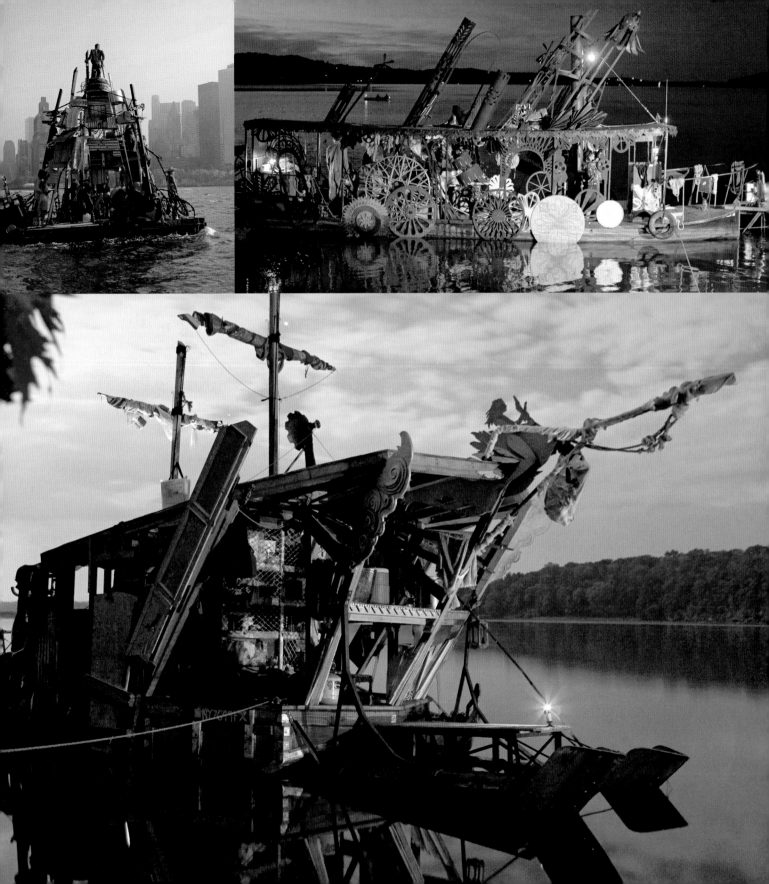

WASHINGTON, DC

BORN 1970, Alexandria, Virginia, USA **MEDIUM** Tape, sculpture
STYLE Urban installation **THEMES** Absurdity, environmental decay,
homelessness **INFLUENCES** George Segal, Juan Muñoz

MARK JENKINS

Mark Jenkins's hyperrealistic humanoid sculptures are a reaction to the inert public art of the city—the bronze memorials and statues of men on horses—and the street furniture that we are so often surrounded by. His work functions through surprise or shock—an absurdist sense of humor compelling a response from the viewer. He strives to generate a moment of pure theatricality in the street and turn an everyday space into a place for art and drama. Influenced by the work of US pop artist George Segal and Spanish sculptor Juan Muñoz, Jenkins wants his works to participate in the life of the street, forming, in his memorable phrase, a "visual heartbeat in the city." He once described his approach as an attempt to "extend the conversation Muñoz was having within the art institution to a larger, more open canvas," creating an oeuvre that is part art, part social experiment.

It was sheer boredom that first sparked Jenkins's interest in sculpture. Working as an English teacher in Rio de Janeiro, he sometimes found himself with a large amount of time on his hands between lessons, and on one occasion he decided to fill it by making a tinfoil ball to play catch with. Thinking back to a time at elementary school when he had made a cast of a pencil from masking tape, he created a second ball by using the original tinfoil sphere as his prototype and covering it with packing tape, which he then sliced off with a knife and sutured back together. Impressed with the results, he went on to make a cast of his coffee pot, and within a few months had gone through "several hundred rolls of tape, casting everything in my flat, including myself."

As his apartment became ever more congested with sculptures, and as they started to grow in size, Jenkins decided to take his work into the streets. He undertook his first outdoor work on Copacabana Beach in 2003, pushing a sculpture of a giant sperm out into the waves so as to watch it surf back into shore. The experience of placing his work in the public sphere in this way made Jenkins realize the true potential of his

sculptures and within a few weeks he had installed the first of his "tape men" in a dumpster adjacent to his apartment. He watched as passers-by became captivated by the sculpture, and later found himself experiencing pangs of anxiety as his self-cast figure was removed and disposed of by the nightly garbage truck. Jenkins became enchanted by the capacity of these humanoid figures to arouse feelings in onlookers and he built on the curious anthropomorphic relationship humans develop with so many inanimate objects—even those without a distinctly human-like appearance.

By 2005, Jenkins had moved to Washington, DC and started work on his "Storker Project," which saw him install life-size sculptures of babies configured in strange positions and set in unusual locations around the city. He later observed that the sight of these giant infant figures outdoors appeared to disturb many onlookers, and speculated that they mirrored both the "beauty and vulnerability" of life. It was the clothed, hyperrealistic sculptures that he started making in 2006, and which he terms the "Embed Series," that really propelled his work into a new dimension, however.

Half stuffed into bin bags or trash cans, peering nervously into (or climbing up) walls, lying prostrate on billboards, or caught part-way through a barrier, his installations became, in Jenkins's own words,

"absurdist beings living in a sort of trans-dimensional zone." It was as if the viewer had stumbled accidentally upon part of a story, one that "came at you out of nowhere when you were walking down the street," he reflected. The concept relates Jenkins's work to that of Juan Muñoz— not only through his use of humanoid sculptures but through Muñoz's self-ascribed status as a storyteller. Jenkins's sculptures have a dramatic (in both senses of the word) effect on the environment in which he has placed them, as if they are actors on a stage. The "Embed Series" shifts the question for the viewer from "Is this art?" to "Is this real?" and sets up a discourse with the street—one that Jenkins instigates but that the public creates through its reaction to his figures.

As his work increases in both scale and imagination, exploring urban social issues such as homelessness and environmental degradation, and taking on more disquieting and more humorous aspects in equal measure, Jenkins aims to continue producing "visual outliers" (his phrase) to enliven the surrounding environment, to persist in playing with the street from below. His sculptures surprise, scare, and enchant us, giving rise to a momentary, ephemeral disturbance in the routine of everyday life, an unconventional spectacle waking the city from its slumber.

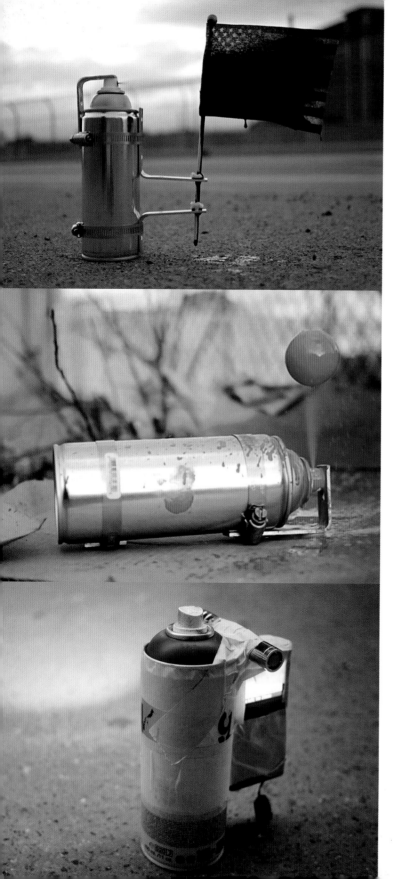

DETROIT

BORN 1978, Michigan, USA MEDIUM Various STYLE Urban intervention, digital art, hacktivism THEMES Censorship, free speech COLLECTIVES Graffiti Research Lab (GRL), Free Art and Technology Lab (FAT) INFLUENCES Open source technology

EVAN ROTH

Interweaving the worlds of graffiti, activism, internet art, and new media, Evan Roth (or "bad ass motherfucker" as he is commonly known online) is an artist whose chief objective is to hack his environment—in both its physical and virtual incarnations. His output is prolific and often provocative; themes such as censorship and free speech are central to his work. Roth's knowledge and irreverent usage of contemporary popular culture is also paramount in a practice that mixes art and technology—the highbrow and the lowbrow—and has resulted in a series of highly effective, often humorous, and always attention-grabbing projects.

As a founding member of the collectives Graffiti Research Lab (GRL) and the Free Art and Technology Lab (FAT), Roth has developed his own individual output but also contributed to that of a remarkably creative group of international practitioners, including Aram Bartholl (see pp.208–9) and Katsu (see pp.28–9). This group's modus operandi is to generate emancipatory tools—in the form of digital software and analog hardware—that will liberate graffiti practitioners and free them from the increasingly negative controls found in both cyber and city spaces.

After growing up in Michigan, attending university in Maryland, and then working in an architectural studio in Los Angeles, it took a relocation to New York City (to study at the New School for Design at Parsons) for Roth to begin taking the graffiti world seriously: "It really came from giving up the car, becoming a pedestrian and walking into lower Manhattan from Brooklyn every day. I think it was, in a way, a pretty good introduction because instead of getting into graffiti through the medias, I just got fascinated by the names I saw repeated around me." The graffiti he encountered on the streets of New York transformed a previously passive awareness into a newfound passion; meanwhile what he was learning at Parsons—computer programming and coding in particular—held an equally strong attraction. It soon became clear to Roth that the thread connecting these two seemingly very different worlds was hacking: "I view graffiti writers as hackers. People that exploit systems for their own means. They do exactly the same things that people in the computer programming world do . . . creating little devious switches you can flip that can completely change what something was before."

1	4
2	5
3	

1-2 *Propulsion Painting: USA* and *Ping Pong*, Detroit, USA, 2012 3 *Can POV*, Vienna, Austria, 2010 4 *LASER* Tag by Graffiti Research Lab, New York, USA, 2007 5 *LASER* Tag by Graffiti Research Lab, New York, USA, 2007 (with HELL)

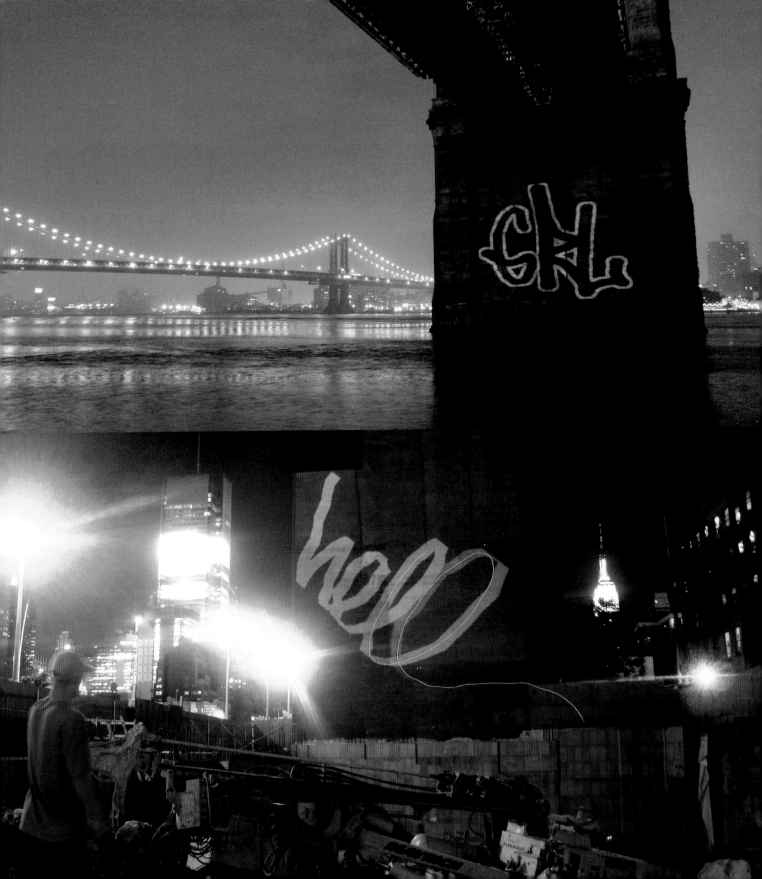

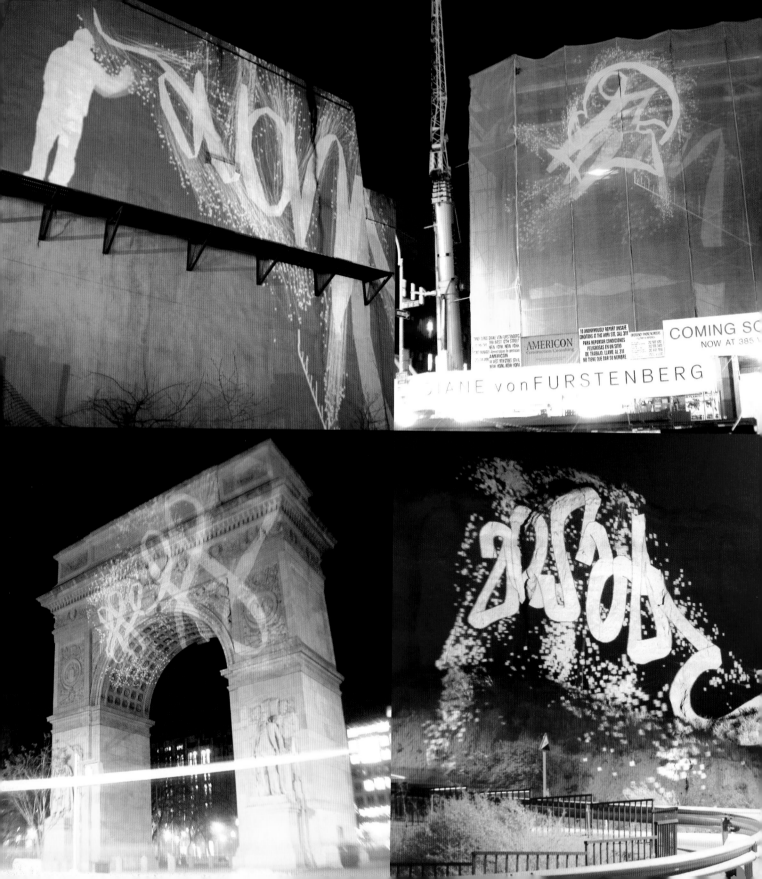

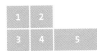

1-2 Graffiti Analysis (AVONE) and Graffiti Analysis (Katsu), New York, USA, 2007 3 Graffiti Analysis: HELL, New York, USA, 2009 4 Graffiti Analysis: 2ESAE, Tudela, Spain, 2010 5 LASER Tag by Graffiti Research Lab, Hong Kong, 2007

For his final thesis at Parsons, Roth completed "Graffiti Analysis"—a multifaceted project that aimed to digitally document the calligraphy and often unseen gestures involved in the writing of a tag. Although his future artistic direction was becoming clearer, it was not until he went on a two-year fellowship to the Eyebeam OpenLab in 2005 and he met artist/ technologist James Powderly that he had the idea to establish the Graffiti Research Lab (GRL). Powderly came from a more hardware-based background than Roth, but their collaboration was inspired by a shared interest in pioneering tools for the graffiti community using open source technologies. They specifically wanted to create products that would be affordable for the people who wanted to use them. They designed a host of inventive tools, including: LED Throwies (magnetic LEDs that could be thrown and stuck onto walls); Night-Writer (a tool for writing pixelated words in hard to reach places); LASER Tags (a projector and computer vision system allowing a tagger to write non-permanently on walls using a high-powered laser pointer); and EyeWriter (a low-cost, eye-tracking system allowing people to draw with their eyes, originally built for a

graffiti artist paralyzed by Amyotrophic lateral sclerosis). GRL developed a unique system of applications (rather than products, as freely available) that transformed the distinctive methodology of graffiti. Wanting to remain true to the roots and intricacies of the practice, GRL's equipment was intended as an addition to graffiti rather than an attempt to move toward a digital projection of the medium.

Roth continues to work on a wide variety of new projects, including his superb propulsion paintings (such as *USA* and *Ping Pong*, see images 1 and 2, p.46), as well as maintaining and further developing many of his earlier initiatives. Graffiti Analysis 3.0, for example, now includes audio and laser input that have added architectural awareness, as well as the capacity to transform original written tags into three-dimensional sculptural form. Roth remains fascinated by the overlap between popular culture and open source and is keen to explore the numerous opportunities for hacking the street and the mainframe. Following the hacker's open source dictum to "release early and release often," he seeks creativity rather than beauty in his practice and brings a hacktivist mentality to the fore.

CAMBRIDGE
BORN 1976, Boston, USA MEDIUM Acrylic paint, plywood
STYLE Classic graffiti, abstract muralism, decorative aesthetic
THEMES Folk art, indigenous art, outsider art INFLUENCES Cost, Revs

1 *PushMePullYou*, Cambridge, USA, 2012
2 Queens, New York, USA, 2012 (with Katie Yamasaki)
3 Connecticut, USA, 2012

CALEB NEELON
SONIK

An accomplished writer in both senses of the term—as adept at applying spray paint to a wall as assembling words on a page—Caleb Neelon is a renowned muralist, fine artist, and educator. Through his publications and his paintings, he has provided the graffiti culture with the authentic voice of a true insider. Managing to cross the line between artist and author while remaining active in both fields, Neelon (or Sonik as he is better known in graffiti circles) has used his dual perspective and passion for the movement to influence a new generation of practitioners. From his seminal articles on Barry McGee and Os Gêmeos (see pp.120–3) to his book projects *Caleb Neelon's Book of Awesome* (2008) and *The History of American Graffiti* (2010), to his films, and his folk-infused muralism, Neelon's manifold contributions to graffiti have pushed the boundaries of the practice.

A trip to Germany in 1990 was the first key turning point in Neelon's artistic development. While there visiting family friends with his mother, a trip to see Berlin's infamous "Wall of Shame" proved to be a revelatory moment. The graffiti and murals the historic site was covered in were unlike anything he had ever seen before. On his return to Cambridge, Massachusetts, his interest in the local graffiti scene blossomed, and artists such as Ryze, Alert, and Sp.One were local sources of inspiration. Neelon's artistry was further spurred by the year he spent studying at New York University in 1994. The radical nature of New York City's street culture at that time, in particular the work of Cost and Revs, opened his eyes to the potential of public art in much the same way as the earlier visit to Berlin. It was a time when graffiti writers were experimenting with different media and materials as never before; they remained firmly within the classic, subcultural traditions of the practice, while also fundamentally adapting its techniques and pushing it in new directions. Neelon recognized the potential of these more openly communicative practices to reach an audience beyond that of the limited community

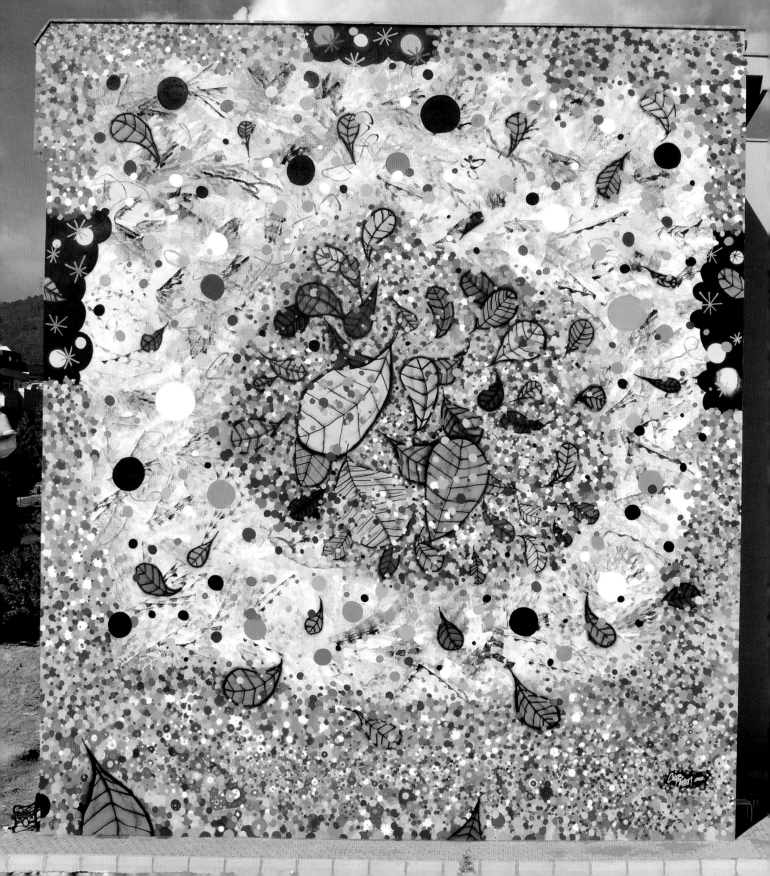

1 Istanbul, Turkey, 2012
2 Tobin School, Boston, USA, 2009

of graffiti writers themselves. Returning to New England to attend Brown University the following year, Neelon's output began to be influenced by these more avant-garde approaches. He continued to write graffiti but initiated his first works using his hand-painted wooden boards, over 700 of which he installed in the Greater Boston area between 1996 and 2002. Having observed that most Boston-area signposts had an extra hole beneath the sign, Neelon bolted his colorful pastiches of traffic signs onto them. On them he displayed phrases, such as "Women I can't afford/And stuff I don't need," together with images, including birds stylized as bombs and anthropomorphic burgers. These "Signs of Life," as Neelon described them, contrasted starkly with other objects around them, marking them out as a unique form of art that was passionate, personal, and relational. Often using conventional and widely available materials, such as plywood and acrylic paint, Neelon's work harnessed a decidedly unaffected, *art brut* aesthetic. The style reflected back on his more classic graffiti work as he developed an increasingly patterned and delicate form of inscription that functioned through the same congenial dynamic as his installations.

However, while Neelon was pushing his individual art into a new sphere, an aesthetic that would culminate in the highly decorative, folk-infused practice for which he is now famous, he also became deeply involved in the wider dissemination of the collective form as one of the principal architects behind seminal graffiti magazine and website 12ozProphet. Writing for 12oz, as well as many other publications including *Blitzkrieg*, *Brain Damage*, and Espo's *On the Go*, opened up another channel for his creativity and helped his personal artistic vision evolve further. During numerous visits to Brazil, for example, Neelon's iconographic and narrative skills were enriched through meetings, interviews, painting sessions, and eventual firm friendships with innovators such as Os Gêmeos, Nunca (see pp.118–19), and Vitché (see pp.124–5). Together with journeys to Nepal that supplied another key influence, Neelon's practice emerged as a rich fusion of outsider art from around the world—a seamless blend of graffiti, folk, and indigenous art. His writing and artwork continue to interact creatively with one another in his unique, multidisciplinary oeuvre.

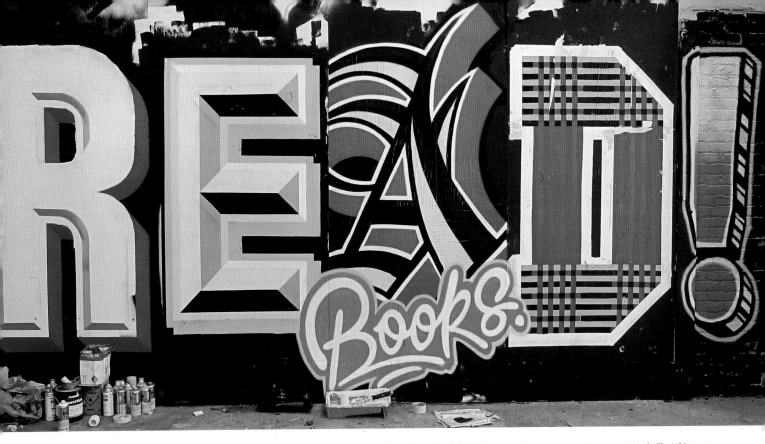

BORN Unknown MEDIUM Spray paint STYLE Typographic graffiti, bibliographic bombing THEMES Bibliophilia, winged skulls, classic American typography, anarchism

THE READER

READ • READ MORE BOOKS • READ UP
HOOD RICH • BOANES • BONAFIDE

The most active coast-to-coast writer in the United States, The Reader's industrious and indefatigable ethico-aesthetic has become a ubiquitous part of the US landscape. It is an aesthetic influenced by classic Americana letter-press design that has gone "all country," pervading cities across the huge extent of its terrain. Taking on a multitude of pseudonyms, names that predominantly follow his obvious obsession with printed matter, as well as using two specific icons of a winged skull and an open book, Read's work is also strongly associated with the hobo culture of image-making and his itinerant existence closely follows the trials and tribulations of this archetypal, American anti-hero. Traveling from west to east and north to south, tallying an estimated 25,000 Greyhound miles across the country, Read both moves to paint and paints to move, working in "the bright lights and in the cuts," in the "alleys," and the "fame spots,"

taking his enactment and imperative toward literacy across the length and breadth of the fifty states of the country.

Although he works for the most part as a proper noun (i.e. The Reader/Read More Books), Read's name is an intentionally suggestive, subversive, and anarchistic one. Yet as an axiom that is hard to refute (without appearing to be a philistine), while simultaneously licentious (literally so in its blatant disregard for the conventions of literary style), his bibliophilic aliases function through a combative and consensual frame in the same moment. Obsessed with visual sampling, a rehabilitation of past design into a mélange of half-recognizable and half-imagined forms, Read therefore aims to confront social norms through his practice while upholding a fast-disappearing, shared cultural history.

As a graphologist and graffitist, as an iconologist and artist, Read can simply be regarded as a figure with an uncontrollable love of text and an irrepressible devotion to the inherent beauty of the letter. His fundamental need to scratch and scrape at the very fabric of the city, can therefore be seen merely as a pursuit of the virtuous rather than the scandalous, as a sanctification of words, text, and the infinite possibilities of the written form.

JETSONORAMA
CHIP THOMAS

TUBA CITY, ARIZONA
BORN Raleigh, North Carolina, USA MEDIUM Wheat paste
STYLE Poster art THEMES Navajo Nation, dialogue, healing
INFLUENCES Eugene Richards, Laura Gilpin, Gordon Parks, Eugene Smith, JR

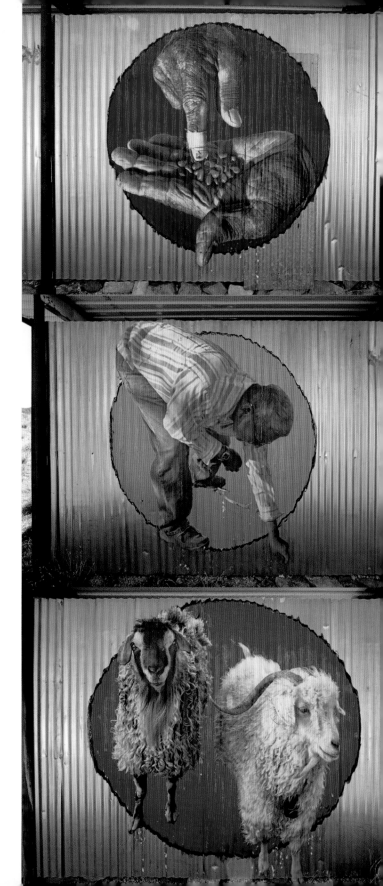

As a physician, documentary photographer, and Independent Public Artist, Jetsonorama (or Chip Thomas as he is known in his formal medical role) is an inspirational figure whose efforts to contribute to his surroundings reach far beyond the scope of most ostensible "community" art. Being truly integrated with his central subjects, the Navajo Nation—with whom he has lived and worked as a physician for more than twenty-five years—Thomas's output has an unsurpassable authenticity. His work challenges us not only through its formal aesthetics but through its ethical and political concerns. There is a visceral veracity to his images—trust and honesty are ingrained within their very surface. Enhanced by the locations in which they are exhibited, Thomas's images work on two levels, both reflecting inward and shining outward in the same moment. As well as providing beauty and inspiration for the local community and presenting the traditional Navajo culture to the outsiders who often disregard their presence, Thomas's wheat-paste project also enabled him to share his images with those who originally allowed him to photograph them; he publicly exhibits in what is, at its root, an always collaborative, joint enterprise.

Thomas's journey into the world of Independent Public Art was a unique one; the first step came through his introduction to photography when he was aged just twelve. He attended an alternative, Quaker institution that instilled in him a strong morality as well as a passion for photography. He recalls that the school taught "about living simply so others can simply live," and his time there profoundly affected him, molding him into an individual intent on both questioning authority and on contributing to the wider community. Moreover, this early education led him to wonder how he could use art for communal rather than individual gain. His eventual move to the reservation—or the "rez" as it is locally known—came as part of a government program called the National Health Service Corps, in which a four-year medical scholarship is provided with the participant's obligation to work in a "health shortage" area for an equivalent period of time. When he moved to the "rez" in 1987 to work as a family medicine physician, he began to pursue photography more seriously. A meeting in 1991 with Eugene Richards, the noted documentary photographer and civil rights activist, inspired him to take advantage of his location—to try and tell true "humanistic stories" about people who are often maligned in the mainstream media. Influenced strongly by photographers such as Laura Gilpin,

1-3 *Things One Might See While Driving the Rez,*
Bitter Springs, Arizona, USA, 2011
4 Cow Springs, Arizona, USA, 2012

Gordon Parks, and Eugene Smith, he used his photography to illustrate both the "misperceptions" and "misrepresentation" that persons of color are so often subject to in the United States, documenting what he termed as a "culture in transition."

As a youth growing up, however, Thomas had also been strongly involved in the early hip-hop movement; he made trips to New York to "check graffiti on trains, going to Keith Haring's Pop Shop and to shows at the Fun House," even drawing graffiti of people break-dancing on the walls of Huntington, West Virginia, where he started his family practice residency. He carried this spirit with him to the "rez," where shortly after moving there in 1989 he undertook a billboard modification ("correcting" a "Welcome to Pepsi Country" billboard to read "Welcome to Diabetes Country," thus commenting on the high incidence of diabetes in the Navajo community). During two extended visits to Brazil, the first in 2004 and the second in 2009, he became aware of the new cultures of muralism that were evolving internationally. However, it was encountering the work of French artist JR in Rio de Janeiro that directed Thomas on his current path and has led him to imagine the reservation in an entirely new way. By transferring some of his numerous images into poster form, Thomas wanted to illustrate the hope that existed across the reservation and counter the usual self-fulfilling, overly melancholic photography taken of the Navajo people. He hoped that by projecting "positive imagery" he could help the Navajo people feel better about themselves, a sentiment that perfectly complements his work as a physician.

Thomas regarded his artistic and vocational roles as possessing a "yin-yang synergy"—one being a "visual art the other a healing art." He states that his work remains instilled by a desire to "help people improve the quality of their lives through my medical practice and through what is hopefully uplifting and inspiring art." As an individual who has effectively raised the issues confronting the Navajo Nation in contemporary US society, he stands out as a shining example to other, perhaps more celebrated public artists. He goes quietly, assuredly, and authentically about his task, committing to his community in an equally faithful and forthright manner.

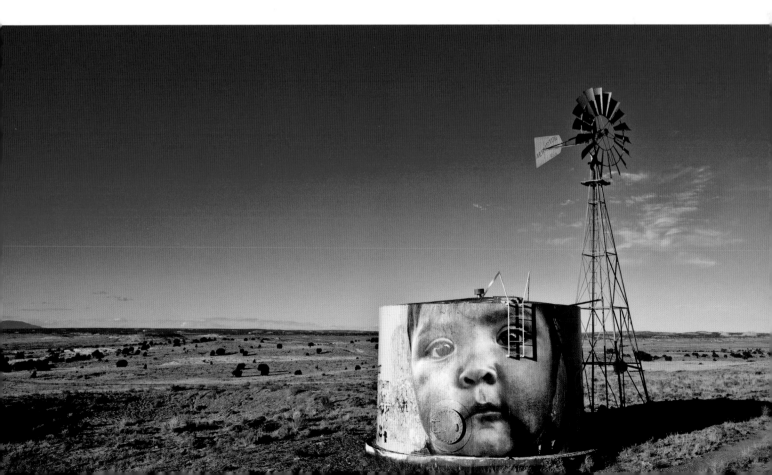

SAN FRANCISCO

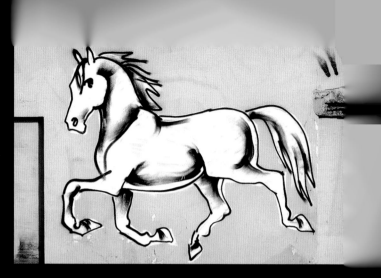

As a world capital of twentieth-century counterculture, few places were more natural early adopters of graffiti and street art than the San Francisco Bay Area, encompassing Oakland, Berkeley, and San Jose. Long before New York-inspired graffiti hit their streets in the early 1980s, Bay Area cities were the site of "happenings," street theater, political protest art, and a thriving mural movement, both Chicano and otherwise. By the time early New York-inspired graffiti arrived in the Bay, with writers such as RIF, Cuba, Ham2, STYLEZ, Dug, and dozens more, they hit the streets alongside artists such as the Billboard Liberation Front and robot-death-match specialists, Survival Research Laboratories, neither of which saw a moral imperative to secure official sanction for their projects.

A native San Franciscan, surfer, and fan of the Survival Research Laboratories, Barry McGee took up New York-inspired graffiti in 1984. McGee took on the name Twist, and by 1988 he had begun to specialize in finely rendered tags—thanks in part to the influence of relocated Cambridge, Massachusetts writer SR.ONE, who gave Twist lessons in Brooklyn handstyles of tags, as well as the crew THR (The Human Race),

that Twist later made famous. A natural figurative draftsman, Twist also took a cue from New Yorker Freedom, and began to paint delicately shaded figures, faces, and icons (screws, hypodermic needles, and so on) in simple silver and black (see image 3). By the early 1990s, McGee was freely blending the work he did in the streets with his gallery and museum work, becoming the first fine art star of US graffiti outside of New York City.

The early and mid-1990s were a seminal time in San Francisco. Its graffiti scene was as productive as any in the nation, as writers who worked firmly in the New York tradition of letters, such as DREAM, Dug, and Krash (see image 2) found themselves sharing the streets with artists whose work—often to the chagrin of graffiti traditionalists—largely abandoned letters. Reminisce painted silver and black horses throughout the city (see image 1), often alongside the traditional throw-ups of her TMF crewmates. While the Bay Area had always attracted creative young adults for short stays, the early 1990s was a particularly strong period. Out-of-towners such as GIANT, JASE, BLES, FELON, SOPE, CYCLE, and others relocated and helped drive the creative competition along with local crews TMF, TWS, TDK, ICP, and many others. Through the 1980s, a Market Street parking lot that writers called "Psycho City," after an early piece by graffiti pioneer Dug, became the hub of the city's scene. After Psycho City was shut down in 1993, rather than go quietly, graffiti exploded across the city.

New Yorker KR (see pp.68–9) arrived and brought a renewed focus on street bombing with simple tags and throw-ups, as well as contributing his signature (and now mass-marketed) medium, Krink (KR+ink), a small-batch concoction with a silver paint base. Ferocious young graffiti writers such as Geso and AMAZE arrived on the scene, and a thriving art scene—variously known as Urban Folk or the Mission School of artists including Margaret Kilgallen, Chris Johanson, Alicia McCarthy, and many

others—freely crossed paths socially, aesthetically, and thematically with graffiti and street artists even if they worked predominantly indoors.

In March 1998, a prolific, eighteen-year-old graffiti writer named TIE was shot and killed by a building resident as he tried to escape down a fire escape from a rooftop he had just painted. The event shook the city's graffiti scene and the friends that TIE had made there, including Saber and Revok (see pp.82–3)—both of whom had relocated temporarily from Los Angeles—MQUE and BENET. The latter two shared TIE's aesthetic of stripped-down street bombing, tags, throw-ups, and massive silver-and-black block letters.

Graffiti and street art naturally thrive on competition—the two most storied Bay Area crews of the 1980s, TWS and TMF, could not stand each other. Saber and Revok's arrival in 1997 was part of a small migration of their AWR/MSK crewmates to the Bay Area. Being an LA crew with a distinctly Los Angeles aesthetic, AWR's presence added a new element to the competition on the Bay Area scene.

The 2000s saw the emergence of AWR artists such as STEEL, NORM, and REYES, with his florid, swirling letters. Artists including Andrew Schoultz and Aaron Noble (see image 5), Apex (see image 4), and relocated New York City old-timer Vulcan reinvigorated the city's mural movement. Norwegian-born Remio (see pp.92–3) exploded onto city streets in San Francisco, while on the other side of the Bay, East Coast transplant Jurne (see pp.64–5) scattered lettering wizardry throughout Oakland. **CN**

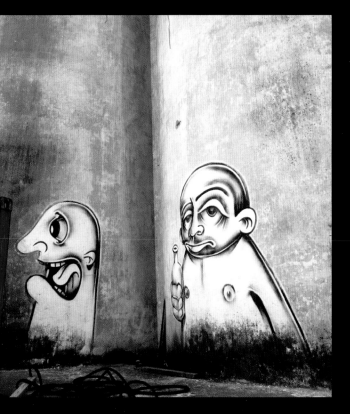

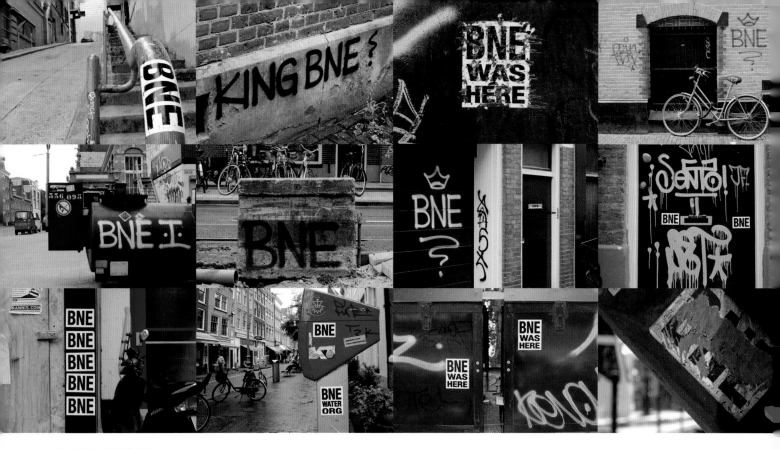

SAN FRANCISCO

BORN Unknown **MEDIUM** Spray paint, stickers **STYLE** Conceptual art, vandalism, bombing **THEMES** Anti-branding, anti-corporate, worldwide water crisis **INFLUENCES** Cost, Revs

BNE

BNE is the first, and perhaps the only, All-World graffiti artist. While being dubbed "All-City King" was once regarded as the highest acclaim an artist could garner in the graffiti world, BNE smashed the boundaries by pasting his infamous, three-letter stickers in thousands of neighborhoods in hundreds of cities across the globe. From New York to Kuala Lumpur, Tokyo to Madrid, San Francisco to Prague, he radically expanded the quantitative possibilities of graffiti, working on a scale simply unimaginable before he arrived on the scene.

Like many others, BNE's artistic journey began with traditional graffiti. As a teenager he tagged his name across the city where he was raised, eventually taking his work across the entire United States, before traveling the world. Working in Tokyo in early 2001, however, he felt the need to change the idiom he was working within and find a message that could be interpreted by far greater numbers of people. Although he had recognized the potential effectiveness of stickers as a tool, up to that point

he says that he simply never had the time or patience to produce thousands of stickers by hand. Attracted to the simple block letters produced by tagging icons such as Cost and Revs, BNE finally decided to simplify his work by designing a minimal, bold vinyl sticker that would attract the maximum amount of attention, but that could be fixed simply and quickly to city walls and street furniture.

Pasting, however, rapidly became an almost maniacal addiction for BNE; he described putting up 400 stickers as easy as "walking a dog or doing yoga." In the process of producing this vast number of stickers and attaching them to any available surface across the world, BNE inadvertently established what amounted to a globally recognized brand, although one with no product or service. He was amazed at the anger his stickers generated and the animosity directed toward his seemingly, non-harmful practice, rather than toward the corporate companies and multinationals who flood the world's cities with their advertisements: "I think the anger comes from people's minds being penetrated by a logo that they do not understand. I don't think it's always about it being 'vandalism.' People are assaulted by so much corporate advertising that they have grown numb to it. But the corporate logos are still very effective,

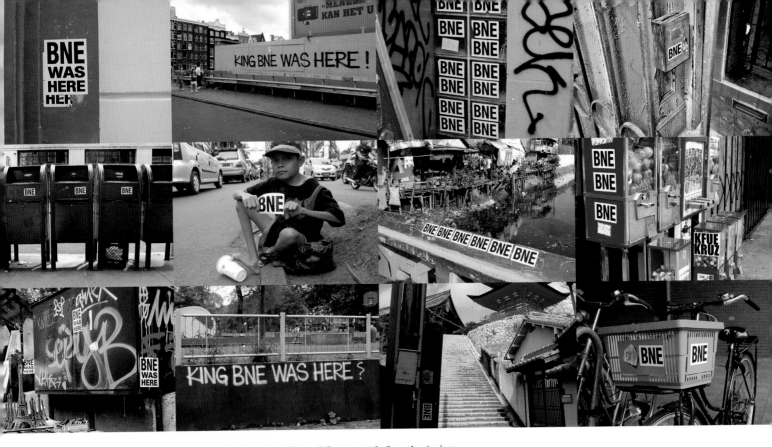

1	4	7	10	13	16	19	22
2	5	8	11	14	17	20	23
3	6	9	12	15	18	21	24

1, 14, 22, 23 San Francisco, USA 2-6, 8, 10-11, 14, 16, 18, 24 Amsterdam, Netherlands 7, 9, 13, 15, 19 Paris, France 12 Bangkok, Thailand 17, 20 Jakarta, Indonesia 21 Hiroshima, Japan

making their way into our subconscious but not staying on your mind or making you angry." For BNE the issue was simple: If Starbucks and Pepsi could force him to look at their logos, he had an equal right to display his.

Having effectively produced the equivalent of a multimillion dollar international advertising campaign reaching untold numbers of people around the globe, BNE soon began to receive offers from corporations aiming to use his work for profit, as he said: "individuals and companies looking to use my life's work to advertise whatever they had to sell." Through his sticker campaign he realized that he had formed a global voice that could "mean whatever I wanted it to mean." He recognized that his BNE brand could be used to communicate with millions of people and bring about positive social change by advocating important issues. He decided to determine what he could do to make the biggest impact on global poverty. While on his travels in Jakarta, Indonesia, BNE had witnessed firsthand the devastating world water crisis. He eventually established the BNE Water Foundation to provide clean water and sanitation solutions to people in developing countries. BNE stresses that his foundation aims to stand for truth: "Most brands are in the business of selling dreams and fantasies. We are in the business of reality, so our

marketing strategy is to simply tell the truth about everything. This is going to piss off a lot of people but it has to be done. I haven't spent thousands of hours on the streets creating a name for it to be used as some bullshit 'charity.'"

Working directly counter to what BNE describes as the "dilution" and "commercialization" of graffiti, the BNE Water Foundation is funded solely through the sale of donated artworks and BNE products, with 100 percent of the income generated going toward the cost of actual water projects rather than salaries or overheads (even PayPal and credit card fees are covered separately). The project attempts to take graffiti beyond being anti-establishment rhetoric and to actually seek to change the system. Having already initiated successful projects in Central Uganda, BNE hopes to change not only what it means to be a graffiti writer but to "encourage everyone to step their game up." He believes that his work—his brand, his tag—is no longer simply about the individual but about giving a "voice to the victims of social injustice who have no voice." For BNE, it is about providing a platform for those who are socially excluded or disadvantaged, just like the graffiti artists themselves who have been marginalized throughout its short history.

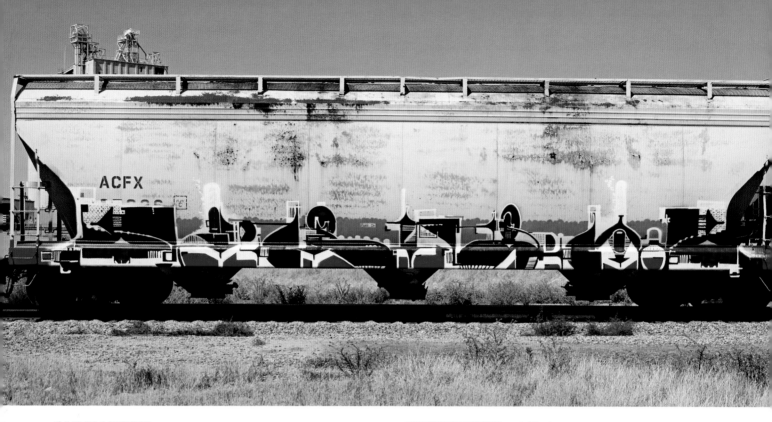

SAN FRANCISCO

BORN San Francisco, USA **MEDIUM** Spray paint **STYLE** Funk lettering, graffiti abstraction **THEMES** Freight trains **INFLUENCES** Grey, Amaze, Sento, Phable, MQUE, Veefer **CREWS** PVC (Pro Vandals Crew), IBD (Infected By Devils)

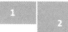

1 California, USA, 2009
2 San Francisco, USA, 2011

GESO

A man of many contradictions and a master of many styles, Geso (IBD/ PVC) is a writer who has consistently refused to compromise his aesthetic. He emerged in San Francisco in the early 1990s and treated graffiti as a full-time job from the moment he started. Currently regarded as one of the kings of the freight train scene (focusing on graffiti rather than the culture of "streaking," however), Geso has always tried to stay ahead of the pack and has continually evolved his designs and techniques throughout his career. He has modified his traditional lettering style into a radically new form of graffiti abstraction, while continuing to push his flawless handstyle into ever more dramatic configurations (see image 2, produced with DFW and IRAK crew member Nemel).

Geso's tags and pieces have been an omnipresent sight in San Francisco for almost twenty years. He became active during the city's graffiti heyday, when he worked alongside local legends such as Twist, Amaze, Reminisce, and Margaret Kilgallen. Working before graffiti

magazines had become a major industry and before the widespread proliferation of the internet, Geso developed as an artist at a time when the only true measure of success was one's presence in the streets and a commitment to the culture was paramount. He initially produced a "symmetrical bar type" of graffiti, but he soon incorporated this with the late 1980s aesthetic that he so loved, merging them to form his famous "funk" style of lettering. However, when this technique was often copied, Geso began to push himself beyond the boundaries that then existed and attempted to produce work "so unique that if you bite it you will look foolish." He initiated a more abstract style of writing in which his stretched-out letters appeared almost as cityscapes. As well as trying to produce totally original work, Geso was also challenging himself and rejecting the warm safety of stasis. Although he is now beginning to show the fine art work that he has been quietly producing since he was fifteen years old, he retains a deep urge to paint within his bones, to get up whatever the cost. Indifferent to fame and prestige, Geso is often considered the graffiti writers' graffiti writer: He is an artist who rejects trends and who pours his soul into every piece, risking everything simply for another chance to place his chosen name upon a material surface.

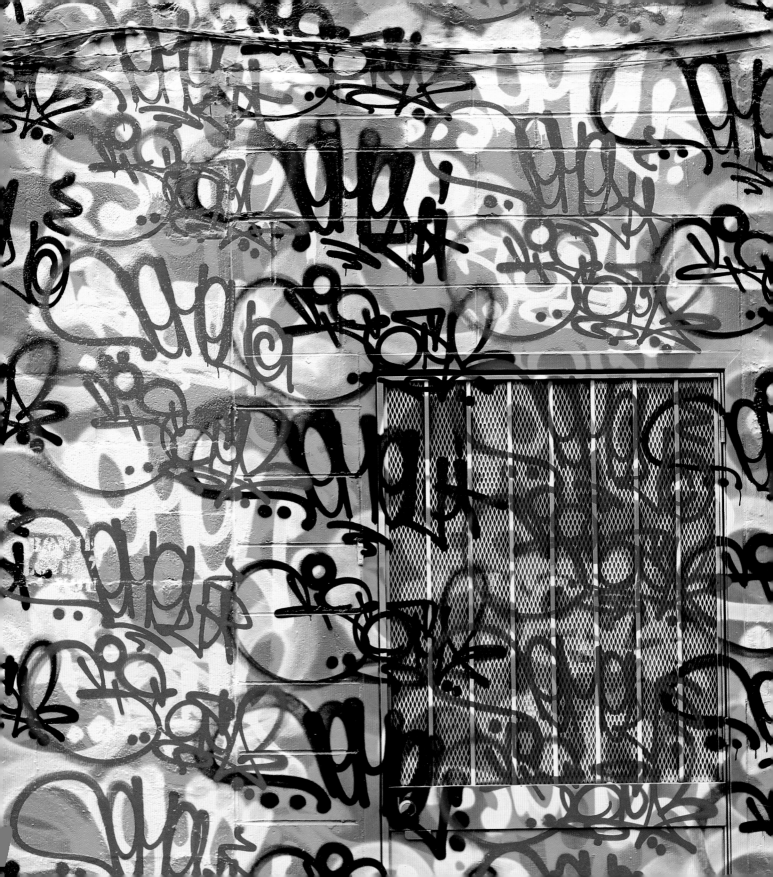

SAN FRANCISCO

BORN Portland, Maine, USA **MEDIUM** Spray paint **STYLE** Classic graffiti,
typographic figuration **THEMES** Writing within writing **INFLUENCES** Past, Learn,
Lack, Bern, Sept, Hence, C&F, Jedi 5, Curve, Rime, Dondi, Bear167 **CREWS** TGE, YME

JURNE

Jurne (pronounced journey) is a visual artist based in San Francisco who
draws on both the abstract and calligraphic essences of graffiti. His route
into the art world was a circuitous one; after gaining a Master's degree in
biology, he worked in stem cell research before deciding to turn his passion
into a full-time career in 2011. Since then Jurne has pushed his classic
graffiti into new terrains and taken his work into a new dimension. He
has developed a chirographic style using letters and purely textual forms
to create representational images that blur the discourse/figural divide.

Growing up in Portland, Maine, Jurne first became active in graffiti
in 1999, when he worked on the freight trains heading through the
northeast of the United States toward Canada. He had no formal art
training, but was a keen student of graffiti and gained the basic
foundations by analyzing the East Coast styles around him. Jurne was
strongly influenced by artists such as Past, Learn, Lack, Bern, Sept, Hence
C&F, Jedi 5, Curve, and Rime, as well as legends such as Dondi and Bear167.

By 2006 he had developed a style that was simultaneously simple and
technical; using unorthodox combinations of color and composition,
yet still following the basic rules of graffiti, he would "stretch, mesh,
and blend ideas of style together" as he says, improvising within the
conventions his work lay within. The movement to what he terms "writing
within writing" happened quite naturally around this time. He repeatedly
inscribed his name in order to compose a larger design of the same
moniker; his use of the letterform aimed to eclipse the traditional idea
of type as merely functional and return to the calligraphic understanding
of its potential power and beauty. He produced typographical works (see
image 4), which Jurne regards as the "most distilled version of graffiti"
and marked a return to the purity of tagging that outsiders often overlook.
As with his maps (see pp.66–7) and décollages in this style, Jurne creates
a text that is neatly legible on a large scale but more mysterious in its
microscopic detail, a stream of consciousness literally put into words.
Regarding graffiti as "both a craft and a science," Jurne has forged an
aesthetic that merges traditional and modern calligraphic methods into a
seamless whole. His is a practice of art-making in which "new techniques
get applied to old formats" yet the original graffiti spirit still holds true.

SAN FRANCISCO BY JURNE

An arabesque, chirographic depiction of Oakland and the Bay Area, Jurne's map can be described as a form of figural calligraphy: A three-fold image that functions through the uncomplicated panorama it portrays and the intricate messages that act as its raw building blocks, as well as the singular, large-scale phrase of its title. *Stories From Our Neighborhood* represents an attempt by Jurne to depict his landscape through all these levels, using the "writing within writing" style that he developed in his traditional graffiti practice. Harnessing the innate malleability of the letter form and adopting the characteristic, curvilinear style of Arabic script, his map demonstrates the ornamental style prevalent within Islamic art. Here, however, a veneration of the letter emerges through a reverence for tagging—the essence of all graffiti—rather than a reverence of God.

Jurne has produced many maps in his practice. He produced a series centered on Paris for his show "Keys to the City" that described the process of making art itself; his map of mainland USA, *48 States*, chronicled the etymological basis for each state's name, illustrating how these titles have "morphed, been bastardized, and shifted to become their modern versions." *Stories From Our Neighborhood*, however, works through the idea that every marking in the city—from a tag to a political message to a love letter—materializes from the "voice of the common person" and "is part of someone's story." Producing a cartographic representation of his feelings about living in Oakland and the Bay Area, Jurne has made a map of the city that, although built out of alphabetical characters, has the individual citizens of the city at its heart. It is a map of the city that perhaps paradoxically due to its purely textual approach takes on a distinctively human-centered perspective.

SAN FRANCISCO
BORN New York, USA MEDIUM Krink
STYLE Minimalist graffiti, conceptual graffiti THEMES Do-it-yourself
INFLUENCES Abstract impressionism, urban environment

KR

KRINK • CRAIG COSTELLO

A famed graffiti artist in his own right, KR (or Craig Costello) has constructed an empire out of ink that has emerged from and remains faithful to its inherently do-it-yourself roots. He is known for his brand of homemade paint, Krink (KR + ink), which has become an ever-present artistic tool in both the graffiti world and beyond. This product has also provided KR with a unique style of visual production that aims to stimulate rather than prevent the leaking or dripping of ink. Through both his output and his brand, KR and Krink have therefore become indivisible, the ink and the inventor fused into one. They both represent color, materiality, simplicity, and innovation on every level.

Moving to San Francisco in the early 1990s from the graffiti-infused landscape of his hometown of Queens in New York, KR wanted to find a singular artistic voice within his new place of residence—to discover a way to stand out and separate himself from the other writers in the city. He began to produce ink solely for his own use at a time when it was a common practice within the graffiti community. Artists made a variety of homemade instruments, as well as inks and paints, because they were difficult to source commercially, but also to differentiate themselves from other writers. KR's first innovation was to embrace what was generally seen as the main peril of home-produced ink—the lack of control and precision due to its inherently rudimentary nature. The resulting drips in KR's work—which would normally indicate a lack of skill and status as a novice—suggested something entirely different, however. They emphasized the fact that the ink was homemade and established a style that broke away from the restrictions and rules of the graffiti scene. What was initially chosen simply to be economical and stemming from the do-it-yourself roots of graffiti therefore became a solution through which KR could push his aesthetic and form a unique style that was soon much copied.

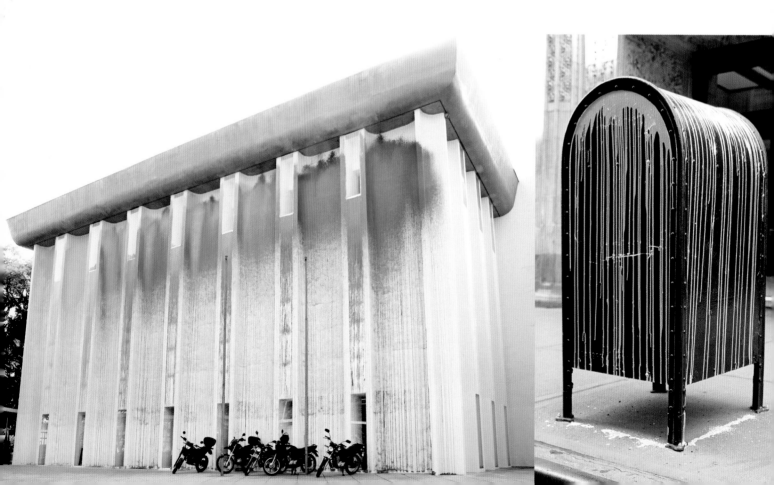

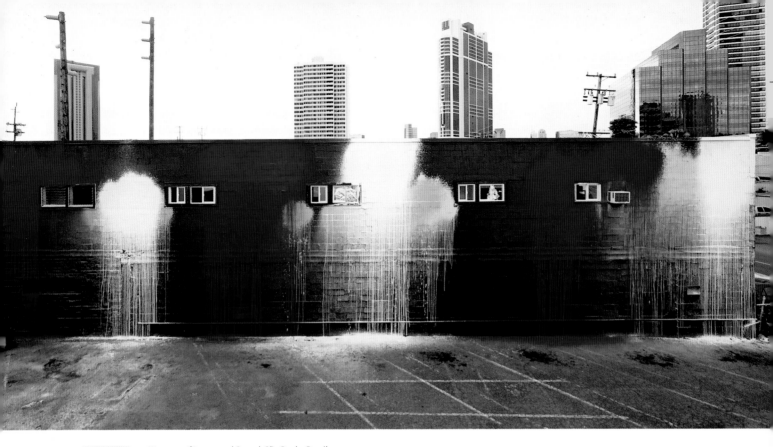

1 Museum of Image and Sound, São Paulo, Brazil, 2010
2 Bleecker Street, New York, USA, 2005
3 Honolulu, Hawaii, USA, 2011

KR's next step, however, was to completely remove his name from his productions, a hitherto unknown technique in graffiti: While the "methods and attitude remained very similar," KR's metallic, drippy style was so inimitable that it became a signature in itself, the clean design and simplicity immediately identifiable as his alone. For KR the usage of the written name at times "got in the way" of the design, whereas without it "it became abstract, it became more open"—a marking or icon that embraced the fluidity, texture, and viscosity of the pigment.

At this point the idea of Krink as a brand was still far from KR's mind. He was making it for his own use, although he soon began to give ink to his friends, putting a "sticker on the bottle [usually a soda bottle] or writing a tag on it." It was not until about eight years after initially making Krink that he sold the first bottle. After moving back to New York, KR teamed up with the legendary Alife collective, who persuaded him to start selling it in their store. He explains: "I was really surprised at the response. We packaged it, put it on the shelf and lo and behold it sold out right away." Crucially, however, it was the street presence of Krink that took the paint brand to the next level.

The Irak crew in particular adopted the paint immediately, "killing streets in downtown NYC." Furthermore, KR left the labeling and branding of the product open: "I wanted Krink to be multidimensional and not specific to one thing. I wanted it to be clean and simple. The packaging does not direct you, it's up to you to use it to create something." With no investment and no marketing strategy, it was the genuine qualities of the Krink brand that led to its success through the "research and development" that visibly took place every day in the streets. Krink has now become a worldwide brand that is synonymous with graffiti culture.

KR has painted all around the world and developed a distinctive, abstract impressionistic style (often utilizing his Krink brand fire extinguishers), as well as producing more products and inks. He has continued to push his creativity not as something "singular" or as "one thing," but as part of his determination to remain "open to new materials and ideas" and to the endless possibilities and subtleties of style. Although he has worked with established brands and multinationals, he strives to tread the fine line between co-option and independence, taking his famed metallic, drippy aesthetic around the globe.

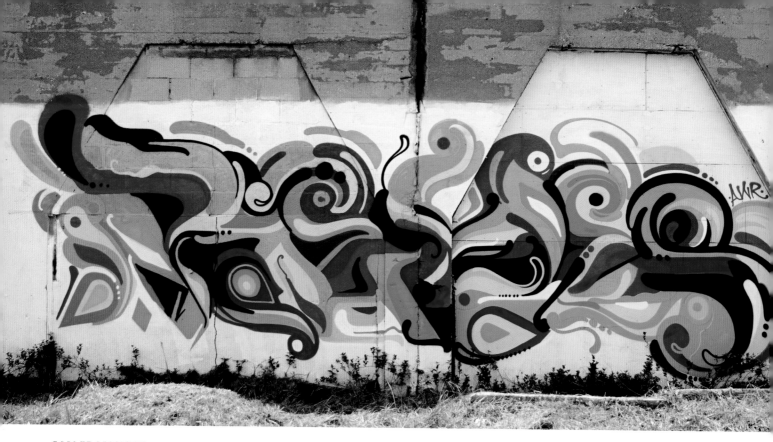

SAN FRANCISCO

BORN 1978 **MEDIUM** Spray paint **STYLE** Folk graffiti, contemporary graffiti
THEMES Single letters, wave aesthetic **INFLUENCES** West Coast graffiti, folk art
CREWS MSK (Mad Society Kings), AWR (Angels Will Rise), The Seventh Letter

1	2
3	

1 Detroit, USA, 2012
2-3 San Francisco, USA, 2011

REYES

The highly ornate, richly vivid, whirling aesthetic that Victor Reyes has originated has a quintessentially Californian character. With their soft hues and organic, wavelike circulation of colors, his images appear to flow naturally from their surfaces (whether that be wall, canvas, or any other that he experiments with) with a strongly calligraphic rhythm and a strong inflection of classic West Coast folk art. Having evolved his technique purely on the street, his output is free from all institutional affectations. Reyes has amalgamated his typographic, graphical, and illustrative skills to form a style of street ornamentation that focuses on communities over corporations and which, while rooted in the graffiti subculture, aspires to connect to a wider, more inclusive public audience.

Reyes started painting graffiti when he was fourteen, after he saw a painting in his neighborhood by Tyke, a member of the legendary collective AWR/MSK (a crew that Reyes himself now belongs to). It was through his more recent *Misspelled* series, however, that Reyes came to more mainstream attention. In what he terms "a personal exercise in aerosol typography," he set about painting every letter of the English alphabet around the city's Mission District, an area in which he has lived since 1998. Taking him more than two years to complete and far exceeding the scope he originally intended, the project has marked a radically new approach to graffiti for Reyes. Although he stylistically morphed the dismembered, singular graphemes of the alphabet through his idiosyncratically surging aesthetic, all the letters were clearly recognizable as coming from his hand alone. He worked mainly on abandoned sites that had been vacated since the financial crash of 2008, however, what is also crucial about the project (as well as much of the recent work he has undertaken) is Reyes's attempt to engage more closely with the history of mural art through his unmistakably social intentions—he experiments with form while simultaneously encouraging the rehabilitation of the city. Engaging in a project of beautification in areas where art is normally a luxury, Reyes therefore uses his graffiti-honed skills and his understanding of place, scale, and locality to form an "art for the people." His production displays a highly refined form of graffiti that follows in the rich lineage of classical folk art and Americana.

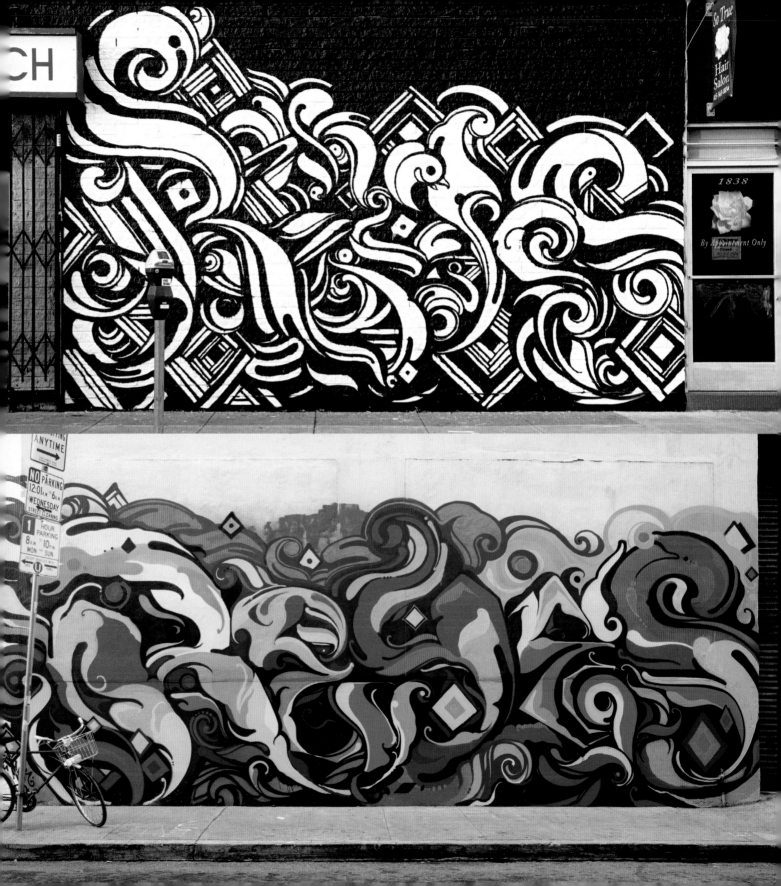

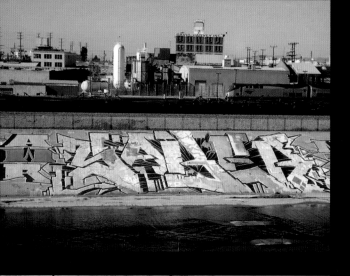

LOS ANGELES

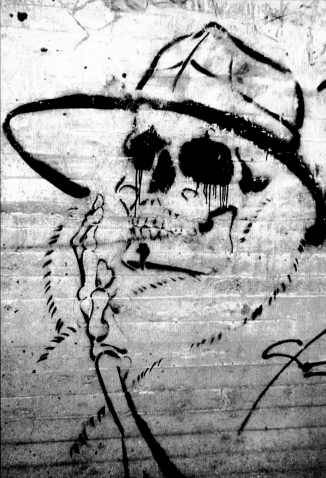

Los Angeles (LA) is a city of the twentieth century, its history one of carefully designed neighborhoods drawn by all-powerful media and real estate barons. In the early 1900s, East Los Angeles became a popular destination for immigrants; an influx from nearby Mexico arrived just as the city exploded in competition with its older rival to the north, San Francisco. Neighborhood gangs began to grow and they took the unusual step of adopting a gothic-style font that they used to write their names and key neighborhood territory.

By the time the New York graffiti style arrived in Los Angeles in the early 1980s, the *cholo* gang style—using calligraphic thick-to-thin brushstrokes and perfectly horizontal baselines—was already decades old in LA. Normally undertaken by anonymous artists who put crew and neighborhood name—and roll calls of friends—above individuality, artists such as Chaz Bojórquez were the exception rather than the rule. His "Señor Suerte" character, a fedora-wearing skull, became an emblem of East Los Angeles (see image 2).

The sprawl of Los Angeles was such that graffiti developed in several areas simultaneously and separately. In the city's West Side, New Orleans transplant RISK began a long graffiti career, often painting at the abandoned Belmont Tunnel, where he and his WCA crew could paint side by side with East Side artists such as Prime and his K2S crew. Other graffiti hot spots quickly developed, like the massive, disused Pan-Pacific Auditorium in Fairfax. Others took on informal names among writers, who referred to the "Motor Yard," "Pico Yard," and so on, in a tip of the hat to the subway storage "yards" of New York.

LA's graffiti developed under the sun and writers were soon finding spaces where they could work on large murals for multiple days. A highly rendered, Technicolor-style emerged, often with characters assuming the forefront from writers, including Hex, Slick, and Revs. Hex and Slick did as much as anyone to open the eyes of New Yorkers to LA's graffiti

development via their pair of well-publicized battles. Los Angeles graffiti was not all relaxed, however; far from it. By 1987, writers from all over LA were writing on the city's transportation equivalent to the New York subways—its massive freeway network, including painting the "heavens," a writers' term for the freeway signs that hung above the speeding traffic.

By the late 1990s, a new breed of graffiti writers was bringing both monumental scale and daredevil tactics to the Los Angeles streets and freeways. To escape the active graffiti removal industry, writers from the LTS crew, such as Ayer and Retna, were climbing and painting in places thought to be unreachable. AWR writer Saber's piece in the Los Angeles riverbed in 1997, the size of a football field and completed on a dare from his friend GKAE over dozens of nights' work with ninety-seven gallons of house paint in a dangerous area, was nothing short of the graffiti piece of the decade anywhere in the world (see image 1). Saber's AWR crewmate Revok (see pp.82–3) had traveled throughout the United States in his teens and early twenties, including a notable stop in Nashville, Tennessee, where he met Sever (see pp.84–5), who relocated to Atlanta, New York, and later Los Angeles.

Murals, whether Chicano or as a part of the Works Progress Administration in the Great Depression of the 1930s, had long been a part of Los Angeles's culture. Hollywood's constant need for set painting, if nothing else, helped keep monumental painters in work. As the graffiti and street art boom of the 2000s spread through Los Angeles, muralists such as Retna, Kofie (see pp.74–7), and El Mac (all frequent collaborators, see pp.78–81 and image 4) as well as Los Angeles original RISK, each created personal hybrids of graffiti with mural techniques all their own.

As street art exploded around the world, Los Angeles became one of the centers of its booming market in the 2000s. It reached its zenith with UK artist Banksy's "Barely Legal" exhibition in 2006 (see image 3), his Oscar-nominated film *Exit Through the Gift Shop* (2010), and the *Hope* image by Shepard Fairey (see pp.86–9) of Barack Obama in 2008. **CN**

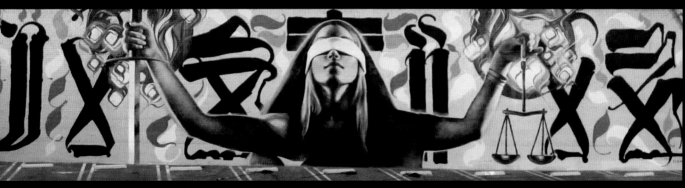

1 Saber, 1997 2 Chaz Bojórquez, 1970s 3 Banksy, 2006 4 Kofie, El Mac, and Retna, 2010

BORN 1973, Los Angeles, USA **MEDIUM** Spray paint, collage
STYLE Contemporary geometric muralism **THEMES** Retro-futurism
INFLUENCES Illustration, architectural drawings

AUGUSTINE KOFIE

KOFIE'ONE

Inspired by the basic building blocks of the geometric world, Augustine Kofie has established a retro-futuristic aesthetic that transforms these shapes and angles into a soulful, organic, yet highly mathematical form of abstraction. Merging his traditional graffiti education—his inclination toward "certain color forms and certain application techniques"—with his deep love of illustration and preliminary design—his fondness for "drafts, architectural renderings, and pre-production concepts"—Kofie plays with form, line, balance, and depth, twisting and manipulating his murals, illustrations, and compositions into ever new and dramatic arrangements.

Born and raised in Los Angeles, Kofie's instinct to draw was cultivated by his mother. While she was studying fine arts at UCLA (University of California, Los Angeles), Kofie used the supplies that lay around his house to experiment with. Although his art education never went further than high school, Kofie's real training came through painting graffiti and he had gained prominence on the Los Angeles scene by the mid-1990s. Graffiti gave him his technical foundation, an extensive understanding of "color and layering, points of perspective and arrangement," but it also provided the underpinning for his love of construction and form. Through drafting and sketching wildstyle pieces—"stretching the letters out and rebuilding them"—Kofie began to understand the architectural basis of writing, which pushed him to focus on the linear rather than alphabetic aspects of his work. Kofie's evolutionary drive led him onward and he began to "distort and manipulate" his work, attempting to "re-contribute and redistribute something new." Developing his aesthetic into an almost pure abstraction that was dominated by the simple squares, triangles, and circles that make up the structural universe, Kofie's relentless desire to experiment with and explore his visual surroundings forced him to constantly test his own mindset and preconceived ideas: Each work was an attempt to find a geometrical solution to a graphical problem. Putting his entire soul into his craft, Kofie has developed an intensely layered, earthy, and dynamic style of contemporary muralism.

1 *Futurino*, Turin, Italy, 2012
2 Design District Mural, Miami, USA, 2010
3 *Graffuturiste*, Wynwood Walls, Miami, USA, 2011

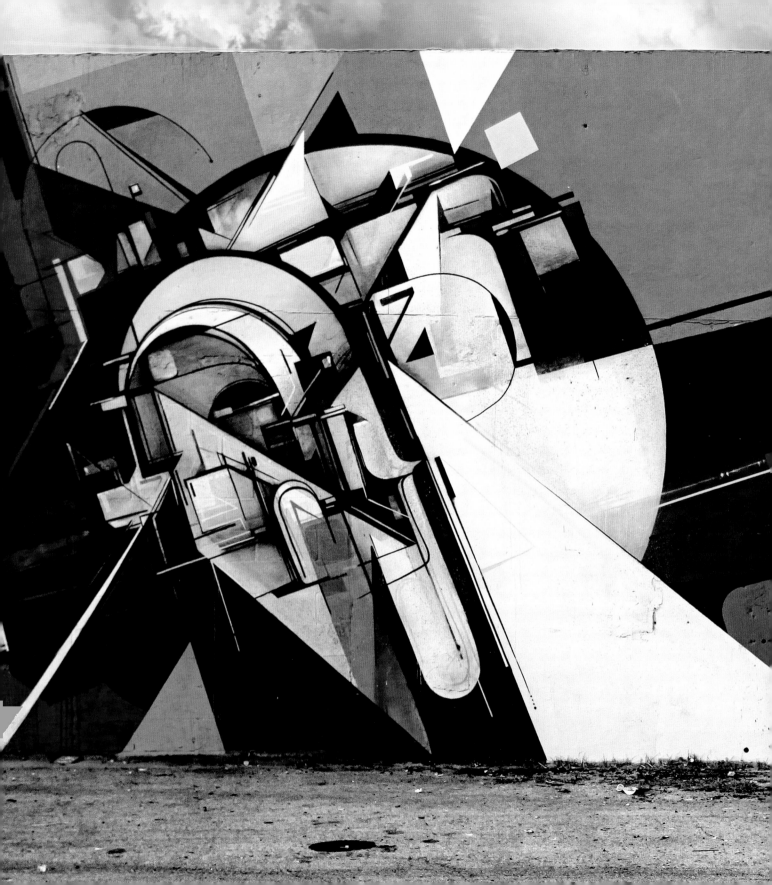

LOS ANGELES

BY AUGUSTINE KOFIE

Augustine Kofie's map of Los Angeles combines the three principal elements of his fine art work—his geometrical abstraction, his retro-futuristic aesthetic, and his love of drafts and architectural renderings. With its soft earth-tones and vintage palette, its collagist's application of ephemera and found graphics (what he has described as a "dissemination of discarded segments of the past re-examined through integration"), Kofie's rhythmic, technical work functions almost as a mind map, a collection of thoughts and ideals that he fuses into a whole. With his map, Kofie explores the theme of suburbia in Los Angeles and to accompany his visual representation, he wrote the following textual description:

We are the many varied people that inhabit the many varied landscapes of this world. We are many. Together we create a system. We function as one, but we live as many. To see ourselves as we are, we must look closely, and then from afar.

The human landscape is made up of human errors and while we attempt to improve ourselves, we must see where our faults lie. We do not deserve a piece of land to call our own. Happiness is not in the deed of a home. Happiness is to each their own. Together we live separately and create a web of human survival. Physically and spiritually. Urban, suburban, rural. They work together. Separately. Each as important as we all are. Individually, they become one unit breathing the same air, looking at the same sky. As important as density is to saving resources, so is the space to grow the food we eat. Suburbia alone should not be about affordability, but accessibility. Do we have access to what we need?

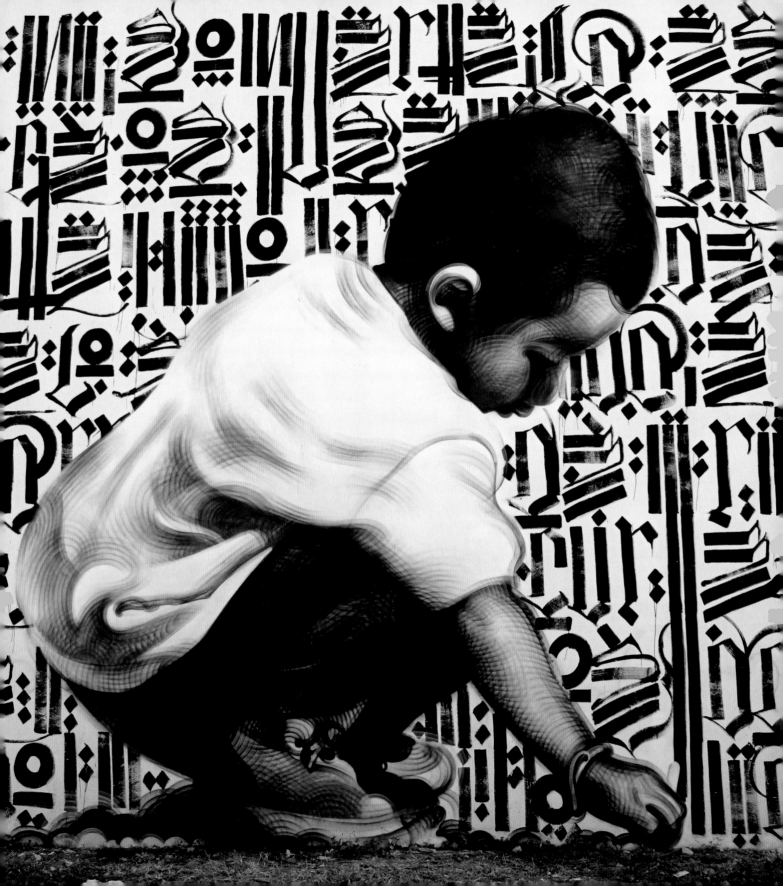

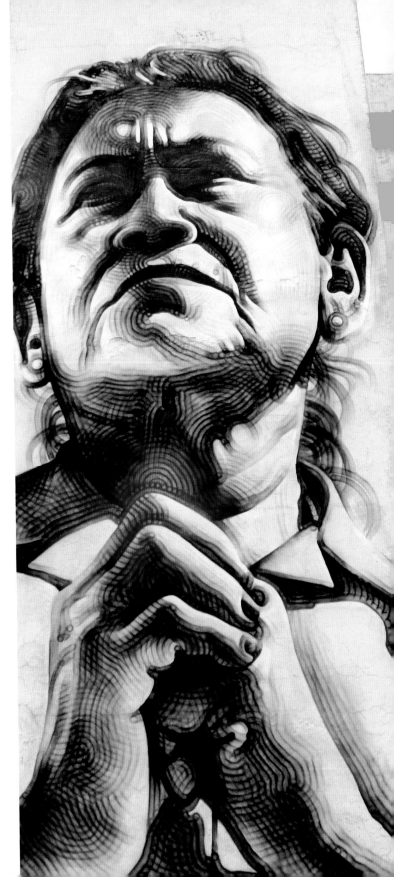

LOS ANGELES
BORN 1980 MEDIUM Spray paint STYLE Contemporary photo-realistic
portraiture, light, pattern THEMES Everyday heroes INFLUENCES Mexican
muralists, art nouveau, Renaissance Masters, reaction–diffusion system

EL MAC

With a distinctly glowing and pulsating presence, El Mac's photo-realistic
aesthetic presents us with a unique example of Independent Public Art, a
form of image-making within the classical tradition of Western portraiture.
Mac's work fundamentally disrupts the all-too common perception of
graffiti as vandalism—as a destructive rather than constructive form of
cultural production. Although he finds inspiration in the rich canon of art
history—his art contains more links to religious icons and the Renaissance
masters than to classical wildstyle or the "Kings" of subway art—he pays
homage to the graffiti movement through his techniques and attitude.
Mac combines a highly detailed observation of the human condition (in
both its physical and emotional aspects), with a dramatic use of lighting
and pattern. His images often depict individuals who live in the area where
he paints, most prominently members of the Chicano and Mexican
community with whom he grew up. This dual approach—his faith in
emotionality and locality—embues his muralism with a consciously
idealistic and tender outlook that has the capacity to lift the spirits of
all those who encounter it.

Born Miles MacGregor in 1980, Mac first became interested in painting
through his artist mother. He began to draw from a very early age, having
taught himself the basic skills through studying the many art books that
surrounded him in the family's Los Angeles home. Although he first began
painting seriously with acrylics, graffiti began to interest Mac in about 1994,
when he, like so many others, came across the influential book *Subway Art*
(1984) by Martha Cooper and Henry Chalfant. He began painting on the
street with his friends Venk and Stoec as part of his first crew, DSC. Working
on both walls and freights, Mac moved toward representational rather
than textual work almost immediately, however. Despite the disapproval
of his graffiti friends, he found that he preferred painting faces to letters.
He understood the distinctions between graffiti and muralism, but in his
mind they clearly sprang from the same roots, and he set out to resolve
the differences in the two discourses through his practice. By 1999, when
he was living in Phoenix, Arizona, Mac had started to paint large-scale
portraits of his friends throughout the American southwest, alternating
these with images of local Mexican farmworkers and his reinterpretations
of "Old Masters." In a very public form of education, he experimented with

1 *Young Scribe*, Miami, USA, 2008 (calligraphy by Retna)
2 *Maria de la Reforma*, Mexico City, Mexico, 2012

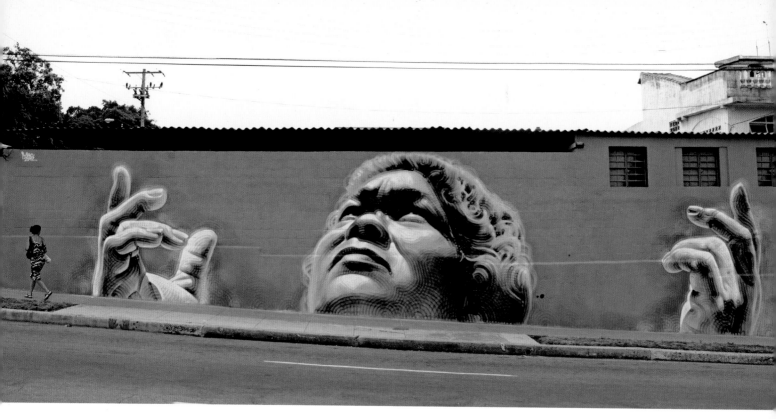

form, shade, and contour, using a smooth, almost airbrushed technique. Having expanded his skills through years of being forced to paint quickly and in the dark, by 2006 Mac had developed a style based on a more refined form of brushwork and patterning using broad, contoured lines that emphasized the wide lines formed through his use of fat caps. He began to move away from his earlier monochromatic designs to ones that were more intensely colored and detailed, as well as starting to use abstract motifs. Exploring the possibilities arising from a fusion of figuration and non-representational imagery (in works often completed with his then partner Retna), Mac constructed portraits using surging, undulating patterns with rich curves, which had an oscillating presence that seemed to almost make them vibrate out of the walls themselves. Mac's striking use of patterns relies on a technique that functions through a process known as reaction–diffusion, inspired by the system discovered by mathematician Alan Turing in the 1950s. Used as a model for pattern formation, the system sets out to explain the patterns that have evolved in the natural world, most famously the skin patterns of animals such as leopards. By applying the seemingly abstract, yet organic, markings of this system, Mac produced images that appear to harness a form of natural energy.

Yet, his work also shows the influence of an eclectic range of artists and artistic styles from throughout history: Mexican muralists, such as Rivera, Siqueiros, and González Camarena; Old Masters, including Caravaggio and Vermeer; and art nouveau symbolists, such as Klimt and Alphonse Mucha. Mac manages to capture the fundamental quality that portraiture can elicit: its ability to not only reveal what literary theorist Roland Barthes has termed the "studium"—the various cultural meanings associated with an image—but also the "punctum"—the element of the work that reaches us through its beauty and establishes a direct relationship between the image and ourselves.

Mac's distinctive style of portraiture has reinvigorated the genre while remaining true to its origins: He produces images with the power to define an individual's spiritual as well as physical essence. Whether using spray paint, acrylic, or pencil, Mac hopes that his works will in time take their own place in the lineage of art history and inspire others in the same way that he has been inspired. Seeing art as a spiritual rather than academic pursuit, he strives to create murals that can truly make a difference to the communities in which they appear—that physically move us in an iconic dedication to the unacknowledged heroes of the everyday.

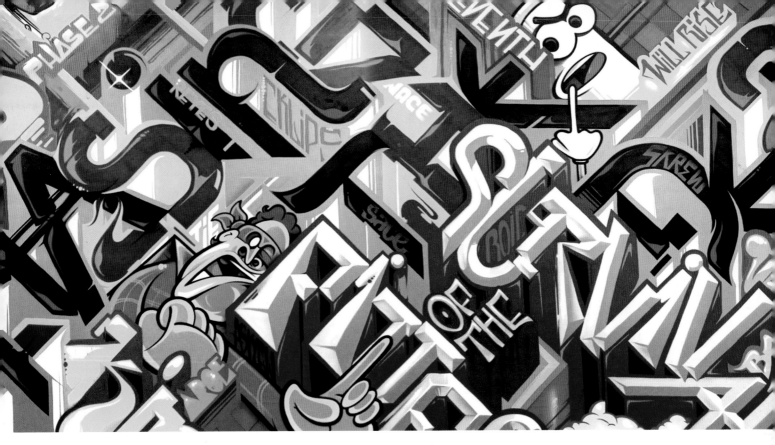

LOS ANGELES

BORN 1977 MEDIUM Spray paint STYLE Contemporary graffiti,
stylewriting INFLUENCES Risk, Charlie, Green, Oiler, Gkae, Ayer
CREWS MSK (Mad Society Kings), AWR (Angels Will Rise), The Seventh Letter

1 Melbourne, Australia, 2009 (with Ruedione)
2 Detroit, USA, 2010 (with Risk)
3 "Art in the Streets," Los Angeles, USA, 2010 (with Rime)

REVOK

One of the world's most influential exponents of contemporary graffiti, a style writer esteemed within the community almost beyond precedence, Revok is also one of the most preeminent and articulate critics of the anti-graffiti movement in the United States. Experiencing the so-called "war on graffiti" at firsthand, Revok has become a lightning rod for the Los Angeles Police Department (LAPD) in recent years: His cogent and coherent rebukes of their actions resulted in a feud in which Revok was harassed, jailed, and forced out of LA. Refusing to be bowed, however, the negative energy Revok met has only inspired an even more engaged positivity in his aesthetic.

By the time of Revok's encounter with the LAPD, he had ceased painting illegally in Los Angeles for some years. Having gone all-city in the mid-1990s, by the late 2000s Revok concentrated on producing commissioned murals rather than bombing the city. The introduction of new laws to ban billboard advertising in most areas of the city, however, led to a crackdown on legal murals (the so-called "Mural Moratorium"). Revok was charged by the police for painting a mural on the side of a local business (with the building owner's permission) and was later sentenced to six months in jail after being five days late paying the $3,000 fine. He believed that he was being targeted partly due to his participation in the "Art in the Streets" exhibition at the Museum of Contemporary Art in Los Angeles, an event that had infuriated the anti-graffiti authorities. He also thought that the reduction of overall crime in the city had led to a concomitant need to find a new problem: Graffiti writers were being vilified to justify the incessantly increasing police budgets. While continuing to embrace the innate creativity of graffiti, Revok uses his art to expose the deep aporias within the anti-graffiti discourse. He has evolved his own practice (in particular with his series of collaged sculptures made from found objects), but also produced a nationally celebrated, community-based project in his new location of Detroit—the Detroit Beautification Project. For Revok, the real war on graffiti is a war on thought: It is an attempt to stop people "thinking that graffiti is something valuable or that the people responsible for doing it are legitimate artists." Refuting this through his continued output, Revok's work becomes a symbol of the power and beauty of graffiti itself, a symbol of its potential and its indomitable spirit.

LOS ANGELES

BORN Unknown **MEDIUM** Spray paint **STYLE** Contemporary graffiti, muralism
THEMES Absurdism, satire, iconoclasm **INFLUENCES** Revok, Tackz, Crome, Dax, Ease
CREWS MSK (Mad Society Kings), AWR (Angels Will Rise), The Seventh Letter

1 *Fuck the Poor*, Atlanta, USA, 2009
2 *Death of Street Art*, Detroit, USA, 2012

SEVER

A member of the infamous MSK/AWR crews, Sever is a peripatetic artist who has painted all over the world. Extending his increasingly absurdist graffiti into ever new physical and conceptual territories, Sever has spent years perfecting his classic style, which has enabled him to modify his traditional approach while staying true to its roots. Tackling issues rather than promoting his pseudonymic identity, Sever has formed a visually dynamic aesthetic with a sardonic, satirical comedy at its core, one that brings the politically and socially conscious element of graffiti culture to a more comprehensive audience.

Sever grew up in the southeastern United States and spent time in San Francisco and Manhattan, however, it was while living in Atlanta that he made his name. A chance encounter with Revok (see pp.82–3) in Nashville influenced his early development (and turned into a lifelong friendship), however, Sever was mainly inspired by the underground graffiti art movement as a whole. Books such as the legendary *Bomb the Suburbs*

(1994) by William Wimsatt and the magazine *Life Sucks Die* gave him a more extensive understanding of its differing movements and methods. As his work developed, however, Sever became aware of the absurdity of the narcissistic brand he had created as well as the absurdity of the "state of the world" generally: Developing a style that could grapple with these dual incongruities—while remaining firmly within the visual regimes of graffiti—Sever playfully used his skills to poke at issues such as poverty in the United States (see image 1, produced illegally in front of the High Museum in Atlanta), as well as the impending extinction of street art, such as *Death of Street Art* (see image 2), a work featuring pallbearers whose iconic faces echo the works of Barry McGee, Os Gêmeos (see pp.120–3), Shepard Fairey (see pp.86–9), Banksy, Futura, and Kaws. Also exploring themes such as the United States's involvement in Palestine, and the CIA's alleged drug trafficking in inner cities, Sever has formed an aesthetic fusing the illustrative and typographical basis of graffiti with a form of social commentary often falsely seen to be the territory of its street art sibling: Blurring the often illusionary lines between these two forms, he has initiated a style of graffiti with a gallows humor at its core, an iconoclastic, rabble-rousing example of Independent Public Art.

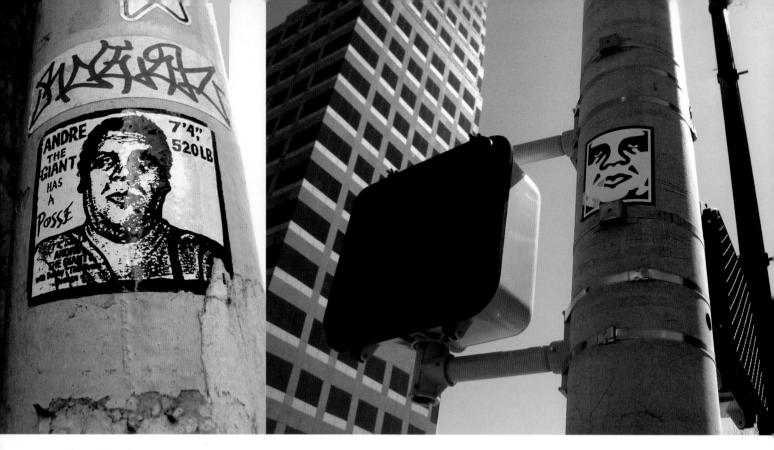

LOS ANGELES

BORN 1970, Charleston, USA MEDIUM Stickers, posters, wheat paste
STYLE Street art, poster art THEMES Politics, free speech, propaganda
INFLUENCES Twist, Andy Warhol, Barbara Kruger, Russian Constructivism

SHEPARD FAIREY

OBEY

As the world's most famous proponent of street art, Shepard Fairey has transformed the status of wheatpasting and poster art from the low-brow, countercultural realm of punk and skate to the highest levels of national attention and esteem. With his iconic image of US President Barack Obama, entitled *Hope* (see image 3)—an image produced independently in the run-up to the 2008 presidential election, but subsequently adopted by the Obama campaign itself—Fairey and his work reached a hitherto unprecedented audience. The work had an arguably far greater impact than any other single artwork before (or, at least, one on a par with other iconic images, such as that of Che Guevera or Mao Tse-tung—images that Fairey has also used in his practice). The

1 *André the Giant Has a Posse* campaign, 1989
2 *OBEY* campaign, 1990
3 *Hope*, Denver, USA, 2008

Hope poster introduced his work to millions of new people, however, Fairey had been an intensely active and renowned member of the Independent Public Art scene for more than twenty years. Although he has won as much acclaim as condemnation for his overtly political aesthetic (for his successes in the institutional art world as well as his connections to the powers he sets out to question), Fairey has become a divisive figure, a "straw man" for those uncomfortable with any crossover between subcultural and mainstream discourses. Despite this, Fairey continues to embrace the communicative potential of the public sphere even as his work becomes increasingly accepted by more conventional institutions. His belief in the power of "free speech and expression without bureaucracy" and in the street as a space for "political commentary and social critique" means that, irrelevant of his success, his hunger to keep producing work in the city remains insatiable.

Skating initially fueled the young Fairey's imagination. Buying his first board when he was fourteen, the combination of the actual practice and the punk soundtrack that accompanied it became an influence that dominates his life to the present day. When he moved to Providence to attend the Rhode Island School of Design in 1989, Fairey already had a

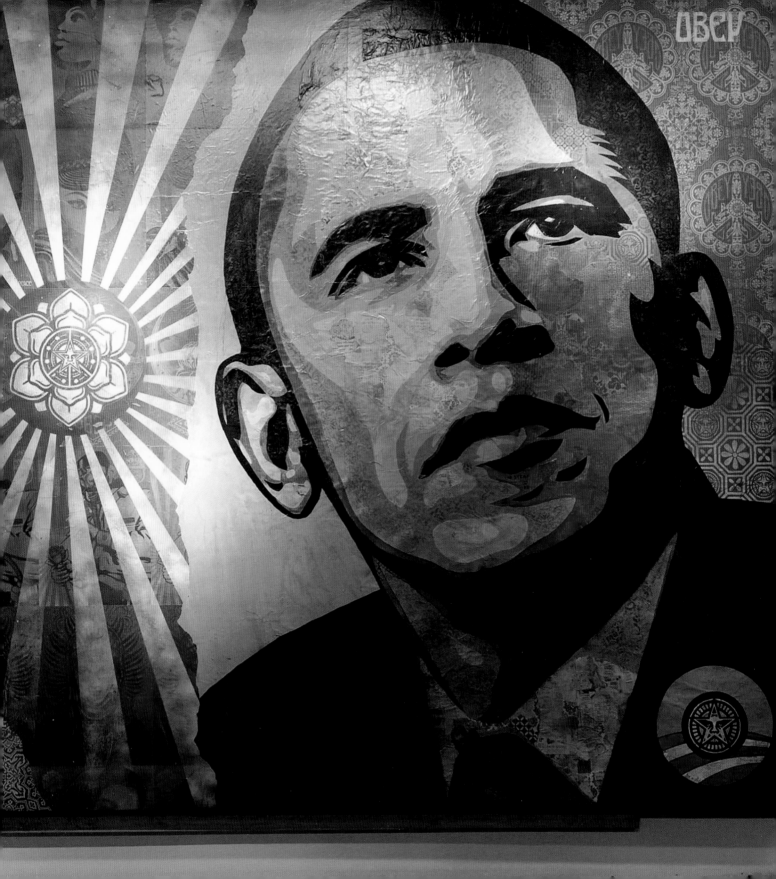

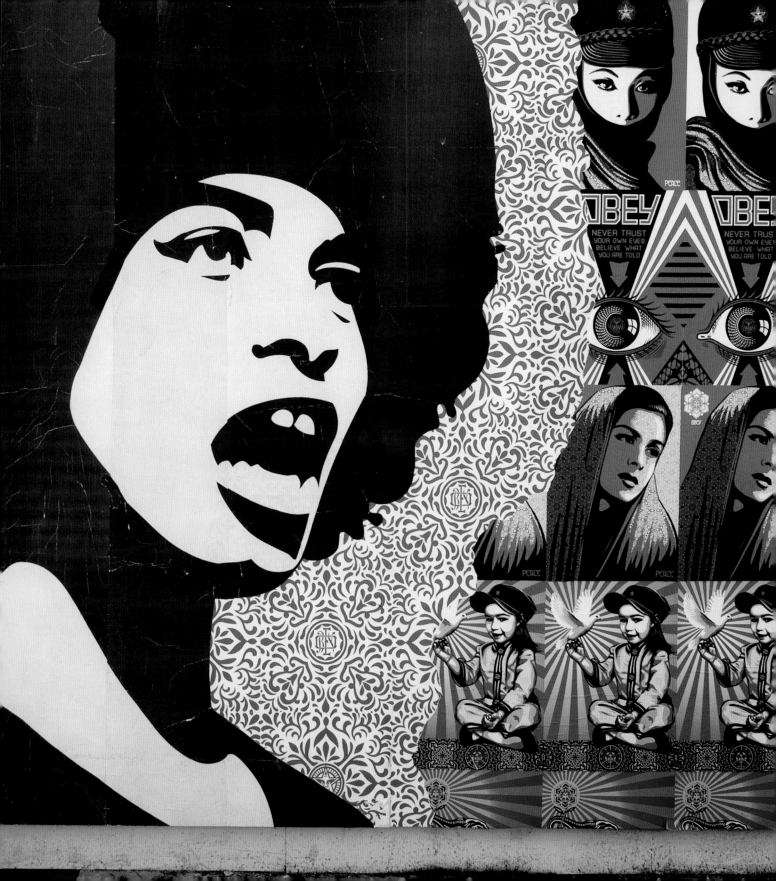

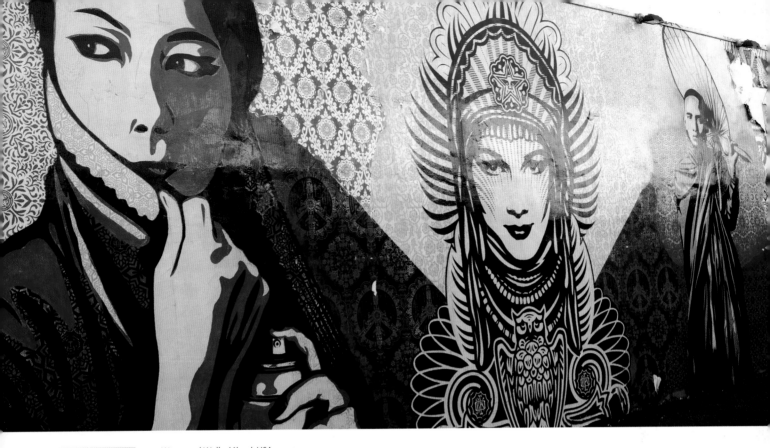

1

2

fairly embedded style in place, a subcultural aesthetic that grew ever more expansive with his formal education. In 1989, in his first year of college, he initiated the *André the Giant Has a Posse* sticker campaign (see image 1, p.86), thinking it would only be "a few weeks of mischief," a project that at the most would gain a response from his "clique of art school and skateboard friends." Combining an image of the French wrestler André René Roussimoff (an image he discovered by chance while teaching a friend how to make stencils) with the mysterious eponymous phrase beneath, he proceeded to obsessively disseminate the images, still with little expectation that anyone outside his close circle would even notice them. Five years later, however, the underground campaign that Fairey created had spread to cities all over the United States and with national media attention came the threat of lawsuits. It was the first of Fairey's many brushes with the law, encounters revolving around either the simple charge of vandalism or the more complex law of "fair use." The experience acted as a catalyst spurring Fairey to create a more simplified, but perhaps even more iconic image of André for his infamous *OBEY* campaign (see image 2, p.86). Paying tribute to the posters seen in John Carpenter's cult movie *They Live*, the *OBEY* campaign aimed to "make people think about

the mechanisms of control" in their environment, acting as propaganda and a parody of propaganda at the same time. Its inherent ambiguity, its simultaneous boldness and opaqueness, was therefore part of the campaign's success: Finding a balance between the "goofy and creepy, humorous and monolithic," it promoted a debate over its nature that would have been impossible had it been more readily classifiable.

It was a debate that Fairey hoped would lead to a reassessment of the state of the public sphere itself. As a tax-paying citizen, Fairey believed he had an innate right to work in public space and highlight the mendacious advertising culture that city residents were subjected to everyday. He felt it was crucial to become "part of the cultural dialogue" and to question "obedience, question the control of public space, question the nature of propaganda." Although Fairey's works have themselves become part of the mainstream and his gallery shows and institutional acquisitions increased, his commitment to the public sphere seems only to intensify. Nothing has softened in the intervening years, the fire and indignation of his teenage years still all-pervading. Even though this makes him open to criticism, both positive and negative, Fairey's authentic belief in his cause and his desire to reclaim the public sphere at any cost remain paramount.

MONTREAL

BORN 1981, Nantes, France **MEDIUM** Spray paint, oil bars, chalk **STYLE** Naive graffiti, outsider aesthetic, streaking
THEMES Folk art, train writing **INFLUENCES** Boxcar graffiti

JIEM
BOXCAR JIEM

Born in France but currently residing in Montreal, Jiem is an illustrator, painter, and photographer who has devoted his life to writing and recording graffiti. His work has an eccentric, instantly recognizable style, a character-driven approach that is simple and accessible. Jiem rejects any desire to be avant-garde and prefers instead to utilize a method that, despite its rough, imperfect aesthetic has a magical, captivating style. He has painted a wealth of naive-influenced graffiti and murals throughout the world but it was his lifelong obsession with the North American railway movement that provoked his recent continental migration.

Growing up in a small town near Nantes, Jiem's first experiences of graffiti came through the railroad. Living only minutes from a freight line, and with his local neighborhood devoid of any form of Independent Public Art, the boxcar graffiti that the trains began to carry in the early 1990s became a huge inspiration for Jiem. Starting to paint with a few

1, 2, 5, 6 Montreal, Canada, 2010
3, 4, 7 Montreal, Canada, 2011

1	2	3		7
4	5	6		

close friends, Jiem soon became infatuated with the complex history and culture associated with train (rather than subway) writing, a tradition of chalk drawings made by hobos and railway men dating back more than 100 years. While his frequent trips to Paris schooled him in the classic techniques of graffiti, moniker painting—or "streaking" as this freight-based practice is traditionally known—still retained a firm place in Jiem's heart.

Jiem eventually moved to Montreal in 2010, intent on finally fulfilling his dream of being able to "see, touch, and paint" these trains. While there he took numerous photographs of this proto-graffiti culture and conducted interviews with some of its most famous practitioners, the results of which can be seen in his self-published book *Outside the Box*. Jiem also made hundreds of his own oil-bar and chalk markings on the freights (see images 1–7), working like others to keep the culture of moniker painting alive. Embracing the adventure and freedom that is so integral to the culture—the smell of the rust, the charm of the freights—Jiem has become part of the history of the movement himself. He engages in a practice that seeks purity, spontaneity, and authenticity—an outsider aesthetic trying to revive the original spirit of graffiti.

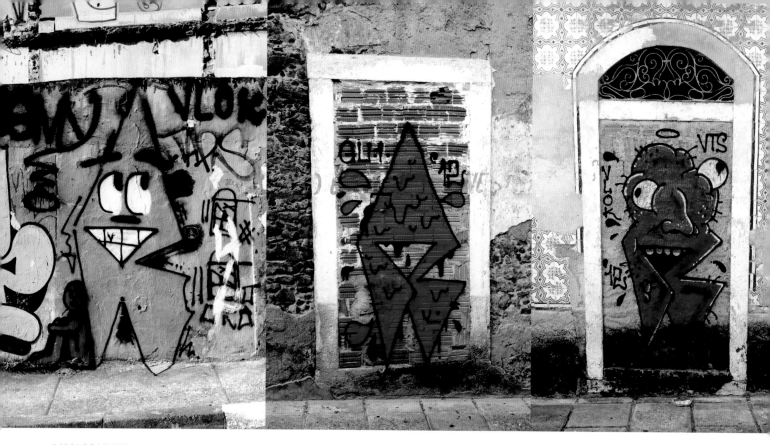

VANCOUVER

BORN Norway **MEDIUM** Spray paint **STYLE** Classic graffiti, bombing
THEMES Characters, do-it-yourself, playfulness, non-consensual art
CREWS VTS (Vandal Team Supreme), DFW (Down For Whatever), VLOK

REMIO

Remio's images are everywhere: Thousands upon thousands of his tags and throw-ups—his famous tilted, jagged, anthropomorphic "R"—proliferate like wildfire around the planet. Yet Remio fiercely guards his anonymity, unwilling to sacrifice his personal identity for the sake of a more conventional understanding of fame. His fame (or perhaps his infamy) is therefore the enigmatic, furtive renown of an aesthetic insurrectionist, a figure still deeply indebted to and in awe of the power of graffiti.

Although he was born and raised on a small island in Norway, Remio has lived a nomadic lifestyle for many years, traveling the world in search for new places to paint and new people to paint with. He first discovered graffiti in the mid-1990s, when he originally tagged the names of his musical heroes, such as Nirvana or Zap40 (in reverence to the birth year of Frank Zappa). Remio devised his current name in 1998, when he reversed the alias he then used, Imer, and added the "O" in homage to the legendary Canadian writer Fatso. Having moved to Vancouver permanently by 2000,

1 *Point of Equilibrium*, São Paulo, Brazil, 2012
2 *For Gusto*, São Luís, Brazil, 2012
3 *Jungle Chud*, São Luís, Brazil, 2012
4 San Francisco, USA, 2012

however, by 2002 Remio had founded the VTS crew (Vandal Team Supreme, Vandal Travel System, Vandalize Till Sunrise, Very Top Secret) along with Kaput and Acter. Although the collective originally consisted solely of members from Vancouver, it has since spread worldwide. Remio's exuberance, dynamism, and obvious devotion to the form has also seen him join two other legendary collectives, Twist's DFW/THR and Os Gêmeos's VLOK (see pp.126–7). Recently invited to Brazil by Os Gêmeos (see pp.120–3) to take part in their whole train project, Remio has taken his famously rough, playful aesthetic to ever new locations, constantly developing, learning, and conveying his visual perspective to the world. Along with his current status as king of the DIY graffiti scene (his output including the celebrated 'zine *Sleepner*, as well as his homemade T-shirts, hats, stickers, and buttons), Remio stands as one of the key contemporary proponents of the all-out bombing, by any means necessary, strand of graffiti culture. He represents its raw, untreated essence. Enamored with non-consensual public art, with the non-filtered, non-approved art of the streets, he has therefore formed an inimitable graffiti practice: In a fusion of stylistic purity, incessant iteration (with all its subtle yet quite crucial differences), and the true virtue of a vandal, his is a dirty yet strangely graceful aesthetic.

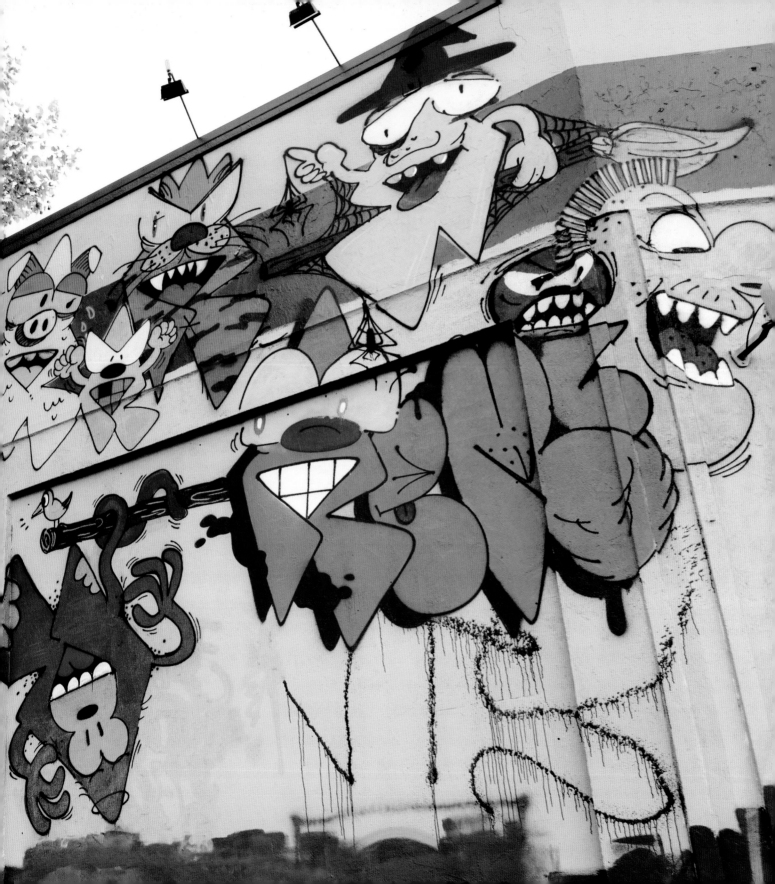

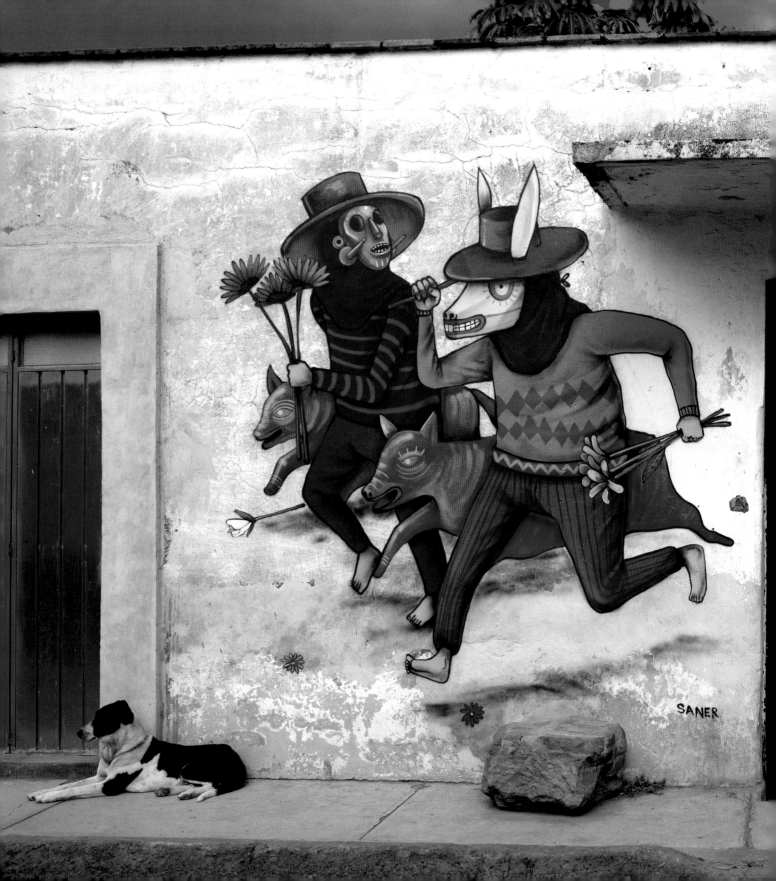

1 *Xolos y un puerco* by Saner, Cholula, Puebla, Mexico, 2012

LATIN AMERICA

MEXICO CITY SÃO PAULO BUENOS AIRES

OS GÊMEOS LOS CONTRATISTAS DOMA NAZZA STENCIL CHU VITCHÉ HERBERT BAGLIONE NEUZZ
INTI CASTRO CRIPTA DJAN DHEAR SANER BASCO VAZKO SEGO Y OVBAL TEC NUNCA FASE VLOK

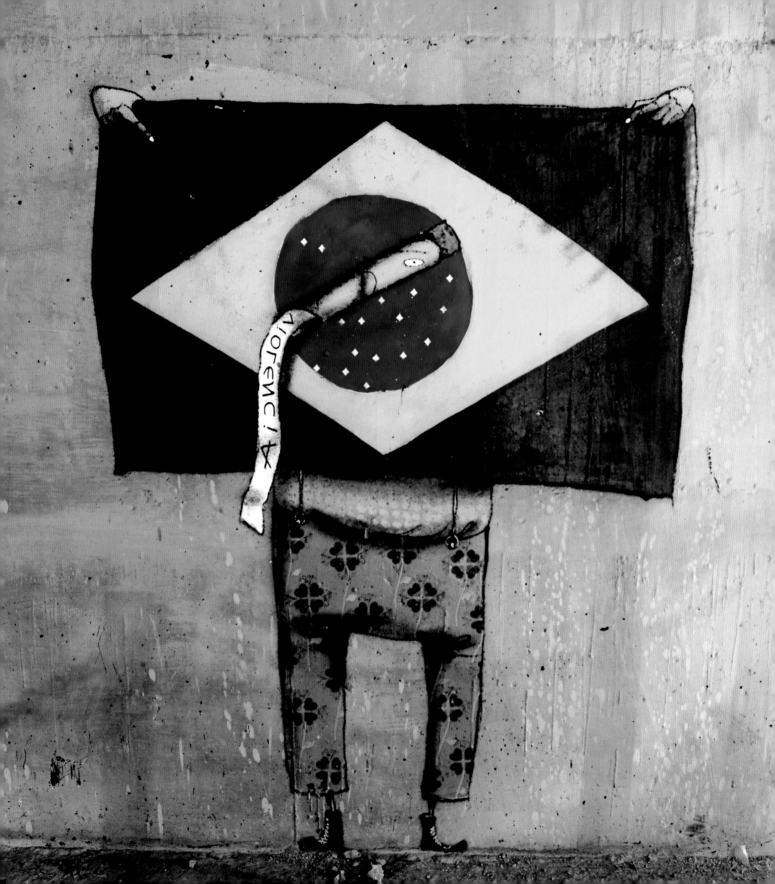

As in many postcolonial locations, Latin American culture has often been seen as a mere derivative of its "Western" counterparts, a mutated, secondary reflection of its Occidental cousins. However, as with its classical art, from its pre-Columbian treasures to its twentieth-century masters, Latin American Independent Public Art has not replicated, but instead instigated numerous movements within the genre as a whole, making it a highly significant location on the global scene. While artists from all over the world have traveled there to gain inspiration (as European artists such as André Breton did in the 1920s), local artists have mined the autochthonous traditions of the continent and linked them to the wider global practice, forming a syncretic, robustly distinctive variety of styles. The aesthetic styles that have consequently emerged in the region—Mexico's primitivist, surrealist muralism, the *pixação* and figurative graffiti of São Paulo, the *Salvajismo* and political stenciling of Buenos Aires—have each developed into notable approaches to Independent Public Art in their own right, challenging the hegemony of their northern equivalents through their overtly Latin American quality and through their equally innovative and indigenous dispositions.

Mexico City (see pp.98–9) has possibly the richest history of public art. The legendary, early twentieth-century tradition of Mexican muralism, headed by the esteemed triumvirate of Diego Rivera, José Clemente Orozco, and David Alfaro Siqueiros, set the stage for future Latin American artists, acting as an influence through their conceptual principles and their clear mission to make art for the people. Although artists such as Dhear (see pp.100–1) and Sego (see pp.106–9) have initiated a more surrealist, ecological style of art that seems to reject the social consciousness of the muralism movement (although Sego's environmental leanings are hard to miss), others such as Saner (see pp.104–5), Neuzz (see pp.102–3), and Los Contratistas from Nuevo Leon in northern Mexico (see pp.110–11), have formed a more explicitly folkloric, spiritual aesthetic that adopts many of the traditional icons of native Mexican culture. As a group, however, they all push each other to progress their work whichever style they choose to initiate, developing without any boundaries.

In São Paulo (see pp.112–13) the local tradition of *pixação* is the iconic visual starting point, a local form of parietal writing that since its re-introduction into the city in the 1980s has become famed across the world. Emerging from an entirely different taxonomic lineage to that of modern graffiti (the style emergent from the East Coast of the United States in the late 1960s and 1970s), *pixação*'s distinctive lettering and militant approach—both in terms of its location of practice and its social underpinnings—has given it an aura of authenticity that practitioners such as Cripta Djan (see pp.114–15) strive to uphold. However, alongside the influence of *pixação*, São Paulo has also developed a form of figurative

muralism that expresses a more spiritual, existential approach. With artists such as Herbert Baglione (see pp.116–17), and Vitché (see pp.124–5), this highly symbolic, allegorical aesthetic has brought issues such as life, death, magic, and ritual to the forefront of the city. Intertwining these two approaches, however, the infamous VLOK collective (see pp.126–7), which includes Nunca (see pp.118–19) and Os Gêmeos (see pp.120–3), among many others, has combined the combative ethic of the *pixadores* (and the typographic style itself) with the more transcendental style that Baglione and Vitché developed. Os Gêmeos in particular have become world leaders in this style, although as their huge, dramatic murals and complex installations have evolved, they continue to push their graffiti at an amazing rate, committing to their street practice irrespective of their successes in the institutional art world.

The last of the three key Latin American cities, Buenos Aires (see pp.128–9), has its own, quite distinctive style of Independent Public Art. Although often called "the Paris of Latin America," it is in fact Barcelona that has been most influential on the region's aesthetic development. Tec's (see pp.140–1) early visit there in 1992 had a significant effect on the latter scene as a whole. Along with Tec's crew FASE (see pp.136–7) and other artists (and close friends) such as Chu (see pp.130–1) and his collective DOMA (see pp.134–5), these practitioners rejected urban grayness and initiated a more colorful, absurd style of art that set out to repudiate the political deadlock they perceived around them: Known as *Salvajismo* ("savagery"), this iconic, instantly recognizable style of work put the city on the Independent Public Art map and, like Barcelona again, turned Buenos Aires into a location where artists from around the world traveled to meet and paint. Although the scene fully matured during and after the financial crisis of the late 1990s and early 2000s, the history of illicit street art stems from the rule of the military junta (1976–83) when the use of stencils and slogans were of huge local significance. Artists such as Nazza Stencil (see pp.138–9) have continued in this political vein, using their work to explore more overtly social and historical themes.

There are, of course, other influential artists from all over the continent, the Chileans Basco Vazko (see pp.142–3) and Inti Castro (see pp.144–5) being two of the most prominent. Yet through their pioneering and transformative work as a group, Latin America's artists have developed a distinctive narrative of their own. Perhaps more concerned with social issues than their northern neighbors, they also use a heightened sense of color (as can also be seen in the comparison between the urban arts in northern and southern Europe). Latin America presents us with a richly colorful, stimulating, and flourishing form of Independent Public Art, a visual regime that continues to push the boundaries of the art world in its entirety.

MEXICO CITY

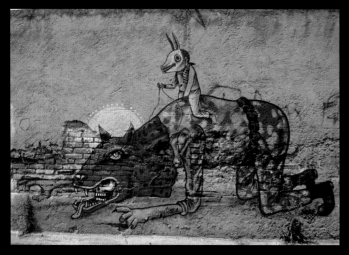

Some Mexican street art refers back to its pre-Columbian roots, but the Mexican mural movement, started by the painters Diego Rivera, José Clemente Orozco, and David Siqueiros in the 1920s, marks its modern beginnings. These murals, commissioned and promoted by the Mexican government for their nationalistic, political, and social messages, can still be seen both inside and outside public buildings in Mexico City. Among the most influential open-air Mexican murals are those by John Gorman from 1950, which cover all four sides of the National University's Central Library—a stimulus for Sego (see pp.106–9) and others in the New School of Mexican Muralism. A less happy connection between student activity and street art occurred in 1968, when the student massacre at Tlatelolco provoked a wave of protest murals, graffiti, and posters in the capital. Mexican graffiti experienced a punk moment during the 1970s, but it did not become widespread until the 1980s when hip-hop culture arrived.

The New School of Mexican Muralism is the exception to the rule: According to graffiti's rebel logic, many contemporary Mexican writers reject the pre-Columbian and muralist movement precedents. Dhear (see pp.100–1) eschews any "discourse rooted in a pre-Hispanic view of the world," preferring "to portray phenomena related to nature" and considers himself a "natural fantasist." In Dhear's graffiti murals every character and animal is capable of transforming itself into another. Dhear's cultural references have included illustration, comics, and science fiction, and have recently evolved to engage with the philosophical outlook perhaps most integrally concerned with potential transformations of beings and of the self: the Buddhist dharma.

Sego (see image 2 and pp.106–9), who is now active in Mexico City, traces his artistic roots to the wildlife of the Oaxacan coast, whereas Seher One (see image 5) looks to international surrealism, which itself was very successful in Mexico City and, like the equally surreal Dhear, to the world of Japanese comics. The original and spontaneous works by Saner (see image 3 and pp.104–5) avoid references to influences, Mexican

| 1 |
| 2 |
| 3 |

| 4 |
| 5 |

1 Neuzz and Zime, 2009 2 *Simbionte*, Sego, 2009 3 Saner, 2011 4 *In Latin America we keep painting in the open air*, KidGhe and Bisy, 2010 5 *Sea Snake* by Seher One, 2010

or otherwise, and "constitute their own laboratory where everything is allowed." Phantasmagoric weirdness provides the common ground for Dhear, Seher One, Saner, and many other Mexican street art outfits, such as Mugre Crew. More than any artistic influences, the hallucinatory quality of much Mexican graffiti can be attributed to Mexico's mescal- and peyote-fueled psychedelic sense of place. Bordering the United States, Mexico enjoys (by Latin American standards) easy access to high-quality North American spray paint, and Dhear in particular exploits the medium to its full potential in his work, through layers of spray paint with organic textures.

Neuzz (pp.102–3) works in Mexico City, but grew up in Oaxaca in southwestern Mexico. His work reflects the stories he was told as a child about *nahuales,* or shape-shifters, characters from folklore who could transform themselves into pumas, jaguars, and other animals. The masked figures in Saner's graffiti murals also reference *nahuales. Nahual* shamanic practices derive from pre-classic Olmec culture (1500–400 BCE), but Saner modernizes them and Neuzz adapts them into a contemporary style that is as accessible to Mexico City's older residents as it is to younger generations brought up on computer games. Skulls, a popular motif in Mexican popular culture, recur in the graffiti of Neuzz (see image 1), Buytronik, and others.

Said Dokins and Laura García's *Intersticios Urbanos* (Urban Gaps) project has brought leading South American artists, including Colombian Bastardilla,

Argentine Nazza Stencil (see pp.138–9), and Chileans Bisy, Inti (see pp.144–5), and the Brigada Ramona Parra, to Mexico City, where they have painted fruitfully with local artists. The significance of KidGhe and Bisy's *In Latin America we keep painting in the open air* (see image 4) is that in Latin America the history of street art predates that of elsewhere in the world. The work of the different Mexico City-based artists represented on these pages share in common the skilled use of spray paint, which together with their original explorations of Mexican, worldwide, and natural imagery, enables them to achieve an organically metamorphic surreality. **RP**

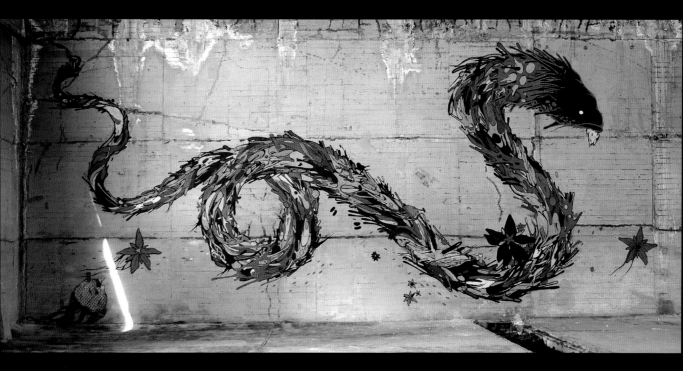

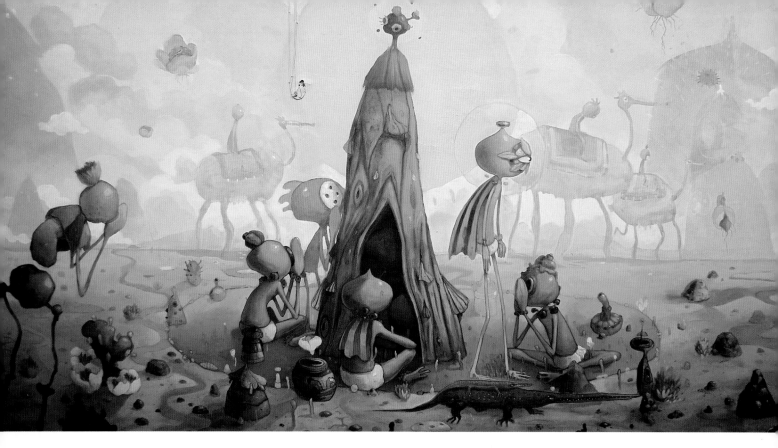

MEXICO CITY

BORN 1985, Mexico City, Mexico **MEDIUM** Spray paint **STYLE** Surrealist, abstract fantasy **THEMES** Nature, myth, magical realism, folk tales, animation **INFLUENCES** Möebius, Roger Dean, Hayao Miyazaki

| 1 | 2 |
| 3 | |

1-2 *Siddharthas*, Cholula, Puebla, Mexico, 2011
3 *Leaving Things Behind*, Valparaíso, Chile, 2012

DHEAR

Seamlessly blending nature, myth, and fantasy, Dhear is a modern graffiti surrealist, whose technical and narrative experimentation has made a quite distinctive contribution to Independent Public Art. He paints in a delicate, intricate style, creating multilayered, surreal panoramas in which elements of the ecological environment, such as bacteria and funghi, assume anthropomorphic qualities. His work conjures up a world that is at once futuristic and prehistoric, familiar yet ethereal.

Dhear's passion for drawing stems directly from his introduction to graffiti at the age of thirteen, when he witnessed early Mexican graffiti pioneers at work on the streets of the capital—writers such as Mosco, Cose, and Mero, and crews including CHK, HS, and SF. Almost immediately he began to draw and, as he describes it, trying to comprehend these "codes on the walls that I couldn't understand." When he traveled to the Tianguis Cultural del Chopo (the central flea market in Mexico City) to buy markers and inks, he met other aficionados of graffiti and he began to

paint with them, both legally and illegally, but particularly inside abandoned factories and at "underground" sites. He was heavily influenced by illustrators such as Möebius, Roger Dean, and Hayao Miyazaki, whose work he discovered through his love of comics, science fiction movies, and Japanese animation. Over time Dhear started to focus more on characters than on letters and pushed himself to adopt a more abstract technique. He studied traditional animation to reinforce his knowledge of drawing. It was after dislocating his arm as the result of a fall while out painting graffiti, however, that he began to concentrate more seriously on his non-illicit work. By 2006, Dhear was creating digital illustrations, canvases, installations, and sculptures, all while continuing to paint illegally on an almost daily basis. It was this combination of licit and illicit, and the consequent amalgamation of these skill sets, that refined his style into its present recognizable form.

Dhear has now started to work on more distinct projects, most recently a series reinterpreting Herman Hesse's classic novel *Siddhartha* (see images 1–2). He explores both beauty and horror in the surrealist, fantastical realms he creates; giving free reign to his imagination he thrusts the viewer headlong into his idiosyncratic, colorful universe.

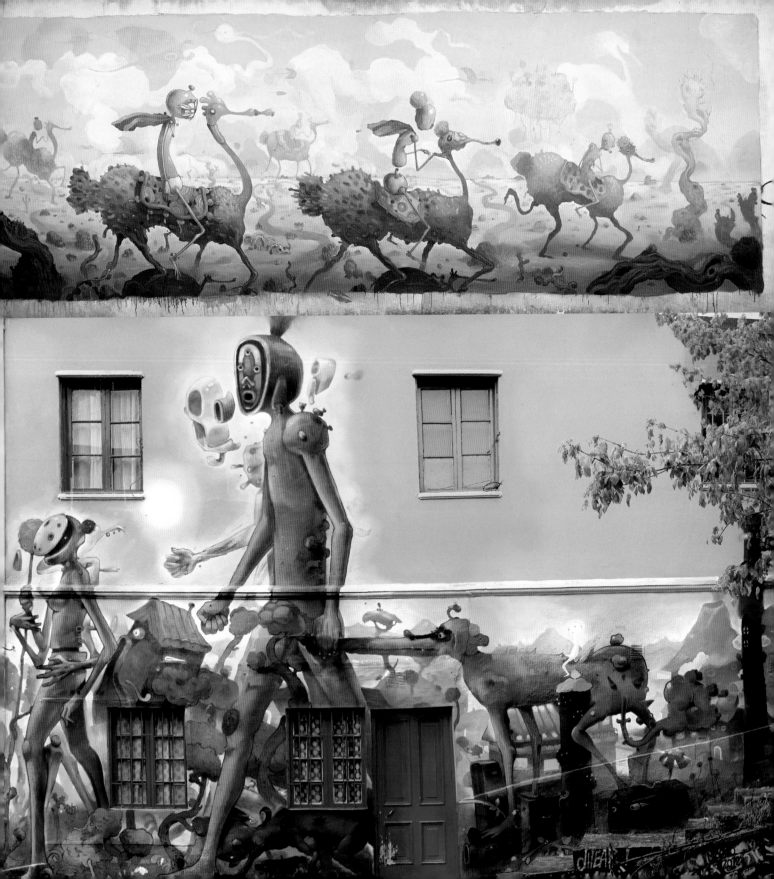

MEXICO CITY
BORN Unknown **MEDIUM** Spray paint, acrylic paint
STYLE Folk graffiti, lowbrow muralism **THEMES** Masks, indigenous culture, myths
INFLUENCES Rufino Tamayo, Rudolfo Morales, José Guadalupe Posada

NEUZZ

MIGUEL MEJIA

With a style that fuses pre-Columbian imagery and Mexican folk art with a naive yet strongly symbolic technique, Neuzz is an illustrator and visual artist whose indigenous, imagistic birthright is paramount to his practice. Rejecting the superficiality often associated with Mexican iconography—the omnipresent mariachis, wrestlers, and Zapatistas—Neuzz combines tradition with innovation. He weaves the stories and myths handed down by his parents and grandparents—a world full of "ghosts, witches, and *nahuales* [spirits], but also of celebrations and festivals"—into a contemporary, lowbrow aesthetic.

While studying illustration and graphic design at university, Neuzz was influenced by artists and cartoonists from around the world, figures such as Charles Burns, Gary Taxali, and Roy Lichtenstein. Although he embraces a very modern style in his designs, Neuzz's visual world has always been tempered by the aesthetic language he discovered as a youth. His knowledge of native Mexican art stems from the time he spent with his grandfather, Goyo; it was through him that he grew familiar with Mexican masters, such as the surrealist Rufino Tamayo, the painter Rodolfo Morales, and the legendary lithographer José Guadalupe Posada. Neuzz's grandfather also introduced him to the folk tradition of masks, a Mesoamerican cultural form that dates back to before 3,000 BCE. Neuzz was fascinated by these sacred objects that are believed to embody an indefinable magic and power. Neuzz explains that he grasped their status as a "tool of communication and spiritual interaction"—as a metaphysical instrument that functions far beyond aesthetics and visual expression.

Neuzz weaves these influences and traditions into his images, explicitly following the tales of his ancestors, for example, in the coyote masked killer (see image 1) or in the "glowing" bones of his grandfather (see image 2). Showing a strong affection for both indigenous art and a geometrical graphic style, Neuzz keeps this mystical form of communication at the forefront of Mexican public life, albeit in a highly contemporary visual form. Fusing the folk art of the twenty-first century (graffiti) with its more traditional counterpart, he cloaks his indigenous values in an entirely modern aesthetic, and forms a highly ritualized practice of image-making.

1 *Cazador Ihuiteco Disfrazado de Coyote* (Ihuiteco the Hunter disguised as a Coyote), Mexico City, Mexico, 2008
2 *Retrato de Mi Abuelo Gregorio, aka Goyo* (Portrait of My Grandfather Gregorio, aka Goyo), Mexico City, Mexico, 2010

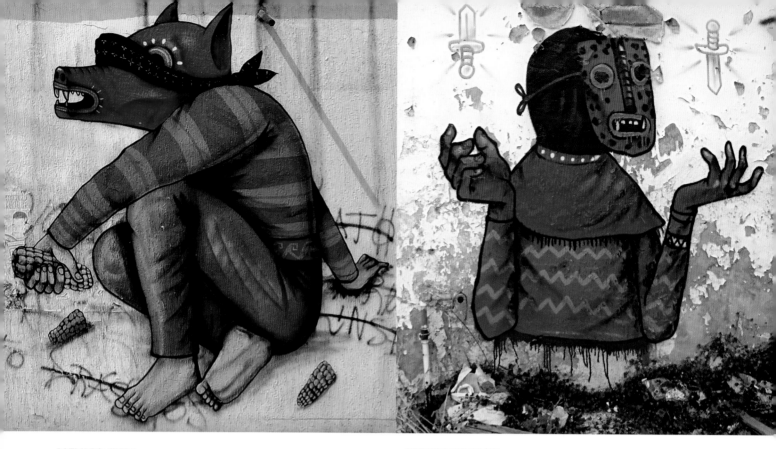

MEXICO CITY

BORN 1981 MEDIUM Spray paint STYLE Folkloric graffiti
THEMES Indigenous history, contemporary politics, Mexican folklore, masks,
bounty hunters INFLUENCES Mexican Muralism CREWS DSR, EYOS

SANER
EDGAR FLORES

Displaying his highly personal vision of Mexican life and culture on
walls and streets around the world, Saner is an artist who approaches
contemporary social and political issues through a classical visual lens,
integrating ancient folkloric themes with a strongly postmodern style.
Taking his name from its literal English meaning (to be of lucid or sound
mind, albeit in an ironic way), Saner sets out to signify the madness of
the present-day world in his work, and particularly the turmoil prevalent
in contemporary Mexican society.

Saner became involved with graffiti through the influence of his elder
brothers, before going on to paint the streets as part of the infamous DSR
and EYOS Crews and study graphic design at the National Autonomous
University of Mexico (UNAM). As his illicit and institutional educations
slowly coalesced, the inspiration of the Mexican Muralist movement
(landmark examples of which can be found at UNAM's campus in

1 *El Secuestrado*, Cholula, Puebla, Mexico, 2012 2 *El Santo
en el rincon*, Mexico City, Mexico, 2012 3 *Los Danzantes*,
Mexico City, Mexico, 2011 4-5 *Xolos y un puerco*, Cholula,
Puebla, Mexico, 2012

Mexico City) further enriched these two paths, not only revalidating the
importance of art in public space, but also its potential to have a social
and political impact. Having spent time as a child in Oaxaca in southern
Mexico, where his mother was born, Saner was also familiar with the
more mystical traditions of his country. He reinterpreted and integrated
these divergent iconographic influences into his personal folklore and his
work, as well as incorporating them with the realities he saw around him
in a consciously self-referential manner. In what has become his signature
style, Saner's highly modern-looking characters wear Mesoamerican
masks, but also appear without eyes; in Saner's mind, they have been
blinded by modern life and his work represents an attempt to reawaken
his viewers and the city around him. Together with another common
motif in his work, bounty hunters, his characters stalk the city in search
of empty souls. With its warm hues, beautiful patterning, and graphically
rich narratives, Saner's imagery is initially aesthetically appealing
although in reality it examines a much darker side of existence.
Attempting to convey his message of opposition within the heart of the
public realm, his artworks can be understood as modern-day, mythical
morality tales—warnings and prophesies that their viewers must heed.

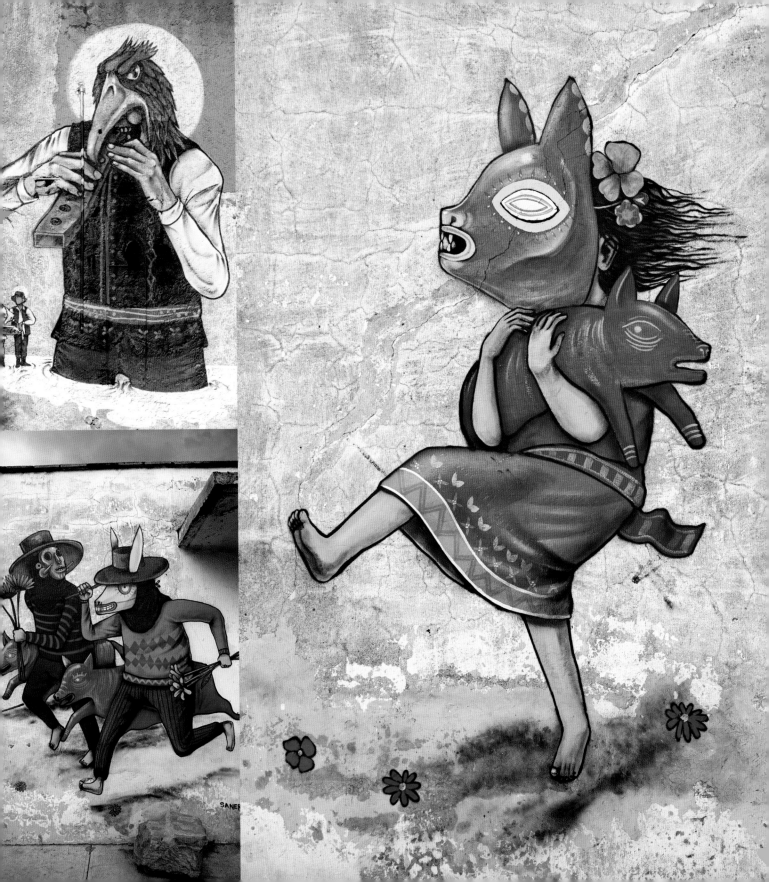

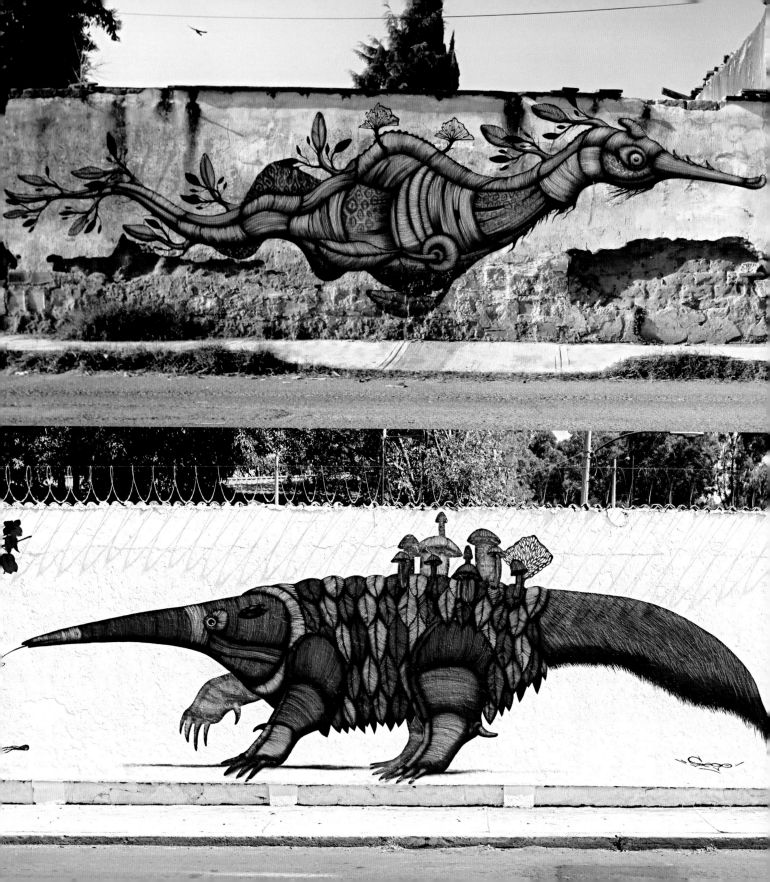

MEXICO CITY
BORN Mexico City, Mexico MEDIUM Spray paint
STYLE Organic surrealist figuration, abstract geometrical graffiti
THEMES Nature vs. culture, ecology, mysticism

SEGO Y OVBAL

As an artist who professes to have no established style, Sego y Ovbal has developed two distinct approaches within his work at a still considerably young age. The first approach embraces a highly detailed, organically rich output that he signs under the name of Sego; the second consists of a more abstract and geometrical technique that he undertakes in his work as Ovbal. Here the focus will be on Sego, the predominant element of his more recent output, although his more design-based production as Ovbal has been more prevalent in his interior architectural work. What remains paramount for Sego is the urge to explore and progress without the limitations that often accompany the term "style"; what is most important for him and his fellow adherents of the New School of Mexican Muralism is to simply continue pushing forward into unknown territories and developing without boundaries of either a conceptual or material nature.

Although he grew up in Mexico City, like his compatriots Neuzz (see pp.102–3) and Saner (see pp.104–5), it was his time spent living in the Mexican provinces that has most influenced Sego's current work. Unlike his colleagues, it was not the stories and traditional myths of these regions that inspired Sego, however, but the richness of the indigenous flora and fauna. When his father was commandeered for work, the family relocated to the Isthmus of Tehuantepec in Oaxaca, an environmentally unique area of Mexico with the highest amount of land-based biodiversity and the last remaining area of tropical rainforest. This close contact with unspoilt nature and with its "exotic reptiles, insects, birds, and fish" had a major influence on the young urbanite Sego and entirely changed his perspective. When he returned to the capital, he began writing graffiti in earnest and the strongly ecological spirit he had assimilated through his experiences of the isthmus in Oaxaca emerged in the material surface of his graffiti.

Alongside this, however, two other life experiences were to determine Sego's future artistic path. The first, the tragic loss of his mother when he was only eighteen, provided the moment in which he decided to dedicate his life to art; the second, a fall outside his house in which he fractured his skull (requiring over forty stitches), resulted in a surprising change in his mode of production—a development and relaxation of

1	3
2	4

1 *Simbionte*, Cholula, Puebla, Mexico, 2012
2 *Simbionte*, Morelia, Michoacán, Mexico, 2010
3 *Simbionte*, Buenos Aires, Argentina, 2010
4 *Simbionte*, Cholula, Puebla, Mexico, 2009

1 *Proteo*, Wynwood Walls, Miami, USA, 2011
2 *Proteo*, Estado de Mexico, Mexico, 2009
3 *Proteo*, Mexico City, Mexico, 2011

technique that remains an inexplicable result of this accident. What viewers encounter in Sego's current work, therefore, is a stunning fusion of the biological world—insects, animals, fungi, corals, human, and plant life—colliding together in a surreal, often aberrational manner. In an oxymoronic blend of the beautiful and the monstrous, Sego somehow manages to bring together these divergent elements into a cohesive whole.

In the series that he terms *Simbiontes* (see images 1–4, pp.106–7) in particular (symbionts being two species that are in an "obligate" relationship, meaning that they entirely depend on one another for their survival), Sego depicts a world that while natural remains imperfect; it is a world in which he plays, as he says, with the "aesthetic of the amorphous, the freaks." Searching for the splendor within what may initially appear to be chaos, his images can therefore be seen to have a connection with alebrijes, a form of folk art spawned by the outsider artist and fellow resident of Mexico City, Pedro Linares Lopez. This art takes the form of brightly colored, papier mâché or wooden

sculpture in which the animal kingdom morphs and fuses into a never-ending set of mystical, often fierce creatures. Sego's imagery demonstrates a similar grotesque style but also alludes toward a visual realm more steeped in mysticism, as witnessed in his adoption of universal icons such as the third eye and the tree of life in his practice, elements that represent, as Sego himself says, both "a different way of perceiving the environment surrounding me; almost like a different state of consciousness" as well as the fine "balance we should have with nature."

Through the fantastical incarnations in his practice Sego therefore sets out to reintegrate a sense of ecological spirituality and a more forceful consciousness regarding the precious, yet precarious, environment in which we reside. He tackles political issues through a consciously non-political modality in an attempt to change our vision of the city. Using public art as a weapon, he has constructed an ecologically mutant aesthetic that is both abominable and elegant, an aesthetic that seeks to create a new understanding of the fecundity of the organic world.

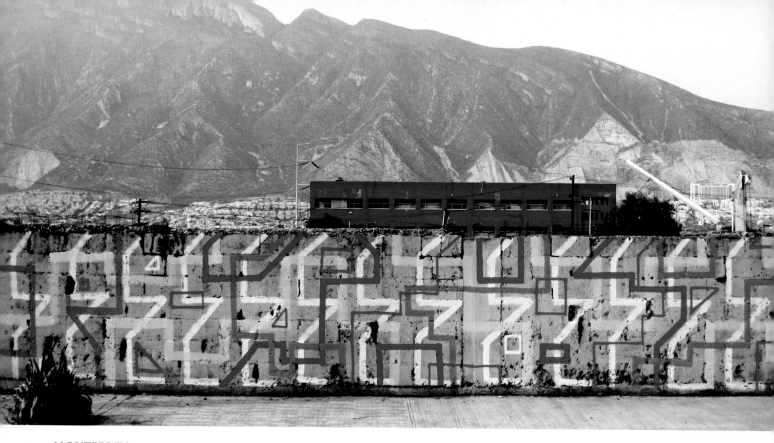

MONTERREY

BORN Various **MEDIUM** Spray paint, stickers, posters
STYLE Folk graffiti, abstraction **THEMES** El Niño Fidencio, animals, folklore
INFLUENCES Primitive art, Mexican culture

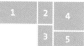

1 Monterrey, Nuevo Leon, Mexico, 2011 2 Paredón, Coahuila, Mexico, 2007 3 Monterrey, Nuevo Leon, Mexico, 2008 4 Playa del Carmen, Quintana Roo, Mexico, 2012 5 Monterrey, Nuevo Leon, Mexico, 2008

LOS CONTRATISTAS

An independent art collective established in the state of Nuevo Leon in northeast Mexico, Los Contratistas consists of Miguel Ángel Fuentes (also known as MAF), Tomás Güereña (known as Screw), and Isauro Huízar. Alternating between art and design, architecture and photography, Los Contratistas produce socially relevant work in a distinctly regional style.

Their name Los Contratistas (The Contractors) derives from the physical labor they invest in each project, as much as their ability to act as painters, carpenters, plumbers, or blacksmiths. The balance of the group is such that they refuse to allow a scarcity of resources or funds become an obstacle for their artistic production. Of the three, MAF has the most multidisciplinary technical knowledge, skills that are crucial to their collective endeavors. Experienced in photography, film, and multiple forms

of print media, his most renowned personal series is known as the *Fidencio Constantino* project, which focuses on a revered local *curandero* (healer), El Niño Fidencio, a figure recognized as a folk saint in northern Mexico and the southwest of the United States. Using various techniques to distribute El Niño's gospel, MAF forms an idiosyncratically regional aesthetic practice that promotes local Mexican cultural values to the world. For Screw, however, although an architect like Isauro, graffiti is his key form of expression, what he describes as a "pure, natural, and primitive" form of production. Creating a variety of strangely figurative designs often based on the animal world, Screw prefers to leave the message of his work open for contemplation. Isauro, the last member of the group, has a more purely abstract style, a geometrical aesthetic that seeks to avoid "prejudices and assumptions," a dramatic, often calligraphic style that embraces all methods, tools, and materials.

Los Contratistas are a group of diverse artists who together complement rather than clash with one another. Mixing passion and spirit with a true workman-like dedication to their task, theirs is a collective in the truest sense of the word. Together they utilize the power that arises when the ego disappears, when the spirit of collaboration and cooperation rules.

FIDENCIO
CONSTANTINO

FIDENCIO.WORDPRESS.COM

SÃO PAULO

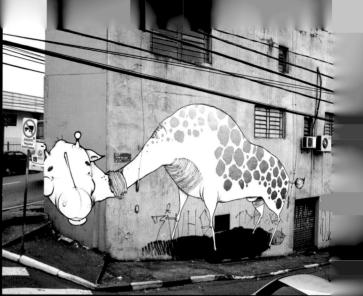

Illegal painting in São Paulo started during Brazil's military dictatorship (1964–85). First and foremost it became visible through *pixação* (meaning writing-in-tar), a protest movement of writing political slogans and names of crews in a distinctive cryptic alphabet on tall buildings, using daredevil abseiling and free-climbing techniques. *Pixação* originated in the 1950s, but took off toward the end of Brazil's dictatorship. Os Gêmeos (The Pandolfo Twins; see pp.120–3) recall their debt to *pixação* and to the pioneering graffiti writers of the 1970s, John Howard and Alex Vallauri. The generation of hip-hop graffiti writers for which Brazilian graffiti is most famous—Os Gêmeos, Vitché (see pp.124–5), Binho, Onesto,

and Zezao among others—emerged in the mid-1980s, and began painting in daylight from 1986. Vitché in particular pioneered techniques that are now widespread in Brazil and South America—covering large walls with latex-painted backgrounds, against which a few touches of spray paint stand out strongly. Onesto's graffiti is site specific and accessible: His pieces are simultaneously funny and compassionate, as exemplified by his giraffe, lowering its neck so as not to become further entangled in the wires that surround it (see image 1). Zezao paints crudely beautiful arabesques in São Paulo's streets and sewage system. The hip-hop generation of writers has evolved beyond its roots: Vitché's stark, bloody early style has mellowed since he has lived and worked with Jana Joana.

Of those who emerged on the streets of São Paulo in the 1990s, Herbert Baglione (see pp.116–17) stands out for his explorations of elongated, contorted, often alien-looking forms, in a monochrome style with touches of gold. Nunca started out as a *pixador* in a poor neighborhood of eastern São Paulo, before his family moved to the center in the 1990s, and he took up grafitti. Nunca's afro-indigenous Brazilian characters play on the accidents of their urban contexts. In the early 2000s, Nunca painted with Os Gêmeos in São Paulo and abroad, including on the riverside facade of Tate Modern, London, and with Os Gêmeos and Nina (wife of Octavio Pandolfi) at Kelburn Castle in Scotland. In 2010 Nunca was commissioned by Nike to design the Brazilian national football team's outfit—a measure of the recognition Nunca and Paulista graffiti had gained. Nunca's work with the Brazil football team is the most notorious example in South America of graffiti artists accepting commissions from sportswear

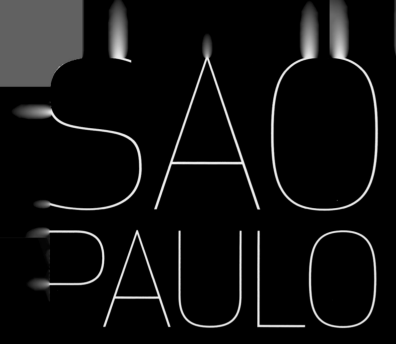

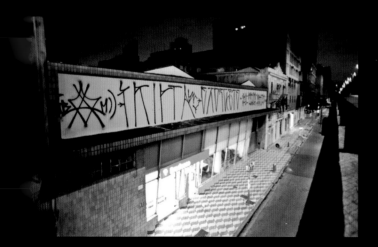

manufacturers. However, some Brazilian graffiti writers oppose such commercialization and resist being sponsored.

 Although São Paulo is one of the more dangerous cities in which to paint streets, female artists have also made their mark. They include Jana Joana, with her feminine figures and lacy patterns (see image 4); Nina, whose big eyed, doll-like characters have been taken up across the continent; and Mexican-Brazilian Fefe Talavera, who pastes her monsters, metaphors for human states of mind, in São Paulo's streets. Anarkia, an artist from Rio de Janeiro, speaks for her Paulista peers as well as herself, about the "political act" of winning spaces for themselves on Brazilian walls and "the feminist process of gaining respect in the scene."

 Of all the street artists who emerged in the 1980s, none are keener than Os Gêmeos to revert to their subversive roots by going out to paint with São Paulo's graffiti crews: Os Gêmeos and VLOK (see pp.126–7), led by FINOK, who moves easily between comic-style spray paint letters and larger, iconic, latex-based murals, have in recent years appropriated many Paulista walls with their characters and *pixação*-derived letters. *Pixação*, such as that undertaken by the Cripta gang (see image 2 and pp.114–15), active since the 1980s, still punctuates São Paulo's skyline, and has become increasingly part of Rio's urban fabric. *Pixação* has been so widely adopted that it has become to Latin American graffiti what wildstyle is to graffiti in North America. In northern Mexico, *pixação* marks a subcultural frontier between Latin and North America. **RP**

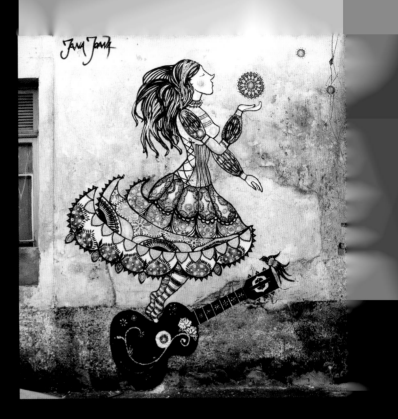

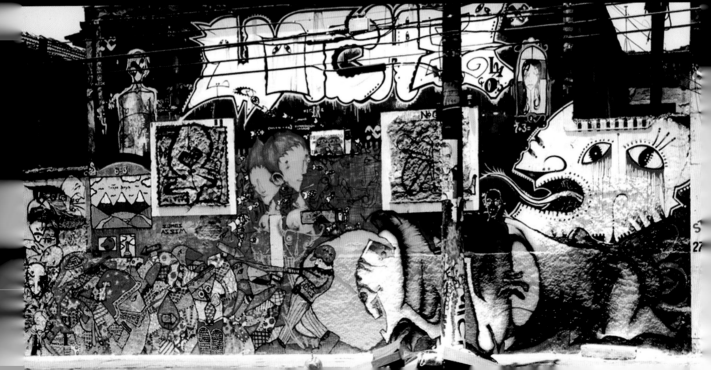

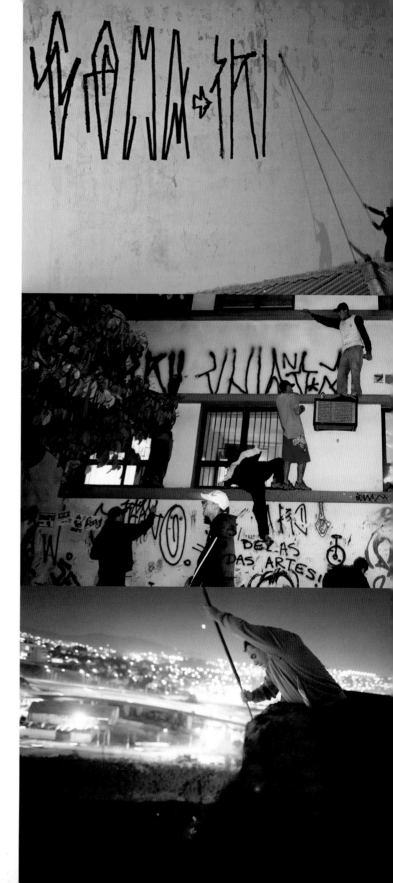

SÃO PAULO
BORN 1984, São Paulo, Brazil MEDIUM Latex STYLE *Pixação*, invasions,
subversive aesthetic THEMES Anti-capitalism, anti-establishment
COLLECTIVE Cripta

CRIPTA DJAN

Quite possibly the most famous practitioner of *pixação* (see São Paulo,
pp.112–13) in the world, Djan Ivson Silva (or Cripta Djan as he is more
commonly known) bears the weight of an entire art movement on his
shoulders. As the spokesperson for this distinctly Brazilian form of
Independent Public Art, Djan articulates the *pixação* discourse through
his writing, films, and his own legendary *pixação* practice. (The word
pixação translates into English as "trace" or "stain.") He has pioneered
stylistic changes in the form itself as well as in the techniques for its
dissemination. As a highly eloquent representative and esteemed
practitioner of the subculture, he has been at the forefront of *pixação*'s
transition from local to international stage.

 Although both he and the movement have become increasingly
better known in recent years, Djan continues to both practice and
preach the innately anti-establishment, anti-capitalist ethos of *pixação*.
He extols the purity and subversity of the form while promoting its
revolutionary potential: "Today we live in a very capitalist society,
where you are 'worth' as much as you own. It's just money and material
wealth. But in *pixação* you find an inversion of values, you don't need
money to be recognized. All you need is ink to write your name and the
will to put it all over the city."

 Born in 1984, Djan grew up in various homes throughout the Greater
São Paulo Metropolitan Area, from the barrios of Barueri, Santana, and
Itapevi, before finally settling in Osasco, one of São Paulo's largest
municipalities. Although he was a keen footballer in his youth, *pixação*
began to consume Djan's life when he was about twelve years old. He
joined the Cripta collective a year later and stamped his visual mark on
the streets at an incredible rate—conquering his district, region, and
then central São Paulo itself, the ultimate site for the city's *pixadores*.

 Although by the early 2000s Djan had become one of the scene's most
important practitioners, he felt that *pixação* was being stymied due to the
lack of any systematic exposure for the movement other than on the city
streets: "I felt the need to see something just about *pixação*, something
produced by ourselves and for ourselves; I was tired of having to settle
for one photo in a graffiti magazine or one newspaper clipping." He
subsequently made two series of films, *100Comédia* and *EscritaUrbana*,
which he both recorded and edited himself. Through the films Djan
expanded the image of *pixação* beyond its traditional representation in
the media; he constructed an authentic portrayal of the culture and linked
it to the larger political and aesthetic themes from which it had emerged.

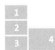
The "invasions" that Djan started to instigate in 2008, together with fellow *pixador* Rafael Guedes Augustaitiz (more commonly known as Rafael Pixobomb), projected *pixação* onto a completely different level, however. The first invasion, primarily organized by Pixobomb as part of his graduation project at the São Paulo School of Fine Arts, occurred in June that year. Protesting about the lack of social consciousness within the art school and at the emptiness, as they saw it, of much contemporary art, Djan, Pixobomb, and fifty other *pixadores* invaded the school during an end of course exhibition and painted the entire building, inside and out. Pixobomb was expelled from the university as a result, but from that point onward the pair continued to stage invasions and etch *pixação* into the Brazilian national consciousness.

Only a few months later, in September 2008, they undertook an invasion at the Choque Cultural (an independent contemporary art gallery specializing in urban and outsider art) to protest at "the commercialization, institutionalization, and domestication of street culture." They then embarked on probably their most infamous incursion the following month at the São Paulo Biennale, during which they tagged the empty second floor of the pavilion, a space in which the biennale had invited artists to make "manifestations." Both of these invasions gave the movement a much higher profile and brought the marginalized of São Paulo to the city's very center. They made it clear that *pixação* was not merely vandalism but is also linked to broader themes of inequality and social invisibility.

Although Djan is not as active as he was in his early years, *pixação* remains a central part of his life and a way of challenging both himself and the world. As he puts it in his own words, he continues to take "risks to remind society that the city is hostile to anyone who is not rich" and to react "with indignation against our elite." For Djan, *pixação* is simply the purest form of art one can produce—one that embraces not only typography and object, but performance and action. It represents a subversive, radical aesthetic practice in the city, a uniquely Paulistano example of Independent Public Art.

SÃO PAULO

BORN 1977 MEDIUM Spray paint
STYLE Existentialist graffiti, monochomes
THEMES Death, sexuality, faith, chaos, isolation, absurdity

HERBERT BAGLIONE

The dream-like, melancholic, often bittersweet beauty present in the work of Herbert Baglione acts directly against the fashions and frivolities of the art world, in favor of a more provocative account of modern life. With connections to themes of death, chaos, sexuality, and faith, Baglione's poignant, often forlorn imagery has strong existentialist roots: Through his phantasmagorical creations he visually explores his own consciousness and seeks to find an authentic mode of being in the world.

Renowned for his almost exclusive use of black and white—a reduced palette that sets itself apart from the often sensationalist and garish nature of popular culture—Baglione rejected any desire to simply display aesthetic beauty in his work at an early stage. Many of his earlier works focused on images of obesity and anorexia, and gave moving public testimony to the effects of the "ideal" body shape promulgated by advertising in contemporary society. In his more recent output he has started to critique the speed of technological progress and how it weakens rather than strengthens social ties. In a society that, as Baglione sees it, is obsessed with the "cult of the creative universe," and in which technology, fashion, and art are key to that "new faith," Baglione's work sets out to emphasize the isolation of modernity.

Images such as the solitary individuals in *Campo De Concentraçao* and *Vela de 30 Dias* (see image 3) are perfect visual examples of the famously untranslatable Portuguese word *saudade*—a term describing an emotional state of longing for that which is now lost and that embraces both past and future. Baglione's oeuvre powerfully conveys this quintessentially existential angst. Displaying a potent mix of nihilistic despair and emotional freedom, each image confronts a need to face the absurdity of the universe. Insisting on proving the existence of the individual in society, on proving the existence of his own self, Baglione continues learning and evolving, attempting to produce works that "will dedifferentiate me from others." Baglione works in the street not only to show the public *how* he feels, but to change the very way he feels inside, working to resurrect himself, to keep himself alive.

1 *08*, Miajadas, Spain, 2010
2 *Invidia*, Luneburg, Germany, 2009
3 *Vela de 30 Dias*, São Paulo, Brazil, 2010

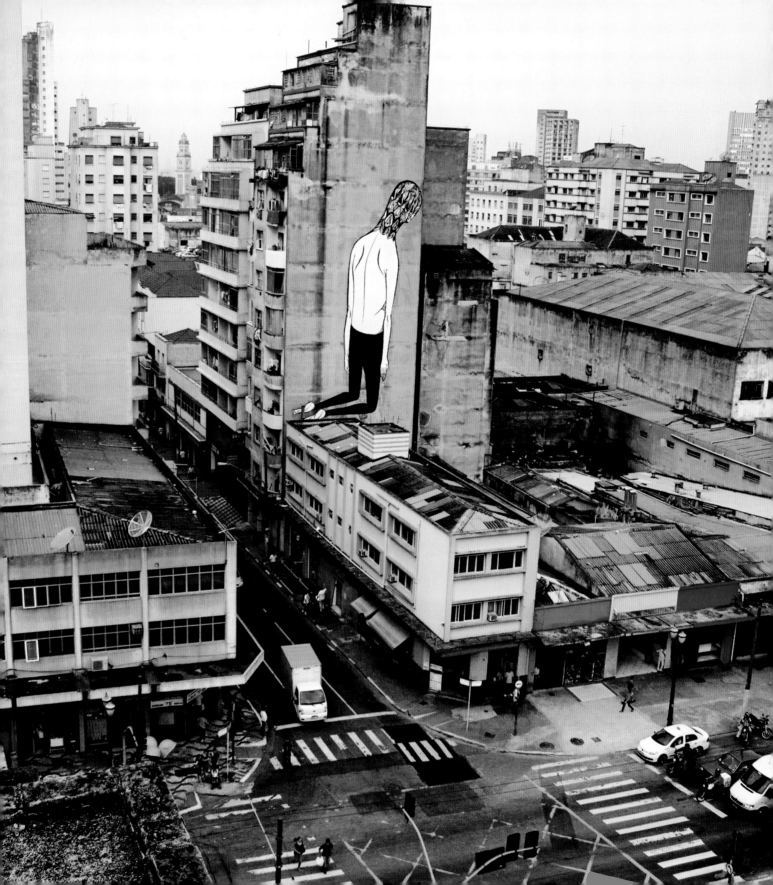

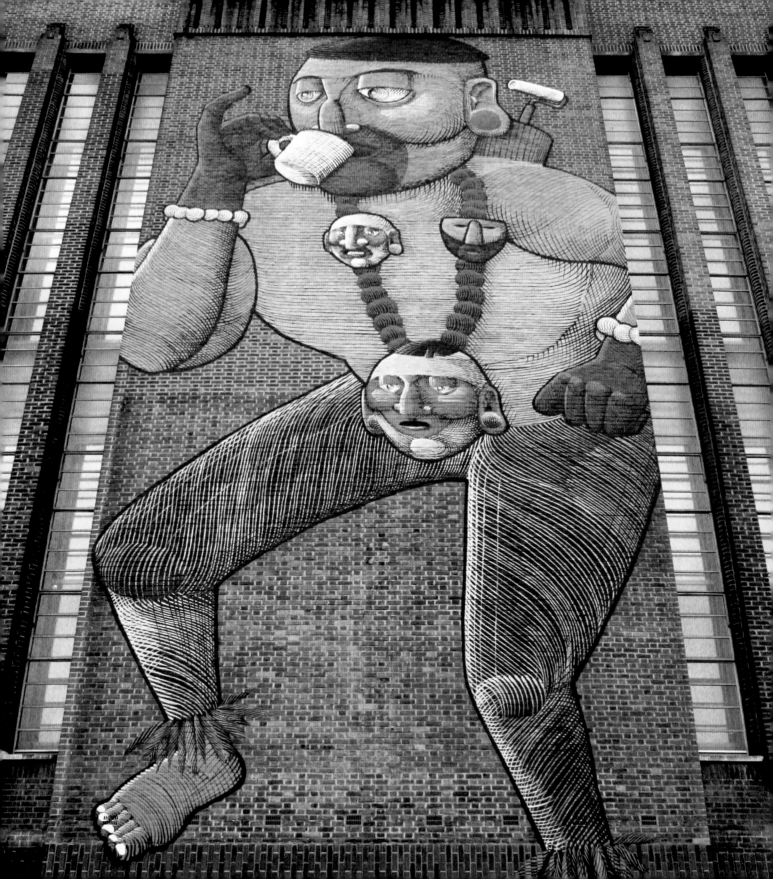

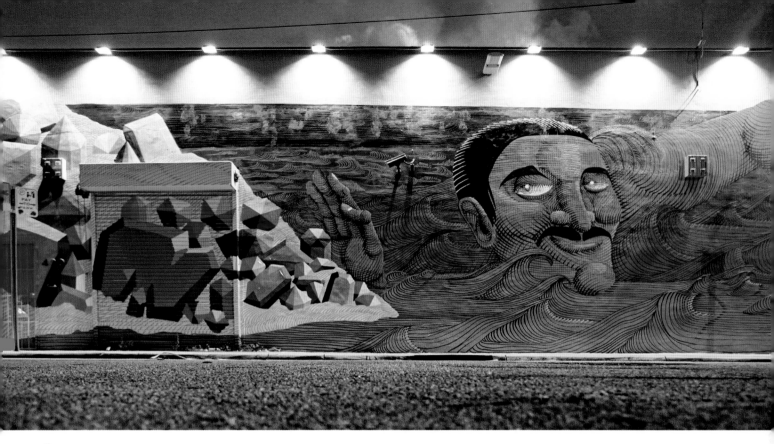

SÃO PAULO

BORN 1983, São Paulo, Brazil MEDIUM Spray paint STYLE Contemporary
muralism, woodcut graffiti THEMES Indigeneity, cannibalism, globalization, mass
consumption INFLUENCES *Pixação*, Glauber Rocha, Darcy Ribeiro CREW VLOK

1 Tate Modern, London, UK, 2008
2 Wynwood Walls, Miami, USA, 2011

NUNCA

Bringing issues of history, race, and ethnicity to the forefront of his
work, the Brazilian artist Nunca has shaped a distinctive aesthetic
that is as richly ornate as it is political. He mixes indigenous themes
and traditional artistic crafts with thoroughly modern subject matter
and material techniques. He uses a crosshatching technique unique
to the graffiti world, an idiosyncratic woodcut or etched style of
patterning that, while seemingly anachronistic, reflects Nunca's
desire to reassess the historiographical depiction of the Brazilian
people and reinstate their indigenous heritage. His practice attempts
to reveal the "origins of Brazilian culture" and understand just "what
it means to be Brazilian."

Born Francisco Rodrigues da Silva, Nunca grew up in the barrio of
Itaquera in eastern São Paulo. He began to paint *pixação* (see Cripta Djan,
pp.114–15) when he was twelve, the time when his pseudonym was born:
His name Nunca (meaning "never") acts as a proclamation to never be
constrained by cultural or psychological limits. After moving to the more
central neighborhood of Aclimação, Nunca developed a more highly
colored, complex aesthetic that modified further under the growing
influence of a group of distinctively Brazilian intellectuals and artists,
including filmmaker Glauber Rocha, anthropologist Darcy Ribeiro, and
artists Ligia Clark and Luiz Sacilotto. He wanted to produce something
more unmistakably local in his work and instinctively followed the
Manifesto Antropofagico ("Cannibal Manifesto") of Brazilian poet
Oswald de Andrade. Consequently, Nunca developed a personal
form of "cultural cannibalism," a mixture of modern and traditional
themes that rejoiced in the mixed heritage of Brazilian culture itself.
Coming from a quintessentially mixed background himself, exploring
his own roots proved similar to exploring the roots of Brazil as a whole.
Working with themes such as the ubiquitous cannibalism, indigenous
exploitation, globalization, and mass consumption, Nunca's complex
imagery promotes a concept of indigeneity seen through a critically
contemporary rather than mythical lens, resulting in a cultural, political,
and ethical narrative that is as dense and rich as the ocher pigment he
uses to paint his many characters.

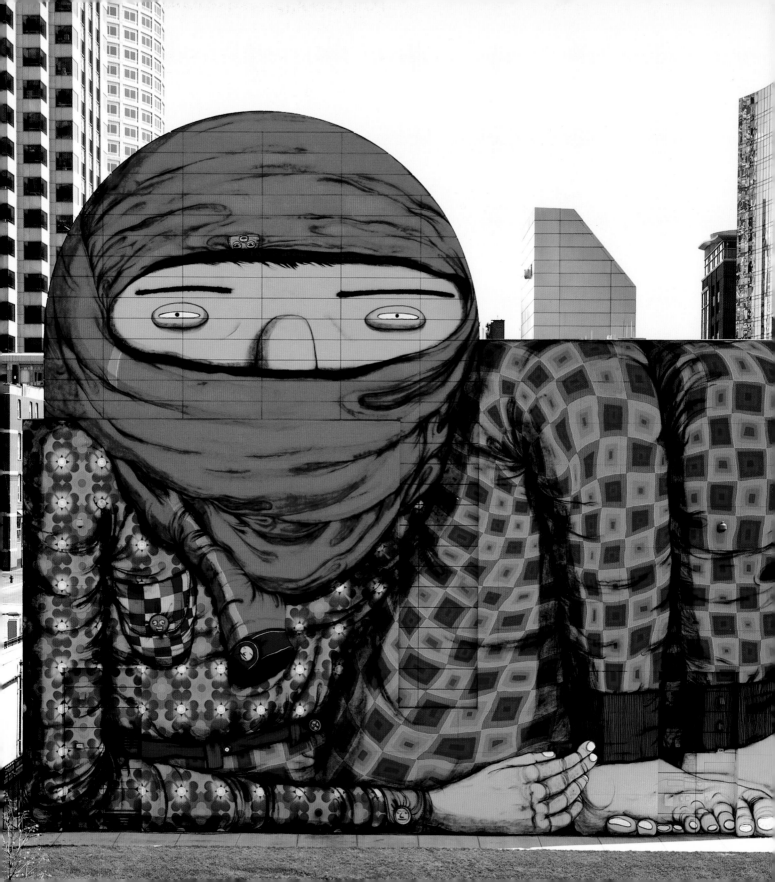

SÃO PAULO

BORN 1974, São Paulo, Brazil MEDIUM Spray paint, installation STYLE Character-based muralism, classic graffiti THEMES Brazilian identity, violence, carnival, social awareness, "TRITEZ" fantasy world INFLUENCES Twist, *pixação* CREW VLOK

OS GÊMEOS

Os Gêmeos (Portuguese for "The Twins") are among the most esteemed contributors to the worldwide Independent Public Art movement. Despite their groundbreaking and innovative museum exhibitions and gallery shows, they remain steadfastly faithful to their production on the street, both in terms of their large-scale murals and their idiosyncratic tags, characters, and pieces. Extraordinarily prolific, they are supremely respected within the graffiti scene from which they first emerged. Renowned for featuring a variety of yellow-skinned individuals within their designs, characters that merge the everyday reality the twins encounter with the fantasy world they have together created, Os Gêmeos delve deep into the roots of Brazilian culture, often functioning through a radical political and social critique. The pair have set the benchmark for the possibilities of Independent Public Art while continuing to forge their own path within it. They have inspired numerous artists all around world by taking their child-like inquisitiveness and perspicacity into endlessly new aesthetic realms.

Born in 1974 and growing up in Cambuci, at that time a quite dangerous barrio in São Paulo, the Pandolfo twins (Gustavo and Octavo) were wayward, disobedient youngsters, as they put it "two kids that liked to try to destroy everything." However, they became passionate about drawing at a young age, inspired by their older brother Arnaldo who encouraged and taught them to express themselves through art. With the graffiti scene starting to boom in their local neighborhood, the twins found a natural outlet in painting on the streets and had begun to experiment by the mid-1980s. This was a time when there was very little information about other graffiti scenes around the world and the twins' production took a contrasting approach to the more dominant and much-replicated style of the New York movement. Working without outside assistance or influence meant that they developed their own distinctive and innovative methods of production.

The pair continued to paint almost incessantly throughout the late 1980s and early 1990s, until a chance meeting in 1994 with the legendary San Franciscan artist Twist (better known today as Barry McGee) led to a significant breakthrough in their style and further opened their eyes to the possibilities of graffiti. The meeting was fantastically fruitful for both

1 Boston, USA, 2012
2 Berlin, Germany, 2005

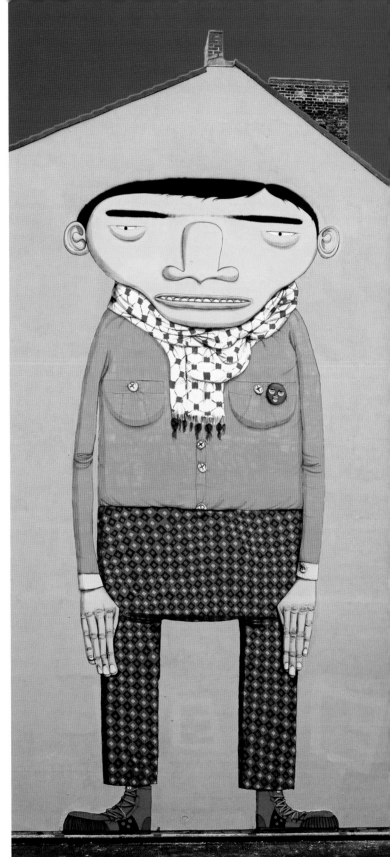

STYLE WARS

artists and showed them different techniques, tools, and styles, introducing them to the bombing mentality of graffiti in particular. Through meeting McGee, Os Gêmeos realized that they did not need to use lots of colors to produce good pieces and that with simplicity came power. More importantly, McGee helped the twins believe that they could live their life through art and later introduced them to influential figures in the United States who helped present their work to a worldwide audience. By 1998, having traveled to Europe at the invitation of legendary German artist Loomit, Os Gêmeos had become the first Brazilian artists to take this distinctly homegrown, Paulistano style of graffiti outside of Latin America where it eventually became a leading school within global graffiti culture.

The aesthetic Os Gêmeos ultimately shaped was one that was positioned halfway between reality and fantasy. Although, in their words, it sought to present a "parallel universe" in which viewers can "dream and live the experience," its roots were still firmly set in the heart of the Brazilian social world. Taking inspiration from a place they call TRITREZ (a neologism meaning "three lives" that signifies their life before birth, their present life, and the infinite life after death)—a mystical wonderland from which all their ideas emerge and which they dislike openly discussing— the twins use this magical realm to form an allegoric representation of the everyday, an otherworldly kingdom that reflects directly back onto the land in which they live. Although Os Gêmeos present us with beautiful reveries and magical scenes, it is a magical realism that is always couched in the everyday, daydreams that are part of the real world in which they themselves reside. What they aim to reveal is both the beauty and the terror of everyday life in Brazil; they use their art, as they describe it, to "fly in the fog" and "float paper boats in the rain." Even though they spend so much of their lives physically facing away from the city and concentrating on their imaginary creations rather than the reality occurring behind their backs, the brothers Pandolfo believe that they are creating a way of opening a "door" or "entryway" to uncover the dreams, obstacles, marvels, and ordeals that both they and their country face. Forming an aesthetic that is as comfortable in the rawness of the street as with the poetry of the afterlife, Os Gêmeos re-present the dialogue of the street while representing the dreams of those who live within it. Their work finds a perfect fusion between the real and surreal, between the quotidian and the ethereal, and merges these dual realities into one.

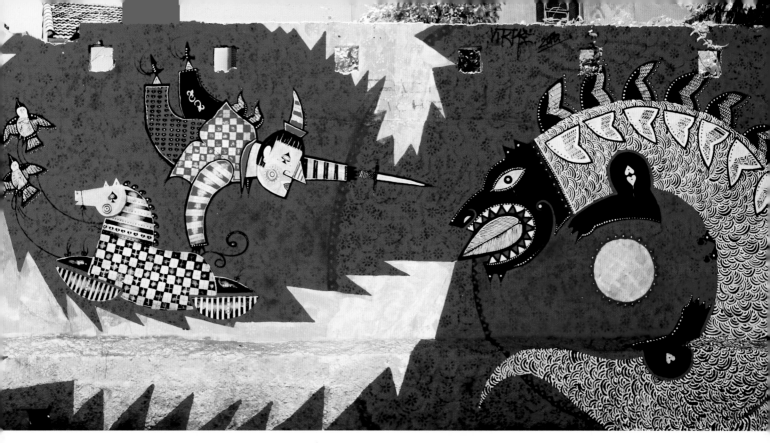

1	2
3	

SÃO PAULO

BORN 1969, São Paulo, Brazil **MEDIUM** Spray paint, installation
STYLE Mythical graffiti **THEMES** Red, black, and white colors, magic,
harlequins, dragons, natural world

VITCHÉ

As part of the first wave of Brazilian Independent Public Art, Vitché's magical, mythical production has greatly influenced the direction of the contemporary movement. His work's romantic yet often political content has paved the way for a whole genre of socially focused, but aesthetically rich urban art. Chiefly utilizing a reduced palette of red, white, and black, and featuring signature characters, such as his harlequins and jesters that are reminiscent of classic playing cards, as well as flying birds and dragons (symbolizing life and freedom, and the modern, uncontrollable megalopolis respectively, see image 1), Vitché explores the uneasy relationship that exists between humanity and the natural world. He examines why we have "lost our connection with nature" and how we can rebuild it.

Growing up in an urban, industrial area of São Paulo, drawing provided an outlet for Vitché from a young age. Embracing color and creativity, he painted the city as a way of bringing vitality to its often brutal reality. Rather than simply being dismayed by the smothering effects of the

urban jungle, or as he describes it the city that is traveling "in the opposite direction of real evolution," Vitché sees art as a form of magic or ritual, a tool by which he can both explore his own consciousness while at the same time confronting the true nature of reality and reintegrating with the "forgotten feelings" that have been "swallowed by the great dragons of civilization." His adoption of the world of the circus, with its clowns and pranksters, was therefore a direct ode to the carnival spirit, an approach to life through which one could "walk the tightrope, laugh at the dragon, and play with his stomach." Vitché's aesthetic attempts to harness this pure spirit and the power of forgotten civilizations who lived harmoniously within their landscape. Whether using found wood, metal, or canvas, he sets out to return a form of balance and harmony to the chaos of the metropolis. He currently works mainly in conjunction with his wife, the artist Jana Joana, and their joint productions—in which Jana's monochromatic and Vitché's signature hues blend seamlessly into one—focus on similar themes. Regarding his art as a small, yet potent aberration in the system, Vitché uses his imagination as a weapon, his work representing an aesthetic counterbalance to the harsh realities of contemporary urban life.

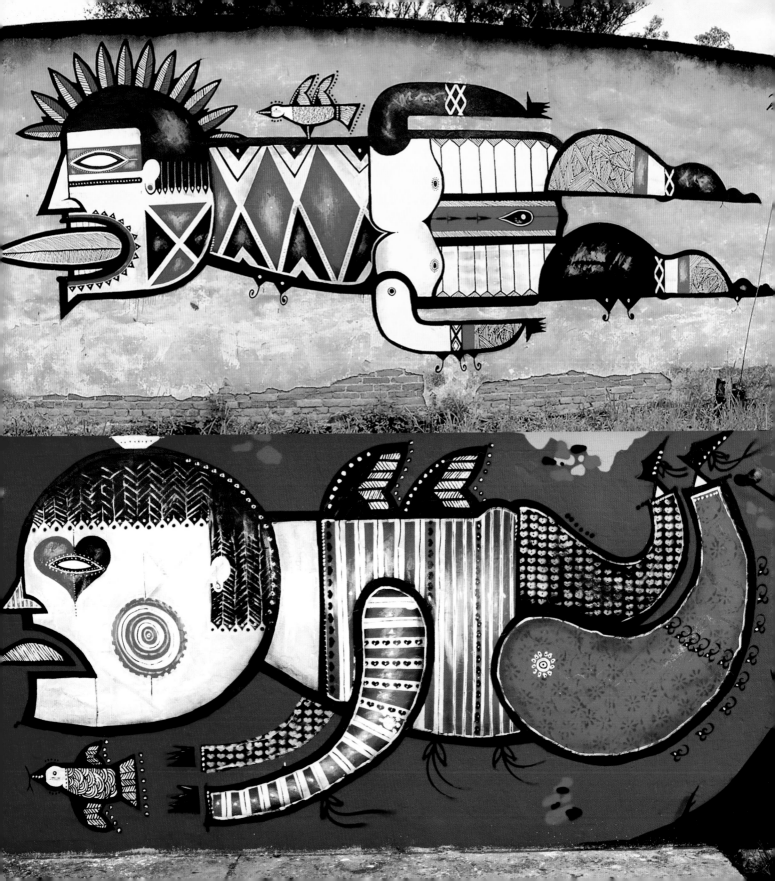

SÃO PAULO

BORN Various **MEDIUM** Spray paint
STYLE Classic graffiti **THEMES** Whole trains, *Cortadinho* throw-ups
INFLUENCES New York graffiti

VLOK

A group of superstars who still retain the hunger of an up-and-coming collective, VLOK are São Paulo's most illustrious graffiti crew. Founded by the twins Gustavo and Octavo Pandolfo, better known as Os Gêmeos (see pp.120–3), VLOK includes members such as Nunca (see pp.118–19), Finok, Toes, Koyo, Ise, Frs, Cekis, Blue, Agit, Peter, Mind, Kaur, and Xabu; the collective also comprises international affiliates such as Barry McGee (DFW), Remio (VTS, see pp.92–3), and Vino (TSK). Active in São Paulo since the early 1990s, they continue to dominate the city today with productions that span the entire range of graffiti activities: From simple tags to highly colorful throw-ups, their work emcompasses practices from the most artistic to the most vandalistic.

Although as a collective VLOK have entirely conquered São Paulo itself, there are two projects in particular for which they are renowned. The first, the Whole Train Project, initiated by Os Gêmeos and Ise, turned a graffiti chimera into reality. Convincing local train operators to allow them to

1-3 São Paulo, Brazil, 2012

legally paint their rolling stock, VLOK—along with a group of invited international artists—have gone on to paint more than fifteen trains all over Brazil, in São Paulo, Rio de Janiero, and São Luís do Maranhão. Instead of having at maximum thirty minutes to hastily paint, using only a few colors and being constantly on guard for police or security, the participants were able to produce end-to-end, whole trains at their leisure, with absolutely no approval process necessary for what they created. The second project, entitled *Cortadinho* (meaning "small cuts"), was first instigated by Koyo and Finok. Attempting to incorporate three or four people within the same spot, these series of throw-ups—a technique in which they each form their unique designs in one cohesive, symmetrically sliced piece—demonstrate VLOK's attempt to both innovate as well as proliferate, pushing their graffiti in terms of quantity and originality alike.

While each member implements a highly distinctive style and is individually successful—Toes's distinctive, futuristic geometry, Finok's obsessive love of green, and Xabu's naive surrealism, for example— together VLOK present an aesthetic that has become synonymous with their native country. Their work now represents a warped, twisted, distinctly Brazilian take on the classic *Subway Art* model of the 1980s.

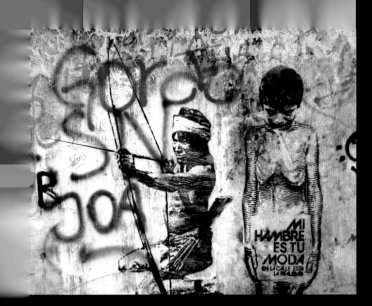

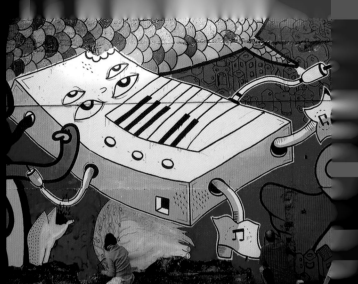

BUENOS AIRES

encounters stimulated the city's native hip-hop graffiteros, including NERF. The DOMA collective, who formed in 1998, have worked in various media—stencils, paint, paste-ups, and blow-up cartoon figures—and in increasingly large scale. Chu (see pp.130–3), a member of DOMA, also produces his own huge paintings using the typically South American medium of latex paint with rollers. There is a strong nucleus of Buenos Aires street artists, including BsAs Stencil, Run Don't Walk, DOMA and Chu, NERF, Nazza Stencil, Gualicho, Jaz, and PumPum. Like Chu, Gualicho (see image 3) paints big cartoon-style characters in latex; Jaz's *filetes*—stylized lines typical of the art deco architecture and hand-painted buses of Buenos Aires—are directly related to the streets he paints; PumPum, another who prefers latex, fuses her self-portraits with the work of others, notably NERF's letters. This hardcore of Buenos Aires artists has grown together:

The street art of Buenos Aires is founded on stencils. Initially used as a rapid and effective form of protest against Argentina's military junta (1976–83), artistic stencils exploded once more on the city's streets during Argentina's economic crisis of 2001: BsAs Stencil and Run Don't Walk both became active in 2002, and remain so today, as is Nazza Stencil (see pp.138–9), who started painting in the 1990s. Stencils can be found all over Argentina, including the famous series of 350 stenciled bicycles "left" in 350 different spots around Rosario, to symbolize the 350 Rosarines who "disappeared" there during the dictatorship. Nazza Stencil (see image 1), who is from Buenos Aires, has made his mark in Puerto Iguazú in far northeastern Argentina, with images of guaraní people indigenous to the region.

Before the stencil explosion of the 2000s, Buenos Aires was already rich in graffiti, mainly because it is an inviting place to visit, especially if you want to paint trains. In the 1990s Os Gêmeos traveled from São Paulo to meet Chile's DVE crew, and paint the subway in Buenos Aires. Such

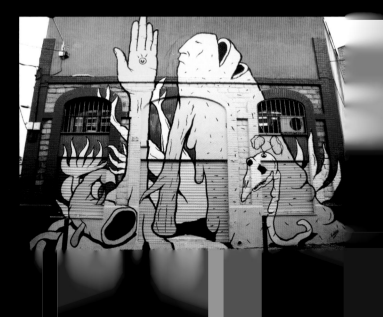

1 Nazza Stencil, 2010 2 *Vaquero Hola, Pedro Perelman*, 2011 3 Gualicho, 2011 4 Ice and Itu, Charquipunk
& LRM, 2010 5 Chu, Tec, and Run Don't Walk, 2010 6 Tec, Defi, Chu, and Pedro Perelman, 2011

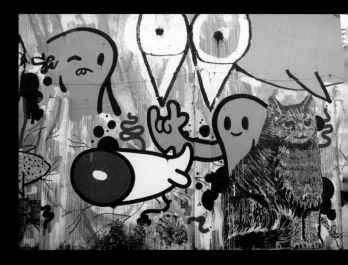

BsAs Stencil, Run Don't Walk, and Stencil Land formed the "collective of collectives," HIC Crüe. Tec, originally from Argentina's second city, Córdoba, is now part of this scene, and of the FASE collective (see pp.136–7), together with Defi, Martin Tibabuzo, and Pedro Perelman (aka PMP/Bleep, see image 2). TEC started painting walls on his own in Córdoba and (remarkably) on the carriageways of urban highways. He now lends his self-taught ability to large multimedia productions with FASE and HIC Crüe. Stencils still play a significant part in graffiti productions in Buenos Aires, but appear in many of the more ambitious contemporary works as lead figures on building-sized scenarios mainly painted in latex.

Strong characteristics of street art in Buenos Aires are its collective ethos and the welcome it gives to visiting artists: Italian artist Blu has painted some of his biggest and best pieces there and writers from other Latin American countries are up all over the city. The hegemony of street artists on the Buenos Aires scene who emerged around 2000 is being challenged by the likes of Ice and Itu (see image 4), Lean Frizzera, and Amor. They share common ground with the preceding generation in their readiness to paint with visiting artists from abroad. In 2011, at the first "Meeting of Styles" festival in Buenos Aires, Peru's finest duo, Entes and Pésimo, painted alongside their Chilean counterparts, AISLAP, and the Paraguayan wizard, Oz. Lälin, an artist from across the River Plate in Montevideo, paints places that conform to the criteria for public art that the Mexican muralist David Siquieros first stated in his "Call to Argentine artists" in 1933. Lälin does what Siquieros could only talk about and paints strategic spots such as level crossings at train lines. Buenos Aires is justly proud of its own evolving style of graffiti and street art and remains a hothouse for Latin American street art's ceaseless innovations. **RP**

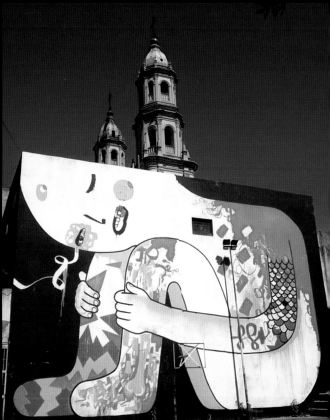

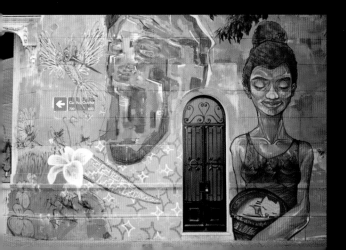

BUENOS AIRES

BORN 1974, Buenos Aires, Argentina MEDIUM Spray paint, latex, digital art
STYLE Abstraction, animation THEMES Carefree characters, geometric patterns
INFLUENCES *Salvajismo*, skateboard culture COLLECTIVE DOMA

CHU

Julian Pablo Manzelli, also known as Chu, is an artist, graphic designer, and animator who is pivotal to Argentina's *Salvajismo* movement—a group named for its rough, primitive aesthetic by his friend and fellow Argentine collaborator Tec (see pp.140–1). A multidisciplinarian, Chu is as comfortable with a roller and bucket of paint as he is with a laptop and tablet. Although he has worked within various creative media—most prominently for the cult Latin American children's animation TV channel, Locomotion (1996–2005)—Chu still acknowledges the street as the ideal location for his work.

His designs, which range from happy-go-lucky characters to abstract geometric patterns, attempt to inject new life and color into the concrete, often brutal reality of the contemporary city. His aesthetic pairs formal simplicity with extreme exaggerated color and functions well on both a small or large scale. Embracing simplicity, his artistic philosophy exhibits a visual effervescence intent on radically altering our urban world.

Chu was one of the founders of the multidisciplinary art/design collective DOMA (see pp.134–5) in 1998. He and his fellow members met while studying at the University of Buenos Aires, and where he later taught for three years. The street was always an obvious choice for Chu because he felt equally drawn to animation and the power of the DIY aesthetic; it was an arena in which he could experiment and develop both passions in mutual collaboration. Although his participation in the DOMA collective has led to a wealth of animation projects, art installations, character designs, and curatorial work, Chu's idiosyncratic solo work, which includes urban interventions and murals, remains central to his practice. He clearly understands that he needs to take advantage of the opportunities and benefits that the commercial art world can offer while refusing to be pigeonholed in any particular medium.

The son of an engineer father and philosopher mother, Chu tries to forge a dynamic aesthetic that follows logic in its composition but that still retains a sense of chaos and randomness. Producing what he terms a "deconstructed universe of people and movement," he delivers imagery that has joy and consensuality at its core—both in its intent and in its form. His is a bold, vivacious *Salvaje* aesthetic.

1 Rosario, Argentina, 2008 2 Córdoba, Argentina, 2010
3 Buenos Aires, Argentina, 2007 (with Tec, Defi, P3dro)
4 São Paulo, Brazil, 2011 5 Buenos Aires, Argentina, 2010
(with Tec and Pepi) 6 Buenos Aires, Argentina, 2006

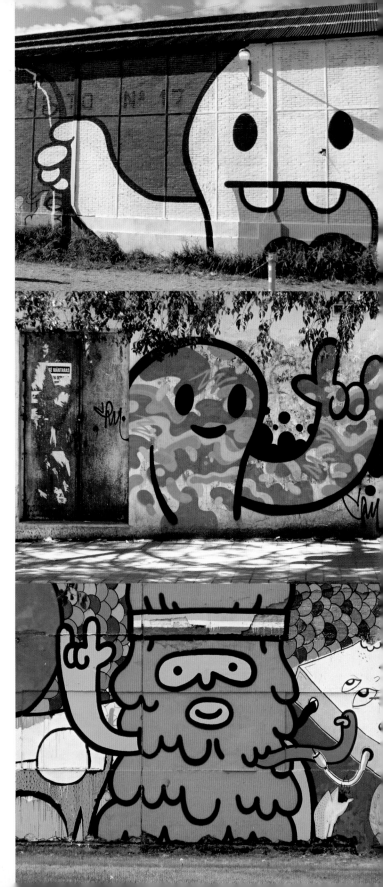

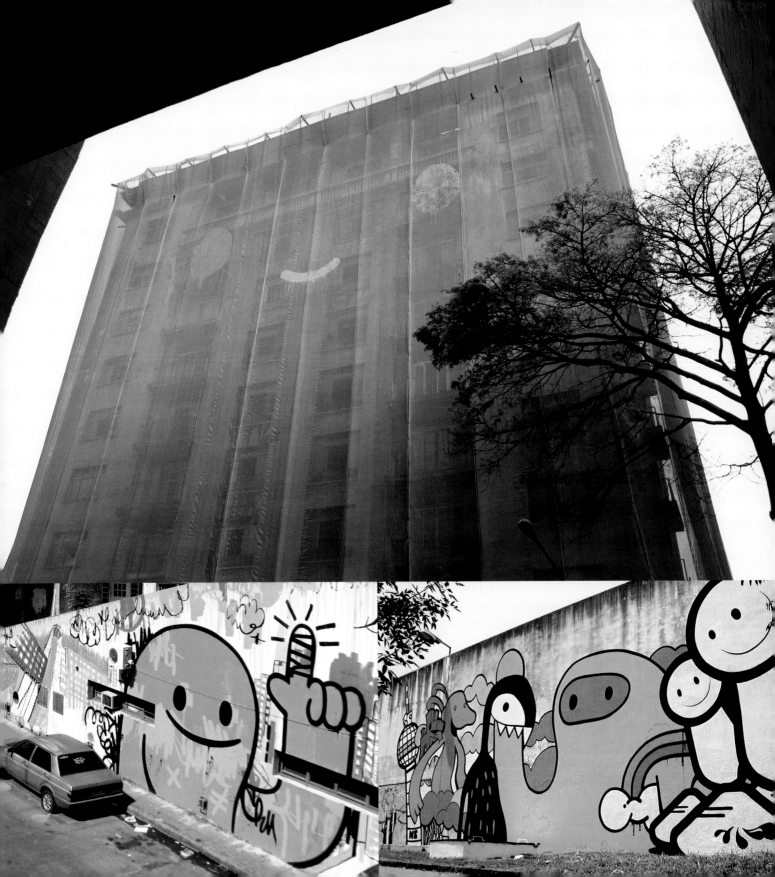

BUENOS AIRES BY CHU

Chu, one of the founding members of the Argentine collective DOMA (see pp.134–5), has produced an equally conceptual and diagrammatic interpretation of his hometown of Buenos Aires. Charting and conceptualizing his movements within the different parts of the city, from the suburbs and the beach to the working-class barrio of La Boca and the

city center, the map—which is made from four individual wooden pieces measuring 12 x 12 inches (30 x 30 cm)—mixes Chu's various styles of work, functioning through both abstract and illustrative lenses. While based on the topography of Buenos Aires, Chu's map turns a rational understanding of the city on its head through the graphic incorporation of his peregrinations (the bold white lines), as well as pinpointing the locations that are of particular significance to him (the colored dots). In the process his map becomes a highly personal and subjective analysis of Buenos Aires. Some of the features you would normally expect to find on a more traditional map of the city are still apparent; the River Plate, for example, is clearly identifiable in the top right-hand corner of the map, reinforced through the distinctive, three-pronged docks that push out into it.

On a subjective reading of the map, Chu's home is to be found at the middle dot of the top band of three, sandwiched between his local skate park on the left and the local park on the right; his studio is marked by the red dot on the far left of the map, just above the blue marking of the Piedra Buena district. At the center of the image (slightly to the left) is HIC, a bar and gallery that was a central meeting point for many of the Independent Public Artists in the city, while on its right is the University of Buenos Aires, where Chu studied and now teaches. Finally, on the far right of the map, is the central DOMA meeting point, a warehouse in which fellow DOMA member Orilo Blandini lives. While these white "paths" around the city reflect Chu's movements—the white line forcing itself down and off the bottom of the map, for example, signifies his journey to the beach—they also indicate the locations where Chu most often paints. As such, the map can be understood in psychogeographic terms: It simultaneously outlines Chu's wanderings in the city and illustrates his subjective, emotional relationship to its terrain.

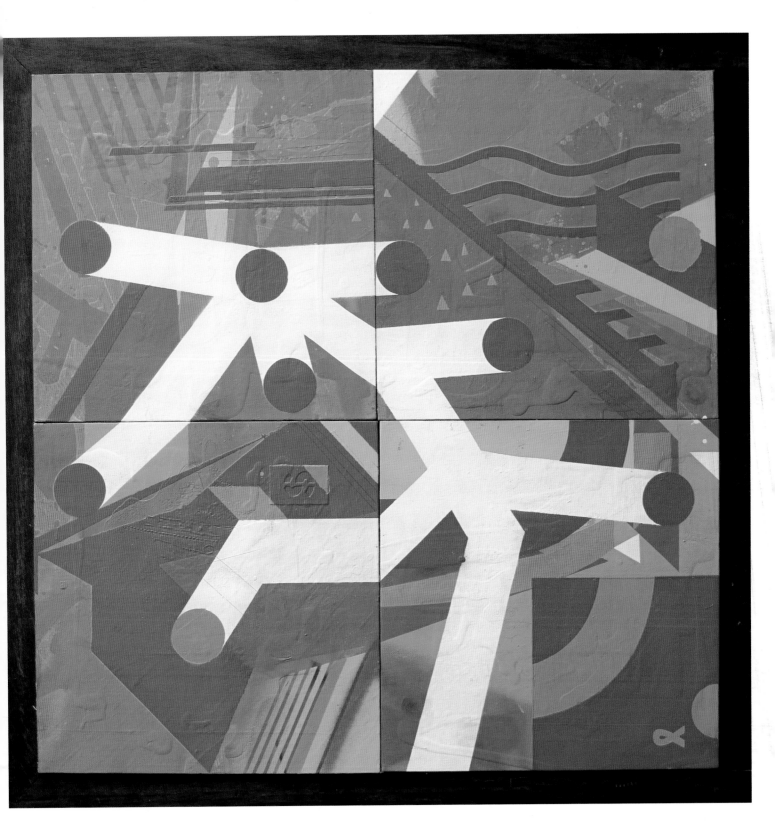

BORN Various MEDIUM Urban installations, stencils, soft toys, street projections STYLE Absurdist urban interventions THEMES Politics, carnival
INFLUENCES Mariano Barbieri, Orilo Blandini, Julian Pablo Manzelli, Matias Vigliano

DOMA

Producing images, installations, animations, sculptures, films, and toys, the Argentinian collective DOMA intervene in our visual world, producing a wealth of projects that explore the contemporary nature of urbanity. Coming from divergent backgrounds and perspectives, the members of the group—Mariano Barbieri, Orilo Blandini, Julian Pablo Manzelli (also known as Chu, see pp.130–1), and Matias Vigliano (known as Parquerama)—jointly embody an absurdist, often surreal understanding of their surroundings. Theirs is a lighthearted yet penetrating practice that strives to initiate a change in public perception.

Commencing work in 1998, DOMA (from the Spanish word meaning to "tame" or "control") emerged at a dramatic point in Argentinian history. After the collapse of both the economy and the political system, a vacuum emerged in which there seemed to be no hope for the younger generation. In the anarchy that resulted, however, DOMA recognized a concomitant relaxation of limits and new sort of freedom. Rather than simply acting politically by adding to the overabundance of propaganda and pessimism already on the street, DOMA took the opposite tack and set out to restore optimism to the city by countering cynicism and depression with laughter and carnival. With projects such as the *Mundo Roni* campaign—their parodic creation of a presidential candidate (complete with website, TV appearances, flyers, stencils, performances); their *Victim* (see image 1) doll—a giant, half-drunk (or half-dead?) dummy installed around central Buenos Aires; or their *Stupid Tank* (see image 2)—a literally elephantine installation that they escorted around Berlin, DOMA fought the political crisis by completely rejecting it and mocking its solemnity: "If the social and political situations are a circus, why not be part of it yourself?"

More recent Doma projects, including the *Criptométrico* temple in São Paulo and their impressive installation *Colossus* (see image 3) in Buenos Aires—a 147-foot (45-m) high, neon-animated figure made from an electricity pylon—have continued to push the boundaries of urban art and its capacity to move the public. As their name suggests, DOMA seek to tame their environment and reinvent their surroundings as a place of play and joy: They seek to overcome the dominant visual modality of the contemporary city by using the farcical and the preposterous as distinctly political tools.

1 *Victim*, Buenos Aires, Argentina, 2001
2 *Stupid Tank*, Berlin, Germany, 2007
3 *Colossus*, Buenos Aires, Argentina, 2012

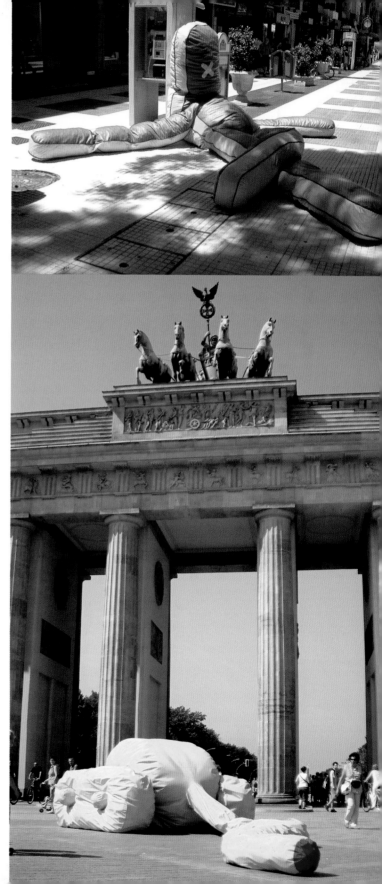

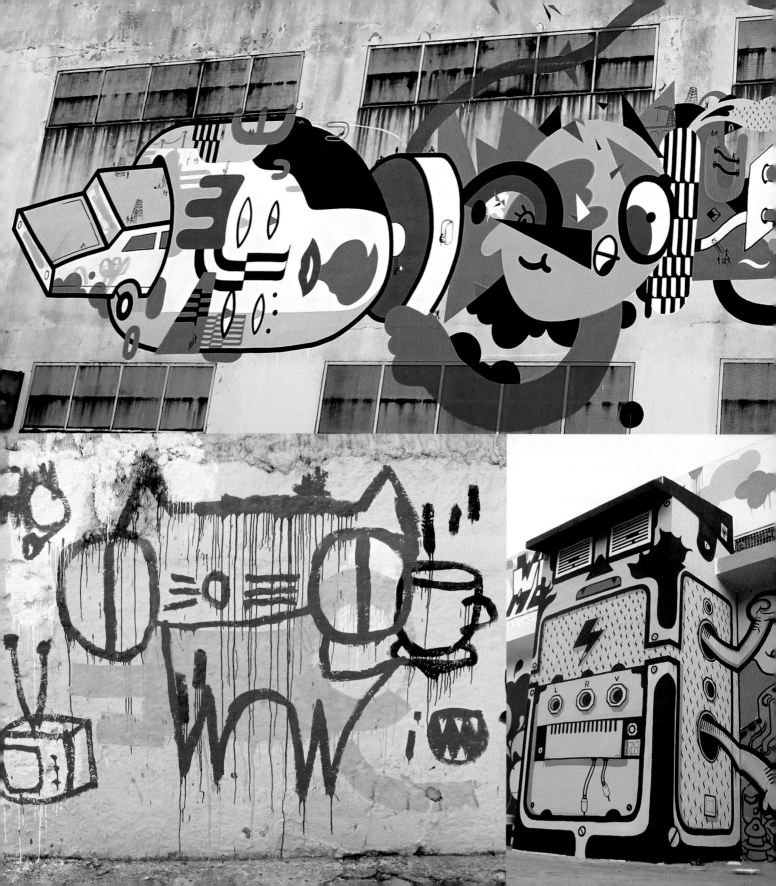

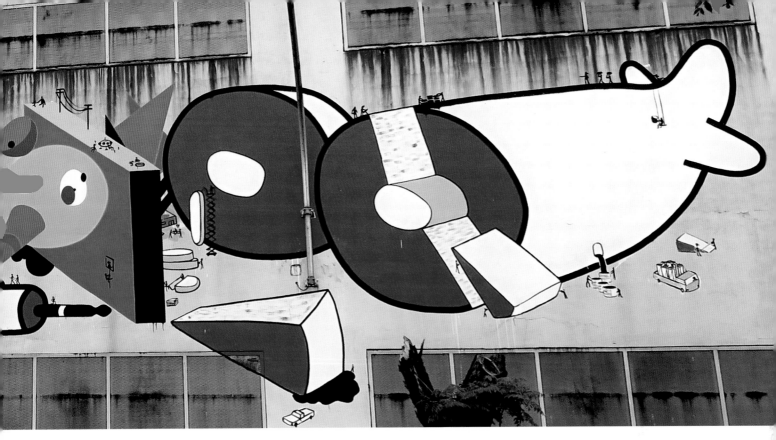

BUENOS AIRES

BORN Buenos Aires, Argentina **MEDIUM** Animation, installations, murals, multimedia, music **STYLE** *Salvajismo* **THEMES** Futurism, folk art, free expression **INFLUENCES** Various

FASE

An integral part of the Argentinian Independent Public Art movement, FASE is a multimedia platform for a group of constantly mutating artists, who collectively produce animations, installations, murals, and music. A core group of four members—Gustavo Gagliardo (also known as Defi), Pedro Perelman, Tec (see pp.140–1), and Martin Tibabuzo (see pp.216–17)— FASE represent an aesthetic vision that utilizes all possibilities of the audiovisual spectrum. Their range of work is, in fact, so diverse that it is easier to say what FASE's work is not rather than what it is. What it is not, therefore, is about stability or immutability, anything that works against evolution and growth. Regarding the "present as confusion and the future [as] unknown," FASE can create a magazine one day and a theater piece the next. As designers, producers, musicians, and artists, they use the group dynamic as a means to extend their personal oeuvres into territories that would be impossible on their own, using its inherent power to create constantly innovative work.

1 Buenos Aires, Argentina, 2012
2 São Paulo, Brazil, 2008
3 Buenos Aires, Argentina, 2006

The work of Defi and Perelman has been crucial to FASE's development, but also to the Buenos Aires Independent Public Art scene generally. Perelman's musical expertise made him the key influence on FASE's audio experimentation, but he also creates murals that focus on a combination of the futuristic (robots and mutant synthesizers, see image 3) and more traditional Argentine imagery (fishermen and farmer characters). As with his music, which is a fusion of futuristic electronica and more traditional folk, his artistic language is rooted in an exploration of resources, a multilayered consideration of his contemporary surroundings. For Defi, by contrast, what emerges most clearly in his imagery is a darkly humorous mix of his childhood pets—a group of bug-eyed cats in particular—and an explosive use of color. His is a confrontational, violent form of imagery that appears on walls, grass, car doors, and clothing. He has his own line of apparel, Lindo Killer, in which he uses fabric just like a canvas. His paintings (see image 2) are about pure action and the moment, rather than about thought. Like the Expression Sessions that FASE initiated in Buenos Aires, raucous street festivals in which the entire community was invited to participate in producing murals, what is ultimately key for the group is the overriding diversity and heterogeneity of their work.

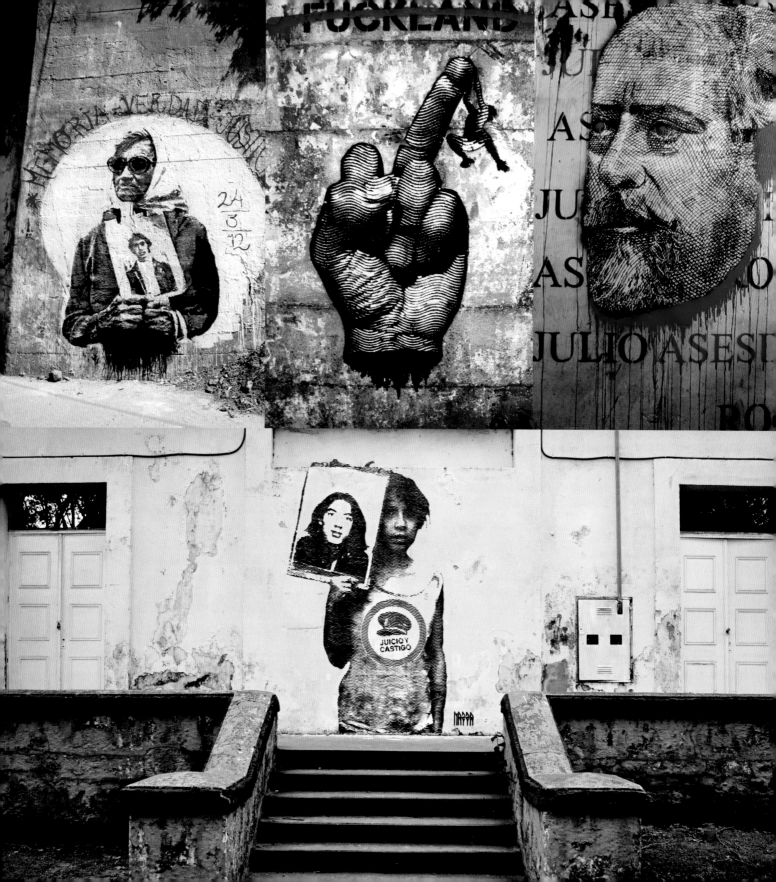

BUENOS AIRES
BORN 1978, Tucumán Province, Argentina MEDIUM Stencils
STYLE Political THEMES The Disappeared, Argentine history and politics,
neo-colonialism INFLUENCES Eduardo Galeano, Mario Benedetti, Osvaldo Bayer

NAZZA STENCIL
NAZZA PLANTILLA

Nazza Stencil (or Nazza Plantilla) is an artist from La Matanza, Buenos Aires, whose work is an aesthetic realization of his political ideals: It constitutes a two-pronged attack on the historical and contemporary crimes of the Argentine state. Seeing himself as a "craftsman" who utilizes the tool of art, each of Nazza's interventions tackles a specific issue that he develops on an artistic level and brings into the heart of the public sphere. What remains imperative for Nazza, however, is that his works appear on the peripheries of the city (such as his home district of La Matanza) as well as in the center. He wants his images to be visible not only to the media eye but to the public eye; his work strives to generate reflection in ordinary people and an opening toward an alternative way.

Although he has been painting on the street since 1994, Nazza's introduction to stencils was not a typical one. He first learned the technique while at high school; stenciled posters were the most economical method of reproducing images and Nazza's adoption of the technique was initially more connected to disseminating political information than it was to forming an artistic practice. His early work on the street followed a more instinctive pattern, however, and his work soon developed certain styles of framing as he sought a form of individual expression, as he describes it, "taking a position with issues, providing images in the streets of the general causes I believe in and defend." Influenced by writers, such as Uruguayan journalists Eduardo Galeano and Mario Benedetti and the Argentine writer Osvaldo Bayer, Nazza has confronted political issues such as the Argentine "Disappeared"—the estimated 30,000 "lost" or murdered during the genocidal military coup—the famous Grandmothers and Mothers of the Plaza de Mayo (the association of women whose children disappeared, see image 1), as well as the silent destruction of Argentina's indigenous culture and people. Persevering in the contract he has made with himself, defending the rights of those who appear to have none, Nazza uses his artistic voice to express himself and the plight of the common people through the space of the city's streets and walls.

1 Isidro Casanova, La Matanza, Argentina, 2012
2 San Alberto, La Matanza, Argentina, 2012 3 Buenos Aires, Argentina, 2010 4 Buenos Aires, Argentina, 2012
5 São Paulo, Brazil, 2012 6 Córdoba, Argentina, 2010

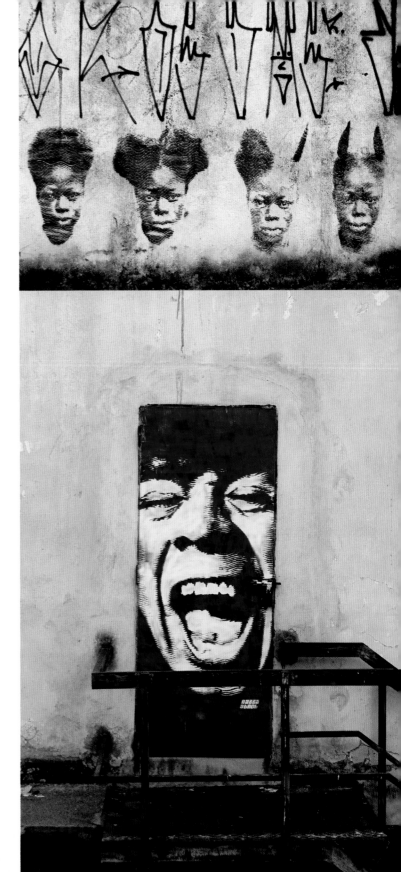

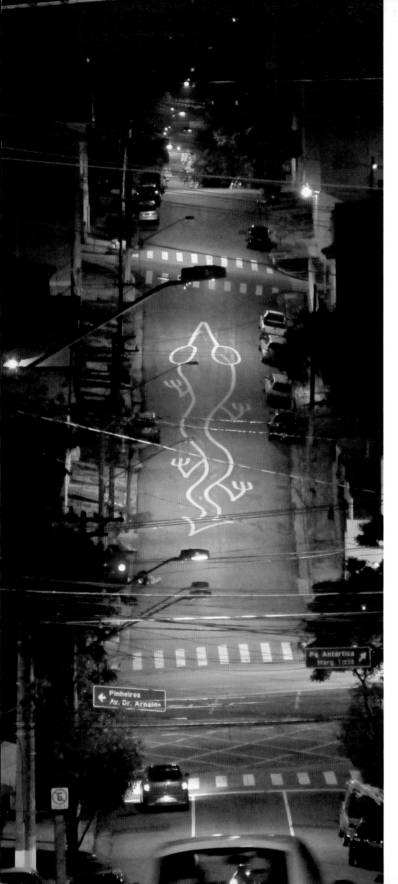

BUENOS AIRES

BORN 1975, Córdoba, Argentina MEDIUM Spray paint
STYLE *Salvajismo* THEMES Children's art
INFLUENCES Barcelonan graffiti, *art brut* COLLECTIVE FASE

TEC

One of the founding members of the multidisciplinary collective Fase (see pp.136–7), Tec is one of the key figures on the Argentine Independent Public Art scene, whose work far exceeds the iconic, headless whale for which he is perhaps most famous. He used this illustrative, intentionally crude image in place of a tag, painting it all over Buenos Aires as well as in cities throughout the world. However, his work has since developed toward an *art brut*-influenced muralism and a style that is highly influenced by the uninhibited artwork of children.

 In the common tradition of rock and punk graffiti in Latin America, Tec first began to paint in the city to promote his band. A trip to Barcelona in 1992, however, completely transformed his understanding of art and the city as he explains: "I took the train from the airport and had the greatest visual experience of my life! The walls on both sides of the road were full of graffiti, colors, and abstract shapes. When I returned to Buenos Aires I showed the photos to my friends, and since then we've never stopped painting." At first Tec simply tagged his name, but the onset of the Argentinian financial crash became the next major factor in his artistic development. Regarding the crisis as a launch pad rather than as a disaster, he worked together with DOMA (see pp.134–5) and his own collective Fase, and became one of the leaders of the *Salvajismo* movement (rather than *Muñequismo*, which it is often mislabeled), so-named due to its rough, primitive aesthetic. They embraced a highly colorful technique that rejected the somber, insipid visuality they felt constrained by. As well as his renowned whale icon, Tec also created a superb range of rollered street paintings that were produced directly onto the surface of the street rather than its walls. However, it is Tec's more recent projects with schoolchildren, in which he has reworked their own drawings (that Tec describes as "stacks of papers filled with genius") into large-scale murals that most accurately sums up his aesthetic (see images 2 and 3). Demonstrating that "drawing isn't just for the Da Vinci's and the Dalí's" and that it is a "pleasure that can reach anybody," Tec seeks to promote the simple, unpretentious purity of painting: "Anyone can paint. The kids get that and so do I. And if someone sees a drawing and thinks, 'but that's something I can do', that's awesome. That is what it's all about for me."

1 São Paulo, Brazil, 2012
2-3 Osasco, São Paulo, Brazil, 2011

SANTIAGO

BORN 1983, Santiago, Chile **MEDIUM** Spray paint, montage, collage, photography
STYLE Abstract graffiti, surrealist graffiti **THEMES** Magical realism
INFLUENCES Abstract expressionism, Herbert Baglione, Os Gêmeos, Nunca

BASCO VAZKO

Born in Santiago, Chile, the artist Basco Vazko is equally influenced by the New York School of abstract expressionists—de Kooning, Rothko, and Pollock—as by Brazilian Independent Public Art—Os Gêmeos (see pp.120–3), Herbert Baglione (see pp.116–17), Nunca (see pp.118–19), and Vitché (see pp.124–5) in particular. His work has developed a unique amalgam of both approaches: an abstract, expressionistic essence fueled by the grit and energy of working on the street.

Basco's artistic career truly took off in 1998, the year that he began painting in the public sphere and commenced work on his exquisite sketchbook, an over-painted, redesigned version of *The Decameron of Giovanni Boccaccio*, which he completed in 2011. While his early street work was clearly representational—in a dream-like, often fantastical vein similar to magical realism—his more recent production has continued to focus on the body, but in a more highly abstract and contracted manner. Whether painting in black and white or in subdued, muted colors, Basco's surreal, arresting, sculptural figures are interwoven with various shapes and structures, producing images that are halfway between letters and objects. Furthermore, while his earlier art was produced on the exterior walls of the city, his more recent output has seen him working in the interiors of empty, abandoned houses. What Basco is attempting to create, in his own words, are works that "feel more accidental, almost like they belong there"—simple rather than spectacular works that engage the viewer in a more unobtrusive, restrained, and naturally effective manner.

With image-making entrenched in his blood (both his father and grandmother are artists) rather than ingrained through systematic education, painting is something that the self-taught Basco never consciously chose to undertake, but has simply been doing all his life. While pursuing numerous other projects—reworking magazine covers in his distinctive style and producing countless collages, photographs, and drawings—he remains active on the street, his unrestrained and unorthodox work pervading public spaces. With his urgent, at times primal aesthetic, Basco has developed a singular approach to producing a street art with raw purity—work that could be described as contemporary surrealist graffiti.

1 *Cuatro Le Madass 31*, Santiago, Chile, 2009
2 *Le Pene Wild*, Santiago, Chile, 2008
3 Santiago, Chile, 2008
4 Santiago, Chile, 2007

INTI CASTRO

VALPARAISO
BORN Valparaiso, Chile MEDIUM Spray paint
STYLE Folk graffiti, contemporary muralism
THEMES Southern cone, Altiplano, pre-Columbian art, Amerindian culture

Although he was raised and still lives in the coastal Chilean town of Valparaiso, Inti Castro is a quintessentially Latin American artist, who draws on influences from pre-Columbian and contemporary Amerindian culture. Inspired in particular by the iconography of the Southern Cone— which encompasses his native Chile, Argentina, Paraguay, and Brazil, as well as the Altiplano (the high plateau of the Andes in which Chile sits, along with western Bolivia and southern Peru)—his illustratively rich work attempts to fuse these varying styles of imagery and form a contemporary, pan-American muralism that transcends political frontiers.

While Inti takes a distinctly continental approach to his work, however, there is no doubt that his native city of Valparaiso has had a powerful influence on his artistic development. Known both as "Little San Francisco" and "The Jewel of the Pacific," the city has a strong cultural and artistic presence but, more significantly, it has no regulations that explicitly outlaw graffiti. Although it is technically illegal throughout the rest of the country, in Valparaiso there is an informal arrangement to sanction this form of public art as long as it remains, as the city's cultural development director pronounced, of a "creative nature" (a highly subjective principle, of course). This local acceptance has enabled artists such as Inti to thrive, giving them both the time and space to evolve their style free from the fear of arrest or imprisonment. As Inti says it has given him the opportunity to "keep trying and experiencing other things . . . to choose places for my interventions that I could really investigate and amalgamate with."

Although his original work sprang more from impulse, as Inti developed as an artist he began to recognize the rich potential of public space and the power that could come from intervening within it "for the common good." By combining his murals with a particularly indigenous iconography, utilizing artifacts such as Chilean *chupalla* hats, Quechua *chumpi* belts, Chancay dolls, and the highly patterned textiles of the Altiplano, Inti has embraced the native visual culture of his country. Like his own name—a Quechua word meaning "sun"—he aims to shine a light on the often hidden indigenous roots of his country and use his work as a means of uplifting, supporting, and exhibiting the native traditions of Latin America.

1 Valparaiso, Chile, 2011
2 Cologne, Germany, 2011
3 *Our Utopia is their Future*, Paris, France, 2012
4 Valparaiso, Chile, 2012

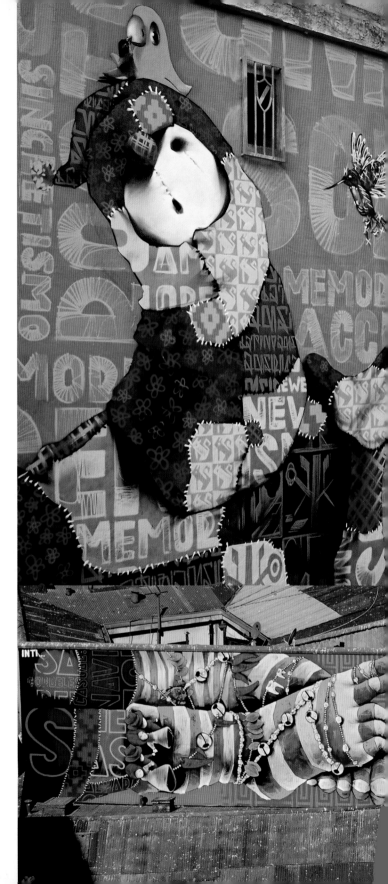

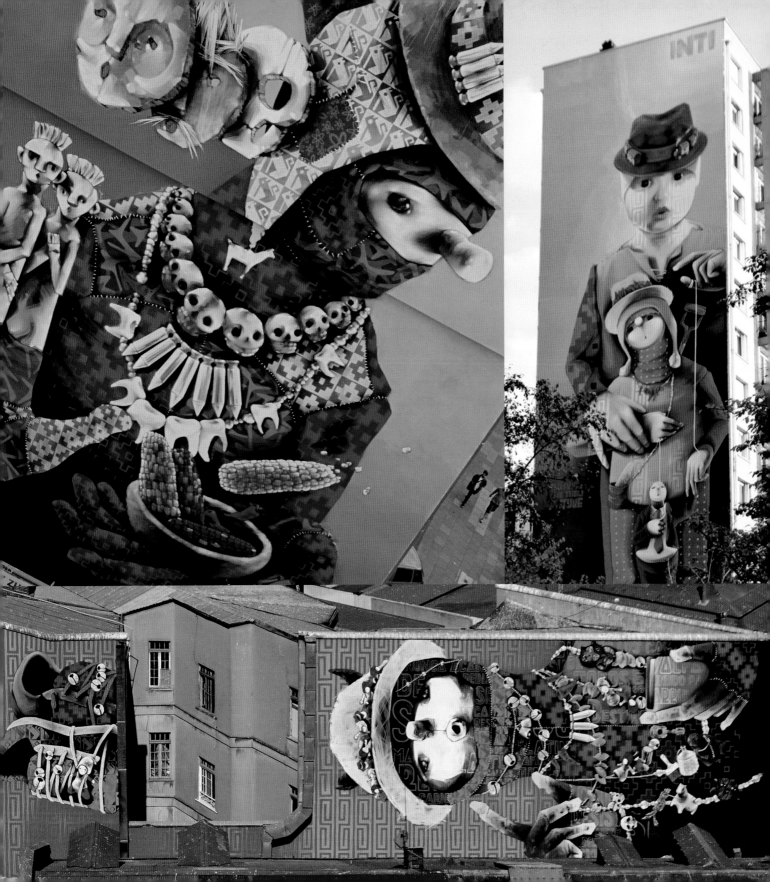

1 *The Mess* by Akay and Brad Downey, Vienna, Austria, 2011

NORTHERN EUROPE

LONDON PARIS BERLIN STOCKHOLM

CEPT RADYA LES FRÈRES RIPOULAIN VOINA EGS EROSIE HONET POINT EPOS 257
BRAD DOWNEY INTERESNI KAZKI HOMER VOVA VOROTNIOV TURBO ZEVS INVADER
ZEDZ AKIM ARAM BARTHOLL EINE OX GOLD PEG CLEMENS BEHR NUG INFLUENZA
HUSKMITNAVN WERMKE & LEINKAUF AKAY AFFEX VENTURA PETRO ZBIOK EKTA

Diverging from a strict geographical definition, this chapter includes artists from the northern, western, and eastern parts of Europe, a split separating this group from their southern neighbors and roughly demarcated through the latter's access to the Mediterranean. As such, the chapter includes the most countries and cities of any other in the book—from the individually profiled cities of London, Paris, Berlin, and Stockholm to established locations such as the Netherlands and the burgeoning scenes of the Czech Republic, Poland, Russia, and Ukraine. Although the art from these various locations is understandably diverse, it could be argued that their styles are linked by a certain conceptual edge.

In London (see pp.150–1) there is generally a quite brutal style of production, an unrepentant aesthetic possibly determined by the city's status as the CCTV capital of the world. Artists such as Gold Peg (see pp.156–9) have worked to both elude and belittle the powers of this surveillance society, adopting a determinedly rough, vandalistic style that embraces anarchy over art. Others, however, such as Gold Peg's Burning Candy affiliate Cept (see pp.152–3) and TFW member Petro (see pp.160–3) have pursued a looser, more carefree style of graffiti, staying true to its essence through their constant desire to find solutions to typefaces while also producing exciting and innovative work away from the street. Paradoxically, however, London has also become the world leader in the market for what has been termed "street art," the sardonic work of Banksy now replaced by a raft of mediocre imitators. Artists such as Eine (see pp.154–5), a close graffiti partner of both Cept and Petro for many years, have tried to find a middle ground between these two discourses, however, retaining a graffitist's obsession with letters while forming a more outward-looking practice that speaks to a wider community.

In Paris (see pp.164–5), by contrast, one can detect a more overt preoccupation with formal flair; artists such as the late Turbo (see pp.178–81) and Honet (see pp.166–9) working with perpetual élan and a seemingly effortless sophistication. While for Turbo and Honet the graffiti culture remains key, however, artists such as Zevs (see pp.182–5) have emerged from this subculture, yet work with issues as much as letters: Often working on the city's billboards, Zevs practices in a lineage established by OX (see image 1 and pp.174–7) in the early 1980s. OX gives his work an intense site-specificity, delicately interacting with the landscape at hand. Like Invader (see pp.172–3), he uses each location almost as a playground, although in Invader's production, it is tiles rather than paint that are his medium. Like his fellow Parisians, however, the work is characterized by a highly sophisticated merging of form and concept, an experimental, urbane model of Independent Public Art.

Heading in a more purely theoretical direction, the featured artists for Berlin (see pp.202–3) have all taken the urban arts into new, highly self-reflexive territory. Although the city has become almost synonymous with street art, it is the artists who have emerged from graffiti who are pushing at the borders of the discourse the hardest: Akim, for example (see pp.204–7), has not only transformed his classical graffiti into three-dimensional realms (as has Point from the Czech Republic, see pp.248–9), but has undertaken interventions that could be seen as social-scientific experiments. Similarly, Wermke & Leinkauf (see pp.218–21) produce projects and films that try to recreate the intimate understanding of the city that graffiti facilitates, rather than producing a graffiti aesthetic in itself. With artists such as Aram Bartholl (see pp.208–9) working in the terrain between digital and public art, Clemens Behr (see pp.214–15) merging two- and three-dimensional space, and Brad Downey (see image 1, p.146 and pp.210–13) challenging ideas of what Independent Public Art itself is, Berlin presents a clearly conceptual array of artists, a group for whom the abstract idea is as important (if not more so) as the resulting concrete form.

In Stockholm (see pp.222–3), the legendary Akay (see image 1, p.146 and pp.224–7) has been at the vanguard of the urban arts—in the first wave of graffiti in Scandinavia; as one of the leaders of the postering and stickering movements; and as a pioneer of urban intervention. Nug (see pp.228–31), a fellow VIM Crew associate, has moved from a militant graffiti aesthetic into video and performance art, producing wild, feverish actions that revel in the emotion and heated sensation that graffiti practice unleashes. Both can be seen to take a more overtly conceptual approach to graffiti than their Scandinavian counterparts, such as HuskMitNavn from Copenhagen (see pp.236–7), Ekta from Gothenburg (see pp.238–41), Egs from Helsinki (see pp.242–3), all of whose work focuses on a more graphic, compositional style. While there are other European artists for whom form is key, such as Zedz from Amsterdam (see pp.194–7), Zbiok from Wroclaw (see pp.250–3), and Interesni Kazki from Kiev (see pp.254–7), all of whom take highly variant yet aesthetically rich approaches, Akay and Nug's conceptual style can also be recognized in the work of other practitioners such as Les Frères Ripoulain from Rennes (see pp.186–9); Influenza from Rotterdam (see pp.190–3); Erosie from Eindhoven (see pp.198–201); Epos 257 from Prague (see pp.246–7); Vova Vorotniov (see pp.262–3) and Homer from Kiev (see pp.258–61); and Radya (see pp.264–7) and Voina from Russia (see pp.268–9). All of these artists and groups have produced work that functions far from the original blueprint of graffiti or street art, forming a style of Independent Public Art that goes beyond any fixed visual discourse. Northern Europe excels in a style that could be termed "graffiti conceptualism" that rejects the growing commodification of the urban arts and which sees much of the beauty of these practices coming from the entire process of the act, not only in its final, ephemeral product.

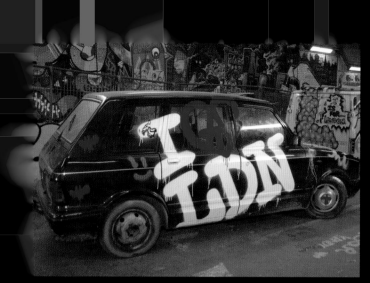

LONDON

Like any history, the story of graffiti and street art in London has many different versions and this article can only begin to scratch at its surface. The city of London has a particular and special character that has shaped its own form of graffiti. London is enormous and heavily policed, and consequently its graffiti has been hard and mean. Although it is a city of extremes, the streets have also borne witness to a less hostile, more gallery-friendly type of work, often labeled "street art." Between those two approaches it has not always been friendly, and many tensions and dramas have taken place on the London scene.

London is vast and each area has its own character and aesthetic in relation to graffiti; for example some districts in the 1990s had a really evil edge. The graffiti was raw—separate letters, ultra legible, with double outlines so that it stood out even more. It was not about who was the most "up" but about who was the most aggressive, such as SKAN BOSH SKATA. Some of the best throw-ups came from GSD and DELS (the best and most militant—solid from East Croydon all the way to Norwood Junction). Shogi and Oker from the same crew also smashed it, bringing characters into the letters that so many people copied but never quite mastered as well. Zonk went "all-city" in the late 1990s, and like any write who has painted their letters thousands of times, there is a fluidity to his style that cannot be faked.

However, things got really raw with the introduction of paintstripper. DDS were the first to discover this tool-cum-weapon and they used it to get one up over the graffiti removal teams: Paintstripper allowed them

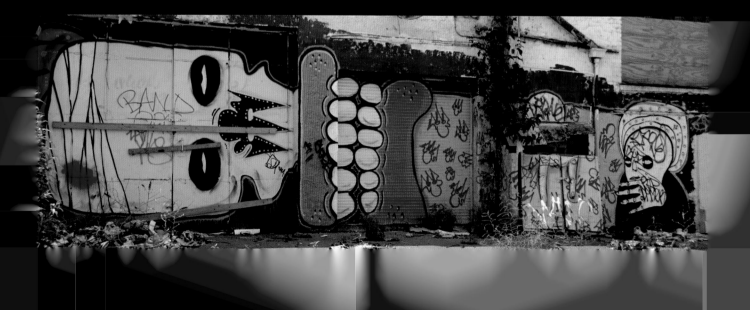

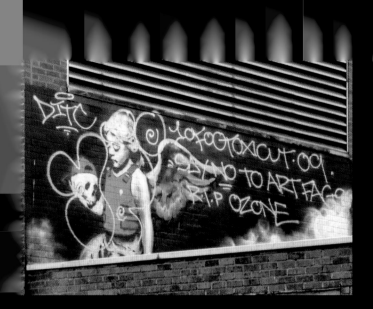

...to literally burn their tags onto the sides of trains so that any attempt to remove it by the authorities only made it shine out better. Tags are still running from ten years ago; Little Mets (Metropolitan Line subway trains) would roll past with Tox02 all the way to Tox09 dripping metallic tags. You would see it on the streets, too, but it was designed for the trains, and it definitely sums up the way it articulated graffiti being on the offensive.

While graffiti was evolving to the point of using paintstripper, a whole separate scenario was emerging. Banksy (see image 5) started running around inventing new ways of getting up, including climbing into Regent's Park Zoo and getting hits on zebras. His stenciled rats sprang up everywhere and people started paying attention. Hot on his heels and spurred on by a buoyant art market emerged a wave of fairly uncreative "street art" that was flooding east London. Graffiti writers Ozone and 10Foot invented the less than subtle term "art fag" to insult the street artists (see image 4), and a binary/strict divide of ethos and aesthetics was constructed through the ensuing war: Getting up illegally for the sake of getting up vs. getting up for the sake of drawing attention to your gallery show; a traditional graffiti letterform aesthetic vs. a pop art image-based aesthetic, often as a stencil or paste-up. Banksy fell into the crux of this war because he became the most famous, but essentially it was (and is) about the love triangle between money, art, and credibility. Work is most credible when it is not about money, but the more credible the work is the more money it can make . . .

Therein lies the dilemma, but the position you could hold was reduced to two fronts and in many ways this paralyzed creativity. Writers were scared to break the mold for fear of being cast as some "art fag" artist, and street artists were still only making art that failed to see beyond the imaginative limits of the consumer. This is not to say that everything went badly; ill-defined between the lines in the early 2000s ATG (see image 1) were using emulsion and some "untraditional" techniques that inspired and enraged equally, but then perhaps fell into a slipstream of self-promotion. Burning Candy (see image 3) broke many rules with the monster triple-extended roller pole collaborations that they somehow got away with illegally. Type (see image 2) and Arx went at it solo with the roller pole technique, and Type took it to such a massive unprecedented and unexpected levels that by the end of 2010 everyone was baffled.

Since the bottom fell out of the art market, much of the "street art" that was flooding Shoreditch in east London has fallen off. This means some of the heat is over in terms of the graffiti/street art wars; however, it is still unclear that anyone knows what to do in the aftermath. With the Olympic Games "clean-up" and a spate of prison sentences for graffiti writers, the situation is not getting any easier but the size and insanity of the city means that there is always space for possibility. Who dares wins. **MS/DB**

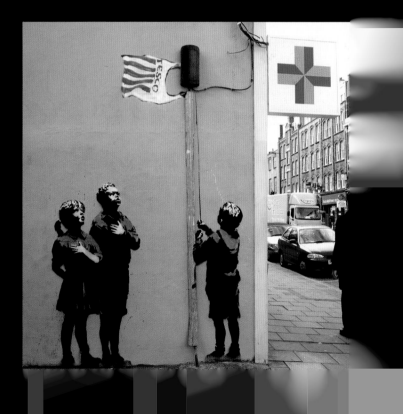

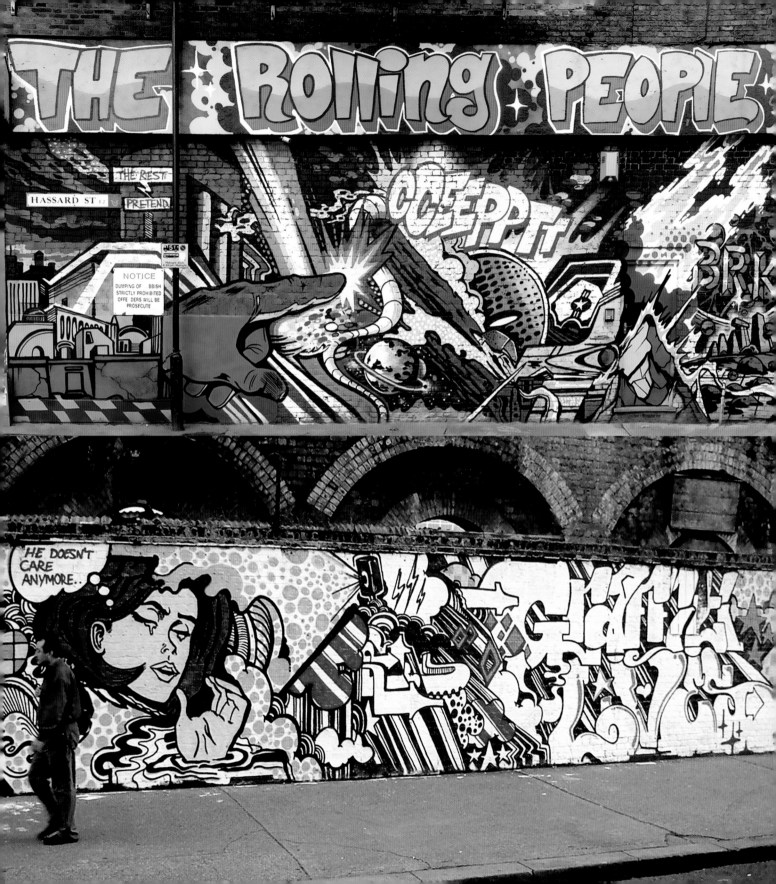

LONDON

BORN 1972, London, UK **MEDIUM** Spray paint **STYLE** Galactic funk
THEMES Retro-futurism, excessive decoration **INFLUENCES** Roy Lichtenstein,
"Silver Age" comic books **CREWS** The Rolling People (TRP), Burning Candy

1 *The Rest Pretend*, Hackney, London, UK, 2012
2 *Graffiti Lives*, Shoreditch, London, UK, 2005

CEPT

A key presence on the London graffiti scene since the mid-1990s, Cept works in a style he terms "galactic funk." He was one of the first artists to push graffiti in the Shoreditch and Hackney areas of east London—now a world center of graffiti and street art—and his playful style is strongly influenced by the pop art of Roy Lichtenstein and the "Silver Age" comic book style that Lichtenstein often imitated. Inspired by the simplicity and emotional veracity of the characters they both used, Cept formed a retro-futuristic style that embraces the fun, loose, party element of graffiti. Although constantly changing, his style stays true to the overly stylized, excessively decorative nature of the 1980s era of New York graffiti.

Born in London in 1972 but raised in a village in North Wales, Cept has been drawing ever since he can remember. He was initially influenced by the heavy metal aesthetic and reproduced the images and calligraphy used by groups such as Whitesnake and Iron Maiden. He began drawing his own name after seeing Martha Cooper and Henry Chalfant's seminal

book *Subway Art* in 1986 and developed his style in a secret train tunnel close to his house. Once he became known in his local area, Cept began traveling to Manchester and Newcastle, where he embraced the freedom that these bigger cities offered. He moved to London in 1995, where he continued to study and paint graffiti, inspired by writers such as Mist, The Art Cru, Popz 100, Third Team Kings, Kast, Drax, and Scam. Although Cept has been painting almost non-stop ever since, dominating the east London scene with artists such as Eine (see pp.154–5), Tase, Snoe, Seks, Spie, and Tek, he also works in the fine art world. Since training at Central Saint Martins College, he has incorporated multimedia styles, including sound and video, into his oeuvre. This darker, more understated side of his practice is strongly characterized by the method of appropriation that is so key to the graffiti sensibility without ever making a direct reference to lettering. Both forms of his practice, however, show a baroque style that is evident in much graffiti, a latent cenophobia, an urge to fill his pieces with everything that comes into his mind. Undertaking a "psychedelic vortex exploration" and pushing his unique brand of "comic book, space knowledge," he explores the possibilities of both his personas, the "funk bringer," the "party smasher," and the "Savant Garde" alike.

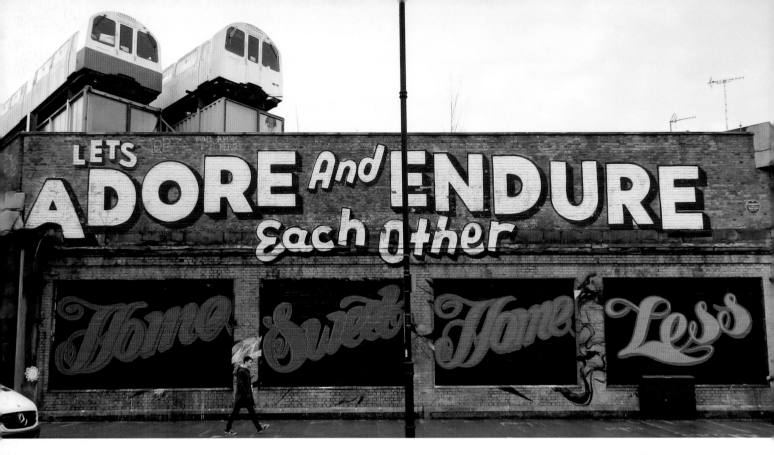

LONDON

BORN 1970 **MEDIUM** Spray paint, stickers, posters **STYLE** Contemporary calligraphy, alphabetic shutters **THEMES** Single letters, poetic phrases **INFLUENCES** Hand-painted signage, hand-painted advertising

1 *Home Sweet Home Less*, Shoreditch, London, UK, 2011 (above *Adore and Endure* by Espo)
2-9 Osaka, Kobe, and Tokyo, Japan, 2010

EINE

A stalwart of the London graffiti scene for more than twenty years, Eine's recent metamorphosis to a more visually comprehensible, stripped-down typographic production has led to huge global acclaim. The change has taken his work from the walls of east London to those of the White House, in the process opening up his distinct form of textual inscription to an entirely new audience. Although he has retained the graffitist's obsession with letters, Eine made the decision to move away from the often inward-looking intentions of the movement and forge an aesthetic that could resonate with audiences outside the subculture. With his alphabetical shutters and juxtapositional phrases, he has fashioned a deceptively simple style and a bold, calligraphic technique that is unmistakably his own.

Born in 1970, Eine spent years tagging all over his hometown of London. A renowned bomber with a distinctive Saba "S" throw-up, as well a notorious train painter who worked with London legends such as Nema, Oker, and Elk, Eine worked constantly in the underground scene until about 2000, when he came close to a custodial prison sentence and decided to retire from his traditional production. Taking note of the street art then emerging in London, he decided to alter his aesthetic and establish a meeting point between his earlier work and this new style of production. Rejecting the highly stylized, complex form of typography he had developed for a method that was more purposefully unstylish, Eine began utilizing posters, stickers, and stencils while keeping the letter form central, trying to take it back to its typographic roots. Focusing on his now famous, large-scale, single letters, he eventually painted the entire alphabet on shop front shutters in the Dalston area of east London. Refusing to sign his name on his works, he embraced their resultant ambiguity while giving them their innate separation from graffiti. Eine also began to incorporate whole words into his work, such as in his infamous "Vandalism" and "Scary" pieces from 2007 referencing the art vs. vandalism debate then raging in the British media. Eine has continued to incorporate hundreds of new fonts into his works, forming increasingly complex compositions with multiple types and backgrounds. However, his undying love of the alphabet still remains consistent in his practice. It is an enduring fixation that has persisted through his life and one that is always mutating, developing, and refining.

LONDON

BORN London, UK MEDIUM Spray paint STYLE Rough,
vandalistic aesthetic THEMES Anarchy, mis-education
CREW Burning Candy

GOLD PEG

Dominating London's skyline since the late 2000s, Gold Peg's rough, vandalistic aesthetic has brought a new dimension to the predominantly chrome-and-black, intentionally ugly London style. With her vibrant, gaudy colors, her obsession with ice-cream and eponymous clothes pegs (or clothespins), and her acquisition of normally out-of-reach spots, she has carved a niche that rejects the restrictive boundaries of the city's graffiti and street art scenes. Following the uncompromising ethic of the bomber and the experimental desires of the innovator, Peg pairs the "mis-education" she has been schooled in with a desire to aesthetically remodel this apparently anti-social behavior, forming an anarchistic, absurd, deeply indignant model of Independent Public Art.

Part of the legendary Burning Candy crew, which has included Cyclops, Dscreet, Mighty Mo, Rowdy, Sweet Toof, Tek 33, and Cept (see pp.152–3), Peg has been a key player in the recent rebirth of graffiti in the capital. This has seen a move away from a highly insular practice to a more outward-looking, colorful, iconic form of work filled with humor and humility. Although graffiti is primarily about fun for Peg, there is a quite self-conscious ideology behind her practice. While some may regard her work as pure barbarism, in her mind it is a "pointlessly destructive act that makes perfect and purposeful sense," an act that is meant to have no meaning and which makes sense through its senselessness. Rather than framing one's understanding of the environment through a primary deference to the law, Peg considers her "vandalism" as a way of breeding a "disorderly mind that sees way more options for action than formal education will ever teach." For her it is a process whereby one works out the correct process of action "according to a set of criteria more directly attached to you—will I die, is someone going to run screaming to the police, how excited will I be when I'm up there, can I get away with it." Refusing to simply produce prints or hunt for commissions, Peg uses the informal education she has garnered on the city's rooftops and train tracks to rework her defiant discourse in new terrains. Whether making ice-cream (with unmentionable ingredients) for art openings or go-karts for bored local youths, Peg simply wants to keep all that is inappropriate and irregular close to her heart, knowing that it is through these apparently immoral acts that morality itself may eventually be found.

1-2 London, UK, 2010

| 1 | 2 |

LONDON BY GOLD PEG

Gold Peg's intricate, darkly comic map of London unconsciously echoes both the heavily populated genre paintings of the Flemish Renaissance master Pieter Bruegel and the riotous, entangled images produced by children's author and illustrator Martin Handford (specifically his *Where's Wally?* series). It is a style of work that can be grouped together under the term *Wimmelbilderbuch* (which translates as "teeming picture book"); Gold Peg's map, with its elaborate, baroquely portrayed morality tales, displays all the narrative and graphic techniques of this approach. She says that it attempts to depict "just one percent of all the events, occasions, or incidents that have happened" during her life and graffiti career. Although neither exact to scale nor technically accurate (the Regent's Canal turns into the Thames and the Westway into the North Circular), the map replicates the vibrancy, absurdity, and anarchy of Gold Peg's work and offers a cartographic presentation of her everyday existence.

Starting off in Hackney Wick in east London (which is burning down due to the Olympics), we encounter the vomit-infested district of Shoreditch, with the soon to be demolished Heygate Estate (the site where Gold Peg produced *Release the Wolves*) set slightly further below. With the unmissable elephant (of Elephant and Castle) adjacent to the Heygate, further to the west lies New Covent Garden Market and Battersea Power Station (taken over by the residents of the Battersea Dogs and Cats Home), with central London above depicted through its descent into Hell (with Selfridges and Top Shop bags attached). Back at the top right-hand corner of the map is an image of Gold Peg, Monkey, and Sweet Toof in Limehouse, marching through a graveyard, drenched in moonlight with their roller poles and paint buckets in tow (in a real-life recreation of one of Sweet Toof's macabre paintings). Along with an image of Gold Peg's old squat in St. George's Circus, a portrayal of an aghast Judge John Clarke (who sentenced London graffiti legend 10Foot among numerous other writers) staring up at the graffitied message "Judge John Clarke Smokes Biftas," together with the plethora of foxes and ice-cream vans that are so close to her heart, Gold Peg's London is a mad yet delicate amalgam of satire, ornateness, and extravagance: It is a city transformed through the physical attachment to its landscape that graffiti has engendered, a city in which adventure, exploration, and excitement are completely intertwined with its topography.

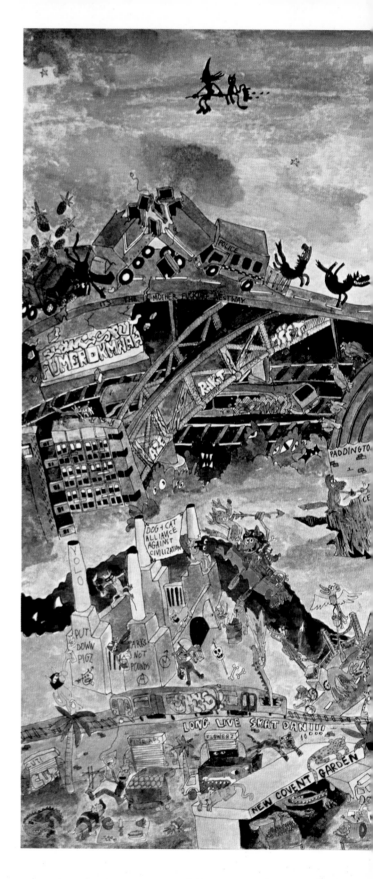

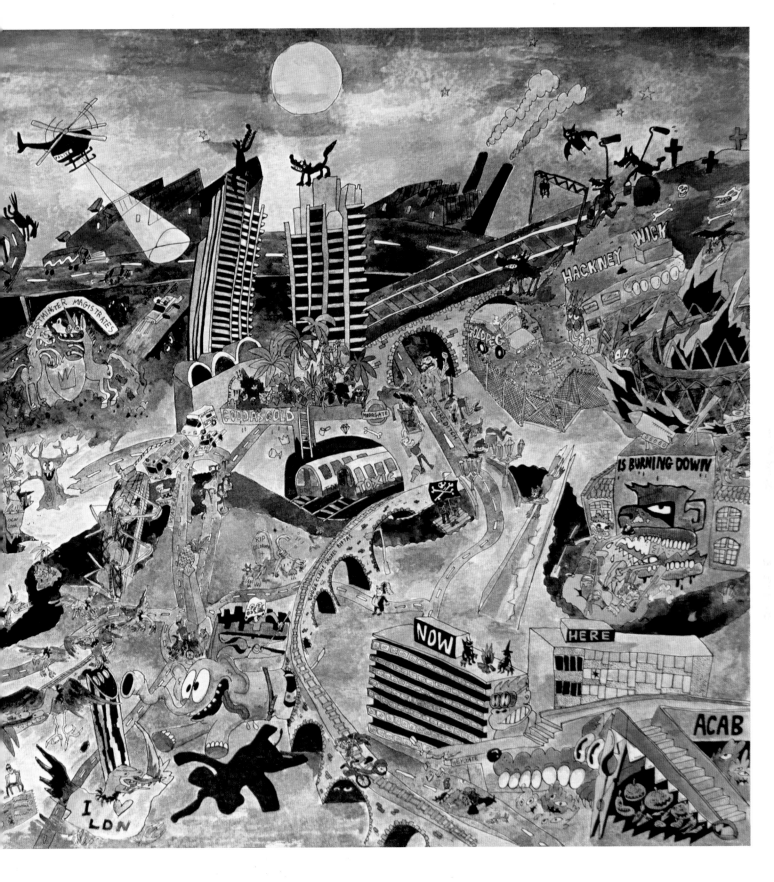

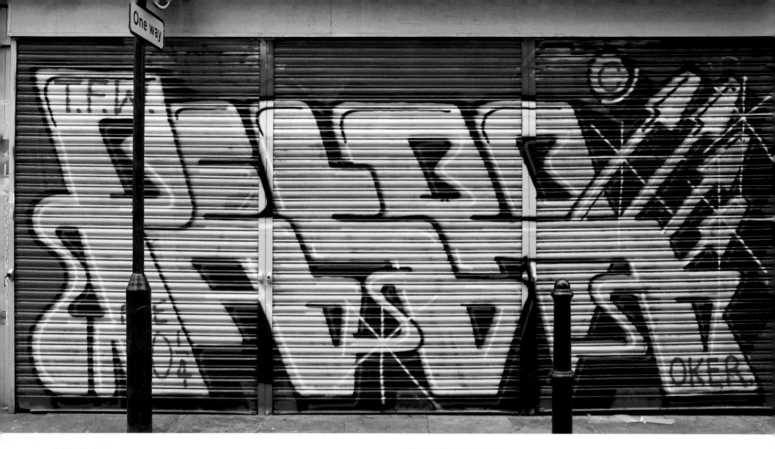

LONDON

BORN 1972 **MEDIUM** Spray paint, installation **STYLE** Bugged-out graffiti, naive aesthetic **THEMES** Typography, letterforms, playfulness, spontaneity **INFLUENCES** Ralph Lauren **CREWS** TFW (The Fresh Worms), WMD, PVC, DHR, FMK

1	2
	3
	4

1-2 London, UK, 2013
3-4 Newcastle, UK, 2012

PETRO

Petro is a London-based artist who has been attempting to "find solutions" to letters and typefaces since 1984. Obsessed by Ralph Lauren and outsider art, he is a restless globetrotter who belongs to an elite cadre of worldwide graffiti purists. He pioneered a loose, "bugged-out" style of graffiti writing in the late 1990s, a naive aesthetic that has since been frequently copied. Still not sufficiently satisfied with his achievements, however, Petro has constantly experimented and altered his work in a relentless pursuit of a new answer to the same problem. He has taken his letterforms into countless different terrains, twisting and contorting them, refusing to repeat and stagnate while the opportunity to improvise and innovate still exists. This compulsion to investigate form recently led Petro into the gallery space, although he continues to adopt a bombing mentality (rather than aesthetic) in this arena. Producing a show nearly every two months for the last three years, and undertaking each project on a tiny budget, yet refusing to simply replicate the last,

Petro's institutional work retains a thoroughly non-institutional approach. Both deeply avant-garde in his output, while remaining firmly rooted in the traditions and mores of the graffiti world, Petro takes his work "seriously *un*seriously," as he puts it, never forgetting the fact that what his work should be is fun, that it should be done with passion, sincerity, and laughter, or simply not done at all.

It took Petro fifteen years of writing graffiti to reach the point where he could revert back to his childhood and start spraying like he was eleven again. Once he had reached a point of perfection with his work, and with mastery of his tools, he made the conscious decision to take it back to its raw purity, to go "loose and weird" with his approach: "I had to go full circle to understand where it came from, to understand all my mistakes so I could see that at the beginning, when I didn't know what I was doing, when I was doing it for a laugh and it was just *fun*, that was the essence of me, and one of the best times I've ever had." Even though many of his peers simply could not understand the direction he was taking, Petro felt that the perfectly formed graffiti aesthetic that had become so prominent was not something he could commit to, not something that had the authenticity he was searching for. Their

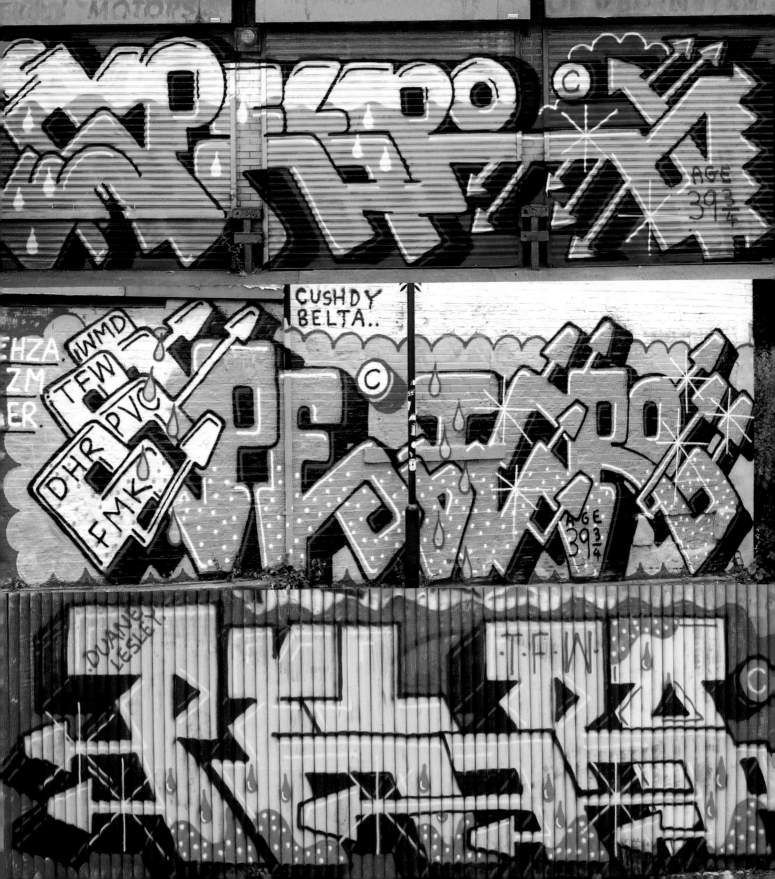

confusion gave him a strange sort of hope, he says: "I was the happiest when people said 'I used to like your old stuff,' then I knew I was going in the right direction." Petro's work soon found supporters among other artists with the same lowbrow, spontaneous attitude, however, who appreciated work that was chaotic, yet which contained something novel within it, and which showed humor and honesty alike. Instilling his typefaces with a strong sense of personality and animation, Petro actively wanted his work to demonstrate the "life of the paint" and be a "textural mess," deconstructed almost to the point of no return, rather than have the flatness of a sticker. Attempting to live through, not simply *relive* his youth within his graffiti, Petro was looking at the world through unaffected rather than nostalgic eyes; his playful approach to form and color was a way of keeping the youth within himself alive.

Just as his distinct graffiti aesthetic was born out of a desire for perennial youth, Petro has taken the same resolutely carefree approach to his gallery production. From building go-karts to crazy golf courses, from constructing thousands of paper planes to printing with the local street food delicacies (including fries, donuts, and a range of "international biscuits"), he recaptures the essence of his adolescence from a contemporary perspective, "dragging myself," the kid he will always be inside, by the "scruff of my neck through adulthood." While his artwork is refining and evolving at an amazing rate (his Ralph Lauren fixation in particular producing a huge array of fascinating projects), Petro refuses to take the simple route to success. He embraces the struggle one must endure to find the perfect solution, employing the indefatigable reasoning and rationality of a graffiti writer whose whole being is infused by the subculture: "Graffiti is my entire self, I'll always be a writer and I'll always have a writer's view on the world. From where you look, to how you perceive space, to where that space will take you. From all the lovely opportunities it gives you to go to different countries, to immediately have a completely new network of friends in those places and seeing their city through their eyes, seeing the real city."

Still considering himself an active practitioner of graffiti, who is proud to represent the eccentricities of the English scene in his many travels around the globe, Petro thrives on his contining desire to "empty spray cans" and his ongoing quest to find the formula, the resolution, and the remedy for his obsession. Both unwilling and unable to pursue any other approach, he puts his entire soul, time, money, and effort into his aesthetic: He creates a conceptually artless art that transcends mere technique, evolving from an unending process of experiment, entertainment, and excess.

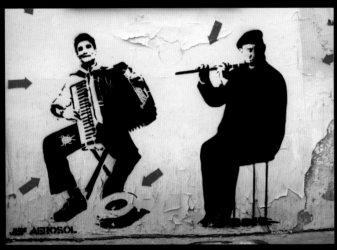

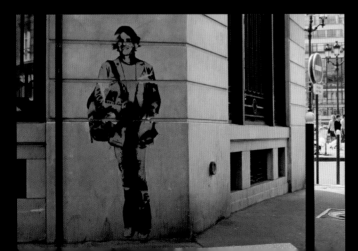

PARIS

The Parisian graffiti scene was born long before New York-style graffiti crossed the Atlantic Ocean from the United States. French novelist Victor Hugo gave an example in his book *Notre-Dame de Paris* (1831), when he describes the word "*fatalité*" written on the church wall. A century later, during the early 1930s, Brassaï took many photographs of the wall graffiti he saw all over Paris at night. In 1933 his images appeared in the Surrealist journal *Minotaure* alongside his article, "Du mur des cavernes au mur des usines" (From Cave Wall to Factory Wall). When after thirty years of documenting wall graffiti, Brassaï published a book titled *Graffiti* (1960), with an accompanying essay by Picasso, it was probably the first time these urban writings had been perceived as a form of art.

In the 1960s Gérard Zlotykamien painted his phantasmagorical "Ephémères" on the fences surrounding the Louvre and Les Halles, starting a recycled art ritual in central Paris. He was followed by a strong generation of stencil artists, who brought a ludic and colorful touch to the French capital, among them Blek le Rat (see image 3), whose intriguing black rats appeared all over the city. Miss.Tic (see image 1), Jef Aérosol (see image 2), Jérôme Mesnager (see image 6), and many others artists were part of the same vanguard of what would later be known as street art.

Hip-hop related graffiti arrived in Paris in the 1980s. Bando, Psyckoze, Nasty, and Boxer used to meet other old-school writers at the Stalingrad Metro graffiti yard. During this period, graffiti spread all over the city, reaching the status of an illegal practice. Some American writers, such as Jonone from the crew 156 All Starz, took up residence in Paris and influenced the emerging French graffiti style.

Today, Parisians are well accustomed to the growing diversity of urban art and actions in the city's territory. Graffiti-related works are produced by an assortment of techniques throughout the city. Paintings by Honet (see pp.166–9) and Monsieur le Chat cohabit happily with Space Invader mosaics (see image 4 and pp.172–3), C215 and Mosko stencils (see image 5), O'Clock and Trane throw-ups, or MPV and NBK's acid-etched tags.

A great way to get a sense of the Parisian graffiti atmosphere is to take lines two and six of the city's subway system. These lines pass above the city, showing the variety of rooftop interventions—Horfe, Conie, Rizot, Chiot—and under it, in the tunnels filled with black and chrome letters—Flask, Soack, Dexa, Hermes—that are illuminated by the light of the trains. As well as graffiti hot spots such as Rue Dénoyez, good places to see French writing are the walls of abandoned buildings— such as those painted by the Zoo Project—and the Petite Ceinture, a

deactivated train line encircling the city that has been appropriated by the creative citizens who jump the fence and enrich this autonomous space of free expression.

Although graffiti has captured the imagination of Parisians, many of the city's inhabitants, influenced by the media and local authorities, would still prefer to see it in an art gallery rather than in a subway tunnel. An example of the ambivalent attitude to urban art in France was shown when the high-speed train company, Thalys, commissioned Jonone, Opak, and other writers, who had painted numerous illegal trains in their time, to paint a brand new TGV train at Gare du Nord, where they were given the red carpet treatment. By stark contrast,

however, in the same period, the railway police BRF (Brigade des Réseaux Ferrés) had imprisoned Azyle and Vices for painting subway trains in Paris.

The double standards surrounding graffiti and street art can be seen all over the world. French street artist Zevs (see pp.182–5), who had already produced his dripping logos at the Art Statements Gallery in Hong Kong, decided to paint a dripping Chanel logo over an Armani boutique the day before it opened. After finishing, he was caught by the local authorities and found himself in jail. The answer to this ambivalence could be in the difference between the money he got for selling his gallery piece and the criminal fine he paid for his illicit action. It appears that graffiti's illegal aura exercises a fascination that has become commercially budgeted. **LS**

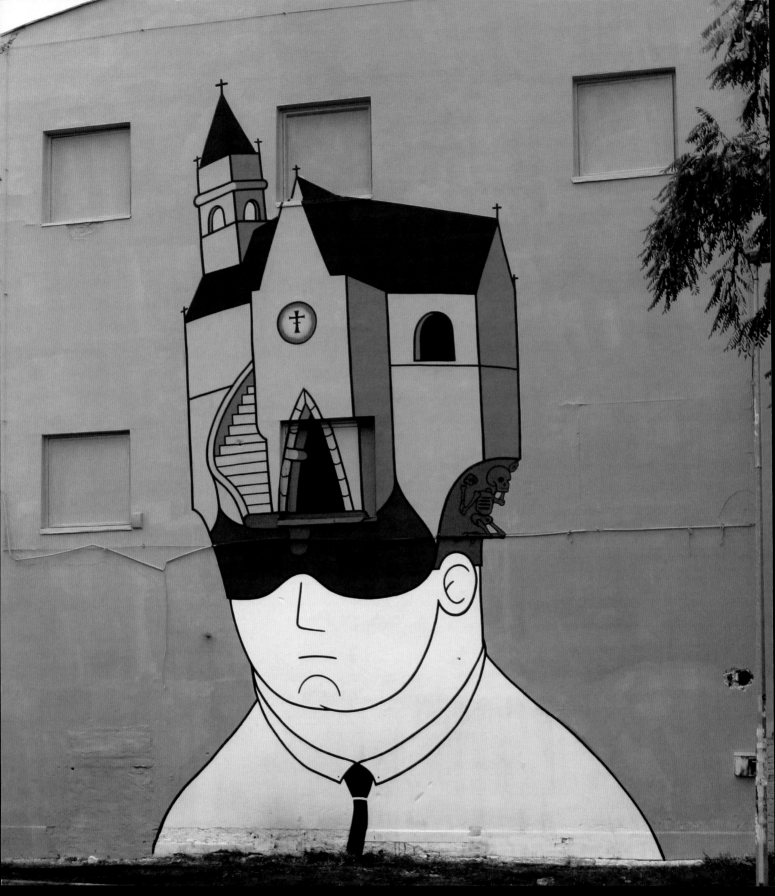

PARIS

BORN 1972 MEDIUM Spray paint STYLE Classic graffiti, figurative graffiti, train painting THEMES Exploration, trains, movement, masks INFLUENCES Punk, ska, skinhead CREWS SDK/WUFC, VAD, TMA, P2B, WMD

HONET

As a successful artist, illustrator, designer, and one of the world's finest style-writers, Honet has been at the forefront of the European graffiti experience since the early 1990s. Working with an apparently effortless ease, Honet has excelled in all aspects of his output, as well as straddling the fine line between commercial success and underground esteem. Like only a few other practitioners, Espo (see pp.18–19) and Os Gêmeos (see pp.120–3) being two prominent examples, he remains a graffiti artist in spirit and practice, while also exploring other mediums and methods. He embraces an idea of graffiti that does not abide by any rules and which continually reinvents itself.

Trains, movement, and exploration are at the heart of Honet's world. He began to paint graffiti in the street in 1988, before moving on to tracksides and rolling stock by 1990; his love of painting on metal had

1 *La Vrai Croix*, Prague, Czech Republic, 2012
2 Paris, France, 2005
3 Antwerps, Belgium, 2009

taken him from Paris around the rest of the world—from London and Moscow to Beijing and Tokyo—by 1993. In Paris itself, Honet painted alongside members of the P2B Crew, a crew of "graffiti outsiders" with members such as the leader RCF1, Stak (Olivier Kosta-Théfaine), Shun, Hoctez, and Popay. However, it was as part of the SDK collective and working with artists including Pum, Opak, INXS, and Gues, that he became part of the growing European InterRail movement and the cross-pollination of artists that this cheap, accessible travel network afforded. Honet explains how these opportunities for adventure and communication spurred the appetite to progress further afield: "The most important thing was just to find a location and then the way to go there. But year after year we needed to go further, to discover new places, new territories, and new dangers." The "map" of Honet's train career grew ever wider; in the early 2000s, however, he was forced to slow his production down when he narrowly escaped judicial punishment after a serious encounter with the gendarmerie. Although trains had been his real passion, he says he became tired of "only thinking about them 24/7."

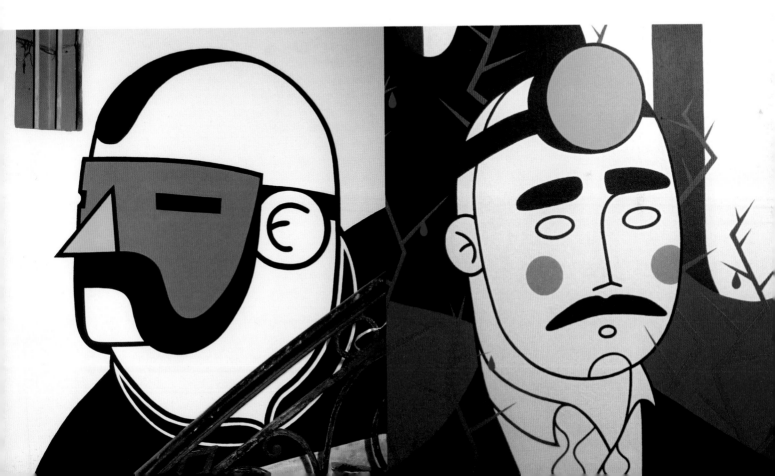

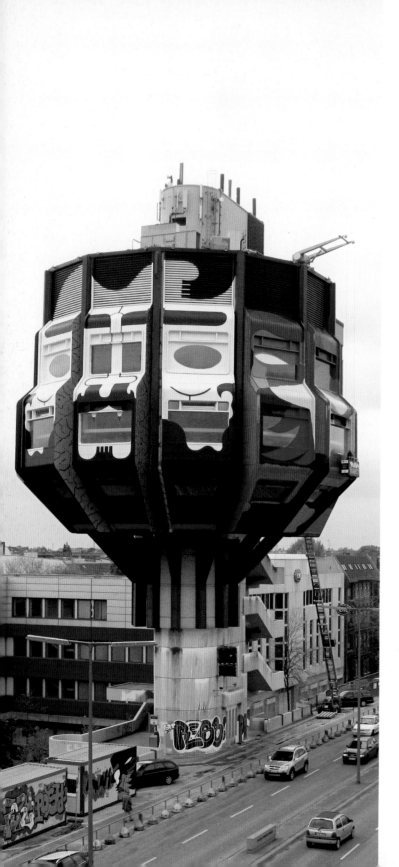

1 Turmkunst, Berlin, Germany, 2010
2-4 Paris, France, 2011 5, 7, 9 Paris, France, 2008
6 Paris, France, 2011 8 Paris, France, 2010

Re-channeling his train-painter energy into the streets, he became interested in investigating the more hidden parts of his own city. He continued to work with letters (albeit in an increasingly atypical style) while at the same time focusing more on his character work—an element that had always been key to his "classic" graffiti output—creating an assortment of instantly recognizable, highly stylized figures.

Honet's characters contain a densely layered symbolism inextricably connected to his personal life: They function as a way of explaining himself to the world and convey their messages through finely depicted minute details and hidden elements that are key to understanding the concept as a whole. His imagery frequently features a strong ska, skinhead, or punk aesthetic—a nod to the graffiti tradition he grew up with, which had punk rather than hip-hop culture at its roots (a subcultural fusion that played a big role in the European graffiti scene). These works use the skinhead to promote an idea of freedom and individuality—a rejection of all rules, even those of the graffiti world itself. Harking back to his youth when the Parisian graffiti scene was strongly separatist (the "greatest time for crews and gangs"), Honet's characters therefore embrace an era that was characterized by freedom as well as violence and insecurity.

Notably, his characters often take a masked form (commonly a domino mask, see image 2, p.167) that acts as a metaphor for the culture of graffiti itself: "If you go out painting, you have to wear a mask to conceal yourself." He goes on to explain: "Actually, if you go even further, our whole life is about masks. I am Cédric and I am Honet; two different persons in one living their lives as contrary as could be, and the symbolism of the masks perfectly matches the split personality I have." Honet is intrigued by the camouflaged, less visible parts of his surroundings—the Parisian catacombs, for example, of which he has a prodigious knowledge. Masks relate to his obsession with the parts of our cities that are hidden in plain sight. They allude to that which is concealed, but in fact presents truth; the mask, as Oscar Wilde pronounced, which can tell us more than a face.

Honet carries on pushing the boundaries of his production into ever wider artistic territory: He has designed collections for Prada and Lacoste, as well as produced gallery shows in Marseille, Tokyo, and Yverdon-les-Bains, and he has published his first monograph *I Want Discipline* (2012). He is keen to stress, however, that he never strays far from his true love: "I can't be creative if I go too far from my pure graffiti bases." He still paints letters voraciously, producing pieces with an irrepressible style, an extraordinary simplicity and grace. Honet refuses to get caught in the trap of "the white cube" and aims to pursue his existence as a "graffiti adventurer." He declares himself firmly bound to what he describes as the "strongest art movement in history" and "proud to be just a brick in the temple of graffiti."

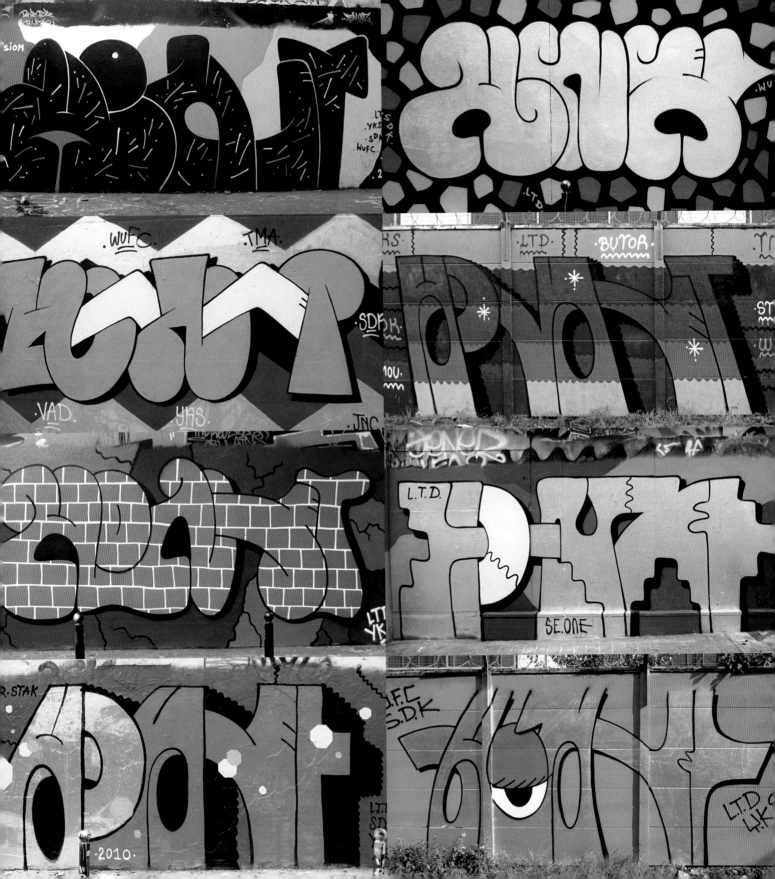

PARIS
BY
HONET

Honet's poetic, mythological map of Paris, entitled *Paris Verticale*, attempts to produce a vision of the city from a contemplative rather than a scientifically rational perspective. Rejecting the static nature of the two-dimensional maps that are so often seen, this map expresses the multifaceted nature of lived space through the potent image of the staircase. This highly symbolic object has often been used to depict the ascent (or descent) between heaven and hell; it has also featured as a vertical reconfiguration of a labyrinth. In Honet's design, however, he plots the journey (as seen by the place names on the side of the staircase) from the Abbesses metro station (one of the deepest in the city) to the Eiffel Tower; or as Honet puts it, "from the nadir to the pinnacle of the capital." Not all the places chosen are celebrated sites, however; instead they represent what Honet calls a "mysterious, esoteric, personal vision of Paris, from north to south, from east to west, including the monuments, parks, and other structures that are important to my life."

The three crests included in the image have particular significance: The Parisian coat of arms appears on the far left; within it Honet has included an image of the Ouroboros (the autocannibalistic serpent), a mythological symbol signifying eternal return. The emblem adjacent to this—a "lantern for the underworld, a cockerel on top of a church bell and two hammers for breaking the walls in between"—acts as a visual condensation of Honet's exploration of the city. The third crest at the far right-hand side is Honet's personal insignia, which is edged with his motto "Aventures Extraordinaires." Although every image on the map has an equally complex meaning attached to it—from the eye behind the keyhole and the so-called "hand of glory" to the Magician and the Hanged Man—the quotations that frame the work (together with its title at the top) provide us with a definitive understanding of the map. They perfectly describe the task Honet has undertaken in his attempt to produce a fantastical, folkloric, figurative map of Paris, a cartographic representation that is oriented through a perpendicular rather than a traditional top-down lens.

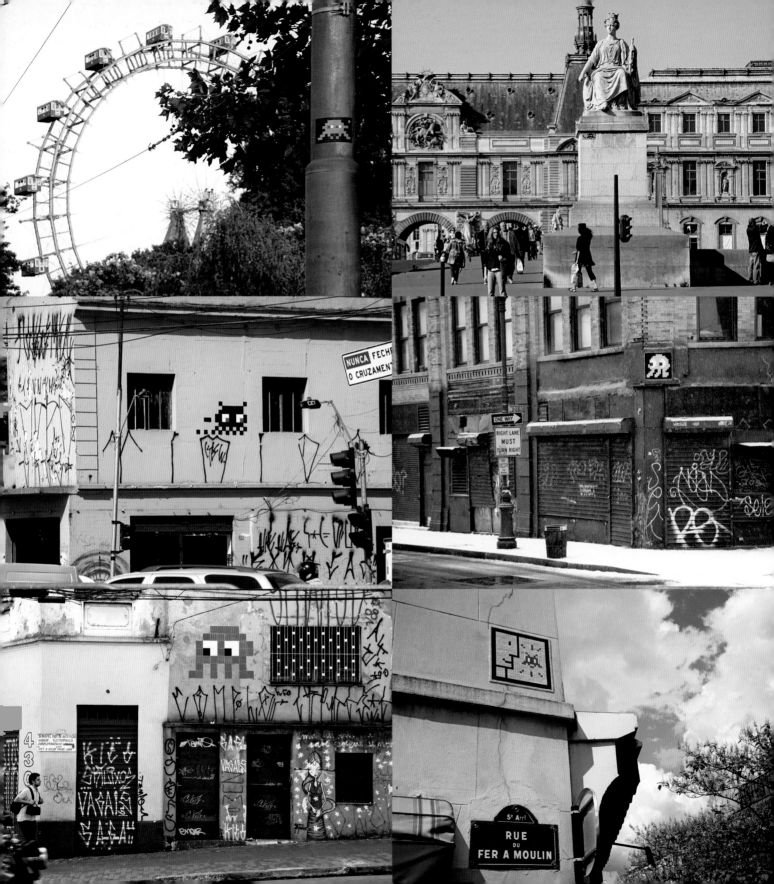

PARIS

BORN 1969, Paris, France MEDIUM Sculpture, mosaic
STYLE Urban installation THEMES *Space Invaders*, 8-bit style
video arcade games, 1980s

INVADER

An "accidental" street artist, Invader has produced his iconic mosaic images throughout more than forty cities and five of the world's continents. Inspired by the early video arcade game *Space Invaders*, he has cemented thousands of his tessellated figures during more than a decade's almost constant work. Since 1998, the *Space Invader* projects have not only blanketed the world's streets with his tiled designs; each mosaic in every city is also tallied into a complex system of scoring—individually graded in terms of its size, composition, and location (on a sliding scale between ten and fifty points). Invader has introduced this highly addictive game across the whole planet, depositing his famous emblems in places as diverse as Paris and Kathmandu, London and Bangkok, Los Angeles and Mombasa. Invader also documents his murals as "invasions" in books and maps indicating where to find each invader. In their entirety, the *Space Invader* projects form a monumental artwork that is audacious for the sheer breadth and scale of its accomplishment.

Unlike the majority of practicing street artists, Invader's first aesthetic interaction with the street came with his very first mosaic installation. He had started out producing art using more orthodox materials and it was only when he began to make canvases using mosaic tiles—exploited to convey the digital style aesthetic he was so captivated by—that he realized they were the perfect medium for creating the pixelated form he was so keen to replicate. The *Space Invader* design—taken from the classic game along with other images from "8-bit" style arcade games and chosen by Invader as a "symbol of our era and the birth of modern technology"—came to figuratively and literally define his practice. Although he has recently returned to gallery work with a project using Rubik's cubes to create pictures and sculptures, Invader continues to travel the world, cementing his invader designs "with the sole objective of getting a maximum score." Having ventured to the depths of the ocean and reached the heights of the stratosphere—he invaded an underwater reef in Mexico and took an invader 22 miles (35 km) above the Earth in a helium balloon in Miami, Florida—the world can only wait to see where he decides to go next. Wherever it is, his high score is becoming increasingly more difficult to beat.

PARIS
BORN 1963, Troyes, France MEDIUM Spray paint STYLE Billboard modification
THEMES Minimalism, site specificity INFLUENCES *Figuration Libre*, conceptual art
COLLECTIVE Les Frères Ripoulin

OX

OX, who is one of the longest serving Independent Public Artists profiled within this book, has been producing work on the street for nearly thirty years. As part of the seminal Parisian collective Les Frères Ripoulin (not to be confused with Les Frères Ripoulain, see pp.186–9—a pair of artists who took their name in homage to this earlier group), he can be regarded as one of the founding fathers of what is now commonly known as street art or post-graffiti. His practice forms not only a highly refined abstract aesthetic—one frequently imitated today—but an oeuvre that works through one of the central sites of production for urban art— the public billboard.

As a student of the decorative arts in Paris in the early 1980s, OX was heavily influenced by *Figuration Libre* ("free figuration" or "free style"), the French equivalent of Neo-Expressionism or "Bad" Painting, and a direct reaction to minimalism, conceptual art, and the highbrow art establishment in general. Regarding himself as part of what French painter Hervé Di Rosa has more recently termed "Art Modeste," OX worked mainly through graphic design and printing, and was strongly influenced by the graphic design collective Bazooka—art directors of the leftist newspaper *Liberation*. OX developed an impulsive, often crude style that distorted and perverted the prevalent pop culture he was surrounded by. He cofounded Les Frères Ripoulin in 1984; the name was chosen, in a double entendre, in reference to both the famous paint brand "Ripolin" that appeared in huge mural advertisements without regulation all over France, and to the word "ripou" (or "pourri" in verlan French slang), meaning "dirty" or "trashy" and alluding to their *Figuration Libre* style. The collective made their first bold moves into the public sphere in 1984, when they proceeded to transform billboards all over Paris. For OX, these spaces were the perfect canvas, like "huge paintings hung in the landscape," providing the group with an "extraordinary support" on which to display their work. Along with the other members of the Ripoulins, Nina Childress, Closky (now known as Claude Closky), Piro Kao (Pierre Huyghe), Jean Faucheur, Bla Bla Bla, Trois Carrés, and Manhu (all of whom were students of either the National School of Decorative Arts or the École Rue Madame), the group did not paint directly onto the billboards but instead pasted previously produced work on the billboards. Competing with the

1 Noisy-le-Sec, Paris, France, 2010

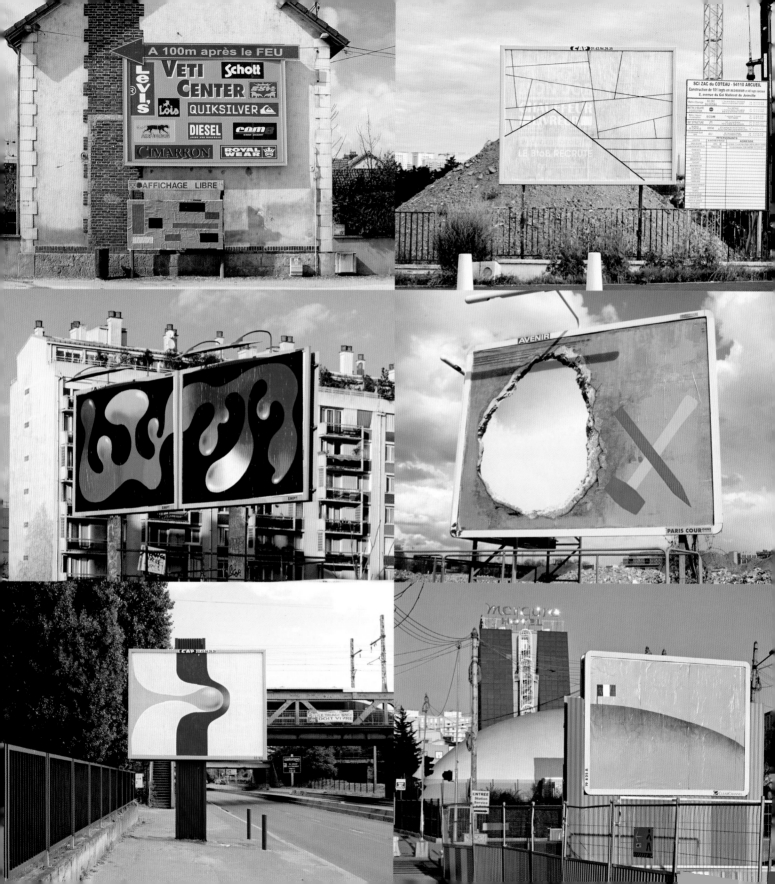

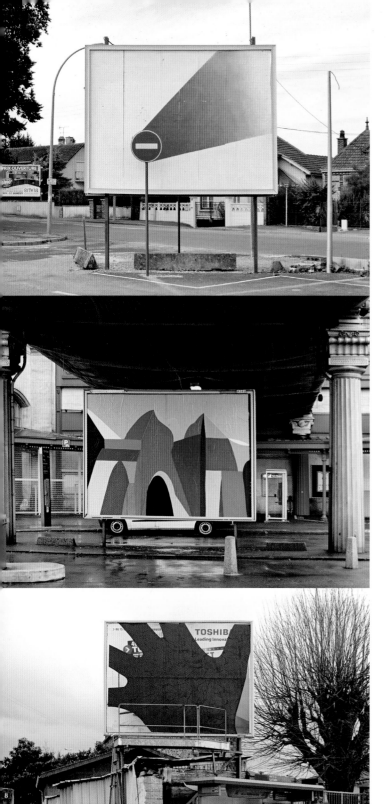

1 Troyes, France, 2006 2 Arcueil, Paris, France, 2012
3 Troyes, France, 2012 4 Paris, France, 2011 5 Paris, France, 2010
6 Paris, France, 2012 7 Villeneuve St. Georges, Paris, France, 2011
8 Paris, France, 2012 9 Noisy-le-Sec, Paris, France, 2012

advertisements through the use of what OX calls "visual impact," they therefore attempted to confront the sheer size of the billboards through a mixture of *Figuration Libre* and a distinctly punk aesthetic, utilizing "big black lines" and "big solids of flashy colors" in order to redirect and reclaim their authority. The collective achieved almost immediate success and caused a deep reverberation within the Paris establishment. Supported by the then emerging designer Agnès b, they were invited to New York by the now legendary gallerist Tony Shafrazi, where they painted with Keith Haring and met Andy Warhol. The collective pushed the boundaries of Independent Public Art during this period and infused it with a studied creativity that reflected an intense knowledge of both the art world and the street.

Although by 1990 Les Frères Ripoulins had disbanded, Huyghe and Closky in particular having gained success within the institutional art world, OX continued to paint. The initial euphoria of the early years gave way to a methodology that questioned the very act of painting itself, examining the format and context of the designs he was producing. Occasionally intervening in the street but for the most part concentrating on gallery work, in 2004 OX fully reinvigorated his street production and went on to paste more than 130 images in his hometown of Bagnolet. Although his early billboard works used the public sphere as a site of pure dissemination, as he describes it, a "means for bringing my work to the public eye and publicizing it in a quick and effective way," during the subsequent period OX's work became more self-consciously site-specific and the surrounding urban space determined many of the principles of his production. Through a decorative and ironic aesthetic that attempted to both destabilize and redirect the surrounding visuality, this approach created a "playful dialogue with the city" and a "discrepancy" to attract the viewer's attention. Parodying the shapes and colors his works are surrounded by, OX therefore twisted the commercial into the aesthetic, détourning rather than directly destroying their visual power: "Advertising is omnipresent in our lives, it feeds our consumer addiction, it exploits and recycles artistic creation and it finances it. It forms a part of my imagination, I draw on its imagery to create and I use its means to communicate. Of course, while I sometimes divert its meaning, I do not have the pretension of fighting it." Like the purity and logographic power of his moniker itself then, its equivalent symmetricality and reversibility, what is key to OX's work is that "no explanation is necessary prior to his apprehension." His images work concretely rather than figuratively, through an "aesthetic shock" in and of themselves: They simply strive to produce a tension with the environment, a moment of surprise, a playful rupture with their particular space.

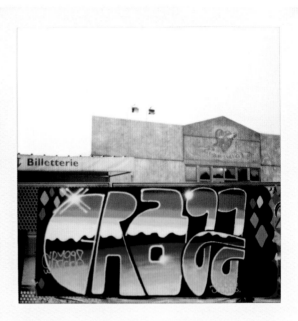

PARIS

BORN Paris, France MEDIUM Spray paint STYLE Naive graffiti, toy graffiti
THEMES Caricatures, animals, Polaroids, humor INFLUENCES *Art brut*
CREWS HDA (Hartos de Arte), MAD, CE Crew

TURBO

TVRBO • OBRUT • OBRVT • KRAGG

"The King of all Toys," Turbo was the Parisian style master and the undisputed champion of the so-called "naive" graffiti aesthetic. Focusing on simplicity rather than subtlety, on imagination over execution, and on flair above finesse, his work showed an irrepressible joy and a nonchalant cool that was impossible to feign. In the spirit of graffiti primitivism or graffiti *art brut*, Turbo embraced the unvarnished purity and flaws in an image and rejected the increasingly stylized, "perfect" productions that were becoming the norm.

His was a style in which technical skill could not disguise a lack of ingenuity or originality, which meant that each piece was justified through its creativity alone. This is not to suggest that Turbo lacked illustrative ability, however. His pieces demonstrated a clarity and vibrancy not often matched; they featured unforgettable characters (his duck-masked dinosaurs and bespectacled, hangdog hounds, for example),

arrangements (such as his vomiting "O" and his grapheme-clasping canine), and letters (twisted and molded into a seemingly infinite number of positions). His work always possessed an exuberant and vivacious quality that could bring a smile to your face.

Turbo started painting in 1986, but took an extended (and forced) hiatus between 1988 and 2004, after the period he described as the "big trouble." After studying at ESAG, a college of design and graphic art in Paris, and working as a graphic designer and illustrator for a number of organizations, his membership of the transnational collective Hartos de Arte (HDA) threw him headfirst back into the world of graffiti. Starting to produce an almost inconceivable amount of new works, hundreds of pieces all over the world on a yearly basis, he developed a style that combined his newfound skills in design with the self-assured, carefree attitude of the neophyte, which allowed him to innovate unselfconsciously, unconcerned about how his work would be received. Equally of interest was Turbo's fastidious documentation of these works and it became a practice for which he was synonymous. He took Polaroids of every piece he produced, again embracing the value of the raw, unrefined tool over its more processed counterpart and extolling the

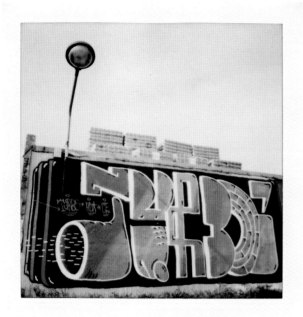

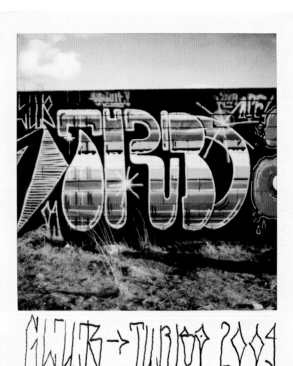

1 2 3 4

1 San Blas, Madrid, Spain, 2009
2 Cabaret Sauvage, Paris, France, 2008
3 Bonneuil, Paris, France, 2007
4 Military Base, El Campamento, Madrid, Spain, 2009

ON FOLLOWING PAGES Polaroids taken by Turbo in Paris, France, and Barcelona, Spain, between 2007 and 2009

idiosyncrasies of the snapshot and the instantaneousness of the directly processed image, over the clarity, yet strange dullness of the digital image. Like his body of work as a whole, it was the unique, unrepeatable act of the analog that was key: He was as indifferent to "perfection" as he was to Photoshop. It was the truth of the piece and the image that mattered—its individuality, its uniqueness, its singularity.

Tragically, Turbo passed away in 2012, but these pages pay homage to Turbo's passion, his élan vital, which lives on through the images illustrated. The following is a tribute from Turbo's collaborator and close friend 3615:

How to express the miserable feeling of loss and yet confront it with the tremendous feeling of luck at having been part of his life and, reciprocally, that he has been part of mine?

I can clearly remember Tvrbo arriving to paint on his old rusty, classy Vespa. One could hear the singular sputtering of the old engine first, then see the man, stylish as always, with his blond hair swaying out of his helmet, and his big bag containing all the best paint and tools for the piece of the day!

Apart from the fact that he appeared and left our lives at the speed of a shooting star, Tvrbo was a rather calm guy, an introvert. Talking in his soft and gentle voice, he would always wear simple, yet elegant, clothes and was so meticulous and clean that, even when rolling huge 15 meter wide by 5 meter high pieces, not a single drop of paint would land on his clothes!

Although considered a king for his extensive pictorial production, to my eyes nothing will ever be more important than Tvrbo's personality itself for this was where his style came from and not the contrary! To me, Tvrbo was a brother. We shared crazy and powerful moments that were punctuated by our own kind of complicity and particular blend of humor, creating our own peculiar language based upon a slang of verlan, Spanglish, and French. We would have a lot of fun over the absurdity of life and mocked seriousness at all cost. This humor can be seen in all Tvrbo's pieces, as well as in that of his mates from CE-MAD-HDA crews.

Last but not least, when remembering the man one must mention his use of Polaroids to capture his every single piece and sometimes ours. Nothing compares to the charm of having this little square of paper signed by Tvrbo! Except maybe living those golden times again!

 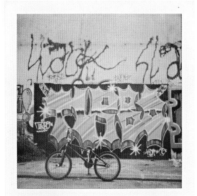 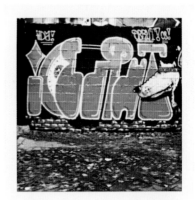

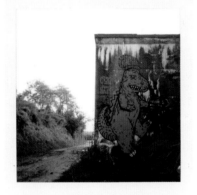 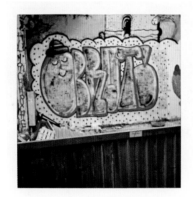 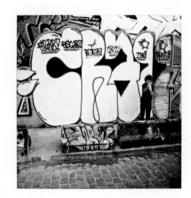

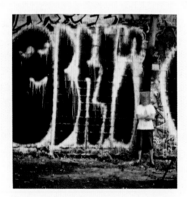 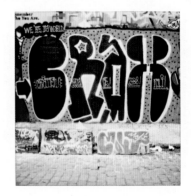

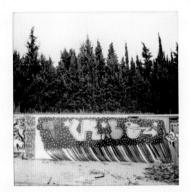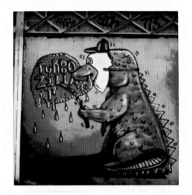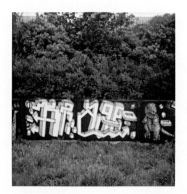

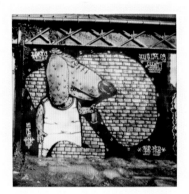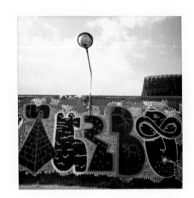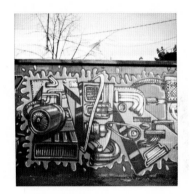

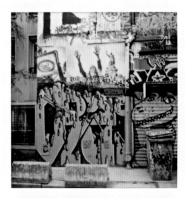

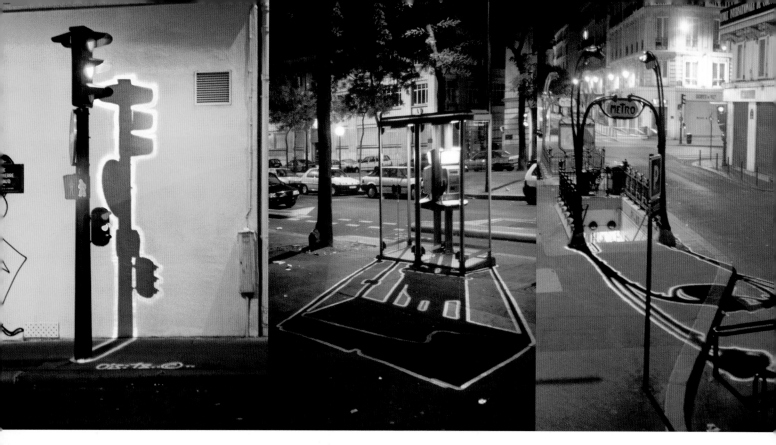

PARIS

BORN 1977, Paris, France **MEDIUM** Spray paint, installation, performance, reverse graffiti **STYLE** Conceptual graffiti **THEMES** Visibility/invisibility, conceptions of dirt, corporate suffusion of the urban environment, liquidation

1-2 *Electric Shadows*, Paris, France, 2000
3 *Electric Shadows*, Paris, France, 2001
4-5 *Proper Graffiti*, Wuppertal, Germany, 2006

ZEVS

A comic book superhero (or from an institutional perspective, perhaps supervillain), Zevs—pronounced Zeus, the "v" being a lower case Greek Upsilon—is one of the foremost pioneers of French street art. He is an artist whose ability to discover new ground and devise fresh ways of interacting with the urban environment seems to continually grow without abandon.

Zevs has many attributes of the superhero archetype: Extraordinary powers (most aesthetically conspicuous in the lightning bolts that emerge in his *Invisible Graffiti*); a strong moral code (which comes to the surface in his crusade against the violence of contemporary advertising); a readiness to risk his own well-being without expectation of reward (the artist's true commitment to the city over any superficial "prestige") as well as the secret identity of a masked vigilante (his distinctive costume—a bright yellow, waterproof workman's jacket and trousers, a leopard print scarf covering his face, and a fedora hat—paradoxically, and

in a chameleon-like fashion, rendering him extremely noticeable and invisible at the same time). Furthermore, his name itself, chosen in honor of the RER train that nearly crushed him while painting in a Parisian subway tunnel (ZEUS being the official service name of the train), points toward a backstory pivotal to any superhero's character: Not only presenting itself as a perfect tag, an ideal combination of letters and sound, his moniker also alludes to a moment of genesis in which Zevs was reborn as the Greek god of sky and thunder, an ideal connection to the world of graffiti in which abundant "kings" reign.

Zevs originally began to search for different ways of aesthetically encountering the city in the late 1990s and the numerous actions that he subsequently undertook fall into two main categories. First, were a group of projects that utilized a classic graffiti methodology but in a more subtle, contextually conscious manner; these projects played on notions of visibility and invisibility. The second group of projects encompassed a series of works that more tightly concentrated on attacking the corporate suffusion and permeation of our contemporary urban environment, and turning the far-reaching power of this visuality back on itself.

Within the first group, *Electric Shadows* (see images 1–3, p.182) was the starting point. For this project Zevs outlined, in brilliant white paint, the shadows cast at night by urban furniture illuminated by electric streetlamps. These simple outlines not only made them not only "more visible during the night," but kept "the trace of the shadows during the day" and created what Zevs termed a "crime scene"—an "art crime"—its chalked-lines similar to those seen drawn around murdered victims in the city of the cinema. They literally and metaphorically highlighted the ephemeral presence of luminescence and shade in the city, creating a surreal, caricature effect with the minimal possible effort. *Electric Shadows* played with the seen and unseen in a way that strangely presaged another of his projects, *Proper Graffiti*. In this instance, Zevs completely reversed the popular conception of graffiti as "dirt" or vandalism by producing work that sought to remove rather than add to its surface and which in fact cleaned rather than spoiled the wall it seemingly "marked." In his cloud graffiti (see image 4, p.183), therefore, a part of his *Proper Graffiti* series that utilized the cloud throw-up that Zevs

would often display (the four letters of his name forming the cloud with the lightning, the "Z" in the center, the "E" directly to its left, the Greek Upsilon "V" at the very top, and the "S" at the right—a perfect visual metonym), (dis)figure and ground are entirely reversed, the images being formed through a high-powered water jet—a technique that usually eliminates graffiti rather than produces it—and returning the wall's surface to its original state. Highlighting the grime on the wall itself, Zevs once more plays with our social perceptions, quite literally in fact with our perceptions of dirt (the famous "matter out of place" as described by the anthropologist Mary Douglas), adding through subtraction and shaping a vandalism through virtue. Like the final project of the first group, *Invisible Graffiti*, in which Zevs used a special fluorescent paint that would appear only at night when the streetlights were illuminated (due to a special UV filter he placed over the lamps) and would therefore never be cleaned by the graffiti removal crews who only work during the day, these various series played with light and shadow,

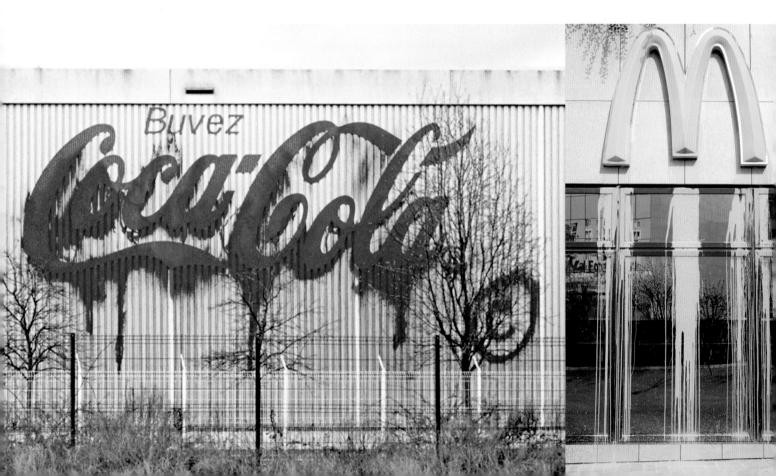

revelation and concealment, illumination and eclipse, utilizing classical graffiti techniques in radically innovative ways.

In his second group of projects, however, subtlety was revoked in favor of a highly overt, insurgent visual practice, a reaction to the violence of contemporary visual culture. The first series, *Visual Attacks* (see image 3), worked directly on the billboards prevalent within the city and attempted to "kill these corporate images" through dripping a torrent of red paint from either the eyes or the foreheads of the models appearing in the advertisements, red paint that appeared to leak like blood from the models themselves. Creating a highly striking visual effect through (once again) an amazingly simple technique, *Visual Attacks* entirely disrupted the message the advertising companies wanted to project and turned the power of these images to Zevs's advantage ("as in the Japanese martial art Aikido"), forming an image that the viewer would be unable to identify with and that served only to undermine the authority of the advertisers.

In one of his most famous actions in 2002, Zevs took the project one step further with *Visual Kidnapping,* when he cut and removed a 26-foot (8-m) high figure of a model from a Lavazza advertisement billboard in Berlin, leaving just a hole in its place. Zevs demanded a ransom of €500,000 from Lavazza and took his "captive" all around Europe, having kidnapped the model as the brand "kidnaps the attention of the public with the purpose of consumer demand." After numerous threats of execution—Zevs even mailed the victim's finger to the company's headquarters—Lavazza eventually paid the ransom demanded in the form of a gift to the Palais de Tokyo in Paris. As with his final project in this group, the infamous *Liquidated Logos* (see images 1 and 2), an eponymous project in which Zevs would appear to dissolve the trademarks of various famous global organizations, all these different interventions attempted to usurp the power of these dominant multinational brands by attacking their *symbolic* power, their Achilles heel, which is the very vulnerability of their brand "identity." Eroding these signs in a deadly yet beautiful attack in which they dissolve in front of our eyes, Zevs turns the solidity of the brands into a viscous liquid, their power literally leaking from within them.

Recently removing his mask and revealing his inner Clark Kent, Zevs announced his true identity as Aguirre Schwarz in 2011. He continues to follow the moral code of his superhero alter-ego, however, driven by a base desire both to protect the public from the power of global corporations and to disrupt the customary public perception of graffiti. Reclaiming our surroundings and disturbing the established status of graffiti as dirt, he plays with the ability of visual culture to reveal as well as conceal, producing bolts from the blue that radically upturn our urban environment.

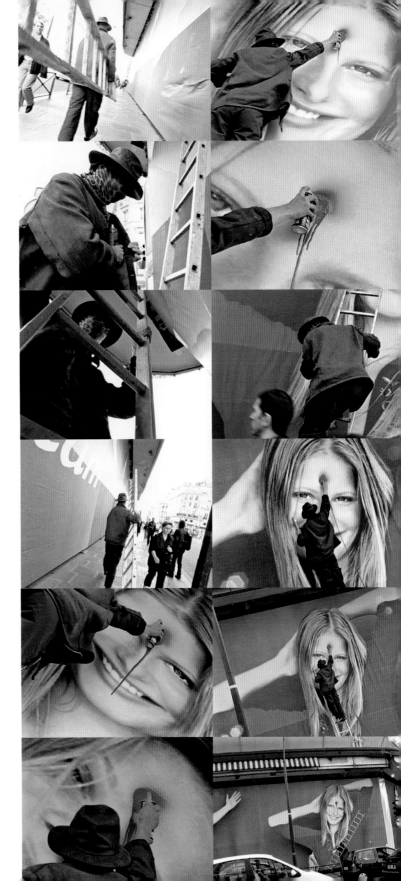

RENNES

BORN Unknown **MEDIUM** Spray paint, sculpture, body
STYLE Urban installation, urban modification **THEMES** Vandalism,
public space **INFLUENCES** Les Frères Ripoulin, vernacular art

LES FRÈRES RIPOULAIN

DAVID RENAULT & MATHIEU TREMBLIN

Although individual artists in their own right, David Renault and
Mathieu Tremblin also work together as Les Frères Ripoulain. Their
partnership seeks to address issues that they describe as "vandalism
and anonymity, space and solitude, silence and invisibility, strangeness
and secrecy." Their installations and performances attempt to heighten
the sense of urbanity through graffiti as a means rather than a particular
end. While some of their work is about vandalism, therefore, most of
it is about practicing and experimenting in the city and about not
being art. Adopting and modifying the celebrated maxim of the
French Fluxus artist Robert Filliou—"art is what makes life more
interesting than art"—they argue that "graffiti is what makes the

1 *Notre Patrie est un Marge*, Rennes, France, 2008
2-3 *Tag Clouds*, Colombier Optique, Rennes, France, 2010

city more interesting than graffiti." For them, graffiti is a "filter for life
and the city"—a way of being that lies "beyond the map."

The pair met in 1998 while studying at the University of Fine Arts
in Rennes. Their first joint experiments emerged from a classical graffiti
dynamic—the tag. What interested them at this point, however, was
not the tag's status as ornament or decoration, but its relationship with
territory—its role in the acquisition and stealing of space. (Tags can be
seen as the diametric opposite of commercial advertising whereby people
buy space to publicize the product they want to sell.) It was not until
2006, however, that they finally abandoned spray paint and started
collaborating on distinct projects. These included working on the walls
of Rennes during the day in the guise of "house painters"; dressed in
workmen's overalls they used roller paint to write slogans and create
messages based on their actual location. Renault and Tremblin's close
way of working and their donning of overalls lent their role legitimacy
and an air of authority. At the same time, it also recalled the original
advertising prints created for Ripolin paint, which featured characters
wearing overalls painting slogans on thousands of walls around France
during the early part of the twentieth century.

In a nod both to the Ripolin brand and the illicit, proto-graffiti that this corporation undertook, as well as to Les Frères Ripoulin, the infamous French urban art collective from the 1980s (see pp.174–7 for a profile on founding member OX), Renault and Tremblin formed their own collective name as a postmodern pun. By adding the letter "a" to the word "Ripoulin" (*poulain* in English means a foal), they signified their work as the child of both historic trends. As Les Frères Ripoulain, the duo created murals in a distinctly vintage style, a form of lyrical, non-commercial publicity that upended the original Ripolin ideal (yet at the same time adhering to their practice and technique), while also attempting to follow the tactics of Ripoulin by hijacking the "cultural aura" of these artistic iconoclasts as OX *et al.* did before them with the paint brand. This strategy made a link between "vandal/political murals and poetic/decorative ones" but it also reinstated the autonomy of French graffiti by embracing its rich heritage and disassociating them from the American graffiti so prevalent on the homegrown French scene. Looking back to Brassaï's photographs of graffiti from the 1950s and the fact that the key tools of graffiti—spray paint, stencils, posters—were a vital part of radical French political culture from the 1960s (with the Situationists a key example), Renault and

Tremblin claimed a distinctly Francophone ground for graffiti, one that fully embodies the complex political and aesthetic history from which it has emerged.

The typographical project of Ripoulainization they first undertook utilized a highly expressive and innuendo-laden form of language, with pieces such as *Notre Patrie est un Marge* (see image 1, p.186), *Lieu Noir* ("black place" as well as a reference to saithe), *Sauvons les Pots Rouges* ("Save the red pots"), and *Fer Ailleurs* ("Iron elsewhere," a complex pun dedicated to the freight trains and shipping companies that also sounds like *Faire Ailleurs* or "Doing elsewhere"). Their later work, however, aimed to more clearly bring ideas from the art and graffiti worlds together and formulate projects that considered both aesthetics and urbanity—the artifact and the environment—in a more reflexive manner. Similar to the philosophy underpinning the work of Jeroen Jongeleen/Influenza (see pp.190–3), Renault and Tremblin aimed to disturb the traditionalist foundations of the individual disciplines—as much as the "conservative tradition in both fields that opposed their amalgamation"—and find the points of tension and the intersections between the two.

In *Chemin du Désir* (Path of Desire, see images 1 and 2), a performance piece completed in Rennes in 2009, Renault and Tremblin set out to actively create a new pathway in the city, an urban crop circle or social trail (supposed to be visible all the way from space) that would encourage other users to participate with and re-perform their performance. Eroding the ground through repeatedly walking the path, *Path of Desire* represents both the shortest or most navigable route between two sites as well as an entirely organic, non-mediated movement that is at odds with the planning of the city and contrary to its technical, top-down construction. Much commented on by French philosopher and poet Gaston Bachelard, these pathways display an ethereal, almost magical rationale, functioning as the wrinkles or laughter lines of the city. Like an urban version of Richard Long's classic *A Line Made by Walking* (a link that can also be seen in Filippo Minelli's *Line*), *Path of Desire* has come to highlight what Michel de Certeau has termed "everyday creativity"—not the (supposedly) innovative creativity of so-called artists but the improvised creativity that these routes index, the hidden, quotidian poetry that the city and its inhabitants exhibit.

While this project emphasized the power of popular urban practices, *Human Hall of Fame* (2010; see image 4), took a different approach and focused on the materiality of graffiti as opposed to its illegality, its status as writing rather than vandalism. Acting as "sandwich board men," Renault and Tremblin became walking advertising hoardings with the advertisements replaced by blankness, what they termed "tag magnets" (such as the white delivery trucks often used as a surface for graffiti in France), which would later be utilized by their attracted prey. The walking performance the brothers undertook not only resulted in an entirely legal manifestation of graffiti, however; it also furtively critiqued the nature of its illegality, a form of writing ascribed as vandalism solely due to its non-remunerable status.

Although the two projects may seem to be different—*Path of Desire* focuses on the city while *Human Wall of Fame* comments specifically on the world of graffiti—both can in fact be seen as linked in two crucial ways that define the practice of Les Frères as a whole. First, they can be seen as united through their embracement of the art that is not art but popular forms of creativity; second, they are unified through the constant search for visibility or presence through an obsession, like the graffiti artist themselves, with the "tracks and routes of their contemporaries." The brothers therefore aim to immerse their work within the everyday and provide familiarity for the viewer while also providing a space that questions and generates meaning. Their work can be understood as uncovering the city's diversity and margins, and shining light on the spontaneous, enigmatic, and autonomous art within the city.

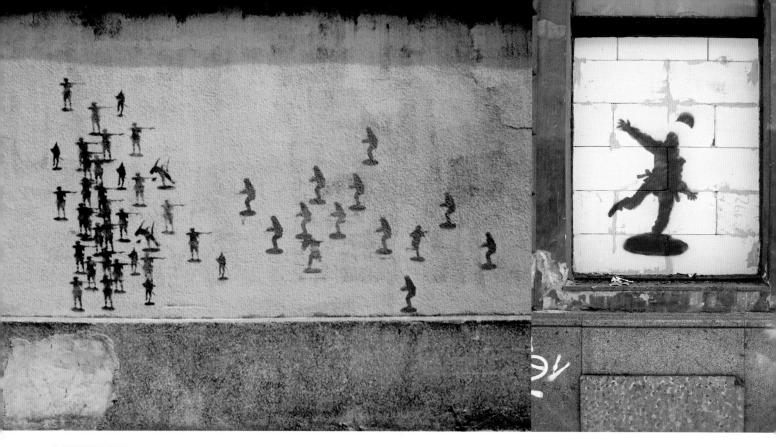

ROTTERDAM

BORN 1967, Apeldoorn, Netherlands **MEDIUM** Stickers, stencils, plastic bags, spray paint
STYLE Urban intervention, conceptual graffiti **THEMES** Urban colonization, rules
and regulations, free speech **INFLUENCES** Fluxus, Dada, Arte Povera

INFLUENZA

JEROEN JONGELEEN

The work of Dutch artist Jeroen Jongeleen, otherwise known as Influenza, is characterized by a distinct stance of dissensus: one that opposes both the superficiality of urban design and the increasing colonization of the street. In a practice that engages with images and public space in a militantly active way, he employs numerous methods and materials—including stickers, plastic bags, spray paints, and even the human body itself—in an effort to enliven the banality and sterility of the modern city. Championing a more liberated public sphere and critiquing the over-regulation of both the city and art, Jongeleen's understated but always ingenious urban interventions are heavily influenced by art movements such as Fluxus (a multidisciplinary group of avant-garde artists in the 1960s), who he sees as the true descendants of the Dada spirit. He describes his motivation to create art as not about "decoration or making people happy, but about free speech and movement, about opposition as

the essence of a truly democratic society." His politically motivated work therefore sets out to illustrate the power and the dynamics of the street, while offering a utopian vision for the future.

Jongeleen grew up in Suriname in South America, but on his return to the Netherlands in the 1980s the starkly different urban environment made a powerful impression on the eleven year old. The traces of both Fluxus and the punk era were still visible on the streets of his hometown, Apeldoorn, and he found himself fascinated by the stencils and huge painted slogans on its streets. Inspired by this, in about 1984 Jongeleen produced his first street markings—characters and variations on trademark signs. He was quickly hooked by what he terms the "American spray can virus," a habit that he had practically abandoned by the time he enrolled at art school in the early 1990s. He went to study graphic design at ArtEZ Art and Design Enschede (formerly the AKI Academy for Art and Design) but once there he became inspired by contemporary art generally. It was not until after he had graduated in 1994 that Jongeleen rediscovered the streets. After moving to Rotterdam in 1997, he carried out one of his first public interventions. Although few people were switching aesthetic discourses at this time—"graffiti writers [were] doing graffiti

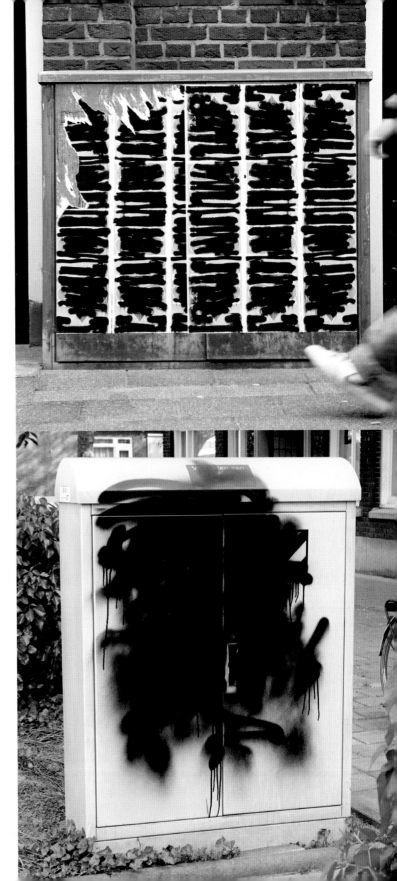

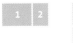

1 *The Art of Urban Warfare*, Paris, France, 2003
2 *The Art of Urban Warfare*, Prague, Czech Republic, 2003
3 *Information Blackout*, Dordrecht, Netherlands, 2005
4 *Elementals*, Rotterdam, Netherlands, 2010

things, vandals doing vandal things, artists doing their art things"—he was determined to shake up the paradoxically traditional nature of both contemporary art and graffiti. He hoped to communicate the exciting ideas and motivations emerging out of graffiti, while also producing graffiti that was informed by the classic techniques of art. Jongeleen wanted to demonstrate that both disciplines could learn from one other and find mutual crossover points between the different worlds. For him urban intervention art is simply another way of using and understanding the image. Graffiti was only one of the crucial starting points for urban art, together with skate culture, land art, Fluxus, punk, Dadaism, deconstructivism, conceptual art, and Arte Povera. For Jongeleen, these artistic movements are all part of the same family.

Although initially Jongeleen only used the name "Influenza" for his gallery or museum work, it soon became the overarching label for most of his public projects through which he made a stand against the increasing commercialization of the public sphere. For *The Art of Urban Warfare* (AOUW, 2002–present, see images 1 and 2) he devised a game to be played in streets around the world. Jongeleen outlined the rules of the game on a project website together with instructions on how players could create their own pieces using a standard set of tools. This featured stenciled figures of soldiers taken from sources ranging from press images of Abu Ghraib to paintings by Goya. These could be sprayed onto city walls in three different colors—green, blue, or brown—representing three competing "armies," which must attempt to take over by literally occupying the streets of the "war zone." While supporting the right of activist artists to make use of urban public space, the project also served as an overt reaction to the wars in Afghanistan and Iraq and an attempt to heighten social awareness. Inspired by ludo-centric (play-centered) artistic interventions and the real life social networking of graffiti and other street art movements, AOUW represented a playful incursion into the grayness of the city while visually demonstrating the existence of a network of hidden international activists. Played in cities all over the world, AOUW reclaimed the space of the street but also brought issues of public importance into the common locality of the street. Jongeleen was eventually arrested in Germany during his preparation for an exhibition documenting the project; this resulted in the removal of the project website and anti-terrorist investigations of the artist by Europol and the FBI.

In a completely different way, a more recent project, *Information Blackout* (2009; see image 3), set out to reduce the amount of knowledge or data found on city streets. Using black spray paint he expunged the textual information on the ubiquitous fly posters that inhabit our city landscapes. Rather than détourning these works in the manner of Ron English (see pp.38–9) or GPO (see pp.350–1), however, Jongeleen

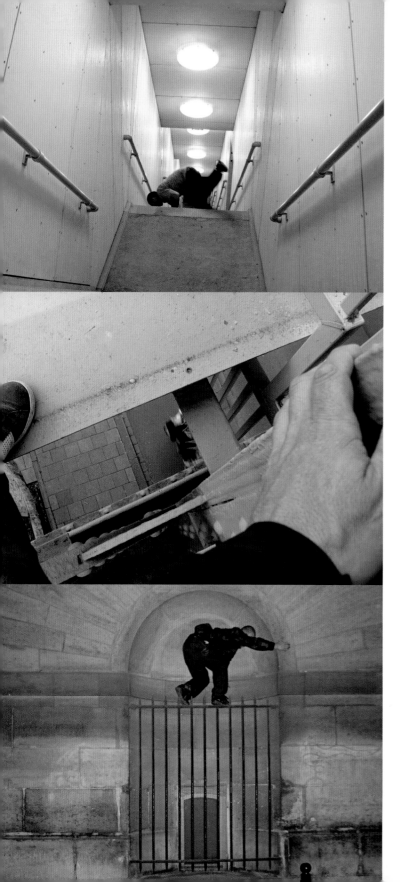

1 Eindhoven, Netherlands, 2005 2 Amsterdam, Netherlands, 2006 3 Paris, France, 2004 4 Rotterdam, Netherlands, 2010 5, 8 Rotterdam, Netherlands, 2009 6 Poznan, Poland, 2004 7 Rotterdam, Netherlands, 2007

simply deleted the information as if the posters were classified documents, carefully obliterating the texts line by line or word by word. This produced a result similar to that seen in his project *Elementals* (see image 4, p.191), in which he created black "smear spots" and "black holes" of information all over the city. *Information Blackout* set out to neuter the violence of such posters; it attempted to harness the primitive power of black and white as opposed to full color—the "tool of the professionals." Moreover, it sought to allow space for the mind "to wander"—a space of tranquillity away from the deluge of information we are so often assaulted by.

Always searching for different ways to interact with the urban landscape, Jongeleen's *Plastic Bag as a Jolly Roger* (see images 5–8) reshaped the city as a "vertical playground": he took found plastic shopping bags and re-created them as proud, colored garlands—flags celebrating what was the ostensible trash of the city. Having repainted the bags with his insignia, Jongeleen then climbed parts of the city, selecting architectural sites he perceived as in need of an uplift and raised his flag upon them. Combining the traditions of abstraction, performance, and vandalism, the project not only brought into play questions of intention and meaning (prompting viewers to ask why and how it was done), but it also attempted to engender a new perspective on the city. It urged people to notice the details they would generally have missed and to pay heed to "the impositions of architecture."

The *Jolly Roger* project had strong connections with Jongeleen's *The Climbing of Buildings, Fences, and Other Opportunities* (see images 1–3): Both works highlighted, as he put it, the "traces of usage and the signs that speak on our behalf." Regarding the world of urban exploring as an art in itself (as has the French artist Honet, see pp.166–9), Jongeleen therefore went on to enter places that should not be entered and climb objects that should not be climbed, in the process leaving the trace of his body and his incursion within these restricted zones. Documenting these performances that he described as "buildering," he stressed the potential hidden within the very restrictions and rules of our cities.

Ultimately, what connects all these diverse projects, however, along with the myriad others Jongeleen has undertaken, is his stringently "anti-design" attitude. He has a deep distrust of the "creative" sphere, which he sees as lacking substance and an engaged relationship with the world. For him, art must steer clear of the "parasitic behavior" of the corporate realm. In all his institutional and non-institutional work therefore, Jongeleen strives to promote a form of active citizenship, urging people to decorate their cities and reinstate themselves within the body politic. He aims to reinitiate a kind of improvisational creativity, to kickstart a powerful, political reintegration to our lived and our built environment.

AMSTERDAM

BORN 1971, Leiden, Netherlands MEDIUM Sculpture, spray paint STYLE 3-D graffiti, 3-D sculpture, geometric muralism THEMES Horizontal/vertical planes, primary colors, assymetry INFLUENCES De Stijl, Gerrit Rietveld CREW Inc

1 Perugia, Italy, 2011
2 Tunis, Tunisia, 2010

ZEDZ

An artist who worked at the forefront of the original 3-D graffiti movement, Zedz is widely considered one of the pioneers of Independent Public Art in Europe. Alongside his affiliate and common collaborator Delta (these days known more widely as Boris Tellegen), he was a founding member of the legendary INC crew; both artists are famous for a highly complex style of production, one that has a distinctively Dutch quality to it.

Their earlier work employed cubic forms and incorporated shadows or bold outlines—a technique that had been utilized by many street artists before them—but also featuring a more radical innovation. Zedz and Delta twisted and shifted their letter forms until they broke, or folded in on themselves, and in doing so the two artists succeeded in creating a futuristic, almost utopian aesthetic—typography set within a distinct topological space.

The inherent three-dimensional nature of Zedz's work could not remain restricted to the physical border of a wall for long, however, and soon he began to work with virtual and architectural space. Along with Delta, he began a collaboration with architect Marc Maurer (MUA: Maurer United Architects) and formed the design team DELTA-MAURER-ZEDZ. The three set about transforming their images into functional architectural designs—albeit virtual ones. From graffiti images they had evolved graffiti architecture; rather than simply tagging a building, the building itself became a tag. Neither architecture nor graffiti dominated in this groundbreaking hybrid form—both were equal partners.

In the wake of this new direction, Zedz moved on to produce numerous physical models of his work, constructing three-dimensional, complex public sculptures (all of which featured his name concealed within them) all over the globe. These large, interactive installations reflected the emerging influence of the Dutch art movement De Stijl ("The Style") in Zedz's work, characterized by an emphasis on horizontal and vertical planes—as opposed to curvilinear shapes—a reliance on

primary colors, and asymmetry. Zedz openly acknowledges his debt to Piet Mondrian in these pieces, but it is the sculptural works of the celebrated designer and architect Gerrit Rietveld, and the highly underrated artist Georges Vantongerloo, that are more pertinent here. Rietveld's exploration of space—apparent in the "Rietveld joint" (comprising three overlapping battens) that was used for his famed Red and Blue Chair—and Vantongerloo's exploration of volume—as demonstrated in the sculptures "Composition from the Ovoid" (1918) and *Rapports de volumes* ("Interrelation of Volumes," 1919)—are clear influences on Zedz's sculptures. His works operate within the tradition of De Stijl's distinctive neoplastic style, reflecting a search for the perfect relationship between positive and negative space, for balance through opposition.

While much of Zedz's earlier sculptural and architectural work was broadly based on typography (even if it remained camouflaged within the designs), in his more recent pieces the artist has taken another new path. While he refers to letters as both the "backbone and the load" of his work, Zedz has become more interested in expressing himself in a non-verbal way rather than engaging with the viewer in "direct conversation" and

communicating via a more personal palette of color and design, as opposed to conventional letters. "If you see a certain assembly of blocks, lines, and squares, a certain usage of color, I want you to recognize it's Zedz," he explained in 2010. "So suddenly the typography layer disappears and goes to the background, and what comes to the foreground is a visual language, one that can replace a sound." This playful, conceptual technique emphasizes rhythm and balance over fixed form, attempting to comprehensively eclipse our traditional writing system. For Zedz, "Letters are just symbols. Making you pronounce something. And I want to go over that, to get to a level where my text becomes more like music, music to the eye."

Over the years, Zedz has continued to refine and reshape his aesthetic, while always remaining true to his graffiti origins. Rather than working with a particular end result in mind, however, he regards the process of creation as an end in itself—which is doubtless the reason why he has never stagnated or remained still. It is about the purity of the journey for Zedz, the "starting points" and the "vanishing points"—the goal is to simply keep on researching and experimenting with the image.

EINDHOVEN

BORN 1976, Eindhoven, Netherlands **MEDIUM** Spray paint, posters, stickers
STYLE Conceptual graffiti **THEMES** Bicycles, target symbol, spontaneity
INFLUENCES Classical graffiti, cycling culture

EROSIE
JEROEN EROSIE

Erosie has traveled the entire spectrum of the visual arts—from his life as a graffiti writer to his role as a professional illustrator, from graphic designer to street artist, and from art director to muralist. Now a prolific contemporary artist, he has both assimilated and adapted his varied experiences within his practice. Hovering at the edges of fine art, commercial advertising, and the dense codes of graffiti, Erosie explores the parallels and nuances of these very different visual languages as he strives to define his own. He describes himself as a "tourist in the culture of the image"—albeit one with a heightened, insider's awareness of the culture industry's machinations—and tries to work against and deviate from currently prescribed discourses and values. Approaching the visual not simply as a professional but as an ordinary citizen, Erosie dissects and then reassembles images to examine their power in contemporary society.

Born in 1976 in Eindhoven, the Netherlands, Erosie was writing graffiti by the age of ten or eleven. Confronted with the images in his local neighborhood, he found himself totally engaged with the medium: "It was outside, it had an edge to it with all these angry characters, colorful shapes, and letters. And the combination of this along with its illegality was really powerful." He initially began drawing mainly on paper and his first walls were produced during the Dutch "golden age" of graffiti in 1993. As a member of the infamous SOL Crew, he continued to paint in a classical style until about 1998. His transition to other techniques—what he likens to the whole "candy store" of spray paints, rollers, stickers, and wheat paste—came about gradually, however, starting with his first iconic logo, the spray-painted target symbol. This introduced Erosie to a whole new realm of possibilities and practices that veered him away from what he perceived to be the conservative, fanatical, authoritarian element of graffiti practice he had become part of. Erosie never let go of the energy and joy of writing graffiti, however; he simply brought together his different inspirations in one practice. He considers himself to be a visual (rather than a graffiti or street) artist—one intent on reinvigorating and amalgamating established codes into a new, unique discourse.

1 2 3
4 5 6

1 *Eroded City Cycles*, Berlin, Germany, 2003 2 *Eroded City Cycles*, Berlin, Germany, 2006
3 *Eroded City Cycles*, Eindhoven, Netherlands, 2004 4-6 *Target Marketing*, Eindhoven,
Netherlands, 2010

Eroded City Cycles, (see images 1–3) a project undertaken from 2002 to 2006, is a prime example of this propensity for fruitful fusion in Erosie's work: a combination, in this instance, of his passions for cycling, graffiti, and illustration. It was a project that helped navigate him during his transitional, post-art school phase—a period during which he neither wanted to do graffiti simply for the sake of meeting the expected standards of his contemporaries nor undertake illustration work for clients to deadlines. The project allowed him a space where he could be free from any constraints and it rekindled his love of both drawing and graffiti. The "ghostbikes" he created acted both as minimal, stripped-down illustrations—drawn with just one line—and as freestyle forms of tags. As Erosie himself has commented: "It was a very pure way of doing a tag, very fast, illegal and in one stroke."

For Erosie, *Eroded City Cycles* connected the freedom of cycling with the freedom of art. The project employed a plethora of different visual techniques: it functioned through stickers, which when placed on abandoned bikes around the city acted as temporary urban sculptures; through more complex bicycle murals; and through a series of fantastical designs of imaginary bikes, some of which were eventually constructed as physical (although unrideable) bicycles by the artist Butch.

Rather than working through a condensed image, however, subsequent projects *Target Marketing* (see images 4–6) and *Wordplae* functioned through purely textual techniques using texts that were both highly conceptual and figurative. *Target Marketing* references the marketing techniques used in commercial advertising campaigns. Using the street as his medium, Erosie attempted to blur the difference between the institutional and independent use of the public domain. He highlighted the techniques of the commercial world through the simultaneously banal yet enigmatic nature of his posters. With messages such as "By the time you read this you have reached the end of the sentence," "Looks like a picture of an image of what you see," and "This is not for you but for the next person that reads it," the purposefully under-designed images reduce form and function to a minimum. They prompt the viewer to question why the poster was there in the first place.

1 *Big Fat Letters*, Le Mur, Paris, France, 2008
2 *Horror Vacui#09*, Poznan, Poland, 2011

These texts play with a particular visual rhetoric: a highly performative textual interplay takes place between the viewer and artist—a comedic, self-referential communication in which the viewer must interpret the meaning of the message beyond its mere textual statement. Erosie's use of the poster to display his messages also questions its usual purpose and function, as either advertising or instructional information. The messages and statements he places on his posters transform the viewer from a consumer into an individual, from a targeted audience into a participant in a dialogue.

In *Wordplae*, however, Erosie aimed to produce an act of speech that could be validated through its own performance. With images consisting of statements such as "Five words screaming for attention," "I hereby apologize for the damage done," and "Big fat letters saying Erosie," (see image 1) Erosie produced utterances—performative writings—that not only passively described a given reality, but also changed the actual reality they illustrated. For example, his understanding of the term "word" itself "both described itself as much as it actually is itself." These works, which link text, image, form, content, as well as decoration, express the innate visuality and performative nature of text itself. The product is the actual image as much as it performs the image—the meaning and content, the form and function, are inextricably intertwined.

Erosie's recent work has returned to employing pure imagery rather than typography. The superb *Horror Vacui* series (a Latin term that describes the fear of empty space and the often manic need to fill it with markings; see image 2) embraces themes such as spontaneity and intuition. However, in the more recent pieces linked under the title *Implosion,* his paintings and drawings are deliberately crushed and compacted in an effort, according to the artist, to "agitate rather than please." Erosie continues to search for the paradoxes within his visual world, to look at the "why" rather than focusing on the "how." Form, aesthetics, and technology are therefore secondary to the importance of finding the creative friction and tension within the visual work. Although Erosie's work may not strictly conform to the "codes" of graffiti, in its essence it always refers back to this illegal form—whether through the pure instantaneous beauty of the act or the visual power it has to communicate with the viewer. Erosie's work sets out to erode and then rebuild our understanding of the visual world, remolding it into something radically new.

BERLIN

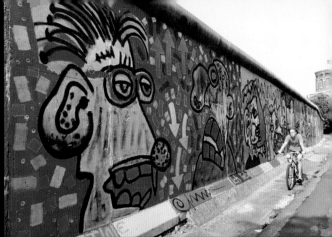

The history of Berlin's urban art is tangled: It can only really be written definitively once its material presence—the palimpsest of its skin—with all its imprints, marks, and signs, has been properly deciphered. Over the last hundred years the city's appearance—as well as the essence of its inhabitants—has been influenced by five different political systems: The German Empire, during which Berlin benefited from industrialization and became a metropolis; the Weimar Republic, which brought about a cultural heyday; the Nazi regime, which made the city a central point in its network of crime; the Cold War, which turned the city into a stage for a twenty-eight-year battle between the East and the West; and finally the freedom of the unified city after the fall of the Berlin Wall in 1989.

From the mid-1980s unofficial record keepers (street artists) started to actively determine the appearance of the city. Their expressions have been as diverse as the surfaces of the "Athens on the (river) Spree," as Berlin has been called. Like any big city, Berlin offers a tantalizing array of possible writing surfaces—from the aerosol marks on gray nineteenth-century facades next to bullet holes from World War II to the pastel-colored facades of renovated old buildings in the newly trendy neighborhoods—but the durability of any graffiti is subject to the cycles of creation and removal, of beginning and end.

After World War II, the Allies divided Berlin into four occupied zones. In 1949 the Federal Republic of Germany was founded on the territory of the western zone controlled by the USA, France, and Great Britain, and the eastern zone, which was governed by the USSR, became the GDR. The dire economic situation and political unrest caused a massive tide of refugees, and the Socialist leaders decided to construct a powerful fortification.

Some twenty years after the Berlin Wall was built, the inhabitants of West Berlin discovered its potential as a surface for street art. In the mid-1980s murals began to appear on the white parts of the inner-city section of the wall (see image 1). Until then the wall functioned as a sort of guest book for visitors to leave comments, and as a canvas for scribbles, political messages, and declarations of love. In the meantime, the northern part of the wall became a trial ground for US graffiti. Impulse contributions from the US Allies, graffiti films, and specialist literature on writing culture examined the vivid letter experiments, which were mostly based on names. The styles to emulate were those seen in Paris, London, Amsterdam, and New York. Paradoxically, the adornment of the wall that cemented the separation of a people expressed the idea of a "window to the free world."

International artists, including Richard Hambleton, Keith Haring, and Gordon Matta-Clark, who originally wanted to blast a hole in the wall left their traces on the much-hated barrier. A fateful event in late 1986 brought the true purpose of the wall once more to the forefront: Five former GDR citizens, who had been imprisoned and later expelled for

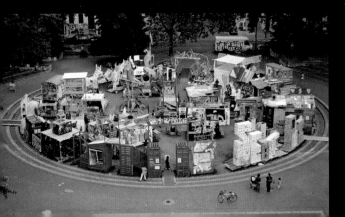

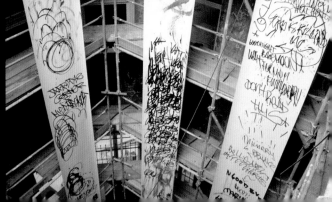

painting graffiti, among other offences, decided to paint a 4-mile (6-km) long white stripe along the wall, partially crossing out the colorful designs. They thought the western part of the wall had become a garish tourist attraction, which disguised the true horror associated with the wall. The question of the wall's ambivalent symbolism was raised once more after its fall: On the one hand people attempted to destroy their collective artwork so that its impossible jigsaw fragments now gather dust in the imaginary museum of history; on the other hand, tourists eagerly make the pilgrimage to the small conserved part of the wall. The popular Open Air Gallery was completed before reunification; its allegorical display was created on the eastern side by more than a hundred selected artists. The now banned Hall of Fame at the back constituted an ever-changing living text, but the murals on the eastern side also began to disappear slowly amid tourist scribbles so that the idea of a static place of memory, with renovation work and anti-graffiti paint, began to take hold. Nonetheless, the names of the unauthorized record keepers continue as a kind of mobile text, beyond the walls of Berlin.

No doubt future generations will inscribe their names on the walls of Berlin; today some contemporary artists are inspired by the typical strategies inherent in the medium of graffiti—the appropriation and irreverent handling of spaces, the exposure of fissures in language and control systems, and clandestine intervention. In 2005 Zast together with Jazzstylecorner (see image 3), organized the City of Names project (see image 2), which allowed the presumed destroyers of the city landscape to become architects of a new type of construction: Wooden structures built by the artists themselves became accessible physical symbols, metaphorical edifices, and adventure playgrounds for temporary inhabitants. Furthermore, in the experience of cohabiting, fundamental questions about ownership and social skills could be explored.

The video installations of Matthias Wermke and Mischa Leinkauf (see image 6 and pp.218–21) stop visitors in their tracks with their surreal exploration of the more inhospitable parts of the city by manipulating and subverting its transport and infrastructure. Clemens Behr's circulating bricolage compositions of color and material deconstruct uniform and space-specific surfaces, and fold the environment in a suprematist fashion (see image 4 and pp.214–15). Aram Bartholl's experiments implement codes and processes of the digital world in the everyday sphere (see image 5 and pp.208–9): examples include anonymous file-sharing spots cemented into walls and CAPTCHA tags that test a viewer's specific perception of the graffiti. Brad Downey (see pp.210–13) dissects and rearranges objects and obstacles with a childlike playful impulse in the almost entirely privatized public space, celebrating the trick of small-scale intervention in his "spontaneous sculptures." JS

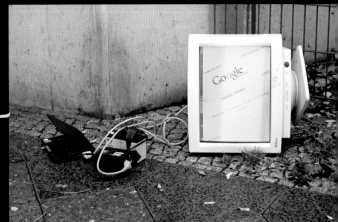

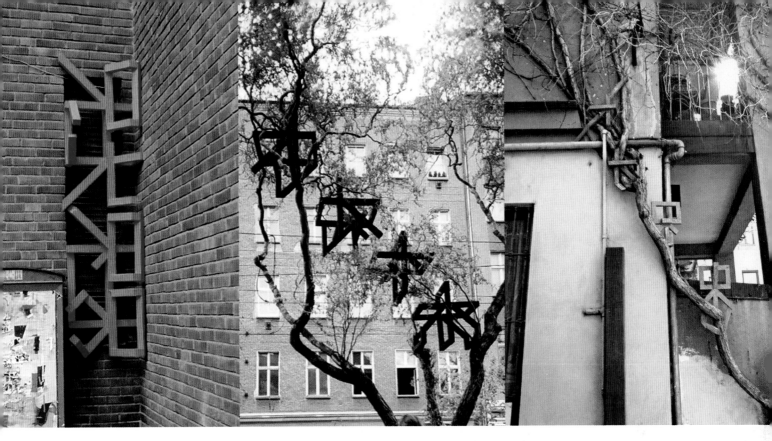

BERLIN

BORN Vietnam **MEDIUM** Roller, sculpture, video, workshops **STYLE** Roller graffiti, 3-D graffiti, relational art **THEMES** Public space, social art, anti-spectacular

1, 3 Berlin, Germany, 2004
2 Stockholm, Sweden, 2007
4 Milan, Italy, 2005

AKIM

The Berlin-based practitioner Akim is an artistic chameleon who has produced a diverse array of distinctly contrasting projects that are all linked by his concern with the overwhelming, multitudinous, ineffable nature of the street. Early on in his career, he developed a uniquely scripted typography and pioneered a sculptural, three-dimensional form of graffiti. Since then, Akim has begun to undertake a more conceptual investigation into what it means to bring the illicit form "inside," also producing works that could be understood almost as sociological experiments. He explores the many issues and debates emerging out of today's fractured, contested public sphere, using every medium to confront and respond to these questions head-on. What remains constant throughout all the varying forms of practice that Akim undertakes, however, is the attitude that emerged during his formative years practicing graffiti. Although this attitude may not materialize in any formal way in his current production, it endures through his basic aesthetic positionality.

Akim first gained fame in the graffiti world with his roller-tagging, a technique in which traditional paint rollers and extension poles are used to form tags, rather than the commonly used spray cans or markers. (This system is famously used in Brazilian *pixação*, see pp.114–15). Although this technique presents probably the cheapest method of "getting up" and grants practitioners access to locations that they might otherwise be unable to reach, the tool itself also sets certain aesthetic constraints on the artist and restricts the curvilinear and naturalistic potential of the work. Together with his continuous investigation into the possibilities of typography, as well as his exploration into the variable intelligibility of street signage in general, Akim developed an alphabet and typographical system entirely of his own. Playing at the conjunction of traditional graffiti and his Asian heritage, it utilizes the "limitations" of the roller to form a structure that appeared to be innately attached to the architecture on which it is manifested. However, inspired by his desire for continual evolution, as well as by the almost innate volume of the alphabet he had constructed, Akim soon transformed his tag into a three-dimensional form by building and installing sculptural adaptations of his script all over Berlin. As these works grew ever more intricate and complex, appearing

both futuristic and ancestral at the same time, they exposed Akim's work to a completely new audience. His illicit sculptural installations have a recognizable yet unfamiliar nature; visible, yet indecipherable, they became ever more conspicuous in the urban environment.

As Akim began to produce a growing number of these sculptural works for festivals around the world, however, he became increasingly frustrated with the thoughtless, often injudicious transplantation of graffiti into the gallery realm. At this point his more conceptual production began to emerge and he developed projects that went directly against the idea of graffiti as spectacle and against its conception as a form of glamorized "urban" beautification. Akim has conducted two projects in particular that highlight the paradox presented by public art in the private realm—*Bringing Ugly Back* (see image 1), which he produced for the "Names Fest" exhibition in Prague in 2008 (curated by Czech artist Point, see pp.248–9) and *Leistungsschau* ("Showcase," see image 2), which featured in the "Based in Berlin" exhibition in 2011.

For *Bringing Ugly Back*, Akim did not produce "art" as most people would understand it, as physical artifacts or images. Instead he simply undertook two acts; the first involved him smashing a window inside the warehouse where the exhibition was being held; the second took place outside where he constructed a number of makeshift scaffolds and ladders that enabled access to the walls of the building. Both the shattered window and the scaffold could be understood as aesthetic objects in themselves—as ready-mades, objects conflating the division between inside and outside—or as performances or acts replicating the destructive spirit of graffiti. More significantly, though, they can be interpreted as subverting the conventions of "urban art" exhibitions, by working to re-establish the status of graffiti as something inherently destructive, but all the more powerful and efficacious because of that. While the outside of the building became totally covered in graffiti, with Akim acting as the enabler (or perhaps curator) of the renegade display, the inside held the ever-present reminder of destruction through the simple visibility of the broken window, which played on the famous

(yet discredited) "broken windows theory" of social scientists James Q. Wilson and George L. Kelling. Both acts that Akim undertook refused the domestication of the interior, and embraced chaos over catharsis, eponymously espousing the rich menace of graffiti.

Working in almost a stylistic parody of many graffiti videos, *Leistungsschau*, on the other hand, shows not the production of graffiti but its destruction—the (almost) total obliteration of the graffiti present on the building where the exhibition "Based in Berlin" was taking place. Documenting the performance on video, Akim first shows the building as it was—covered in illicit inscription. He later reveals the results of his "work"—the painstaking removal of the building's outer layer of plaster, which contains the residue of the hitherto unacknowledged artists' acts. Carefully extracting the graffitied segments, the layer of paint interlaced with its plaster surround, Akim collected these remnants and placed them in a rough wooden pallet that was then displayed in the exhibition space. Highlighting the basic irrationality of graffiti occurring anywhere other than on its parietal surface, as well as acting to scar the building much like the original graffiti itself (but perhaps in an even more "unsightly" way), Akim's work underscores graffiti's inherently ornamental nature

and the fact that it is irrepressibly bound to its surface, a surface that is the street and that can only ever exist within the public realm itself. It presents graffiti in the only way Akim believes it can be achieved in a gallery setting—as an archaeological remnant, a pile of rubble, the lifeless remains of its previous existence.

Akim's latest work continues to investigate the city and focuses on "collecting and analyzing analog experience." From his work *Stammbaum* ("Family Tree"), for which he collected information about various generations of urban artists in Berlin to *Dinner for the Unknown*, when he cooked specially prepared food for his fellow street inhabitants, the "gangsters and prostitutes, the homeless and insane" that exist alongside the graffiti writers (in an illicit gesture toward Argentine contemporary artist Rirkrit Tiravanija), Akim has developed a group of practices that seek to push the boundaries of urban art by silently and modestly propelling graffiti out of its aesthetic straightjacket. No longer interested in the "look" of his art, it is simply the feelings it evokes and the issues it explores that are key: For Akim, this is the essence of graffiti—a living rather than formal aesthetic, a way of appreciating, comprehending, and revealing the city.

BERLIN

BORN 1972, Bremen, Germany MEDIUM Various STYLE Geek graffiti, digital art, public art THEMES Hacktivism, public vs. private, virtual space
COLLECTIVE Free Art and Technology Lab (FAT Lab)

ARAM
BARTHOLL

Aram Bartholl's interdisciplinary oeuvre functions in the hazy terrain between digital and public art. In his attempt to interconnect our virtual and concrete environments, Bartholl has staged numerous projects that independently utilize the street, tearing down the boundaries between real and virtual, and transforming the open source, hacktivist ethic into the physical space of the city itself. He has produced many public experiments that practice as well as preach his *Speed Project* manifesto in which one must produce an entire piece of work in an eight-hour time frame.

In his hugely successful *Dead Drops* interventions (see image 1), Bartholl started with the idea of a flash drive inserted into a wall. Intrigued by the concept of having to physically attach oneself to the architecture, as well as the "gesture of connecting a $2,000 laptop to a wall, and not even

1	2	3
4	5	

1 *Dead Drops*, 2010–12 2, 5 *Map*, Les Recontres d'Arles, Arles, France, 2011 3 *Map*, Sculpture Park, Berlin, Germany, 2007 4 *Map*, Taipei, China, 2009

knowing if you're going to get a virus or not," Bartholl intended the drives to be used for anonymous, peer-to-peer file sharing. The devices initially contained nothing than a readme.txt file explaining the project and were only latterly filled with data inputted by the public themselves. *Dead Drops* stressed the importance of people having local control of their data in view of the curtailments of freedom with cloud-focused online storage systems.

With *Maps* (see images 2–5) Bartholl aimed to bring the virtual world into the physical world and highlight the ways that the digital world flattens our perceptions of the everyday. Observing that the virtual map pin used by Google Maps cast a shadow on the digital map as if it were a physical object, Bartholl built 19-foot (6-m) high wooden replicas of these objects, which he then placed in the exact spots designated as the center of the city by the application. Visually displaying the relationship between digital information and the physical space, Bartholl's maps questioned the influence that companies such as Google have over our imagination. Emphasizing the power of the analog in our "fragile digital world," he used the project to unfold the space between these two spheres, forcing us to recognize both the potentials and pitfalls they encompass.

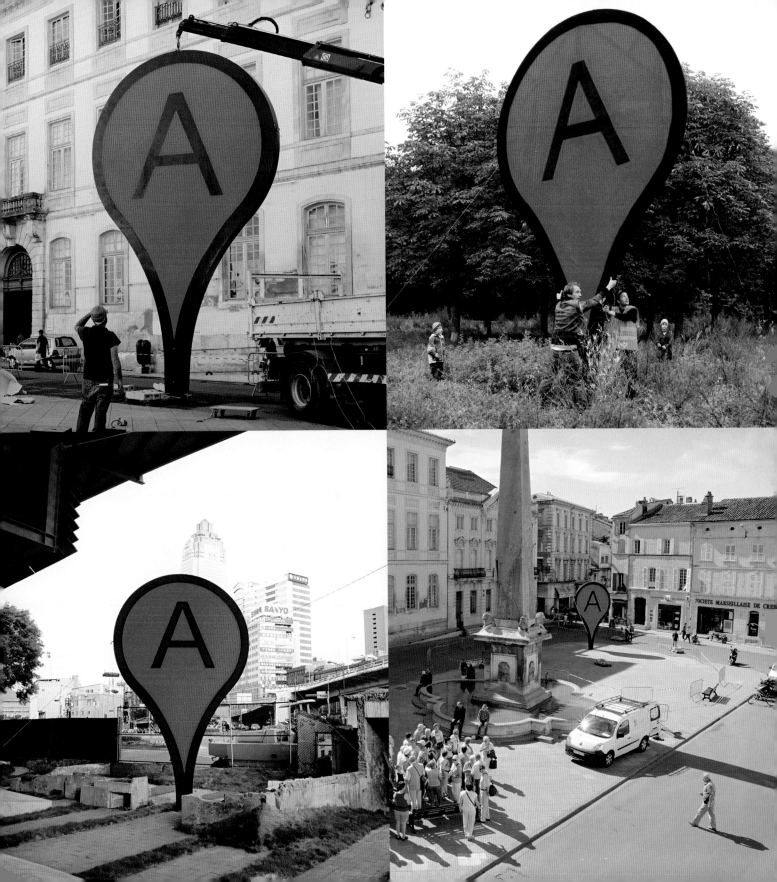

BERLIN
BORN 1980, Kentucky, USA MEDIUM Found objects, street furniture, film, painting, sculpture STYLE Conceptual graffiti, urban juxtapositions THEMES Urban regulations, urban transformation, vandalism art INFLUENCES Revs, Akay, Adams

BRAD DOWNEY

Best known for his anarchic transformations of street furniture, Brad Downey is one of the most highly versatile proponents of Independent Public Art. He is an artist whose wide body of work is as comical as it is contentious, bitingly critical and humorous in equal measure. Linking all of his projects is a concern about the customs and conventions of the urban environment, the invasive measures that have become so embedded that they are perceived as the norm. This general failure to "question [our] surroundings and reality," in Downey's own words, this "lack of discourse around rules in general" is his starting point. Whether he is confiscating CCTV cameras or filling phone booths full of balloons, building sculptures from car tires or impaling bicycles (as if by magic) at the top of lampposts, Downey takes existing objects and, by "changing their composition or orientation to give them a different function and purpose," invites the viewer of his works to reevaluate them too.

Born in Louisville, Kentucky, Downey was a member of a United States Marine Corps family and traveled widely across his country of birth as a youth, never settling in one place for long. After moving to New York City in 1998 to study at Pratt University, however, he was struck by the vitality and vibrancy of the graffiti around him, the way you were "immediately punched in the face" by its effervescence. Although he had never previously been particularly interested in any form of illicit art, Downey now found himself deeply drawn to it, and having just started a degree in film, he decided to amalgamate this burgeoning interest with his more formal studies, resulting in his movie *Public Discourse* (2003). Although a student project, it became a minor success, with screenings at more than seventy venues including London's ICA and the Copenhagen Documentary Film Festival. It included work by artists such as Obey (see pp.86–9), Nato, Swoon (see pp.40–3), Revs, and Desa (the so-called "Million Dollar Vandal"), yet it was the inclusion of the graffiti artist Verbs that changed the course of Downey's career, turning him from a documenter of artistic practice into an artistic practitioner himself. Having initially assisted Verbs (real name Leon Reid IV, but perhaps more famously known as Darius Jones) on his projects, Downey soon started to develop concepts and ideas himself, which the duo put into practice collaboratively, working together constantly from around 1999 to 2005.

1–3 *Tile Pry*, Amsterdam, Netherlands, 2008

1 *I'm Lovin' It*, Lüneberg, Germany, 2009
2 *Don't Worry About That Shit, René*, Berlin, Germany, 2008
3-4 *Buff the Fucks*, Lisbon, Portugal, 2010

Known as Darius and Downey, the partnership, which consciously aimed to reach out beyond the graffiti community, was incredibly fruitful. After first developing a new style of large-scale roller graffiti—as seen in their infamous *Honk if You Love Graffiti*, *Clone Jesus*, and *To: You, From: Darius and Downey* (also known as *The Gift*)—the pair utilized the street furniture seen in every modern city, modifying Leon IV's existing sculptural works to encompass the artifacts already situated within the street.

Moving to London to continue their studies—Downey at the Slade School of Art, Leon IV at Central Saint Martins—the duo grew ever more daring and unique with their installations, which included intertwined or divided Belisha beacons (*The Kiss* and *The Break Up*, respectively), subway sign modifications (*Your Arse*), and converted street lamps (*The Tree*). Yet after Leon IV's return to Brooklyn in 2005, and decision to halt his illegal installations, Downey left London for Berlin (where he still resides), a move that had a marked effect on his style and approach. Sharing a studio with the artist Akim (see pp.204–7), and influenced by artists such as Akay (see pp.224–7) and Kripo Adams, Downey took to Berlin as a place that still felt open for exploration—one where, he says, he could "still do weird things without anyone noticing." The move to Berlin also led to a

shift away from street furniture, as Downey began to take a more interrogative viewpoint on the practices of Independent Public Art.

In his 2009 film *Don't Worry About That Shit, René*, Downey documented the uproar surrounding his commission from luxury department store KaDeWe in 2008, to mark their seventy-fifth anniversary. Encouraged to participate by an event agency, Downey was asked, with eleven other street artists, to reinterpret the Lacoste crocodile emblem; the pieces were later to be sold off at an auction. Having submitted a proposal that stated only "Something outside will turn green"—a proposal that, to his surprise, was accepted—Downey used a fire extinguisher to spray bright-green paint along the shop front (see image 2). The proprietors reported him to the police for vandalism, but Downey's action can be seen as a critique both of the complicit commodification of Independent Public Art by ostensibly radical artists, and at the way this form of art had been commandeered for pecuniary purposes by the companies themselves. The KaDeWe action was similar to his *I'm Lovin' It* (2009) mural (see image 1)—an excact replica of a McDonald's advert—at the Leuphana University as part of the ARTotale project (essentially a rebranding exercise for the university). In both cases, Downey was reacting against the use of urban

art to add mystique to brands, be they companies or universities, and the logo-centric activities of many street artists and their failure to react and respond to the specific localities of place.

In contrast, Downey's project *Searching for Something Concrete* (2010)—a collaboration with professional art restorer Magdalena Recova—set about recovering the hidden layers of graffiti within a small section of the Graffiti Wall of Fame in Vienna. Using a variety of mechanical and chemical processes, which he later described as an attempt to "unlock the illusion of two dimensional space," Downey rediscovered a past history of graffiti from more than fifteen years of practice, a hidden palimpsest lying beneath the surface. Just as with his project *Tile Pry* (see image 1, p.210). Downey was trying to reinforce the fact that underneath so many layers of gray we can find not only history but art, a dense deposit of one of the truly hidden archives of the city. In many ways, it works as a mirror image to his 2010 project *Buff the Fucks* (see image 3), in which Downey set about a process of "reverse buffing": covering a derelict factory in the Alcântara district of Lisbon, including the windows, doors, metal barriers,

and paving stones, with the kind of gray paint usually used for covering up graffiti. In a complete reversal of the usual practice, Downey preserved and restored the graffiti. In so doing, he was inverting the traditional order of things, treating graffiti—the lowest of the arts—as if it were the highest, subjecting it to the processes of repair and renewal usually associated with museum-based restoration. Highlighting some of the more archaic and faded inscriptions within the Alcântara work, such as the word "Solidariedade" ("Solidarity"—most likely left over from Portugal's revolutionary period in the 1970s), Downey was investing value back into this so-called "vandalism" by enhancing and enriching what was already there. Like the multitude of other works he has undertaken, these projects show his intensely playful, mischievous intent—evident in even his earliest work—and his commitment to change the idea of the public sphere, the way we understand the visual and material culture that surrounds us. Offering us a beguiling mixture of the sublime and the ridiculous, Downey mocks the (ridiculous) nature of urban restrictions and regulations while also offering us a glimpse of the (sublime) latent potential within them.

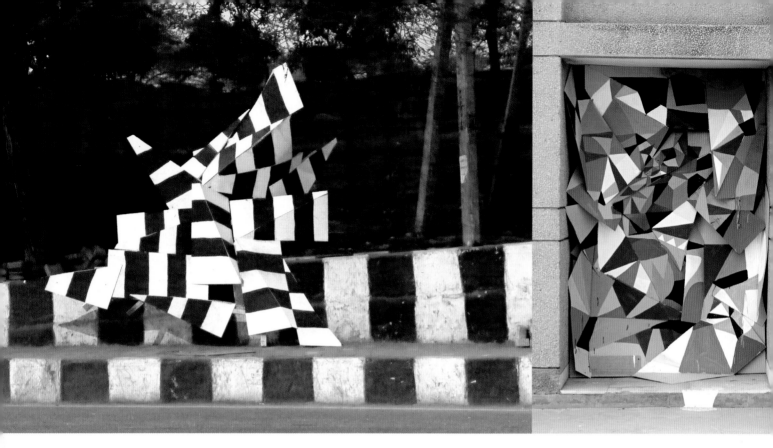

BERLIN

BORN 1984, Koblenz, Germany **MEDIUM** Cardboard, tape, plastic, spray paint
STYLE Geometric, abstract, collaged sculptures, junk aesthetic **THEMES** Geometric
patterns **INFLUENCES** Merz, Dadaism, skateboard culture

1 *Delhi Highway*, New Delhi, India, 2012
2 *Delhi Tent*, New Delhi, India, 2012
3 Amiens, France, 2011

CLEMENS BEHR

Clemens Behr's large-scale, uncommissioned origami-style installations emerge from their surroundings in a strangely organic manner. Merging two- and three-dimensional spaces in a single plane, the geometric shapes and abstract forms he creates subtly distort the viewer's perspective. His highly ephemeral, site-specific artworks seamlessly integrate painterly and sculptural techniques, while his use of cheap, everyday materials such as cardboard, tape, and plastic waste bags shows the influence of the "junk aesthetic" inherent to both Dada and "Merz"—the latter, a term coined by German Dada artist Kurt Schwitters, refers to found objects or waste materials that Schwitters used in his collages.

Behr's signature style materialized almost by accident. He had originally intended only to make cardboard frames for his paintings, but these frames eventually grew to eclipse what they were meant to be simply embellishing. Instead of just painting shapes, Behr began to physically create them, folding sheets of cardboard to produce pyramid-like geometric forms. Utilizing resources that were freely available from the street, such as cardboard, wood, and paper, also guaranteed that he would never be without materials; he needed nothing more than a knife and a staple gun to start work. The random colors and shapes of the materials that he found determined much of the works' final outcome.

Behr believes that his aesthetic has been primarily influenced by his background in graffiti and skateboarding. He developed a tacit understanding of space through the numerous hours spent searching for places to paint or skate, but the structures of his installations can also be regarded as a reflection of the order and patterning of graffiti—letters disappear into abstraction, while shape, scale, and use of color prevail. If Kurt Schwitters's Merzbau—the artist's unparalleled attempt to form a living sculptural artwork within his Hanover home—is one of Behr's inspirations, so too is the Dadaistic proclivity toward ephemeral objects and found fragments. Not only do the angles and shapes of Behr's artworks provide a latent visual tension, but so too does the fact that, in his own words, "in the end, it's just a bunch of trash, arranged aesthetically" and could disappear in a matter of hours, days, or months.

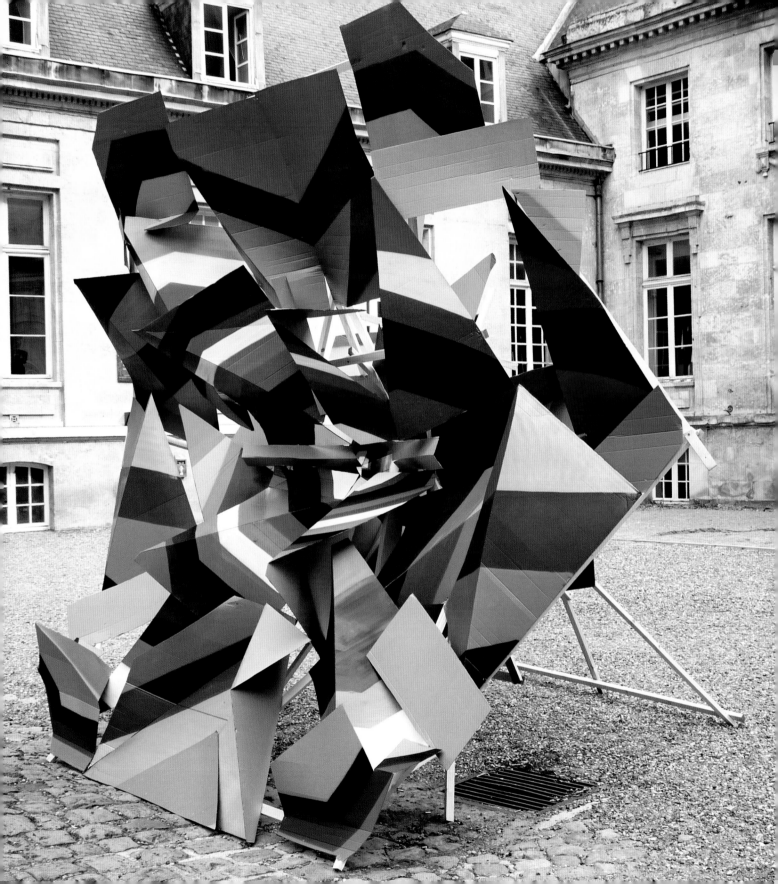

BERLIN
BY
MARTIN
TIBABUZO (FASE)

Although originally from Buenos Aires and now living in Nuremberg, Germany, Martin Tibabuzo (a member of the collective Fase, see pp.136–7) has produced a map of the capital of his new country of residence, Berlin. He has created many cartographic works within his oeuvre, all of which act as a form of aide-mémoire, an imagistic mnemonic similar to the various city sculptures he has constructed or the scale models of former houses he has reassembled. He initially began creating these works after he contracted a medical condition in the early 2000s; Tibabuzo explains this condition, as well as its eventual aesthetic resolution, in the text below:

In my twenties I used to be a workaholic (I'm still not completely recovered). Of course, I never thought that working too much could be something bad; so during the day I was doing it for the money and at night for my pleasure. But then it started to happen. First I started to forget non-important things like birthdays, then appointments, names, and conversations. Nothing really serious. Later I started to fall asleep in weird situations, mostly at night, but on two particular occasions—when I fell asleep talking to someone and another time while writing some notes on paper—I began to get a bit worried.

I went to a doctor and he gave me two pieces of advice. The sleeping issue was easily solved doing something easy: Sleeping. However, the memory situation was more complicated and required some homework: Memory exercises. I hate homework, so it never happened.

A few years later, however, I began to link those exercises with my art. It was a perfect idea. All the homework turned into artworks. I made a long and detailed timeline of all the important events of my life— holidays, jobs, friends. I turned trips into maps and places I had lived into scale models. I can't certainly say that my memory improved, but I definitely sleep more. And my artistic production now has a nice motive behind it, helping me to remember and relive all the interesting things that have happened in my life.

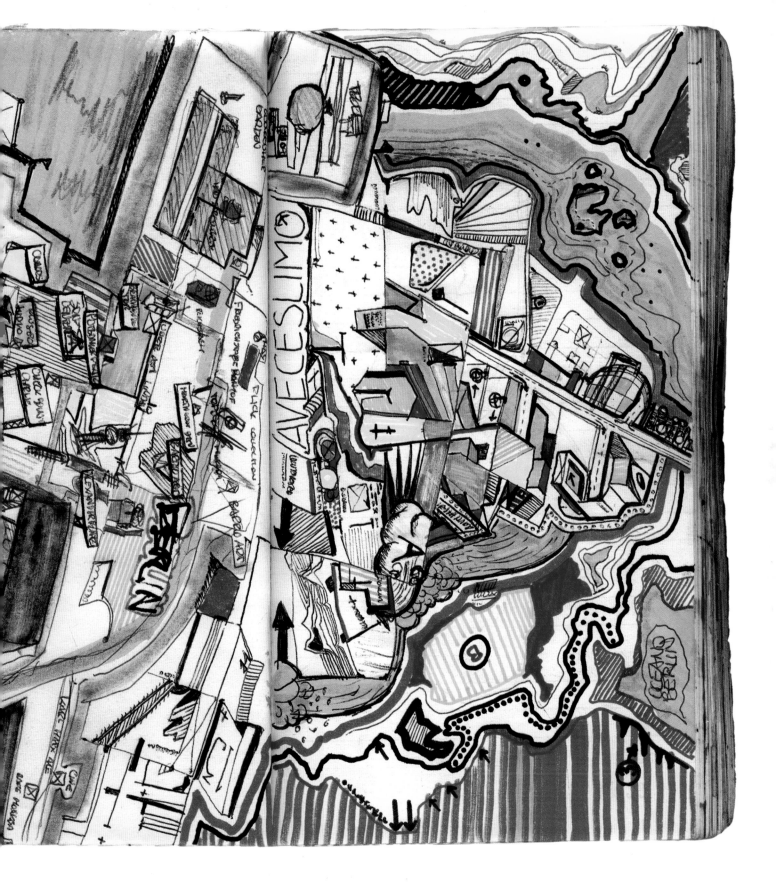

BERLIN
BORN 1977 (Wermke), 1978 (Leinkauf), East Berlin, Former GDR
MEDIUM Performance **STYLE** Video art, urban performance, conceptual graffiti
THEMES Public space, rules and regulations, *dérive* concept, contradictions

WERMKE & LEINKAUF
STOP MAKING SENSE

Of all the artists featured in this book, Matthias Wermke & Mischa Leinkauf have most successfully accomplished the transition from the space of the street to that of the gallery. Forming an aesthetic that is both conceptual and corporeal, their provocative video installations document audacious interactions with the city and its architecture, which seek to provoke new imaginings of the city and find new ways of physically and mentally approaching its geography.

Wermke & Leinkauf were born in East Berlin (GDR) at the end of the 1970s and their partnership developed out of years of close association. They grew up on the same street and experienced together the years of training and traveling associated with the graffiti world, touring Europe to paint from the age of fifteen. Although by 2000 they had become established members of the international graffiti scene, Wermke & Leinkauf began to feel uneasy about the changes resulting from the street art boom and the institutional collaboration that was becoming the norm: "On the one hand it was attractive, there was an interest in your work, but the work that people were showing belonged to the street, not to the gallery: It just didn't make sense to us to exhibit this kind of work in an institutional context." Wermke decided to try and separate these two worlds, refusing the opportunities these exhibitions presented while becoming more interested in the theories and models of contemporary art. Meanwhile, Leinkauf halted his graffiti production entirely and focused on his burgeoning career in film. After working as an assistant director and producer for about five years, however, Leinkauf began to miss the independence and spontaneity of the graffiti world. The paths of the two friends eventually crossed once more and Leinkauf with his camera equipment in tow began to accompany Wermke on his explorations around the city. Rather than Leinkauf simply recording the actions Wermke was undertaking, however, the pair soon began to formulate a project that would have a more conceptually defined idea at its heart.

1-4 *Drifter*, Tokyo, Japan, 2012 5-6 *The Neonorange Cow*, Berlin, Germany, 2005 7 *Drifter*, Tokyo, Japan, 2012

1 Cologne, Germany, 2012
2-3 Berlin, Germany, 2010
4 Toffia, Italy, 2007

The first of these joint projects—*Die Neonorangene Kuh* ("The Neonorange Cow," see images 5–6, p.218)—attempted to capture the "feeling" of experiencing a new sight in the city that is so extraordinary and arresting that you cannot decide whether or not it is real. Starting with a black screen and a snippet of conversation between Wermke & Leinkauf—about building and displaying a neon-orange cow in the city, a scene so strange that no one would believe they had actually seen it—the film fades to a darkened tunnel in which the viewer can see a steadily moving, but strangely obscured shadow. As the camera angle switches to a wide-view, however, we see the lights of a rapidly approaching train, which, as the train sweeps past, illuminate a man who, dressed all in white, is energetically swinging on a homemade swing. Plunged into darkness after the train's departure, the film continues through numerous scenes that include the same man swinging beneath an overhead train line on a Berlin street, beneath a bridge (with his feet almost scraping the water), and from a giant hoarding on what looks like busy overpass. Yet wherever he is the viewer is left with a plethora of questions: How did he get there, what is he doing, and why is he doing it? What is important for Wermke & Leinkauf, however, and is as important as the basic

inconceivability of the act is its transient, fleeting nature: What was left was "something permanent but it was in the imagination. For me, for over a year after, I would come to a spot and then in my head I would imagine swinging there. And we wanted to see if it was possible to put this feeling into a film project to give this form of imagination to the viewer."

Although *The Neonorange Cow* was exhibited via a single channel projection, Wermke & Leinkauf's work quickly began to increase in size and scope, using multiple displays, split screens, loops, and incorporating narratives entirely without any discernible beginning or end. They found the milieu of film festivals too constrictive—time was too dominant and "narratives" rather than "situations" were expected—and instead began to investigate exhibition spaces—spaces in which the viewer was not forced to watch their films in any set or linear fashion, and where they could sit and either explore every detail at leisure or capture the meaning of the project in a fleeting look. Furthermore, because one of the key concepts of their work was, as they put it, about "going to a place for how long we want for whatever we want," they believed that their audience should have the same opportunity. Just as Wermke & Leinkauf were exploring their surroundings, the viewers of their works should

also be allowed to go through the same emotions as them and experience the physical reality of a voyage.

Drifter, one of Wermke & Leinkauf's more recent works in Tokyo, can be seen as the culmination of all these ideas. In an attempt to recreate a way of understanding the city from an alternative perspective, by going under its sewers and tunnels, and over its rooftops and skyscrapers, *Drifter* can be understood as a personal challenge to authentically explore the city and to play in it with the innocence of a child's natural curiosity. Treating Tokyo like a huge playground therefore and utilizing the inherent accessibility of its architecture due to its status as an earthquake region, the pair filmed themselves undertaking aimless journeys across the city. They made sure, however, that what they later displayed in the gallery space showed the city in its detail rather than in its entirety. They wanted to abstract their journeys through the city and to reduce the sensationalist element that was attached to them (see images 1–4 and 7, on pp.218–19). This reinforced the idea that the project, in their words, "was not just about risk but about using the architecture in a playful manner": It was not about the spectacular, neither was it a testosterone-fueled proclamation of triumph (as witnessed in much urban exploration).

Wermke & Leinkauf's intrepid explorations set out to push people to discover their own paths in the city and to find their own ways of feeling at home within it. Demonstrating the navigable routes of the city that are so often perceived as impenetrable, the duo wanted people to be inspired to see the city as a place in which they could simply drift, take an unplanned, unconscious journey, and experience the authentic aesthetic contours of the urban environment.

Standing firm with the basic inalienability of graffiti and its uncommodifiable status, Wermke & Leinkauf have therefore moved to the established art world while still remaining faithful to the core tenets of graffiti—its independence, adventure, spontaneity, and freedom. Whether building a handcar to ride the train tracks of the city (in the project *Zwischenzeit/In Between*) or building a house on the threshold between Asia and Europe in the middle of the Bosphorus (in the project *Mendiregin Üstünde*), Wermke & Leinkauf refuse to become a brand or provide more wares for the insatiable market: "It's less of a product, it's more difficult to sell our art, and that is its beauty." It is a beauty that comes from the production of feelings rather than artifacts, of ideas rather than images, and conceptions rather than commodities.

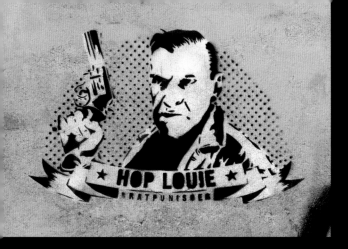

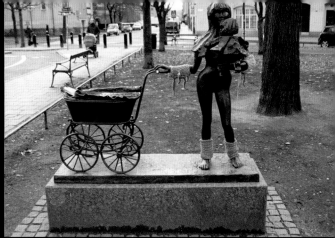

STOCKHOLM

Contemporary graffiti writers and street artists in Sweden commonly regard the arrival of hip-hop culture in the early 1980s as the starting point of their artistic tradition. However, there was a movement that could be considered a precursor of street art in Stockholm—the so-called painting brigades of the late 1970s. Inspired by the muralist traditions of Latin America, young artists and art students started working illegally in the streets, and sometimes in the subways, frequently with political messages. In 1979 a group of these artists even gained institutional recognition at Moderna Museet (the Museum of Modern Art, Stockholm) with the exhibition "Brigade-painting: Collective creations." Despite this movement, graffiti and street art in their more contemporary senses did not truly begin until around 1984, after Swedish television aired several documentary programs about New York's hip-hop and graffiti culture, including *Style Wars* (1984). As there were only two television channels at the time, these films were seen by literally hundreds of thousands of young people and had a significant impact.

The first generation of graffiti writers were mainly boys from the working-class and lower middle-class suburbs, who painted on, in, and along the local transit system. During an early experimental and consolidating phase (*c.* 1983–87) the most famous artists included Baze, Zip 17, Merley, Zack, Snow, Amen, Wackman, and crews such as RMCA. Zappo's *Crush the War* (1986, see image 4) is an early example of a writer mastering graffiti art, while Slice's *2 My Bro' DJ Rock Ski* (see image 5) a year later was perceived by many as a preeminent piece.

The period from the late 1980s to early 1990s could be dubbed the era of classic Swedish graffiti when there were many complex and detailed productions from writers such as Cazter, Buzter, Ceios, Atom, Erse, Code, and crews including DST and VIM (initially comprising Akay (see pp.224–7) News, Dudge, Terror, and Spade). The buffing industry had not yet developed and in many locations the biggest threat was a lack of good spots. Highly regarded burners, therefore, could often last for many years. Circle and Weird's *We Don't Need No Tragic Magic* (see image 3) is an example of their intricate and complex production, as well as the then common practice of working in pairs (Circle with lettering, Weird with characters). Writers such as Reson and Weston represented another direction in Stockholm's graffiti, of quantity over complexity, while Viruz

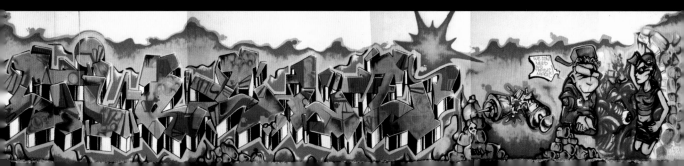

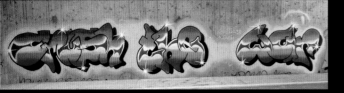

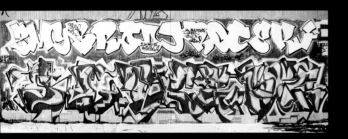

drawings that were often closely connected with traditional graffiti and were probably seen as such if only done along the transit system and with more colors. The rockets painted by Unik, visible in almost every street at the beginning of the new millenium, resembled throw-ups.

Openly political stances were also a more common component of the street art scene, perhaps most evident in the conceptual installations of Prao and "propagandistic" stencils by Mogul and Hop Louie, such as *Bratpunisher* (see image 1). Andy introduced a naive approach and Folke started working the border of visual art and poetry using absurdist messages. Like Caper (see image 6), Ontop, and IOH, they utilized stickers and posters as their preferred media. In more recent years, the Stickkontakt crew have introduced the concept of craftivism into the genre, for example in *Super Heroines*, a series of works in which they have added textiles, such as knitted superhero mantles and "flaming" gloves, to the often naked female forms of public sculptures (see image 2). **JK**

had a foot in each camp. The artists Pike and Duane, from Malmö and Gothenburg respectively, also moved to Stockholm around this time and subsequently joined the VIM crew.

A more dominant but also diverse trend was that seen in the so-called "ugly-beautiful" graffiti, which was characterized by faster, more spontaneous image-making, and made a conscious break with the ideals of classic New York graffiti. NG (Norrlands Guld: Ribe, Ikaroz, Slak, Deepo, Moer *et al.*), a crew of writers who moved from the north of Sweden to Stockholm, was pivotal in this development. However, "ugly-beautiful" graffiti was also fueled by the increasingly rigid anti-graffiti policy that was adopted during the years around the start of the millennium: *Nolltolerans* was a local and more far-reaching version of New York's infamous approach of zero tolerance. Sweden's policy included a massive campaign against graffiti, stricter legislation and survelliance, and the closing of exhibitions and legal walls. It resulted in perhaps the most repressive attitude to illicit public art in any European country.

It is in this context, and at least partly as a reaction to the media representations of graffiti as a single monolithic problem, that the street art scene grew in Stockholm. Many of the early artists had been graffiti writers and in some cases still were or regarded themselves as such. Yet by referencing wider popular culture, artists such as Akay and Adams could create and in some senses break with a stereotypical understanding of graffiti. Made, who was a well-known tagger in the late 1980s, for example, stated creating his name with mosaics.

In contrast with graffiti, the street art scene was from the start largely a phenomena in the bourgeois parts of town—the inner city and suburban middle-class areas of Stockholm. Kropp and Unik produced

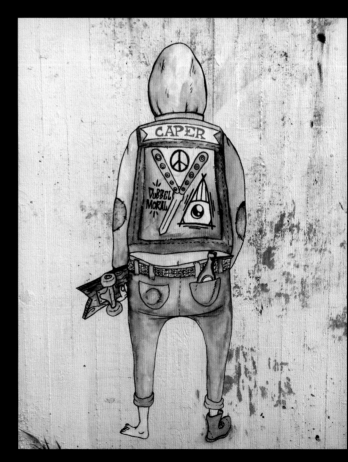

1	2		4
			5
		6	
3			

STOCKHOLM
BORN Unknown MEDIUM Various STYLE Classic graffiti,
insurgent architecture, urban intervention THEMES Urban recreation,
anti-gentrification, activism CREW VIM COLLECTIVE A-APE

AKAY

Refusing to be bound by genre, technique, or medium, Akay is one of the most remarkable contemporary practitioners of Independent Public Art, who has not only contributed toward but also initiated three separate movements within its recent history. He spearheaded the Scandinavian graffiti scene in the early 1980s; he was a progenitor of poster art in the 1990s; and he has been a pioneer of urban intervention since the early 2000s. He has always welcomed the manifold possibilities of the street and investigated different reactions and responses to its heterogeneous nature. Almost irrationally modest about what he does, Akay refuses to call his work art, however, and rejects the pedestal it is often assigned: "I think the role of the artist is so ridiculously overrated. And then it gets weird when the things we do are suddenly valued higher than graffiti, when in a lot of ways it's actually the same thing."

A founder of the infamous VIM crew in the early 1980s—with Nug (see pp. 228–31), Aman, Duane, News, and Pike—Akay was active in the Scandinavian graffiti movement until the mid-1990s. At that point he felt that his artistic development had stalled and that his earlier work was superior to his current production. Determined to change direction, he began to take a serious interest in photography. Although this experimentation was highly productive, Akay missed the involvement and physical relation with the city, and he set out to formulate a way of regaining his attachment to the street. It was here that "Akayism" was born, a pseudo-political, guerilla marketing campaign that promoted nothing other than itself—a form of visual propaganda with an ironic lacuna at its heart. "Akayism" utilized Akay's keen sense of space (developed, of course, through his classical graffiti background) to inundate the city with vague, yet strangely discomforting messages carried within an amorphous series of posters. These were linked by a dystopian, Orwellian aesthetic and accompanied by an iconic globe logo. Enjoying the sense that he was no longer working as an individual but more like what he describes as a "weird organization,"

1 *Rainbow Warrior*, Lisbon, Portugal, 2011
2 *The Mess*, Vienna, Austria, 2011 (with Brad Downey)

he felt that this was an element that intrigued people even more about the true nature of "Akayism." It was its lack of coherent ideology that made people notice it and its status as a message that seemed to work so fundamentally against the ubiquitous commercial visual culture in the city. Idiosyncratically edgy, it stood out as an anti-discourse and unabashed critique against the highly saccharine nature of the advertising industry.

While the groundbreaking work of "Akayism" greatly influenced what later became known as "street art," Akay developed a highly successful and influential collaboration with the artist Peter Baranowski (also known as Peter or Klisterpeter). Coming together as the Barsky Brothers, and active between 2003 and 2007, the pair produced a huge array of projects that aimed to reshape the space of the city, a body of work that can be seen in their book *Urban Recreation* (2007). A number of the Barsky Brothers's projects were linked through their attempt to construct living areas in the city that expropriated hidden, dead spaces and transformed them into functioning, warm, intimate homes. With *Traffic Island*, perhaps their most renowned intervention, Akay and Peter transported an idyllic, miniature, Swedish summerhouse to a small hill by the Eugenia tunnel (one of Stockholm's main traffic junctions). They fitted it with electric lights (running from the public street lamps), "grandma style" curtains, framed pictures, and a front garden complete with a picket fence and a clothes line hung with drying garments. For *Albano House*, they hand-constructed a living/hiding space at an industrial site in Stockholm that was awaiting demolition; they expressed their skepticism about the area's impending commercialization by daubing comments on the walls (such as "Why does it always have to end like this" and "Praise the concrete"), as well as through their actual presence at the locale itself. For *12m³*, they built a house hanging on a cliff side—a non-space in planning and legal terms through its suspension in the air rather than being set on the land, and therefore one unable to be removed by the local authorities. All of these projects questioned issues of ownership, property, legality, and bureaucracy, and commented on the possibility of escape and freedom. Taking the do-it-yourself hallmark of graffiti to an entirely new level, the Brothers became (insurgent) architects, builders, and developers, who improvised with their surroundings in complex, yet often joyful, ways.

Together with other actions such as *Urban Swings* (a project in which huge swings were illicitly placed all over the world), *Highway Buffet* (in which a large, sit-down party took place between two busy highways),

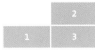

and the superb *Graffiti Is not a Crime* (see image 3)—in which the pair emblazoned colossal-sized texts onto the Scandinavian snow, using well-known graffiti aphorisms or proverbs as their source, the Barskys continued to work in various mediums and styles. Yet, they always focused on a keen interaction with the street and a dialogue with its inhabitants.

In his solo work Akay has returned to the simple, arresting, vandalistic qualities of graffiti, however. Producing devices known as "Rainbow Warrior" and "Robo-Warrior" for his project *Instruments of Mass Destruction* (see pp.224–5), Akay has honed his DIY skills to produce intricate, purposefully over-elaborate instruments for the construction of the most incongruous seeming vandalistic image—the rainbow. Attaching these machines to his trusty bike, "Robo-Warrior" forms a vertical, thirty-color, mist-style display proceeding for as long as the cyclist (or the spray cans) last. "Rainbow Warrior" produces a perfectly semicircular, six-color, bold motif that is electronically controlled and can function on many different surfaces. Both projects aimed to demonstrate that the beauty of vandalism occurs within the entire process of the act—not only in the momentary distribution of

paint to surface, but in the painstaking preparation, in the detail, and the idea. As with his short film *Dressed for Success*, in which he reveals a mind-boggling amount of pens, spray cans, and ink hidden in his black suit, Akay revels in the entire method and means of graffiti. While this line of work has persisted in his collaborations with Brad Downey (see pp.210–13) as Brakay (in particular *Tipping Point 2* and *Bombing*), his work with Kidpele, Made, and Eric Ericson under the collective A-APE (especially *Public Secrets*), as well as his film work with Made (*The Machine* and *The Box*), Akay has managed to invent increasingly more ingenious projects that diversify and extend his ever-growing ouevre. The common thread through all his projects, however, from his earliest graffiti to his more recent innovations, is their status as what he terms "mudlevel" (rather than "grassroots") projects, which function without funding, permission, or license. Akay simply needs an idea and he will make it happen, irrespective of the financial or physical costs. All he needs is an opportunity to do something that has not yet been done—in his words "to rearrange the furniture," to "fix things up"—and to welcome the boundless potential of the city.

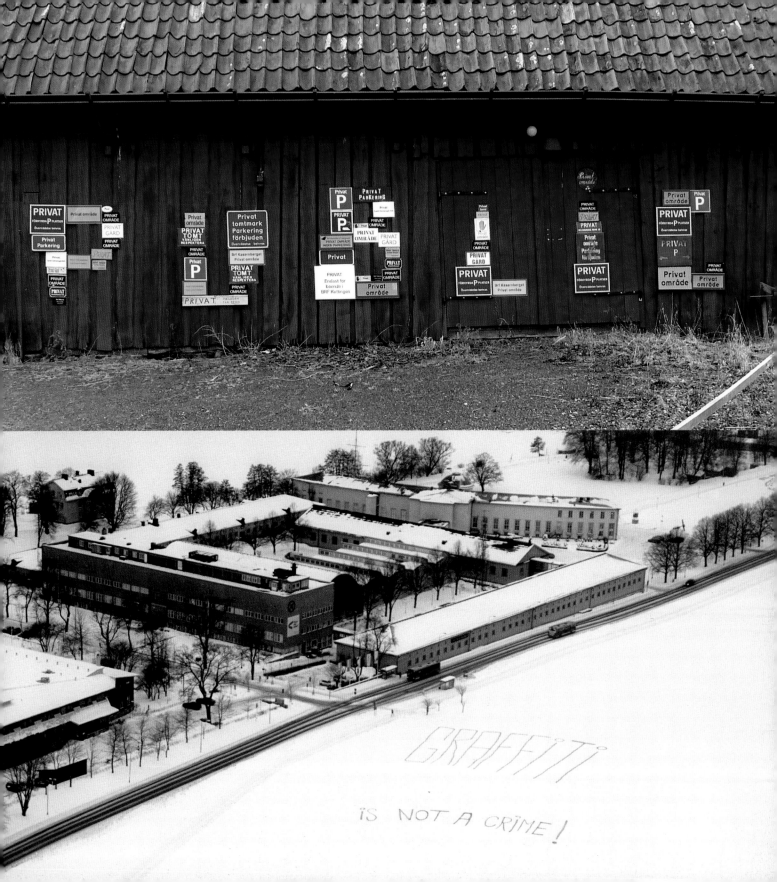

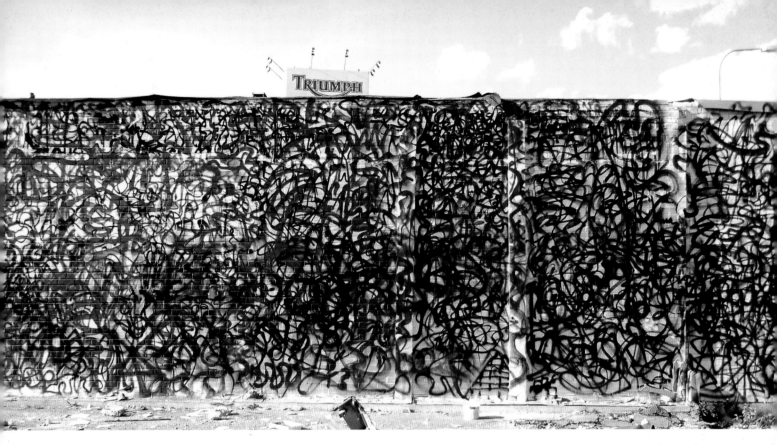

STOCKHOLM

BORN 1972, Stockholm, Sweden **MEDIUM** Spray paint, video, installation
STYLE Classic graffiti, anarchic performance **THEMES** Chaos, emotion,
sensation, anarchy **CREWS** VIM (Vandals In Motion), MSN, MOAS

NUG
DUDGE

When a contemporary artist's press release mentions the phrase "graffiti writing history" it usually indicates that the artist in question tagged his name for less than a week more than fifteen years ago. However, Nug, who has recently made a powerful impression in the wider fine art world with his video and performance work, is incontestably committed to the graffiti culture and has earned a legendary status in both Europe and beyond. Yet even with this newfound institutional attention (and the attendant indignant scrutiny by the media, judiciary, and Swedish Minister of Culture herself), Nug refuses the lure of celebrity and wider exposure, allowing his work to speak exclusively for itself. What is most important for him is to push his sense of aesthetic and personal freedom to the absolute maximum.

Active in the Scandinavian graffiti scene since 1985, Nug remains a key member of the infamous VIM Crew, or Vandals In Motion, alongside other

key affiliates including Akay (see pp.224–7), Aman, Duane, Iano, News, KAOS, and Pike. Throughout the early years of his production Nug worked relentlessly, painting at every possible opportunity. Often working alone, he was one of the first artists in Scandinavia to popularize backjumps, a process whereby a train is painted while in service rather than at the depot, surfing the train to the next station if he had failed to finish the piece at the previous stop. Interrailing and hitchhiking around Europe, trains were Nug's medium of choice, which meant that stylistic purity, speed, and inventiveness were crucial. With trains, painting became purely "physical"—a bodily act: It was a channel through which he was forced to work quickly and without thinking, a method of disassociating himself from the everyday, released briefly from social and material constraints.

Although he continued to paint illegally, by the mid-2000s Nug had begun to study art more formally at Stockholm's Konstfack—the largest university college of arts, crafts, and design in Sweden. There he set about trying to represent the pure energy and explosive vivacity of the graffiti act, not in images but through performances. For Nug, the essence of graffiti lay in its charged, ephemeral execution, in the adrenaline it

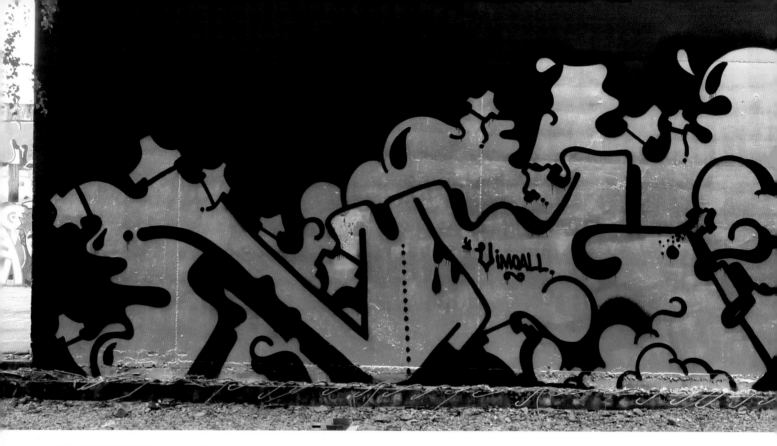

fermented, in the rush of the event. He created various film works with his VIM partner Pike, including *Best Things In Life For Free* (in which the "hero" steals beer from a store before riding and eventually flying off the back of a speeding train) and *It's So Fresh I Can't Take It* (in which a spray can appears to be in control over a helpless artist, furiously forcing him to paint over the walls and floor of an underground station). In 2008, his final Master's project, *Territorial Pissing* (see image 3), continued to capture this electricity and intoxication of the moment, but in an even more intense manner. It opens with the image of a masked, black-clad figure on a commuter train tagging the wall and window adjacent to him, while the other passengers look passively on; the figure becomes increasingly animated and frenzied, scribbling in a progressively wild way and ripping off advertisements to paint the entire wall of the train. Smashing the window with his spray can as the carriage pulls into the station, the character dives head first through the shattered remains of the window as the train emerges into the station. Proceeding to run along the outside of the train, spraying it haphazardly (in what Nug has termed SPAG or spaghetti graffiti), the finale sees the character back on the train destroying the windows, walls, and floor of the carriage with an ink-fueled fire extinguisher.

The film was shown as part of a collection of graduate work at the prestigious Brändström & Stene gallery in Stockholm, where it was seen and condemned by the Minister of Culture, Lena Adelsohn Roth. The media storm that ensued called for a criminal investigation and for Nug's degree to be rescinded. For Nug himself, however, this work was not about vandalism or destruction but about instinct and feeling; he was exploring the primal, elemental essence of graffiti, rather than trying to replicate or subdue its formal or decorative qualities. Like his more recent works, such as *The Concept Is Fuck You, Yes You*, which was performed at the Fame Festival in Grottaglie, Italy (in which the heroic solo character is replaced by a band of crazed insurgents) or his joint show with the artist Erland Brand entitled *Dödslack* ("Death Paint"), these actions cannot be understood simply through the trope of art as violence or transgression (like the Viennese Actionism of Otto Mühl), which reinforces the sanctioned, endemic, yet closeted violence of wider society. Nug's practice revels in emotion and heated sensation rather than barbarism or intentional cruelty. It is about liberation, exhilaration, and passion not power. It is a visual presentation of the dopamine-soaked, endorphin-laden, serotonin-provoking anarchy of the graffiti act itself.

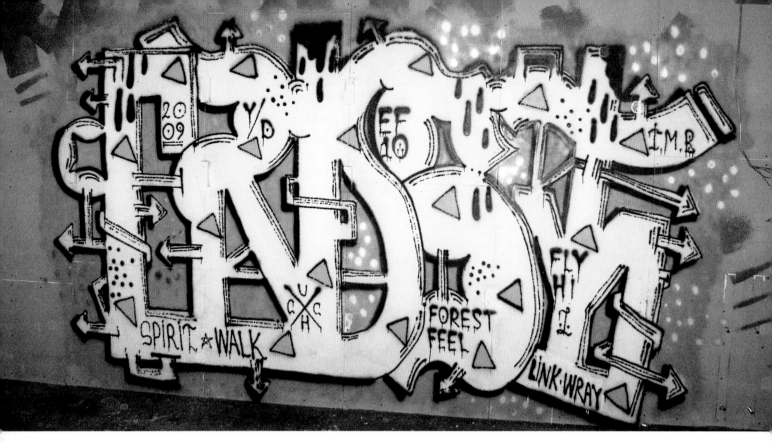

COPENHAGEN

BORN 1980, Haderslev, Denmark **MEDIUM** Spray paint
STYLE Avant-garde graffiti, punk graffiti **INFLUENCES** Experimental music, punk **CREWS** United Hands City Circus, EF10, IMB

AFFEX VENTURA

JAN S. HANSEN • KOMET • CRUST • TRAZY

With a style that has evolved from a history and continued activity in experimental music, Affex Ventura's dark, witty, often twisted graffiti shows a truly eclectic set of influences. From the visual regimes of American hardcore to tattoo culture and anti-establishment political movements, Ventura (perhaps now better known in fine art circles as Jan S. Hansen) has embraced a "low-life style" in his illicit production and an aesthetic inspired by the "hobo-drifter" culture, the DIY ethic, and an independently minded socio-philosophy.

Born in Haderslev in 1980, Hansen's first major influence was the punk and skate culture in Denmark; he first commenced painting anarchy symbols and band logos around his hometown, and by the mid-1990s he

was also beginning to make classic graffiti. He traveled widely from around 2001 and the various impressions and ponderings that emerged through his journeys began to find their way into his art. Transforming these observations into a "visual anthropological mash-up," his works started to take further cues from outsider art, inner city trends, and a steady dose of "punk attitude": Many of his outside and fine art works at this time featured poetic fragments of text mixed with both detailed and crude images.

By 2002 Hansen had established the group EF10 (Extended Family10) with a group of like-minded writers who first met in Barcelona and later regrouped in Copenhagen. The group now counts around twenty-five members—a diverse constellation of artists, musicians, graphic designers, and tattooists. The members find time to paint graffiti in one form or another, complementing each other in style, as well as in other creative outlets. As well as EF10, Hansen's work is also linked with his crews United Hands City Circus and Curbkids, groups who take what they call a "freecycling" approach to life. What remains central to Hansen's practice, however, is the strange experimental mix of punk philosophy, ethnology, and sardonicism that his work continues to employ.

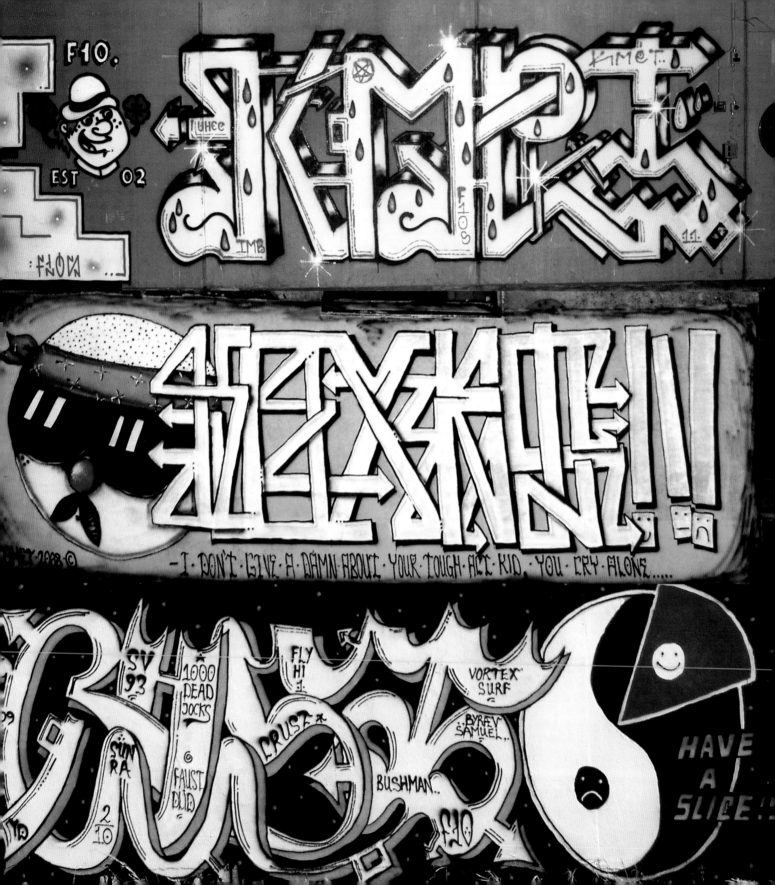

- I DON'T GIVE A DAMN ABOUT YOUR TOUGH ACT KID - YOU CRY ALONE.....

HAVE A SLICE!!

COPENHAGEN BY AFFEX VENTURA

Affex Ventura's map, entitled *Dumpstermap of Nørrebro*, is a locational guide to the key sites for dumpster diving (often known as skipping in the United Kingdom) in Copenhagen's northwestern Nørrebro district. Produced with an accompanying fanzine entitled *In the Trash*—as well as an accompanying bin key strung across the piece itself, a crucial tool for any dumpster diver—the objects provide what was, in 2006 when the piece itself was made, a conclusive account of the various options available to one searching for discarded yet valuable objects in the city—from fruit and vegetables, to house and oil paints.

Dumpster diving itself is a practice with many links to the graffiti world. An act often undertaken by artists looking for materials and by environmentalists seeking to reduce their ecological footprint, it has associations with the "racking" element of graffiti culture (the refusal by many artists to ever pay for materials), as well as the hobo culture that stresses a way of living outside conventional means. The attitude of many dumpster divers, as with the culture of squatting in general, therefore follows the anti-establishment, anti-capitalist ideals that many graffiti artists take on. The depiction of the location of the famous Ungdomshuset or "Youth House" (a now demolished site that was a focal point for underground music and art in Copenhagen) in the Nørrebro area on Ventura's map is therefore no accident.

Guided by the fanzine and the map, the viewer (or the dumpster diving novice) can therefore learn where and when they should explore in order to undertake a successful diving mission. "Nr. 1: Behind the gate. Good place to find house paint and oil paint and sometimes various items in the bulky refuse pile." Or "Nr. 5: Bakery. Enter through the gateway in Gormsgade. There's bread and cakes in these containers." Or perhaps "Nr. 7: Kvickly supermarket. The big baller of food and many things. Here you can find a lot of different things, like power tools, DVD recorders, phones, lamps, clothes, exercise bike (!) and after xmas you can stock up on chocolate for two months, or get fruit and vegetables everyday." With this wealth of information, Ventura's map provides us with an insider, bottom-up view of Copenhagen, a hidden realm of knowledge presented through the cartographic medium.

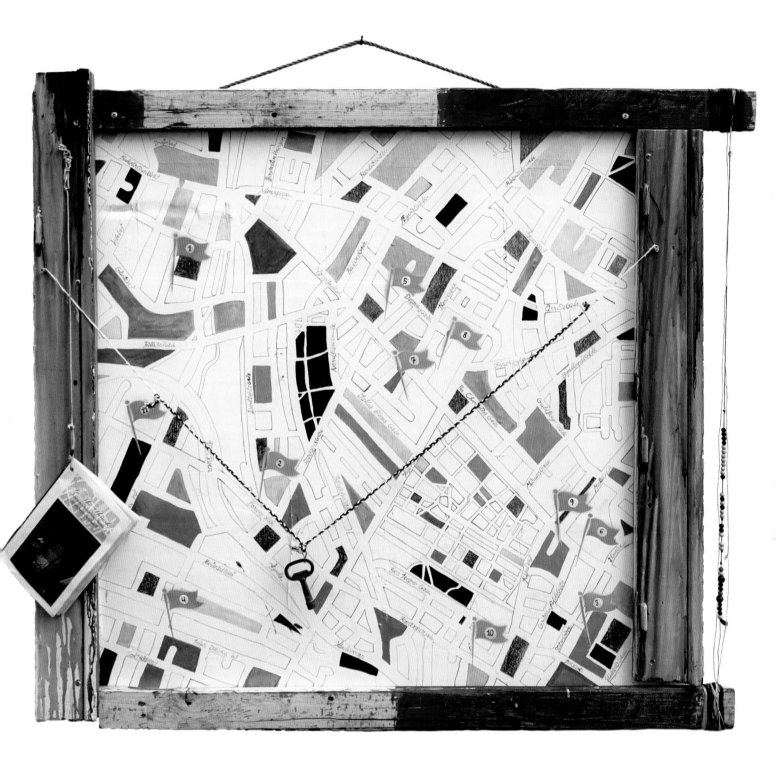

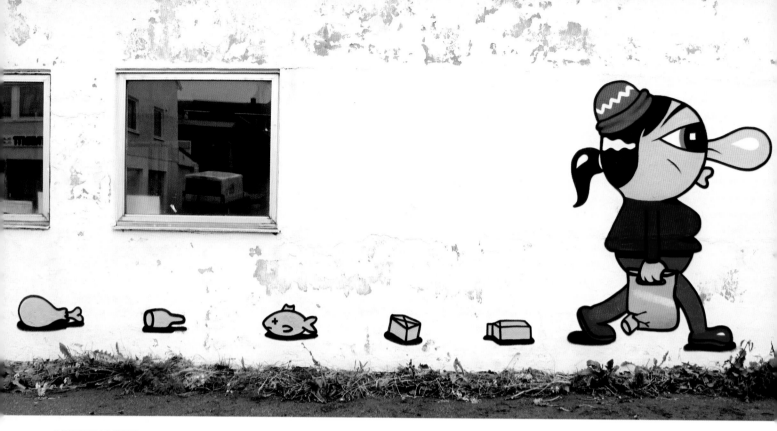

COPENHAGEN

BORN 1975 **MEDIUM** Spray paint, 2-D sculpture **STYLE** Melancholy Walt Disney **THEMES** Absurdity, satire **INFLUENCES** Donald Duck, Lucky Luke, Astérix, Mode2, Delta, Pike, Hex, Cliff159, Blade **CREWS** BEA, ASS, VTS, Lag

1 Vardø, Norway, 2012
2-3 Copenhagen, Denmark, 2012

HUSKMITNAVN

Wryly describing his style as "melancholy Walt Disney," HuskMitNavn (meaning "Remember My Name") is a graffiti artist from Copenhagen. He brings a humorous, lighthearted approach to his productions, which comment on the absurdities of everyday life, contorting reality through a mirror of irreverence and satire. He honed his work ethic through years of practicing graffiti, but Husk's prodigious output never sacrifices quality for quantity; his perpetually novel, yet always recognizable characters have grown both in their craftsmanship and clarity, moving effortlessly from paper to wall, and from newspaper to gallery.

Husk became obsessed with drawing at a young age. He remembers seeing graffiti dotted around Copenhagen in the early 1980s, but it was not until 1993 that he moved his workspace from sketchbooks to the city itself. By 1996, he had resolved to work full-time within the art world, but not knowing any professional artists he struggled for a number of years,

trying to fathom how to turn this ambition into reality. After stints working as a postman, cleaning assistant, and helper in a retirement home, he trained as an art teacher. The experience forced him to "think of better ways of doing things than I was taught," he revealed in 2011, which helped him to develop his signature style and resolve on a direction to take.

In 2000, he started a famous poster campaign in Copenhagen, transplanting the comically impudent creatures from his graffiti pieces into the public arena. This led to invitations to work on more art projects, but it was his series for the Danish newspaper *Politiken* (Denmark's most widely read paper)—for whom he produced more than 500 editorial cartoons between 2003 and 2012—of which he remains the most proud. More recently, he has been working on two-dimensional sculptural works and larger-scale murals.

The one constant in Husk's career to date is the drive to keep on creating. His graffiti education taught him the importance of hard work and maintaining a tight focus. With his ten-drawings-(or-one-painting)-a-day habit, Husk continues to follow this rigorous ethic across a variety of media, building up an oeuvre that can boast abundance and excellence in equal measure.

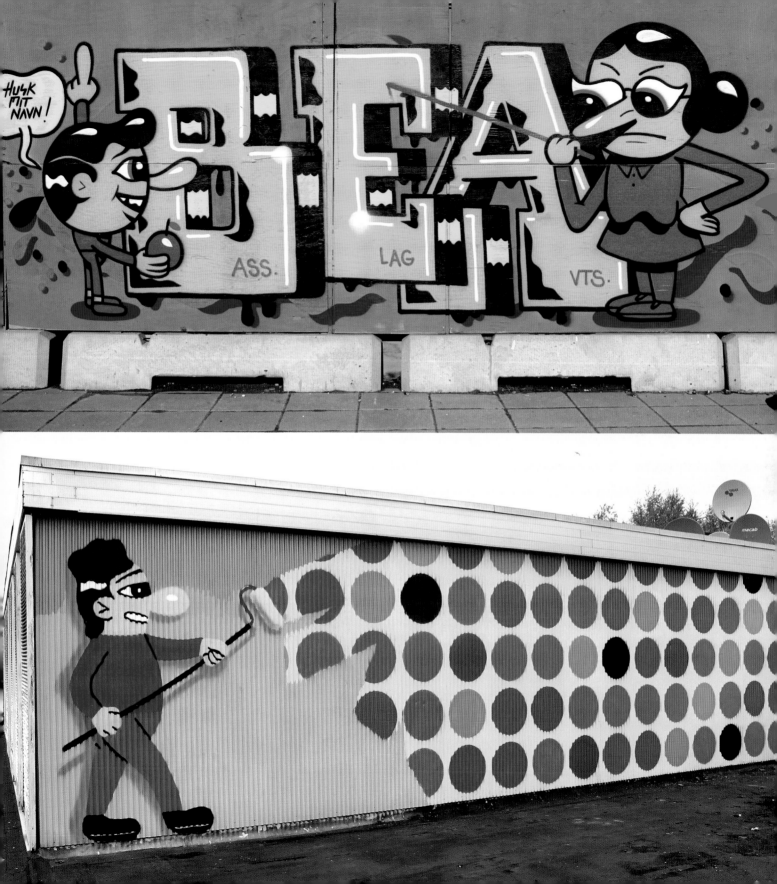

GOTHENBURG

BORN 1978, Falkenberg, Sweden MEDIUM Spray paint, acrylic paint
STYLE Abstract muralism, abstract figuration THEMES Balance, symbolism
of objects INFLUENCES Don Martin, Philip Guston, Max Andersson

EKTA

Ekta is perhaps the most prolific of the artists profiled within this book, someone who seems to need to paint and draw solely to survive. Pushing every theme he develops to the limit, playing with color and form until every possible permutation has been tested, he refuses to get too comfortable with his work, forcing himself to continuously progress and develop. His earlier efforts show the marked influence of both the American Neo-Expressionist Philip Guston and the Swedish underground filmmaker and comic artist Max Andersson, in particular their mutual proclivity toward dark humor and cartoonish, figurative forms. More recently, Ekta has begun to represent objects, or perhaps more correctly, characters as embodied through objects. This symbolism is just one of his many aesthetic channels, however, merely another way for him to discharge his illimitable impulse to create.

Born Daniel Götesson in 1978 in Falkenberg, a small coastal town in southern Sweden, Ekta was obsessed by drawing as a child, spending hours sketching, filling every scrap of paper he could find with letters and characters. At that point, his main influence was the legendary *MAD* magazine—in particular "*MAD*'s Maddest Artist," Don Martin. But it was as a teenage skateboarder that Ekta's lifelong commitment to art was confirmed. The small art sections in skate magazines such as *Thrasher* and *Slap*, featuring the work of artists and early influences such as Mark Gonzales, Chris Johanson, Ed Templeton, and Neil Blender, gave Ekta an insight into the possibilities of visual expression; they were to prove similarly influential for sometime collaborator Nano4814 (see pp.328–31). He also credits these artists with helping him to "ignore the fact that art is not normally presented as an option in life, as something you can do when you're an adult."

Having moved to London at the age of eighteen to skate with one of his close friends, Ekta ended up staying for nine years, graduating from the London College of Communication in graphic design and illustration in 2005. While London helped revive earlier flirtations with graffiti, and gave him a solid illustrative grounding through his studies, he left with no clear artistic direction. Having moved back to Gothenburg, where he still resides, it took around two years (and some awful jobs) for him to make the transition to the style we now know.

1 *The Whole Is Greater than the Sum of its Parts*, Växjö, Sweden, 2011

STRUKTURA ŻYCIA
JEST WRAŻLIWĄ
FORMĄ.

1 *Life Structure*, Wroclaw, Poland, 2012
2 *Vanity*, Gdańsk, Poland, 2011

1

2

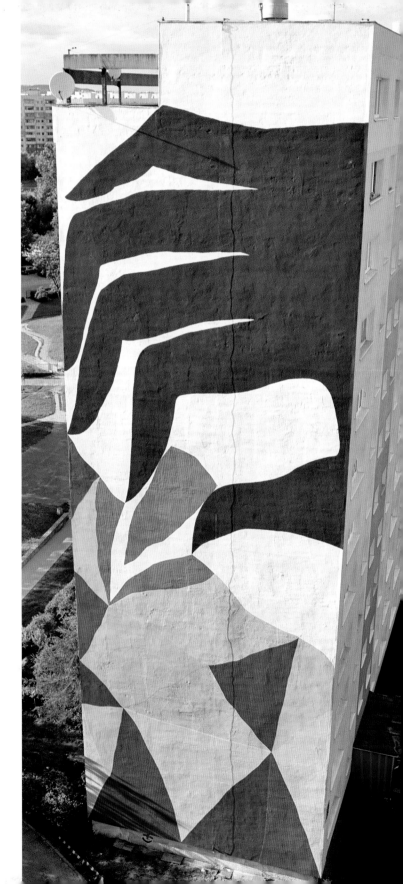

Two emblematic pieces provide illuminating insights into one of Ekta's signature styles: *The Whole Is Greater than the Sum of its Parts* (see pp.238–9), produced in Araby, Växjö, Sweden, in 2011, and *Life Structure* (see image 1), produced in Wroclaw, Poland, in 2012 for the Out of 5th festival curated by Zbiok (see pp.250–3). Having asked people that he met around his chosen sites to tell him what was most important in their lives, Ekta reflected their replies in the objects and symbols he painted, linking these to other artifacts that were personally important to him. The delicate, complex, precarious structures in the finished artworks convey a sense of vulnerability. Ekta's compositions stress not only the interconnectedness and fragility of community but also of life itself, the intricate balancing act that we each confront on a daily basis.

Ekta has revealed the story behind several key objects in *The Whole Is Greater than the Sum of its Parts*: a Romeo character sporting a dunce's hat at the top left (perhaps the artist himself?); the blindfolded head of a Neo-Nazi at the bottom right with a pig's nose ("He's got a big ear to grab real hard," Ekta notes), a possible allusion to the city's history of far-right tendencies; and a switchblade (a recurring image) at the middle edge on the left. A laughing head at the center right is a tribute to deceased artist (and further influence) Roger Risberg, and a figure just under the moon (top center) was inspired by "a drawing a little girl from the area made of herself reading a book." A golden feather at the top stands for a man he met who loved peacocks. The weights to the left "symbolize problems in life pulling you down," while a group of shapes forms a bicycle for the many children who told him that bike-riding was their favorite pastime. Toward the top right, a group of objects make up the name of his son, Ilja.

The half-full heart at the very peak of *Life Structure* was, "for my family, with the initials of my girlfriend and son," while the pencil referenced a woman he met who was an author. The neck of a guitar was "for a guy with a recording studio nearby"; the almost empty bottle recalled a "local drunk who watched me paint the whole day." The volleyball alluded to a "guy living close who told me his life is dedicated to this sport," while the hat was a tribute to the Croatian cartoon series *Professor Balthazar*.

In both paintings, symbols contain a plethora of meanings, a range of significances that could be appreciated either for their different implications or for their basic aesthetic appeal. Our eyes are attracted to the whole and its parts, the small details, the points of physical stress, the way the images seem to teeter. While Ekta continues to extend his oeuvre, producing more sculptural works, installations, collages, and even editorial illustrations (including a recent commission by the *The New York Times*), he always returns to the simplicity of drawing, the compulsion to give his mind free rein on a surface.

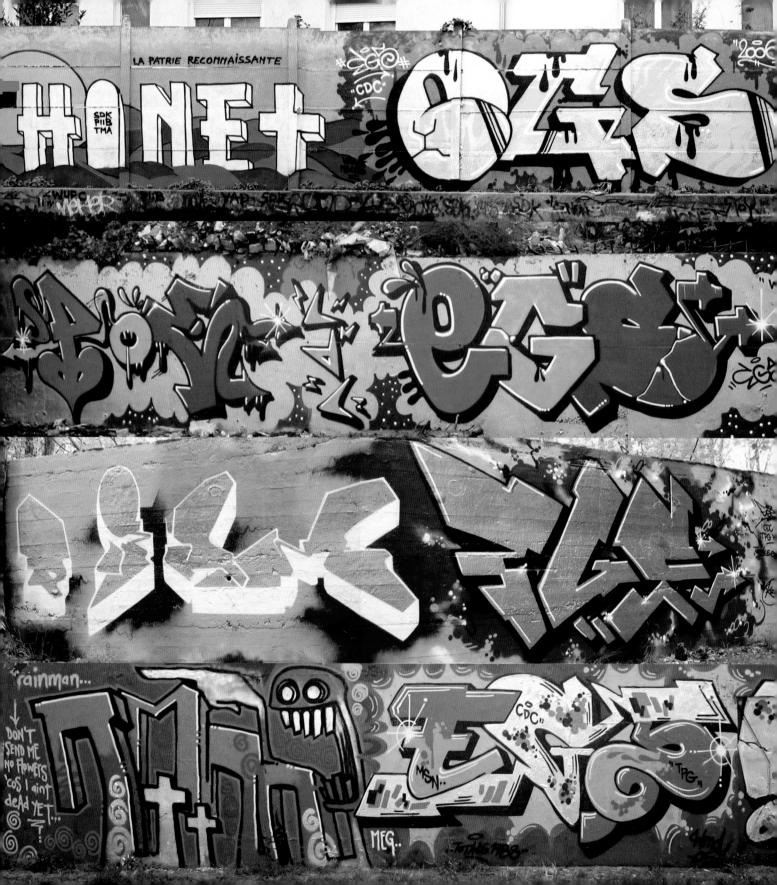

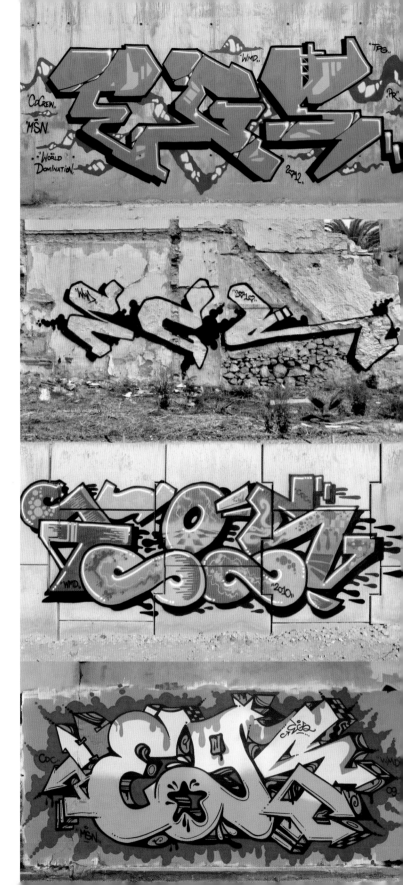

HELSINKI

BORN Unknown MEDIUM Spray paint, India ink STYLE Classic graffiti, monochrome calligraphic drawing, abstract lettering THEMES Anthropology, folklore INFLUENCES Typography CREWS WMD, TPG, MSN

EGS

Egs is remarkable not simply because he has painted all over the world—over five continents and more than forty countries from Bucharest to Buenos Aires, London to Lagos, and Shanghai to Santiago. He has also painted with everyone from all over the world—from Ket to Lodek, Rainman to Risk, Petro to Pike, and Honet to Hes. A self-proclaimed, graffiti anthropologist, Egs is not only a style master but a writer who was producing work in the 1990s that still appears ahead of its time today. Moreover, he has also been pivotal in the historical documentation and dissemination of the practice: an artist-archivist spurred by an intense desire to explore both the formal and folkloric truths of graffiti, and uncover its social as well as material foundations.

While Egs's more recent output has become increasingly abstract (see map pp.244–5), his ongoing illicit work has resulted from a long and intense study of the form, in which he has juxtaposed the different eras that he loves through his collagist style. He started out in the mid-1980s as part of the first wave of graffiti in Finland; by 1988 he had traveled to Stockholm and Paris to discover and document their burgeoning scenes. Although he lived in one of the most geographically distant parts of Europe, Egs was fascinated by the regional connections graffiti generated and travel became integral to his life. His inquisitive interest in regional graffitti led him to form close links in France, Sweden, Denmark, Germany, and England by the early 1990s.

All of these experiences converged when he formed his now legendary crew WMD, an international conglomeration of artists including Honet (see pp.166–9) and Petro (see pp.160–3). This group is a testament to Egs's entrenched internationalism, as well as the highly cosmopolitan nature of graffiti itself. The bonds he has formed through this collaborative global work are therefore as much a part of his personal practice as the homages he makes to graffiti folklore, as he puts it, through every "wave, star, drip, or block" he paints. Traveling the globe to both paint and investigate, to build relationships and share knowledge with other diverse practitioners, he has developed an almost unmatched insight into the vast graffiti culture worldwide. His work shows an acute understanding of the endlessly manipulable possibilities of the alphabet, as well as the various movements, styles, and traditions of graffiti itself.

1 Malaga, Spain, 2012 2 Athens, Greece, 2010
3 Madrid, Spain, 2010 4 Istanbul, Turkey, 2009
5 Paris, France, 2006 6 Bucharest, Romania, 2007
7 Stockholm, Sweden, 2004 8 Budapest, Hungary, 2005

HELSINKI BY EGS

Egs's map of Helsinki, a pen-and-ink rendering undertaken in his classic inkblot style, is deeply influenced by the calligraphic essence of graffiti. Silver and black are his favorite colors for writing graffiti both to help his letters stand out and because they "cannot be fixed or camouflaged with other colors." His use of Indian ink and brushes in his fine art work attempts to connect these two practices, as well as force the viewer to recognize the purity and complexity of the graffiti image itself. Persisting with a typographical theme in his designs on paper—each work containing the three letters that make up his name, albeit abstracted almost beyond recognition—the map he has produced is not only an abstracted version of his hometown of Helsinki, one including the islands, bays, and peninsulas that make up the capital, as well as its bridges, ships, and cranes, it also exemplifies Egs's inimitable chirographic style. Twisting and reshaping the topography until it proclaims his own name, his map also displays his love and admiration for the city of Helsinki. It is an emotional and physical attachment that he explains himself below:

> Helsinki was a great place to grow up. The cold war was still frozen hard and Helsinki was one of the few gateways between these two blocks. The city was great for adventures: Docks; freight trains; old trams; inner city factories and warehouses; abandoned and empty lots still marked by World War II bombing; and old drunks who were veterans of the war itself. These places were my childhood playgrounds and the sea connected them all. The sea also brought my grandfather to Helsinki. He was born in Vyborg and worked in a fish smokery. After World War II, when Vyborg was taken over by the Soviet Union, my grandfather fled to Helsinki and started a small smokery in Helsinki harbor. Helsinki's location in the far corner of Europe made me and my friends travel a lot, too. The writers from here were among the first InterRail generation, traveling to meet other writers around the world. This remoteness helped to create the unique Helsinki style in the pre-internet era. I really like it up here.

PRAGUE
BORN Unknown MEDIUM Various STYLE Urban interventions,
urban installations THEMES Appropriation of space, social action
INFLUENCES Guerilla art COLLECTIVE Ztohoven

EPOS 257

A member of the notorious Czech artistic collective Ztohoven, EPOS 257 has created a form of popular, confrontational protest art within the city, one engaged in questioning what he describes as the "heap of banalities" that exist in the public sphere. EPOS takes his inspiration from contemporary urban life, which he examines from different perspectives, shaping and building a relationship with it through active participation and transformation.

Although many of his works can be amusing, he laments the fact that art is so often "degraded to a mere joke," an attitude that serves only to domesticate its violence and ignores the fact that the issues it tackles are substantial and serious. Striving to address the general public, not just those familiar with street art or the art world, EPOS focuses on, in his own words, the "experience, the sensation of a given environment,"

reaching out to wider community through galvanizing the "shared space that surrounds us."

EPOS has evolved his particular brand of urban interventions after years of being steeped in graffiti culture, and derives a huge amount of motivation and inspiration from this earlier part of his life. He admits that the experience of painting his first metro in 1999 "triggered an avalanche" inside him: "The adrenaline, the sweat, the stress, paranoia, energy, satisfaction, it was an incredibly strong experience," he recalls. "In that moment I knew that I lived at 100 percent. Everything went away, school, athletics, friends, but at the same time I found all these aspects and even more there." Creating a world of adventures in the dark corners of the city gave him an understanding of the urban landscape from a very different standpoint, one that taught him "not to be afraid to show what I do, to do things to the absolute fullest." While continuing to draw on the values and principles of graffiti culture, his work slowly began to move away from traditional forms. He began to experiment with different materials and media, embracing the worlds of performance, sculpture, and architecture.

1 *50m² of Public Space*, Prague, Czech Republic, 2010
2 *Urban Shoot Paintings*, Prague, Czech Republic, 2011

Two of his more recent projects underscore this shift in perspective. *Urban Shoot Paintings* (see image 2), which took place in and around central Prague in 2009 and 2011, harked back to the very roots of guerrilla art, representing an attack—literally, a visual assault—on the billboards of the city. Utilizing a homemade weapon and ammunition, EPOS fired bullets filled with colored paint onto these unspoiled white surfaces in an act that dramatically voiced his opinion and created an abstract artwork at the same time. As an onslaught not upon one specific advertisement but on the concept of billboards as a medium, EPOS sought to reclaim these city spaces for art and to make people reassess the omnipresence of such hoardings and their suitability for our urban environments—indeed, the reasons why they are there at all.

50m₂ of Public Space (see image 1) had a similar premise to that of *Urban Shoot Paintings*, but worked in a more subtle, perhaps more insidious way. EPOS appropriated a 50m₂ section in the very center of Prague's Palackeho Square—known locally as the "Czech Hyde Park" because it is recognized as a space where people may freely assemble—enclosing the space with a large, square metal fence that bounded it off from the public. The project—which remained in place for an incredible

fifty-four days, from September 4 to October 27, 2010—sought to expose the idea of public space of a myth, by emphasizing how accustomed we have become to having our living space infringed, how readily we conform, how willingly we accept restrictions as the norm. Simultaneously, however, EPOS was also poking fun at the inefficiency and incompetence of the institutions that govern us—highlighted by the numerous phone calls to local councils and various authorities that are revealed in a short film he made about the project—showing us the cracks and crevices that can be exploited within them.

For EPOS, art in a public space both offers him a larger degree of freedom and makes him feel greater responsibility toward the urban environment, linking him more closely to the city through what he sees as a "clear and specific interaction." In his work, he strives to expose our increasing indifference to our environment, the lack of care—or perhaps lack of consciousness—about how we can affect it. Instead, he shows us how we can come to administer it, returning it to the fold.

By actively engaging with the urban environment, and creating a dialogue with it, EPOS aims to reclaim our rights to the city, striving to remind us not only of its pitfalls but also its possibilities.

PRAGUE
BORN 1978, Prague, Czech Republic MEDIUM Spray paint,
installation, sculpture STYLE Urban installation, graffiti
sculpture THEMES Beauty vs. urban decay

POINT
JAN KALÁB • CAKES

Probably best known for his large-scale, three-dimensional, alphabetical
sculptures, Point is one of the most genuinely multidisciplinary
independent artists working today, who utilizes a diverse array of media
and materials in his public practice. He works in a classic graffiti manner
under the name Cakes and in a fine art vein as Jan Kaláb; however, it
is his practice as Point that is discussed in depth here, taking in the various
installations and projects (on both micro and macro levels) that he has
undertaken all over the globe.

Strangely enough, Point's first move from two- to three-dimensional
work, which occurred during his first experience of exhibiting in 2001,
took place inside the gallery rather than in an outside space. Although
at that time he was still painting graffiti (as part of the second wave of

Czech writers, a scene that emerged with the fall of the Communist
regime in 1989), Point had recently commenced studying at the
Academy of Arts, Architecture and Design in Prague under the
tutelage of the sculptor and conceptual artist Jiří Beránek. At that
point he had only ever painted directly onto walls, but as he was
forbidden to use this method in the Manes contemporary art gallery
where he had been invited to exhibit, he needed to find a new method
and form of working. With free access to chipboard and tools, it occurred
to him that he could cut his name directly into the wood and screw
it into the gallery wall itself. From this early, almost enforced, yet
highly successful experiment, and with the increasing access he
had to wood, metal, and plastics in the workshops of the academy,
Point went on to design more complex and large-scale installations,
the most famous of which he installed in Jan Palach Square in central
Prague in 2004. Erected without permission, it survived in the historic
square for more than three weeks and was discussed by nearly every
news outlet in the city.

1 Berlin, Germany, 2007 2 Prague, Czech Republic, 2006 3 Prague, Czech Republic, 2007 4 Prague, Czech Republic, 2004 5 São Paulo, Brazil, 2010 6 Nymburk, Czech Republic, 2012

The enormous scale of the Jan Palach Square project offered a stark contrast to his next incursion in the public sphere. The *Pointíci* sculptures (see images 1 and 2), over 200 of which Point mounted between 2004 and 2006, were positioned all over Prague. Often mistaken for dragons, UFOs, or birds, these small statues, constructed out of plaster and iron, displayed his name in a highly intricate manner and were inspired by a childhood memory of a lost ball that he once saw lying on the roof of a department store. "I wondered how it got there, and what its fate would be," he has revealed. As a result, he produced the *Pointíci* to recreate this childhood feeling and generate a sense of wonder in terms of the genesis, meaning, and eventual destiny of his statues. Although many of his sculptures were lost to the city, either destroyed or "liberated" by its inhabitants, many remained in place for years. "I don't actually know why I had bothered making so many large and heavy objects, which were so short lived!" he later admitted; "The smaller the piece, the bigger its chance for survival, the lower [the] cost, the quicker it is to make and the lighter and less bulky it is, which means less labor intensive. I should have thought of it ages ago!"

At the same time as he was working on the *Pointíci* sculptures, Point was involving himself in numerous other projects, two of which employed the damaged street surfaces of Prague as their medium. *Colored Pavements* worked directly upon the city's broken tarmac sidewalks. Recognizing the beauty in deterioration, as "abstract paintings" in need of assistance, Point worked in a similar manner to a "child filling in a coloring book," walking through the city and painting directly on the tarmac patches. Similarly, his *Cobbles* project (see image 3) made use of the loose stones that can be found on every Prague street corner. Removing them from their site, painting them (rather like the national tradition of decorating Easter eggs), and later returning them, the simple project, much like *Colored Pavements*, had a powerful visual effect.

Since then, Point has returned to creating three-dimensional installations, producing two in São Paulo in 2010 at MuBE (Museu Brasileiro da Escultura) and at MASP (Museu de Arte de São Paulo) in 2011. These gigantic sculptures have taken a more explicitly architectural turn and demonstrate a cleaner, more pared-down formation, similar to the polystyrene "Pointing" installations he has also been recently producing. Together with his more recent experimentation with abstract fine art, his curation of the Names Festival, and his return to large-scale muralism, Point continues to diversify and experiment with every possible avenue of artistic production: Never limited by any form of technology or material, or by any methodology or medium, Point simply seeks a passionate encounter, a way of transforming the images he visualizes into reality, a way of establishing a true "presence in the city."

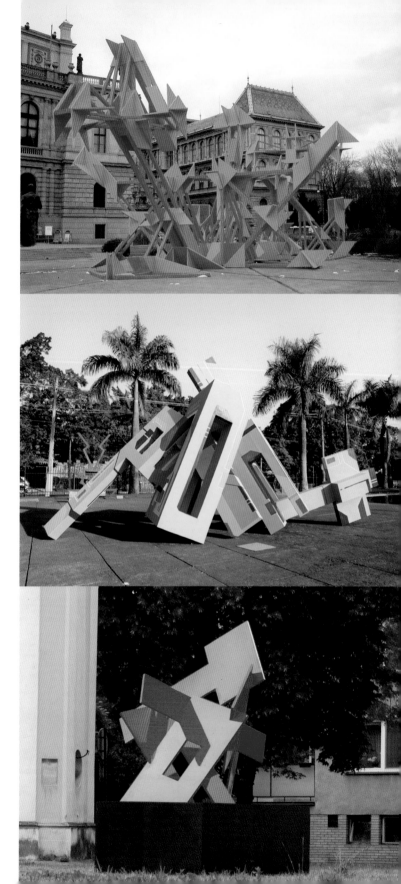

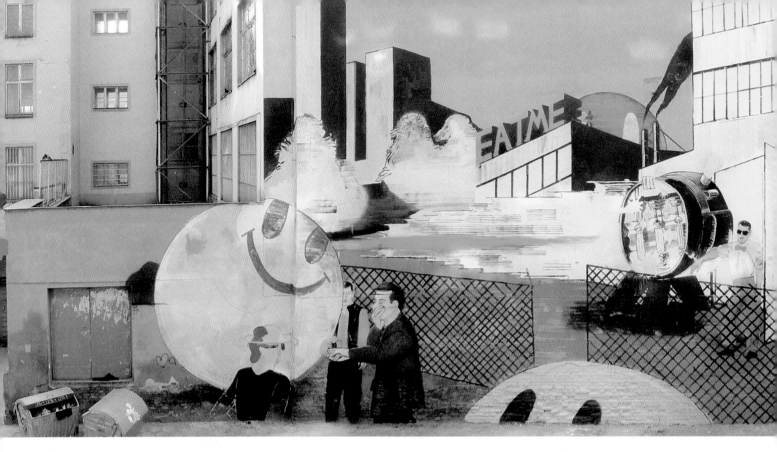

WARSAW

BORN 1982, Wroclaw, Poland **MEDIUM** Spray paint **STYLE** Contemporary muralism **THEMES** Longing, escape, desire **INFLUENCES** Polish punk, cartoons, protest art, Orange Alternative, graphic novels

1	
	2

1 *Eatme*, Wroclaw, Poland, 2012
2 *Good to Know*, Wroclaw, Poland, 2012

ZBIOK
SLAWEK CZAJKOWSKI • ZBK

The curious, often provocative work of Polish painter Slawek Czajkowski, known more commonly as Zbiok, casts a sure, unwavering eye over contemporary popular culture, forming a graphic style of production that is influenced in equal measure by the cartoons of his youth and Polish protest art of the early 1980s. His work consists of strange, often dream-like scenes and tense panoramas that are unsettling in their formal and narrativist dimensions. His more recent paintings show an enchantingly hybrid, cosmopolitan style that embraces Eastern European heritage and uses it to its advantage as a tool for experimentation. His practice is also inspired, however, by the spirit and aesthetics of the Polish punk scene, which was highly critical of the Communist regime. Demonstrating a deeply rooted link to the dissident ethic prevalent in Polish art, Zbiok's work takes themes such as longing, escape, and desire, and embues them with real political gravity.

Born in 1982 in Wroclaw, the largest city in western Poland, Zbiok grew up during a time of massive change. It was a period in which the fall of the Iron Curtain and the end of state censorship facilitated a radical change in societal consumption, both aesthetically and commercially. Naturally, with the increasing influence of the West, a distinctly American brand of graffiti had taken root in the country by the mid-1990s and Zbiok became deeply involved only a few years after its establishment. Although there had been a strong history of urban aesthetic street actions in Poland prior to the fall of communism, these native elements were pushed to the margins during this era and the "hip-hop" style of production almost totally dominated the Polish graffiti movement. Studying art due to the influence graffiti had upon him, however, Zbiok soon discovered this overlooked indigenous work and was influenced by a whole new avenue of possibilities. Groups such as the Orange Alternative (an underground protest movement from Wroclaw who famously painted comical dwarves on the remnants of anti-regime graffiti that had been erased by the police) and Luxus (who made the first conscious fusion between the fetishistic luxuries of the West and the dull grayness of Poland under martial law) had a huge impact on Zbiok's attitude to art in terms of its

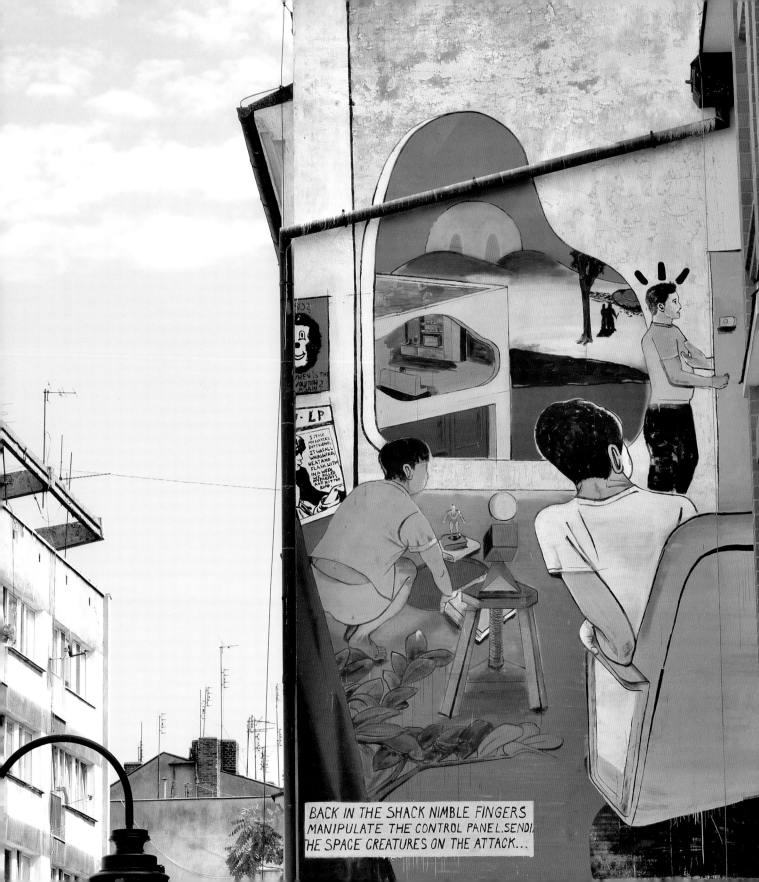

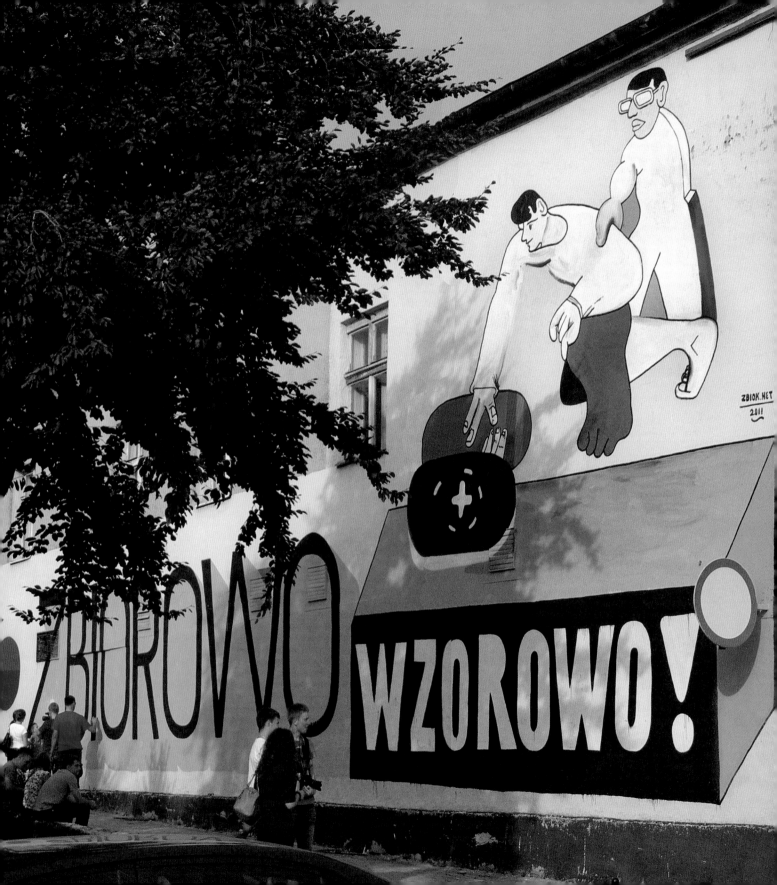

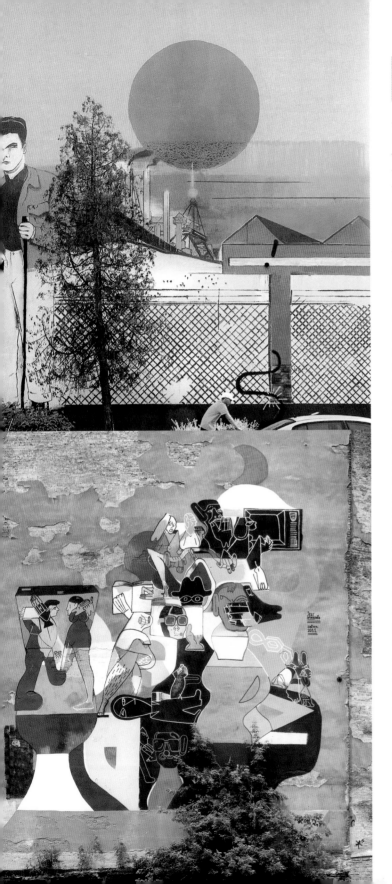

1 Jarocin, Poland, 2012
2 *Zbiorowo—wzorowo* ("Collectively–perfectly"), Oświęcim, Poland, 2011
3 *Jest spokojnie* ("All Is Quiet"), Krakow, Poland, 2011

social and aesthetic potential. After graduating from the Institute of Plastic Arts and Culture at the University of Zielona Góra in 2006 (under the tutelage of renowned Polish artist Ryszard Woźniak), Zbiok became what he terms a "painter working in urban space," rather than a graffiti writer or a fine artist. Although his style had profoundly altered, he explains that what remained crucial was the "dialogue between form, color, and potential message," the way one would "approach specific spaces" and attempt to "correctly fit in to them." His practice responded to the city as "more than a wall," as a living and breathing space with rich social, historical, and political contexts.

Zbiok's first work studying at Zielona Góra was overtly influenced by the subcultural imagery of hip-hop, skate, and punk, and featured numerous hooded or masked characters and a thematic undercurrent of violence. However, his more recent work has developed to a more cartoon-like style similar to that of the graphic novel or movie stills. Works such as *Eat Me* (see image 1, p.250), with its huge and vaguely unsettling smilies, its high-rise buildings, and shocked characters, or *Good to Know* (see image 2, p.251), with its stunned figure and fearful couple stood in front of a crashed UFO (with the archetypal caption, "Back in the shack nimble fingers manipulate the control panel sending the space creatures on the attack," and, for those with sharp eyes, the Raymond Pettibon poster lying in the corner), give the viewer a small insight into a wider world, an eerie scenario that we stumble upon without being able to reach any final, clear meaning. These snapshot, one-frame images with their extraterrestrial themes, Americana influences, and their latent tension, fuse a 1960s comic-book aesthetic with a more refined, painterly technique, forming what he terms "cultural garbage," a patchwork pastiche of all his influences. They open up a plethora of possibilities, rejecting any easily reached conclusions but instead encouraging the viewer to become wrapped up in the moment of the image. Inspired by the New Leipzig School and artists such as Neo Rauch (although more by its science fiction than its social realism), Zbiok feels it is crucial that these works do not merely function as "pretty" images, but as paintings with uncanny and thought provoking allegories revealing a wealth of hidden signs and symbols. Alongside the allusions toward Independent Public Art in the narratives of some of his works (in *City Kids* and *StreetArt* for example), allusions with a similarly ethereal content to his other recent images, Zbiok continues to develop aesthetically and thematically, finding new sources of inspiration and new graphic techniques. He has no desire to tell people what to think through his images, but aims to explore the social world using an East-West, retro-futuristic aesthetic that works at the edge of the commonplace and the ambiguous, the natural and supernatural, a timeless surrealist pop.

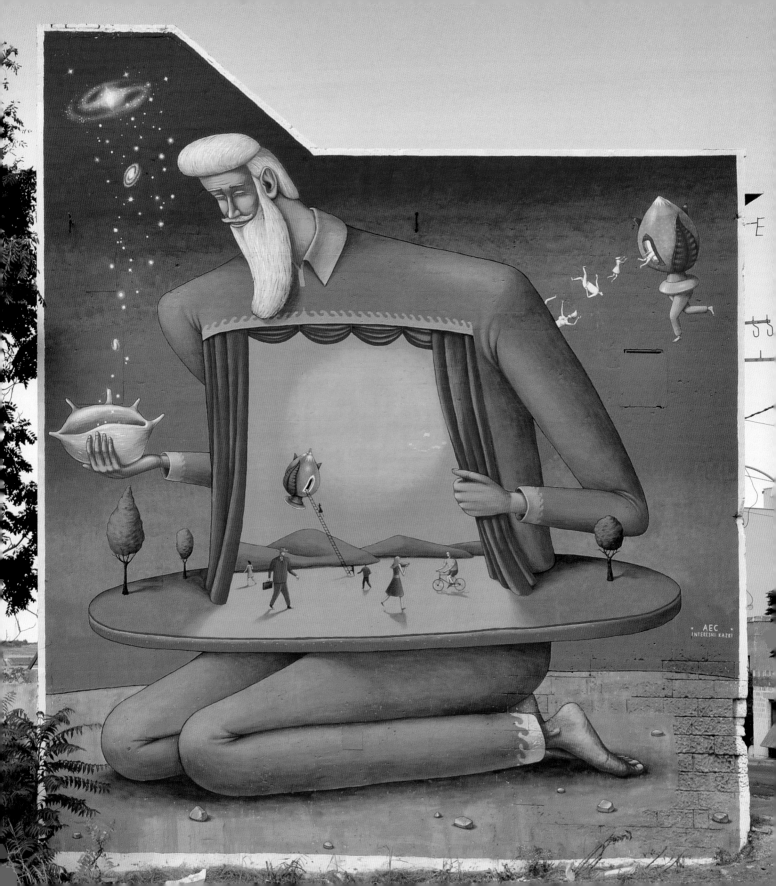

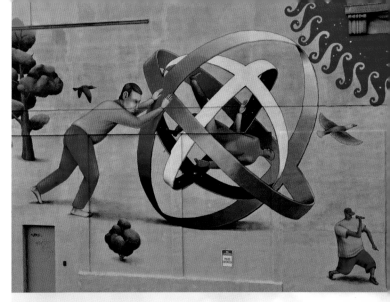

BORN Kiev, Ukraine MEDIUM Spray paint STYLE Contemporary muralism THEMES Spiritualism, allegory, mysticism INFLUENCES Dalí, Möebius, Ukrainian muralist tradition, native fairy tales

INTERESNI KAZKI

AEC AND WAONE

The celestial, allegorical paintings of Interesni Kazki (a name meaning "Interesting Tales") strive to bring the spiritual and the mystical into the everyday. Intertwining folk history and religious imagery with science fiction and fantasy, their images present the viewer with a profusion of mysterious narratives and visual fables that they must attempt to disentangle. Inspired as much by artists such as Dalí and Möebius as by the Ukrainian muralist tradition and native fairy tales, Interesni Kazki have formed a style of contemporary muralism with a transcendental, emotive aesthetic at its core, a popular, ethereal form of public art.

Consisting of two members, known as AEC and WAONE, Interesni Kazki have been painting together since the early 2000s. They started out as prototypical graffiti writers, following the hip-hop wave that hit Kiev in the late 1990s. However, after a few years of concentrating on style writing they became frustrated by the restrictions they perceived to exist on the local scene and felt the need to experiment outside the boundaries of the letter. Equally exasperated by other external influences prevalent in the Ukraine—both the consumption-fueled power of the West and the continual reminders of Soviet propaganda and power—by 2004 they had taken a conscious decision to reach back into their own Slavic culture for inspiration. Exploring the "language of fairy tales"—a language that they regard as a "symbol of life that could give a fuller viewpoint than pure realism"—they therefore adopted a more allegorical visual style, a symbolic form of communication that they argue functions on a higher level of perception than the literal. At the same time, however, Interesni Kazki also felt compelled to explore spiritual themes, using imagery and myths from a religious as well as folk milieu. Believing this to be a technique that could encourage viewers to "reflect on the meaning of life," Interesni Kazki used their surrealist visual stories to search for a way of reinstating spirituality in Western life, rejecting the religion of material wealth, and seeking instead to illuminate a more divine form of affluence.

1 *Pumo*, Grottaglie, Italy, 2012
2 Baltimore, USA, 2012
3 *The Big Bang*, Lublin, Poland, 2012

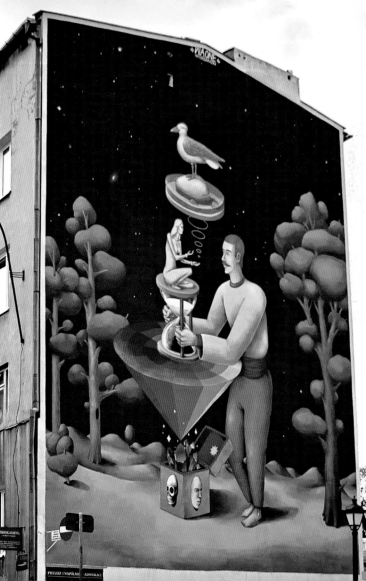

WAONE's recent work completed in Lublin, Poland (see image 3, p.255), and AEC's work in Grottaglie, Italy (see image 1, p.254), are perfect examples of Interesni Kazki's intriguing blend of religious, folk, and popular art, as well as their deeply allegorical, spiritual, symbolic approach. As WAONE has explained, the Lublin image is about the "origin of life . . . the moment of creation from the ancient Aryan legend of the birth of the Universe." The central golden box is a visual metaphor representing "the whole universe before the big bang" and the main character shown is Hindu god "Brahma (the first person born by primordial Light, outside of time and space) opening the box through which our reality appeared: He is putting reality into linear time, and Shakti (the energy, motherly aspect of God) was then born into our material world." In his mural, however, AEC was trying to invent his own "cosmological myth" around the *pumo*, an ornamental ceramic artifact native to the region of Grottaglie (see mural top right and center): "In my myth," he explains, "this old man is both God and universe, who has a human race and an entire civilization inside him in the scene; the mysterious *pumo* at the top of the stairs is like a portal to another dimension and also a symbol of death and a step to eternity." Illustrating the deep significance imbued in each image Interesni Kaki produce, these explanations also reveal how the pair try to positively affect their viewers through presenting "this world with something from above." The pair also stress, however, that many of their images, which they regard as a form of meditation or dream, are beyond their control and even their own understanding. They produce their works intuitively, through a "mystical tool" beyond the "mind and body with its physical senses." Although their works can contain multiple meanings, Interesni Kakzi always preserve the status of their murals as windows onto different, perhaps more sacred, worlds.

Functioning as a lens through which universal truths can be described, Interesni Kazki try to channel a divine spirit within their work that can enlighten human consciousness. Using their work to make sense of the world around them, they have established a uniquely spiritual, parable-infused aesthetic in the world of Independent Public Art.

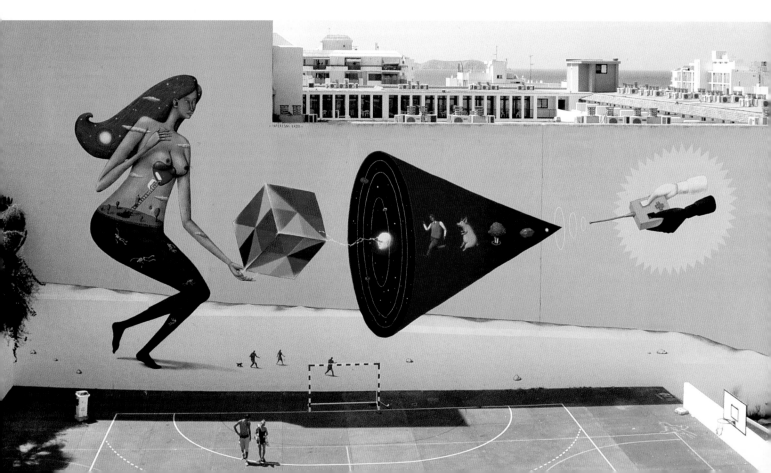

BORN 1986, Kiev, Ukraine MEDIUM Spray paint, photography
STYLE Conceptual graffiti, abstract graffiti THEMES Juxtaposition, abstraction, conceptualism

HOMER
SASHA KURMAZ

Although currently establishing a career as a successful still life photographer, the Ukrainian artist Sasha Kurmaz (or Homer as he is known in the graffiti world) emerged from and continues to contribute to the Independent Public Art movement, forming a distinctive, highly conceptual graffiti aesthetic. He originally picked up a camera to document his illicit street art; however, the abstract, often humorous nature of his photographic work can clearly be discerned within his parallel street production. There is an equivalent juxtaposition of colors, shapes, and objects that represents a unifying thread in both forms of practice.

The Kiev-based artist first started to paint graffiti at the turn of the millennium and his early works, grouped into a project he titled *Vandalism*, demonstrate the off-kilter, unconventional approach to urban art that he has continued to pursue. In one piece the principal letters of his tag hang precariously along a horizontal bar made out of the first character of his name, while a host of others lie in a pile beneath as if lifeless. These early works are prime examples of his unorthodox creativity, a style that is seemingly naive and avant-garde at the same time.

By 2009, Homer's street work was heading in a number of varying directions, one of which saw him move directly against the grain of common graffiti practice. Homer proceeded to actively erase many of his own tags around the city, albeit in a strangely, visually suggestive manner, however (see images 2, 3, and 4, p.261). He described this action as an act of "progression"—an attempt to develop and move forward from his previous production. Similarly, he embellished the actual painted-out erasures that the city authorities had imposed on his works (see image 1, p.260). While providing Homer with an "opportunity to revive and look for the new in the same work," it resulted in abstract, colorful shapes with "subcultural nuances." Both projects turned the fundamental conviction in graffiti's discourse upside down. In a temporal sense they cut short the already ephemeral life span of his tags in a way that was reminiscent of auto-destructive art. Aesthetically, however, the ghostly, blocked-out markings were similar to a Duchampian ready-made.

1, 3 Kiev, Ukraine, 2010 2 Warsaw, Poland, 2010
4 Kiev, Ukraine, 2009 5-6 Kiev, Ukraine, 2010

1-2 Kiev, Ukraine, 2009 3-4 Kiev, Ukraine, 2010 5 *Conceptual Artwork*, Kiev, Ukraine, 2010 6 *Illegal Inscription*, Kiev, Ukraine, 2010
7 *Spray on the Wall*, Kiev, Ukraine, 2010 8 *Fat Cap*, Kiev, Ukraine, 2011

With *Spray on the Wall*, a series initiated in 2010, Homer's practice returned to its typographic origins, although in a manner that represented a distinct move away from the previous work. These pieces, which Homer described as "conceptual inscriptions"—including *Fat Cap*, *Conceptual Artwork*, *Illegal Inscription*, and the eponymous *Spray on the Wall* (see images 5–8)—removed all evidence of the original graffiti apart from the literal sign itself. In this way they functioned as performative acts—acts that perform themselves or produce an action through their very enunciation. *Fat Cap* therefore is a fat cap, *Illegal Inscription* is an illegal inscription: each sign executing its announcement and making a proclamation through its self-same production.

At the same time as he was making these visually forthright, overtly unambiguous, and unembellished works, however, Homer was also creating pieces that operated in an almost contrary fashion. Although these works showed the same underlying humor, they were entirely decorative, deeply ambiguous, and visually elusive. These experiments with color and form (see images 1–6, pp.258–9) were far removed from any other work then being produced: They were anarchic and innovative to the point of incomprehensibility. Yet, they still remained consistent with Homer's previous work, which searches for the "other" in urban art and the space outside our comprehension. As with his photography, these works enhanced the strange beauty of their commonplace surroundings through their overtly expressive appearance. They provide the viewer with hitherto unmade connections between shapes and shades, and suggest new, often startlingly surreal, associations between objects and ornaments.

Although the art world's emphasis on authorship can inevitably create boundaries for artists, Homer continues to innovate and progress an oeuvre without limits or restrictions, avoiding the trap of being confined to one style. He constantly strives to look for something new in his practice, whether it be graffiti, collage, or photography. Always highly responsive and sensitive to both his philosophical and physical surroundings, his work takes our understanding of Independent Public Art into truly unexpected and exceptional directions.

CONCEPTUAL ARTWORK

ILLEGAL INSCRIPTION

SPRAY ON THE WALL. 2010

FAT CAP

KIEV

BORN 1979, Chervonograd, Ukraine **MEDIUM** Spray paint, photography, performance **STYLE** Abstract graffiti, conceptual graffiti **THEMES** Indexicality, iconicity **CREWS** Psia Crew (Dog's Blood), ETC **COLLECTIVE** La Petite Porcherie

VOVA VOROTNIOV
LODEK • VOL.VO

Vova Vorotniov's artistic production takes its cues from a quite unconventional intellectual heritage, shaping an oeuvre that is as decidedly philosophical and contemplative as it is brutal and illustrative. Inspired as much by the "children's vandalism of the USSR" as by artists such as Kazimir Malevich or David Burliuk, Vorotniov's work shows both (neo-)primitivist and futurist influences and forms a style of graffiti that is distinctly set—both theoretically and formally—within its Eastern European origins. Consequently, his work is both partly identifiable and partly unrecognizable in terms of more "traditional" graffiti production. Following an all embracing, yet always highly qualified approach, it exists in a highly individual arena of its own.

Vorotniov was initially attracted to the "spontaneous communication" of art in the public sphere, which functions, as he says, like "throwing a bottle into the sea with a letter of SOS." His first venture into the street started not with the typical New York-style graffiti, but with the inscription of band icons and various other "badges of anarchy" (a similar root, in fact, to that taken by the *pixação* movement in São Paulo). When he moved from his hometown near Lviv to the capital Kiev, he became involved with more traditional graffiti writing, however. By 1999 he had formed the collective Psia Krew (or Dog's Blood, an antiquated and now almost satirical profanity) and later the meta-crew ETC and collective La Petite Porcherie. Painting murals and trains, stickering and tagging, Vorotniov was highly active within the graffiti scene in this period. He was already beginning, however, to draw on the iconic language of his homeland, utilizing an "ironic logo-image" known as "Le Cozaq Sportif" (a character incorporating the classic forelock hairstyle of the Ukrainian Cossack), as well as a sticker series employing a portrait of the poet and national hero Taras Shevchenko in a parody of commonly used political images. The abstract graffiti style Vorotniov has gone on to develop, however, a style he calls "Abstro" (see image 1) and which he undertakes under his pseudonym Vol.vo, has merged all three of these initial phases—his early metal, punk-influenced production, his traditional graffiti writing, and the avant-garde tradition native to the Eastern Slavonic region. Artist David Burliuk, the father of the "Ukrainian Avant-garde" as well as Russian and Japanese Futurism, has played a significant role therefore in

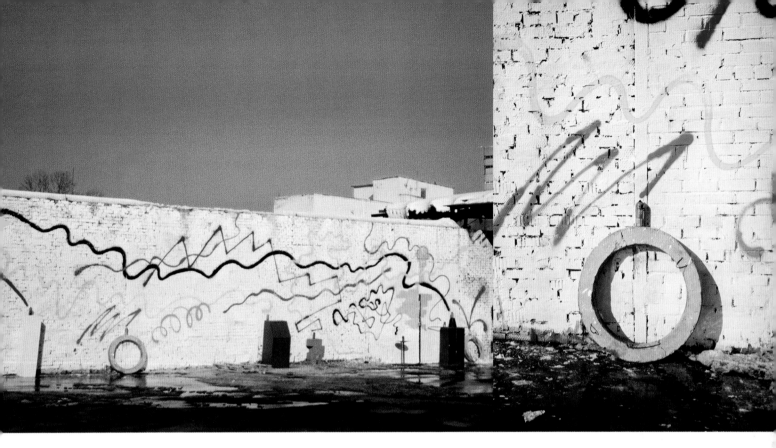

1 Wroclaw, Poland, 2010
2 *Spray as Index 1*, Warsaw, Poland, 2011
3-4 *Orchestral Maneuvers*, Moscow, Russia, 2012

Vorotniov's practice: Burliuk's fusion of folk and high art can be seen as an acid-infused reflection in Vorotniov's work and in the production of what he terms "figurative spam," a "mindless decorative fresco" that follows Burliuk's maxim to function through "a slap in the face of public taste."

Following on from this highly illustrative and uncompromising aesthetic, Vorotniov has produced several more conceptual, performative projects that take a theoretical approach to the production of graffiti itself. *Spray as Index I* (see image 2) a large-scale work completed in 2011 in Praga North, Warsaw, saw Vorotniov not so much attempting to paint a mural as trying to form the remnant of an action, an "indexical mural" that takes "spray" as simply the "manipulated traces" of a performance. In this sense the image acts as an index of the artist's presence, but iconically (and perhaps ironically) working to frame the space itself and highlight the possibilities of the wall. Hinting at the work of another influence, Russian Futurist, Kazimir Malevich, *Spray as Index I* uses the wall as a site for aesthetic interrogation rather than aesthetic spectacle, as a production that does not surround the wall *with* ornament but instead provides an ornamental surround *for* it. In a similar way, *Orchestral Maneuvers* (see images 3 and 4) also takes indexicality as its starting point,

pushing the theme one step further, however. Placing the various instruments of production alongside the markings produced by them—paint rollers and cans either leaning against the wall or placed carefully on the objects adjacent to it—Vorotniov lays bare the tools of the trade, explicitly presenting the trails of the previous performance and the bodily movements that went into the production of the piece. Although the work can be appreciated purely aesthetically (as an abstract sculptural work the choice of colors and objects form a quite distinct harmony), its phenomenological status is more important: Vorotniov is trying to stress the commonalities between graffiti and "dance," the sense in which the final visual remnant is only the surplus or excess of the act; as he puts it the "music" not the "ballet."

Using a multitude of other mediums, including photography, so-called "abstrash" installations, and *objets-vus*, Vorotniov explores the aesthetic possibilities of the street in both its formal and performative senses. Through creating a body of work that is as bound to its local history as it is to that of contemporary graffiti culture, he has embraced a hybridity that intensifies his aesthetic and forms a unique example of modern Independent Public Art.

BORN 1989, Ekaterinburg, Russia MEDIUM Various STYLE Urban installation,
political art THEMES Nationalism, history, myth, contemporary national politics,
public secrecy INFLUENCES James Nachtwey

RADYA
TIMOFEI RADYA

1-3 *Eternal Fire*, Ekaterinburg, Russia, 2011

Although Russian Timofei Radya first began to produce Independent
Public Art less than three years ago, his politically charged, fascinatingly
inventive street installations have made a huge impact, both in Russia
and beyond. Tackling issues such as nationalism, history, myth, and
contemporary national politics, his projects discuss matters that have
a direct affect on the daily lives of their viewers—issues that are often
neglected, shunned by the media, or simply hidden away.

Radya's work takes real risks. His stated aim is to release a vast
potential within Russia's cities—as he has said himself, "In the phrase
'street art' it is street that is important for me. I am convinced that the
walls and streets of our cities are storing a huge energy." Whether the
stance he adopts is political or more poetic, his projects are united

through one desire: to inspire the city and its inhabitants, to energize and
to galvanize them. Even if a project is of help to only one person, Radya
has argued, it is worth all the effort that he has put into it. A focus on
social recuperation and on social conscience, lies at the heart of every
new work that he undertakes.

Radya was born in Ekaterinburg, Russia's fourth-largest city, and still
lives there today. His hometown—still best known internationally as the
location where Tsar Nicholas II and his family were executed in 1918—is
on the border between the European and Asian parts of the country.
Radya studied philosophy, ethics, aesthetics, and the history and theory
of art at the Ural State University. Initially he worked as a photographer,
but his enrolment at the nonprofit ArtPolitics School in the city (under
the tutelage of Arseniy Sergeyev—one of the country's only experts in
public art) prompted his first real movement to the street. At first, he
practiced stencil art. Soon, however, his projects began to grow
dramatically in size and scope, focusing on themes such as (in his words)
"accuracy, versatility, and durability"—elements that he felt were lacking

1 *You Were Cheated*, Ekaterinburg, Russia, 2011
2-4 Red Square, Ekaterinburg, Russia, 2011

in Russian social and political life. Acting as an ethnographer of his own city, he sought to bring the feeling of astonishment—so commonplace when visiting a foreign country—back into familiar surroundings, to use his art to instill a sense of surprise in local streets, and in so doing to highlight the historical, social, and political realities often shrouded from both himself and his fellow compatriots. Drawing out these "secrets"— secrets that the public chooses to keep from itself—Radya aimed to use his candid street art to provoke, shock, and openly the display the contradictions and paradoxes of society for all to see.

Nothing New (2012), *You Were Cheated* (see image 1), and *Red Square* (2011), dispense this candor through highly forthright, unequivocal means. Painted on billboards high above the city—the first on a main road, the second on top of a high-rise apartment block—*Nothing New* and *You Were Cheated* (or perhaps more accurately, "You Were Fucked") were produced during the days after the latest, highly controversial Russian elections in 2012, which prompted the largest protests seen in Russia for twenty years. Produced in the style of a ballot paper, with a droll but almost painful check mark after the statement, the works confronted the issue of genuine enfranchisement head on, foregrounding the reality of the situation, which people already knew but were perhaps reluctant to declare publicly. Both endorsing and simultaneously participating in the protest, albeit only for the one day they were in existence, the two works functioned as visual symbols of dissent, a refusal to consent.

In *Red Square* (see images 2–4), Radya made his protest more metaphorically, this time to convey his disgust at the illegal demolition of an eighteenth-century building sacrificed to make way for the construction of a new skyscraper. He daubed red paint on the ground to mark the void left by the house, plotting out its ghostly disappearance by working directly upon its snowy burial site to symbolize the death of an architectural space. Producing this blood-red stain, which he described as "The new glass house on the blood of an old one," Radya was again stating openly something that local citizens were already aware of, taking the secret into a public zone where it could not be denied.

With *Eternal Fire* (see images 1–2, pp.264–5), however, a work that brought Radya to the attention of a worldwide audience, the message he intended to communicate was more subtle, even if there was nothing at all understated about his methods. Firstly, he and his team of collaborators created six mammoth portraits of Russian World War II combatants, all of whom hailed from Ekaterinburg—Guard Major Fedor Spekhov, Colonel Formichev, Guard Sergeant I.D. Serebrjakov, Guard Lieutenant V.A. Markov, and two unknown soldiers—out of layers of bandages. Then, they set the portraits ablaze by hurling Molotov cocktails at them; the variations in the thickness of the dressings created tonal variation: thicker piles left lighter areas; thinner layers burned through more easily, and were darker. Once the flames had been doused, the fire having "brought life" to the faces, the portraits were hung over the windows of an abandoned hospital that had been used to treat wounded soldiers during the war itself. Drawing heavily on the work of James Nachtwey, an American war photographer and photojournalist, *Eternal Fire* aimed to reassert the chasm in Russian society brought about by World War II, to see it as a cause for sorrow rather than celebration. By producing the work on June 22—the day in 1941 that the Axis powers invaded Russia, instigating the war there—rather than on May 9, the date of the Russian Victory Day celebration, Radya underlined his point that "The memory of the victory erases the memory of the terrific beginning of war." Moreover, he used a tool of resistance—the Molotov cocktail—to resist the glorification of war. While Radya admitted "We can talk about war ad lib but we can't imagine even a smallest part of it and of that pain, which just a single bullet can bring," he hoped to bring the lives of these soldiers—young volunteers, as they were—back into the consciousness of their home city, to make visible their painful memory.

As an artist attempting to open up new ways of looking at both the contemporary and historical state of his country, Radya maintains the role of art in his work as a distinctly social practice and one that is unflinchingly set at the very heart of society. Weaving his work into the public environment, his illicit installations continue to evolve with each fresh project. At all times, however, he seeks to use his work to articulate that which cannot be articulated. As such, Radya's street art is clearly in the tradition of the observation made by critic and philosopher Walter Benjamin that "Truth is not a matter of exposure which destroys the secret, but a revelation that does justice to it."

ST. PETERSBURG

BORN Various MEDIUM Installation, performance, paint
STYLE Radical political art THEMES Political critique, social critique
INFLUENCES Protest art

VOINA

Almost certainly the most radical and politically vigorous collective in international Independent Public Art, Voina (meaning "war" in Russian), are a collective who work at the very edges of art and activism. Founded by husband and wife team, Oleg Vorotnikov and Natalia Sokol (their three-year-old son, Kasper, and ten-month-old daughter, Mama, are its youngest members) in October 2005, the collective's two other key members are Leonid Nikolayev ("Voina President") and Alexei Plutser- Sarno ("chief media officer"). Voina have been in the public eye since around 2008 and more than 200 activists have participated in their happenings, with splinter groups existing across Russia and, increasingly, the world. Under the umbrella of what they term "political protest art," Voina have carried out a wide range of independent public practices: These include staging a mock lynching in Moscow's biggest supermarket (to highlight the xenophobia, homophobia, and anti-Semitism prevalent in Russian society, see image 1); throwing live, stray cats at staff in a McDonald's restaurant

(to mark International Workers' Day and to help "snap the workers out of the dull routine of menial labor"); and hanging a portrait of President Dmitri Medvedev on the prison bars of a police station in Bolshevo (alongside posters displaying messages such as "Kill the immigrants" and "Abandon hope all ye who enter here"). Refusing to function in the institutional art world, Voina have produced a wealth of increasingly extreme and seditious actions. Although these events have gained the group a worldwide audience, they have also attracted the wrath of the Russian authorities, and almost twenty criminal cases have been brought against them. Vorotnikov and Nikolayev were incarcerated in St. Petersburg from November 2010 to February 2011 on charges related to their *Palace Coup* action, and both face up to seven years of prison. Since August 2011, Vorotnikov and Sokol have been declared international wanted fugitives and they now live in hiding with their children.

Of their many projects, two in particular stand out. For *Dick Captured by the FSB* (see image 2), Voina's most famous action undertaken on June 14, 2010, the group produced a giant painting of a phallus (entitled *Giant Galactic Space Penis*) on the Liteyny drawbridge in St. Petersburg, which directly faces the headquarters of the city's Federal Security Service (FSB),

1 *In Memory of the Decembrists*, Moscow, Russia, 2008
2 *Dick Captured by the FSB*, St. Petersburg, Russia, 2010

formerly the KGB. Although the work only lasted for two hours before it was removed, it acted, as Plutser-Sarno explains, as a "symbolic fuck you to the entire vertical of Russian mafia power that has completely eradicated democracy in this country, making a mockery of human rights and focusing exclusively on plundering the oil dollars." *Dick Captured by the FSB* was a protest against the Russian state and employed an intentional crudity to mirror its actions and that of the FSB itself.

Similarly, in *Palace Coup* (September 20, 2010), Voina overturned a police car outside the Mikhailovsky Palace in St. Petersburg, Russia's largest art museum, in an attempt to reflect the violence of the security forces. As seen in their video documentation of the action (Voina fastidiously record their work to show online), the group approach a vehicle on the pretence of retrieving a ball that Kasper has kicked beneath it. They rock and then flip the car onto its roof before handing the ball back to Kasper and disappearing into the night. The statement that appeared after the event: "I helped the child—and I will help the country," make the meaning of the action unequivocally clear. Apart from the

inherent wordplay—the words "coup" and "overturn" are interchangeable in Russian—it was an event that Voina believed had broken judicial laws, but not "moral and ethical" ones. Moreover, both implicitly and explicitly rejecting the institutional art system through the location of the action (Voina define contemporary artists as "enemies"), it was an act that set themselves at war with the deadening apathy of contemporary art.

Regarding art as a "mode of thought," Voina undertake these insurgent aesthetic acts in their search for an ethical riposte to the contemporary Russian state. Whether protesting against the police by climbing over a moving police car with a blue bucket placed on their head (*Leo the Fucknut Is Our President*) or shoplifting a chicken through the use of the artist's vagina (*How to Snatch a Chicken*), their often comic yet always highly subversive acts speak out against the continuing debasement of Russian society in which corruption and lawlessness have become endemic. In a conceptually and aesthetically unique example of Independent Public Art that embraces a sense of carnival and of the absurd, Voina push both themselves and the Russian state to their very limits.

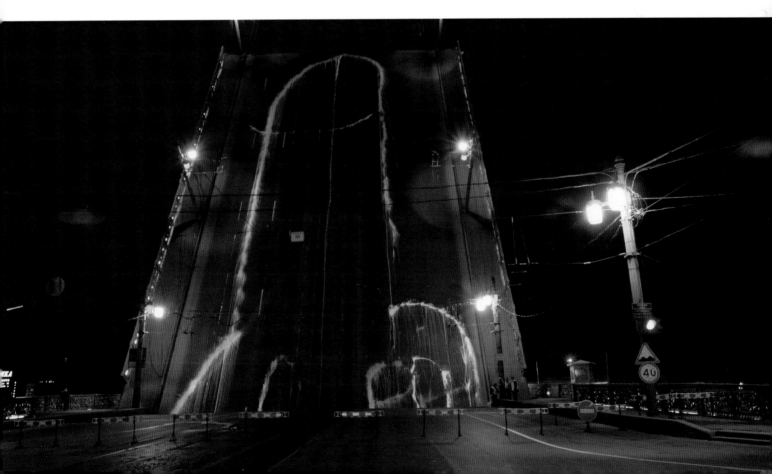

SOUTHERN EUROPE

MADRID BARCELONA ATHENS

MONEYLESS DEBENS ELTONO BLAQK PELUCAS ESCIF ARYZ DEMS333 GPO 3TTMAN 108 SPY NURIA MORA SIXEART SAN REMED LIQEN ZOSEN SUSO33 VHILS SPOK NANO4814 KENOR FILIPPO MINELLI ALEXANDROS VASMOULAKIS

1

The countries in the chapter covering southern Europe represent an amalgamation often classified as Club Med (or, more pejoratively, the PIGS nations), incorporating Portugal, Italy, Greece, and Spain. Like the other regions, southern Europe possesses a certain flavor that sets it apart from its neighbors, a more vivid, graphic aesthetic, which places it in contrast with the sterner, more earnest output of its northern counterparts. Although still infused with the spirit of conceptualism, it is one characterized by a generous dose of Latin vivacity and effervescence culminating in a unique style of Independent Public Art.

Barcelona (see pp.298–9) became one of the world centers of Independent Public Art in the early 2000s. Although political graffiti had existed in the city during the Franco era, it was the icon-based graffiti pioneered in the late 1990s by artists such as La Mano, also known as Nami (who painted an infamous raised fist), and El Pez (whose smiling fish was a common sight) that marked the first steps toward its future illustrious status. While these artists used more accessible-looking images in comparison to traditional tags, their work had a more provocative rather than consensual edge and they both used a bombing mentality to totally inundate the city with their work. At the same time, other artists such as Debens (see pp.302–3), Kenor (see pp.304–5), Sixeart (see pp.306–9), and Zosen (see pp.312–13), who also emerged from the graffiti underground, adopted a more experimental edge in their work. The use of color in all these artists' work in particular is unmistakable, the bright hues following the long days of sunshine that the city is so blessed with. Yet the almost total freedom to paint that these artists had during the early to mid-2000s, which both enabled their experimentation and provoked a migration to the city by artists from around the world, was soon cut back through new government regulations on all forms of public performance. While this has meant that the number of tags and simple throw-ups have overtaken the more colorful murals in the center of the city (due simply to the speed it takes to complete them), new artists such as Aryz (see pp.300–1), Grito, and Yesk (also known as Sagüe) have formed a new school of Barcelona style that maintains the polychromatic approach for which the city is so renowned.

While the *Barcelonés* and *Madrildeño* artists are all extremely close, however, in Madrid (see pp.274–5) there is a slightly different, perhaps more investigational style of practice. Starting with the legendary Muelle, whose pioneering "spring" graffiti left its mark on the city from 1980, the artists who have come to light in the capital have brought a strange twist, a recognizable yet speculative aesthetic, to their work. 3TTMan (see pp.276–9), whose contemporary murals perhaps come closest to the Barcelona style, also undertakes numerous projects of a more experimental nature, such as his concrete and billposter installations,

which emphasize social issues as well as formal aesthetics. Although his common collaborator and lifelong friend Remed (see pp.286–9) has developed a highly spiritual, cosmic style of his own, both Eltono (see pp.280–3) and Nuria Mora (see pp.284–5) have formed a playful style of practice in which theory and form are often entirely intertwined. Similarly, both SpY (see pp.292–5) and Suso33 (see pp.296–7), two artists who have been active on the Madrid graffiti scene since the late 1980s, have developed an equally dramatic way of utilizing their environments. SpY's urban interventions radically subvert urban space by twisting the regulations we all blindly adhere to, whereas Suso's performative action paintings attempt to reveal both the movement and history inherent within it. There are, of course, a wealth of more traditional graffiti writers in the city (with its strong history of train writing) as well, Spok in particular (see pp.290–1) being one of the most renowned and most experimental. What can be detected in Madrid generally is a slightly more abstract and theoretical style of work than in Barcelona; it is one that retains the southern European sense of color and vibrancy, yet pushes it in a more conceptual direction.

The three artists featured for Athens (see pp.344–5) all show quite radically different approaches to Independent Public Art. The huge, surrealist murals and collagist installations of Alexandros Vasmoulakis (see pp.346–7) contrast sharply with the typographic, calligraphic, and abstract urban designs of the duo Blaqk (see pp.348–9), whose style again stands out against that of the collective GPO (see pp.350–3) with their entirely spontaneous, improvisational manner in which dirt, haphazardness, and sloppiness reign. Like the variances that can be detected all over Italy, with 108's abstract, monochromatic graffiti (see pp.334–7), Moneyless's neo-Arte Povera (see pp.338–9), and Filippo Minelli's juxtapositional, investigational image-making (see pp.340–3), what could still be argued to connect all of these artists' quite distinctive styles of work, however, is a comparable introspection, a deep level of thought that pervades their various practices. As can be seen in the rest of Iberia—with artists such as Escif (see pp.314–17) producing a modern style of urban editorial cartoons; with San's (see pp.320–3) delicate, intricate, haunting aesthetic; Nano4814's (see pp.328–31) love/hate relationship with the creative act; Vhils's (see pp.332–3) archaeological style of portraiture; Dems333's (see pp.318–19) futuristic graffiti; and the intense yin-yang dynamic of twins Liqen (see pp.324–5) and Pelucas (see pp.326–7)—Iberia as a whole currently encompasses a diverse and exciting group of young artists. Just like the southern European region it belongs to, it possesses a new breed of artists who are pushing not only the formal possibilities of Independent Public Art, but the very nature of the discourse itself.

MADRID

There was little or no graffiti in Madrid during the dictatorship of General Franco (1936–75). However, with the onset of the countercultural movement, *La Movida Madrileña*, in the 1980s, artistic growth and transformation began to take place within conventional and illicit art. Muelle, the artistic pseudonym of Juan Carlos Argüello, was by far the most famous of the early practitioners of indigenous *Madrileño* graffiti. His tag, meaning "spring" (a name he apparently gained as a youth after fabricating a bicycle from the remnants of car parts), was first noted in 1982 in the Barrio de Campamento area of the city. The image featured his name with his eponymous coiled spring below it and his registered trademark above (see image 2). It was a sign that was much repeated by both Muelle and his imitators, and soon dominated the Madrid landscape.

As the 1980s progressed, other practitioners (or "flecheros" as they were commonly called due to the arrows they used) emerged on the local scene. Tifon and Max501 were among the most prominent of these artists, although Glub and Remebe began to twist the flechero style with a more classically New York-inspired archetype. By the latter part of the decade, these artists, alongside crews such as QSC and PTV, had moved the chief site of practice from the streets to the train yards. One of the key pioneers of the train scene, Hen (aka Smart aka Coas—now known as the graffiti theorist Javier Abarca) was also the first of the Madrid artists to begin InterRailing, and was therefore responsible for the first international contacts with mainland Europe. Along with Kami, whose status as part of the New York-based crew TFP brought the Harlem resident Sento to the city on a regular basis, Madrid slowly opened up to a more international style.

The 1990s saw the arrival of another group of writers and styles. While developing as a traditional graffiti writer, Sus033 (see image 4 and pp.296–7) became the pioneer of image-based graffiti in the city, using pictographic rather than epigraphic tags. His first icon, a distended eye, was soon replaced by groups of haunting silhouettes, and later by large, looming faces. His crewmate SpY (pp.292–5) also emerged from the more traditional graffiti of the 1980s, but moved away from a spray can-based technique in its entirety. Appropriating urban elements through

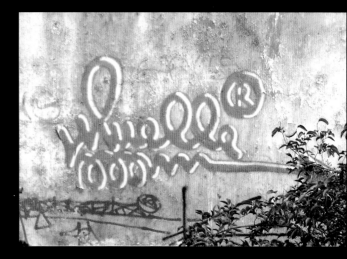

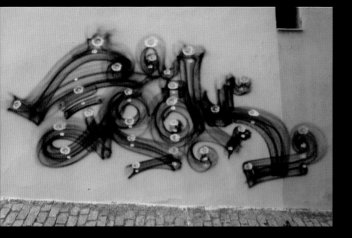

of visual culture. More recently, the Noviciado Nueve collective, to which Eltono and Spok also belong, have come to dominate much of the city's contemporary cultural production. Along with 3TTMan (see pp.276–9), Nano4814 (see pp.328–31), and Remed (see pp.286–9), these artists have been highly active on the city since the mid-2000s, working within all genres of Independent Public Art, from tagging and murals to installations and posters. Together with other artists such as San (see pp.320–3), Okuda, and Neko, these loosely grouped practitioners are active both in Madrid and on a worldwide scale. Although the city is still dominated by classic graffiti (especially within the Malasaña barrio), a huge diversity of illicit urban images also exists in the city. From graffiti artists doing light installations to street artists producing throw-ups, urban art in Madrid represents a joyous plethora of forms.

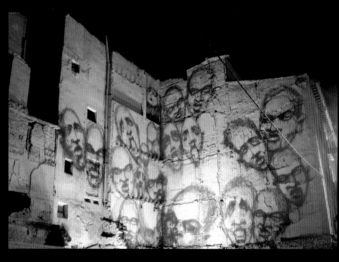

transformation or replication, he attempted to comment on urban reality through utilizing elements such as traffic lights, road markings, and public statues to subvert the normative understanding of the city.

By the late 1990s, however, crews such as TBC (Alone, Colbie, Know, Sha, and Spok—see image 3 and pp.290–1), KR2 (Buni, Deno, Fred, and Til), TVE (Deon and Waine), and 091 (Odio, Raro, Queso) were reviving a more classic graffiti aesthetic in the city. Working predominantly in downtown Madrid and focusing on simple, silver tags and throw-ups rather than the multicolored pieces then only prevalent on the city outskirts, they brought the focus back to classic handstyles, which for many remained the true essence of graffiti. This return to the classics took place at around the same time that BNE (see pp.60–1) was resident in Madrid, and he was an important influence on the city's change of style. As trains became harder to paint, however—due to the stringent approach by security staff and the immediate cleaning of "defaced" trains—new tactics appeared. The *Palancazo Madrileño*, a technique (first initiated by Spok) in which writers pulled the emergency brake of a running train and then painted it while it was still in the station, became a key method of graffiti writing in Madrid. The method was soon disseminated in the global arena.

At the same time, however, artists such as Eltono (see image 5 and pp.280–3) were modifying the very nature of Independent Public Art. Moving away from his more traditional work (as part of the famous Parisian GAP crew), Eltono started employing masking tape and acrylic paint to form geometric tuning fork shapes that functioned with the precise colors and medium of the space used. Often working with Nuria Mora (see image 1 and pp.284–5), the two artists attempted to reinvigorate neglected parts of the city, using their keen, graffiti-schooled knowledge of urban space to promote a more open form

MADRID

BORN 1978, Lille, France MEDIUM Fly posters, spray paint, cement, mosaic tiles
STYLE Urban modification, contemporary muralism THEMES High vs. low art, urban
renewal INFLUENCES Vernacular art, religious art COLLECTIVE Noviciado Nueve

3TTMAN

3TTMan (a name derived from the French *trois têtes* or three-headed man
that is a recurring figure in his work) dubs himself as the *agitador de medio
ambiente* (or agitator of the environment). As a significant presence in
the contemporary urban art scene of Madrid, he has forged an aesthetic
combining the punk heritage of graffiti—its do-it-yourself, by any means
necessary attitude—with a style showing a strong influence of vernacular
and popular religious art. Working on a multitude of surfaces (from fly
posters to self-laid concrete) and utilizing a myriad of techniques (from
ceramics to mosaics), 3TTMan's production purposefully blurs the
boundary between art and craft, and challenges prevailing conceptions
of "correct" practice in both fine and public art.

3TTMan painted constantly throughout his early years but resisted the
urge to move his work into the streets until he had developed a distinctive
approach. He did experiment using stickers and posters together with his
childhood friend Remed (see pp.286–9), but it was not until 1999 that he
found what he considered a more expansive way of bringing his art to the
public. He cofounded the label 102%—a "pop-shop" style brand focused
on unique, one-off, handprinted clothing. While directing his artistic
energies into textiles, he tentatively continued to work in the street.
However, it was Nano4814's *City-Lights* project of 2004 (see pp.328–31)
that finally gave him the inspiration to fully shift his practice into the
urban environment. Initially, 3TTMan worked purely on street furniture;
he détournéd objects such as mail boxes, lampposts, garbage containers,
enlivening and animating them with amusing, often grotesque imagery.
Although these early works gave him a taste for the action and potential
of the street, he had yet to find a project that he could wholly embrace.

His work with fly posters changed all that, however. While unwilling
to work directly on the city's walls, and unhappy with the limited room
available to truly experiment with street furniture, 3TTMan noticed the
vast space taken up by fly posters in Madrid; this seemingly semi-legal
form of advertising consumed nearly every single vacant or neglected
structure in the city. Fly posters provided him not only with a ready-made
surface to work on in the heart of the capital, but they also presented him
with an automatic response to any encounter with the police: If the fly
posters themselves were an illegal form of visual culture, how could

1 *Esto es graffiti*, Madrid, Spain, 2011
2 *No me gusta escribir en las paredes*, Madrid, Spain, 2011
3-6 Madrid, Spain, 2012
7 Tarifa, Spain, 2012

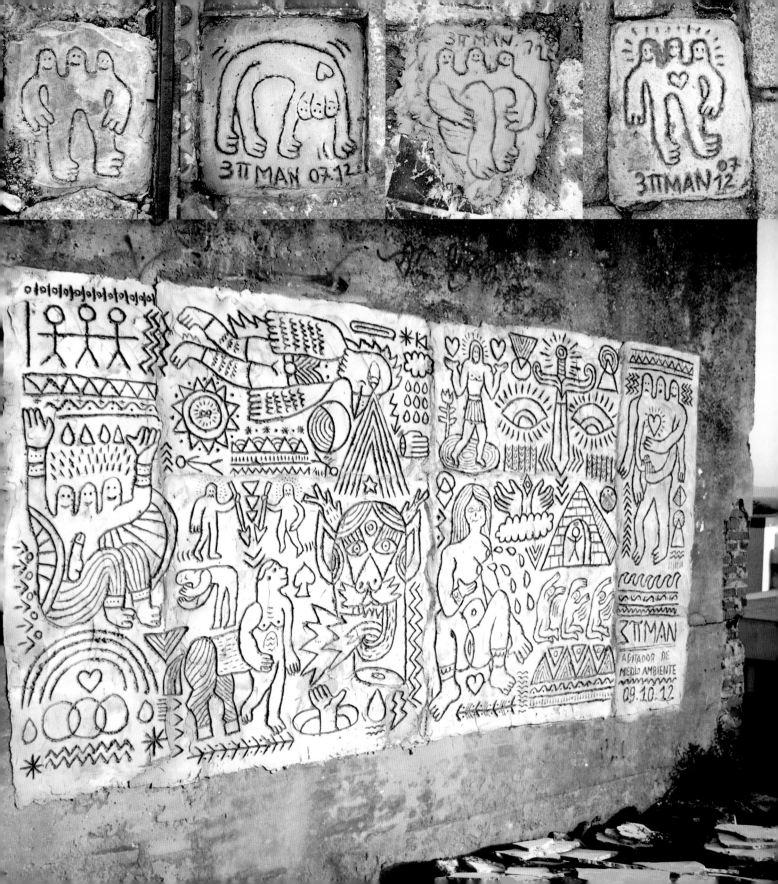

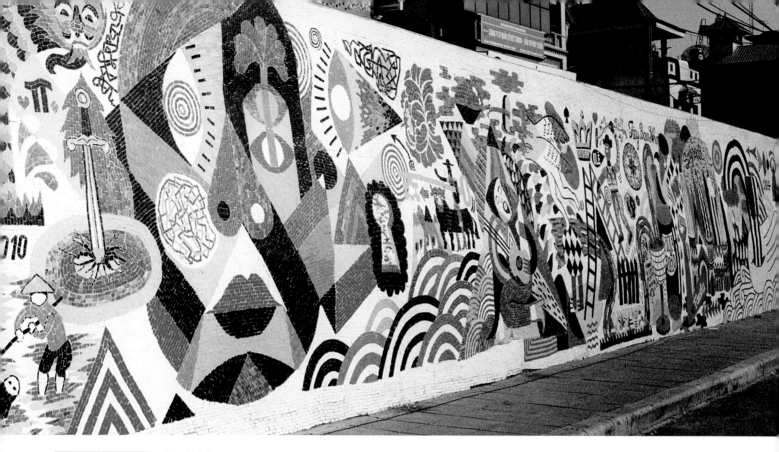

1	2
	3

1 Hanoi, Vietnam, 2010
2 *Fighting Peacefully*, La Laguna, Tenerife, Spain, 2012
3 La Laguna, Tenerife, Spain, 2013

painting on top of them be considered illegal in itself? Wearing overalls, 3TTMan often passed unnoticed as a laborer working in the streets. He openly painted on these surfaces—in the middle of the day and in some of the city's most conspicuous sites—and happily argued with the police when they arrived on the scene. His approach gave him the time to produce complex collages; never simply painting on top of the posters, he used what was already there. He took a purely commercial medium, challenged and played with it, converting it into a space for interaction and enjoyment.

Although he continues to work with fly posters (in addition to his canvas-based work), 3TTMan has since adopted numerous other ways of interacting in the street—producing large-scale murals, mosaics, and *piñatas* that stretch the borders between folk and high art. More recently, however, he has focused his attention on one of the most seemingly unaesthetic of materials—cement. Fascinated by the spontaneous writings that often quickly appear on unset concrete in the street, as well as the experience of rebuilding his studio in Madrid, 3TTMan, armed with sand, cement, and water, began to make his distinctive cement tags on the city streets. He concentrates on the potholed pavements that have been left dangerously unrepaired and bricked-up shop fronts of abandoned

or empty buildings that, like the fly posters, proliferate in the city. Applying cement onto these sites, he etches texts and illustrations on the surface before it has had the chance to set (see images 1–4, pp.276–7): He inscribes paradoxical or word-playing statements, such as *Esto es graffiti* ("This is graffiti") or *No me gusta escribir en las paredes* ("I don't like to write on walls"). In a recent intervention he placed miniature cement castles around the city to draw attention to the problems of over-construction in Spain.

As with his exploration of ceramic mosaics in Vietnam, his Indian "wildstyle," or street-based painting-by-numbers, the concrete projects can be understood to fuse three key themes within his work: his obsession with popular aesthetics; his desire to critique the sanctity of art; and his endeavor to represent the contradictions and multiple viewpoints possible in any given situation. Like his three-headed character itself, a creature that suggests the manifold possibilities of every situation, he strives to stimulate thought in the viewer rather than making judgments. His works function through revelation rather than explanation. Expressing the inherent imbalance of the three themes in his practice, he brings a witty, joyful spirit to the street, a lowbrow, popular, yet highly refined technique that refuses to stand by the demarcations set by the art world.

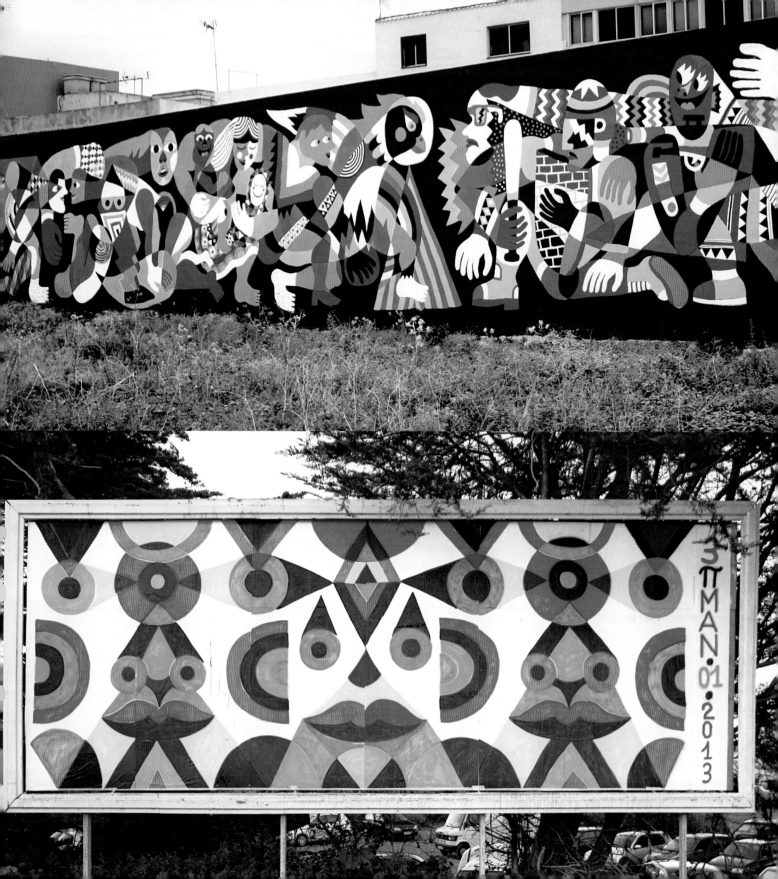

MADRID

BORN 1975, Paris, France **MEDIUM** Acrylic paint, masking tape, wheat paste **STYLE** Abstract graffiti, urban interventions **THEMES** Tuning fork, geometry, play, chance **INFLUENCES** GAP **CREW** Noviciado Nueve **COLLECTIVE** Equipo Plastico

1 Rio de Janeiro, Brazil, 2011 (with MOMO)
2 *Eredu*, Bilbao, Spain, 2011

ELTONO

Eltono's name literally describes his work (*el tono* means "the pitch" or "the tone" in Spanish). Although his style continually morphs and shifts within the various visual games that constitute his practice, it is his eponymous, tuning fork design that forms the baseline unifying his artistic work—the root "note" from which he conducts his spatial experiments.

Growing up originally on the outskirts of Paris, Eltono became firmly entrenched in the city's classical graffiti subculture from about 1992. This was the year he became a member of the infamous GAP crew, when he was known as Otone and worked with writers such as Zepha, Wope, and Desa. Eltono focused mainly on the railway lines to the northwest of the city, painting in the traditional silver and black, block-letter Parisian style. By 1997 he had started using posters and stickers in his practice; however, a move to Madrid in 1999 proved to be the crucial turning point in his work. From this point he radically transformed his practice by developing a new type of message directed at a different constituency of the city.

When Eltono arrived he found the center of Madrid totally saturated with tags and throw-ups; he quickly realized he needed to form a style of urban image production that could stand out from the visual cacophony taking place. Adding the Spanish article "el" to his name (which in Parisian *verlan*—reverse slang—had already turned into "Tono") provided him with his iconic starting point. He started painting his two-pronged, tuning fork design in a classical, three-dimensional graffiti style, rather than his letter-based name. Still not happy a few months later, however, Eltono discontinued his use of spray paints and experimented instead with masking tape and traditional acrylic paint. The change forced him to integrate his work more judiciously into the environment—the natural limits of his materials promoting a vertical and horizontal patterning that had to work within the basic borders and restrictions of the street.

His previous graffiti experience meant that his practice continued to feature iteration, but variable organic repetition rather than mechanical duplication. The seemingly identical images he produced, just like tags or throw-ups, were thus alike yet individually distinct. These abstract geometric shapes could be seen as a distillation or purification of Eltono's moniker into its essential form—the original tuning fork design now modified into a protean "C-shape." This shifted his practice into an iconic rather than textual idiom and introduced his images to a public that had previously been oblivious to his work. Finding himself communicating with a wider social audience, Eltono embraced this new direction in his highly numerous and varied street-based projects, many of which featured in his book *Line and Surface* in 2012.

Completed in Turin in 2009, *Coriandoli* (see images 7–9) perfectly demonstrates the type of visual experimentation Eltono constantly undertakes in his practice. Using a bucket of wheat paste and generous amounts of colored paper and metallic confetti, Eltono produced installations in the street, in commuter-train tunnels, on windows, on the backjump of a tram, as well as in a traditional gallery space. As with all of his works, the basic tuning fork design remained central, along with Eltono's determination to push this basic shape to its conceptual limits. *Coriandoli* also marked the continuation of an inherently playful practice that has contrasted medium and material (the perceived aggressiveness of graffiti with a "gentle" material associated with weddings and celebration) and recurrence and divergence.

More recent projects, such as *Plaf* (completed with the artist MOMO, see pp.30–3), *Script 1.2*, and *Traces*, have displayed a deepening focus on arbitrariness. While still following a geometric simplicity, these projects increasingly leave the final work subject to chance, and the whims of the viewer or the environment itself rather than the artist. While highlighting his interest in working within the constraints of regulations and risk— issues that undoubtedly arose through his graffiti practice—these pieces illustrate his desire to produce work that is open, unresolved, and enigmatic, as he explains: "Visual communication in the city is all so easy to understand, all resolved. It's all indications, prohibitions, ads... There is very little room for imagination. With my paintings, I do not want to send a message but instead let the viewer imagine it." Eltono wants those who encounter his work to question the reason for its existence. He values the free interpretation that can result from more abstract imagery; the fact that it is not instantly recognized and assimilated makes the work less visible. However, as he points out: "When a connection does happen, the encounter will naturally be more intimate and deeper. And it thus opens the way for the viewer to think by themselves rather than just receiving; generating information rather than being forced to swallow it whole."

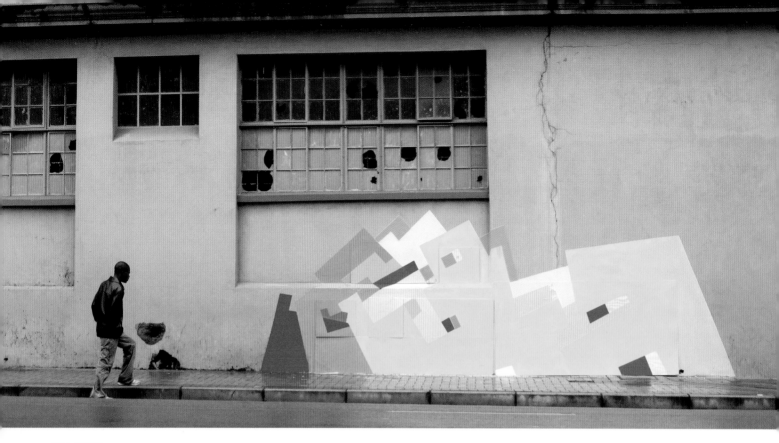

MADRID

BORN Madrid, Spain **MEDIUM** Acrylic paint, installation, string, glass etching
STYLE Abstract graffiti, geometric graffiti **THEMES** Public space, silence,
harmony, surface **COLLECTIVE** Equipo Plastico

NURIA MORA

There is an intrinsically subtle nature to Nuria Mora's work that is
fundamentally harmonious and pertinent. Even when it confronts
the viewer in an unexpected manner, the effect is always delicate and
calming. This is not femininity in terms of painting typically female
themes, however; her hard-edged geometric aesthetic avoids any
curvilinear softness. Yet through her way of working with the structure
rather than against it and not trying to dominate the surrounding
environment, she attempts to give the viewer a fresh appreciation
of space and a new way of seeing the urban milieu.

Nuria's ever-present motif—a key (or *el llave*)—which acts as the
starting point in all her work, first emerged in 1999 through her early
collaborative work with Eltono (see pp.280–3). Although her original
reason for choosing to work in the street stemmed from its latent
capacity for communication and the opportunity for presenting
aesthetic ideas to people without any interest in institutional art,

as Nuria continued to practice within this space her motives began
to change. Although the integrity of the image itself was crucial for
her, it became just one element of a much wider story, as she explains:
"For me, the most important part of the work is the site. I need certain
characteristics, not only a place with good visibility but a place in which
what is interesting is the actual structure itself." What Nuria wanted
was an explicit dialogue and interaction between herself and the
surface she worked upon, an interchange between herself and the
medium. Working directly with the city itself—with its angles, shapes,
colors, and textures—the intricacies of the surrounding space, the
particularities of place and the associated environment became
fundamental to her practice.

Although Nuria negotiates these immediacies in a highly adaptive
and accommodating way, her work can only be properly understood
through what it is acting against—through its effort to combat the
saturation of signals that people are overburdened with in everyday
city life. Her practice therefore functions through what she calls an
"open language"—a silent, sensitive poetry that creates a "place
of free thinking" and "a space of dead time." The intention is that

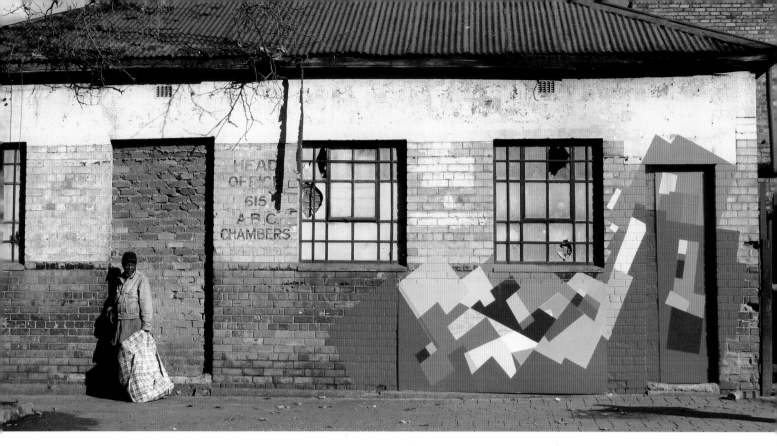

1-2 Starfish Project, Johannesburg, South Africa, 2011

encountering Nuria's work will lead to a moment of comfort and ease in the city. Her use of an abstract, universal language provides a calming, mysterious beauty within the cacophonous tumult of contemporary urban visual culture.

There is more to Nuria's aesthetic than her street productions alone, however; her work inside galleries and other institutional settings never seeks to simply replicate her outside projects within this desiccated context. Producing installations, murals, watercolors, and sculptures, Nuria re-creates her world within these alternative contexts while always connecting it with the wider space of the city and the outside world beyond "the white cube." Her recent work in Johannesburg, the *Starfish Project* (2010), is a perfect example of this principle. Starting with the construction of a giant wooden cube inside a gallery space in the center of the city, Nuria proceeded to create a second skin on the structure by wrapping it with removable wooden shapes. All of these shapes were painted in her classic style during the first week of the project. Once finished, however, each panel was then dismantled from its base, with each section becoming the starting point for an outdoor mural, the works overflowing from their original wooden

boards onto their concrete surroundings (see images 1 and 2). Mirroring the capability of the starfish to form new life from its composite parts, the breaking apart of the original gallery-based work served to reinvigorate life within the city—new offspring emerging from the original maternal figure. Rather than the traditional approach of street pieces entering the gallery after they had been created outside, Nuria reversed the process; the original works escaped the confines of the institution and the audience were similarly forced to move from inside the gallery to the outside environment.

While Nuria continues to discover new methods of undertaking her practice—forming origami takeovers within bus shelter advertising hoardings or using a diamond cutter to incise designs on the glass windows of these same spaces, for example—her work remains faithful to its central philosophy: To be courteous to the city, sensitive to the surroundings, to make a delicate reformation of the street. Always striving to "invite reflection and calm" and "give value to the surface," she interweaves herself within our public spaces in a civil and respectful manner, combining herself with the architecture and constructing a discourse with the street.

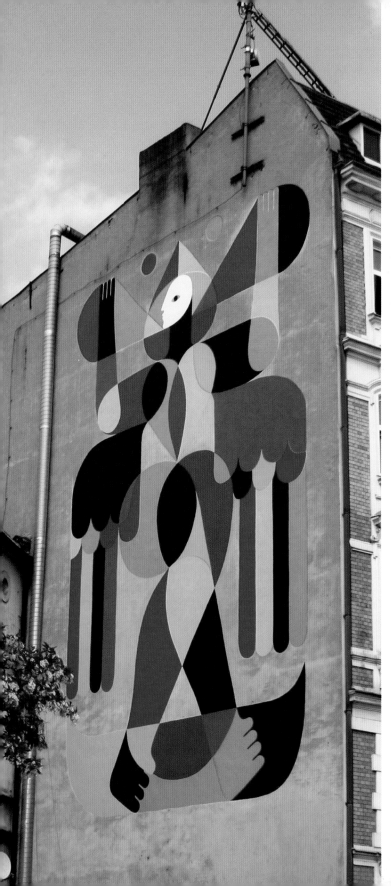

MADRID

BORN 1978, Lille, France MEDIUM Spray paint, acrylic paint, chalk, sculpture
STYLE Muralism, geometric figuration THEMES Harmony, mathematics, geometry
INFLUENCES Modigliani, Fernand Léger, Islamic art COLLECTIVE Noviciado Nueve

REMED

Influenced in equal measure by twentieth-century artists, such as Modigliani and Fernand Léger, and by the Moroccan art of zellige—a form of highly decorative, enameled terra-cotta tilework—Remed's work has a unique, immediately recognizable quality in both its micro and macro manifestations. Working at the conjunction of mathematics and calligraphy, and seeking harmony between the flow and energy of the line, Remed strives through simplicity to find a universal language of form and color.

Although now based in Madrid, Remed grew up in the northern French city of Lille with his close friend and most frequent artistic collaborator 3TTMan (see pp.276–9). Following him first to after school art classes and later to a college of the applied arts (where he studied "space-communication"), Remed was destined for a career in graphic design before a friend with whom he was studying introduced him to graffiti. Two years on, after six months steadily decaying in front of a computer at a design agency, he quit his job when the opportunity arose to work independently and teach graffiti to children at various schools and social institutions. The experience enabled Remed to learn more about the history of the urban arts and his work with children would later climax with the art he created at the Children's Museum of the Arts, New York City, in 2011. It was a chance meeting with the Algerian artist Mahjoub Ben Bella that convinced Remed that it might be possible to live his life through art, however, and he began to use the time that had become available to him since quitting his job to concentrate more seriously on his artistic work.

By the time he moved to São Paulo, Brazil, in 2006, Remed's style had evolved into its present distinctive and recognizable form. He started to produce large-scale murals and to develop a highly cosmological and spiritual visual language of his own. With a Moroccan influence increasingly taking hold on his art through a fusion of geometric and calligraphic elements, his figures almost disappeared within the vivid colors and flat patterning he created. Although his work began to demonstrate greater graphic simplicity, the narratives it referenced became more complex. Remed wove intricate stories similar to parables or folk legends into his images, although the deeply embedded

1 *Winged Being on Boat*, Poznan, Poland, 2011
2 *Duality*, Lodz, Poland, 2011

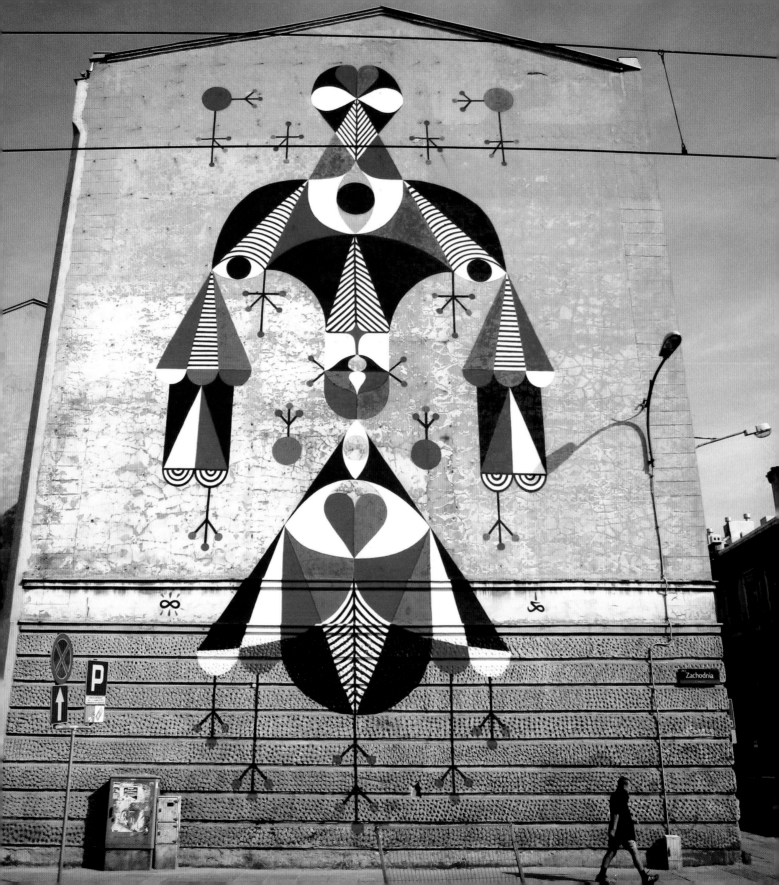

1 *Fishbird Man*, Morocco, 2012 2 Léon, Spain, 2011
3 Madrid, Spain, 2012 4 Léon, Spain, 2011
5 *The Rising*, Atlanta, USA, 2009

significance of these stories was often overshadowed by the decorative beauty of the art. He became fixated on the relationship between mathematics and aesthetics, as well as with the intertwined harmony of the world around him. Remed's work became steeped in the balance, consonance, and contrasts so prevalent in Islamic art—a visual aesthetic in which all parts of the image are involved in a search for synchrony and nothing is left to chance.

However, while his artistic experiments flowed from a very personal space—his urge to paint functioning similarly to a "diary, a notebook of inventions, or philosophical essay"—he was at the same time seeking to transcend the personal and reach out to others. He was striving to create something approaching a shared dialect, a language that would traverse social and cultural conventions through an almost primal visual regime. With his imagery, Remed attempts to communicate the classic themes and dualities of existence—life and death, illness and health, good and evil—working between the figurative and the abstract in order to find a shared ground with those around him.

Since returning to Madrid where he has now settled, Remed has continued to refine his work and develop his inimitable style. Although he has increasingly begun to produce more artworks on canvas away from the streets, Remed has maintained a strong presence in the urban environment. His recent street work in the Spanish capital has included tagging (albeit in a now highly experimental manner), inscribing philosophical calligraphic messages (often in chalk) onto city walls, etching into metal, as well as both pasting and painting his more complex designs throughout the city.

As far as Remed is concerned, all of these artistic activities are equally important, each providing an opportunity for experimentation and communication, for performative release as much as communal exchange, as well as a chance to "rhyme" with color and form. For Remed, art is a way of healing the soul and curing the mind, a form of very public, outward therapy. It is a way of blending science and soul, of coping with pain and happiness, exploring love and hate, light and darkness, a remedy for life itself.

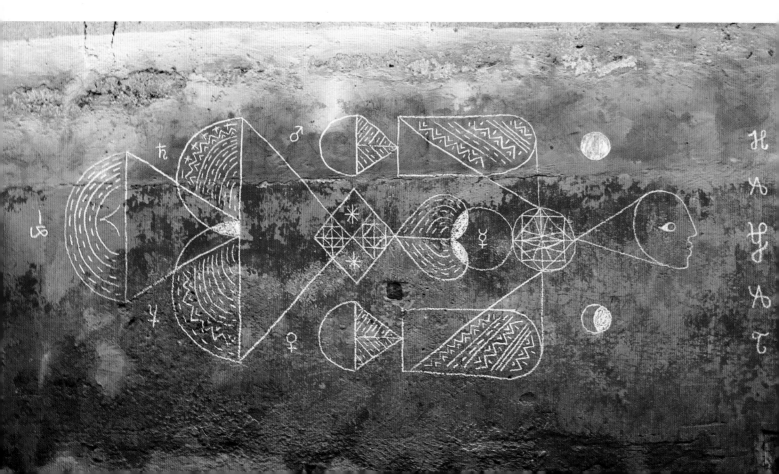

MADRID
BORN Madrid, Spain MEDIUM Spray paint, installation STYLE Classic
graffiti, photo-realistic graffiti THEMES Portraiture, satire, farce, calligraphy
INFLUENCES New York graffiti, Giuseppe Arcimboldo CREW TBC

SPOK

One of Spain's most respected graffiti artists, Spok emerged in
the mid-1990s as part of the TBC crew. His work is characterized
by a legendary sense of humor that is often shrouded within a
deep layer of subcultural nuance. Whether in its typographical,
photorealistic, or more experimental form, Spok's work possesses
a plethora of possible interpretations that the viewer can take either
on a purely visual or conceptual level.

Like many other artists around the globe, the seminal book *Subway
Art* radically changed Spok's childhood. From the moment he saw it,
the world of graffiti became his central avenue of exploration and by the
age of fourteen he had painted his first train. He later went on to study
fine art at college, where he specialized in photorealism. Although he
continued to travel the globe in his increasingly frenzied hunt for trains,
Spok's more formal training soon started to seep into his illicit work, his
uncanny, hyperrealistic representations merging with his calligraphic,
letter-based ones. The landmark murals that Spok produced at London's
Tate Modern in 2008—a pair of highly abstract, surrealist portraits
of his close friends Eltono (see pp.280–3) and Nano4814 (see pp.328–31)
—represent the ultimate expression of this fusion (see images 2 and 3).
These portraits utilize objects in place of features—items that belong
to their subjects but are reformulated as physical indexes in a manner
reminiscent of the Italian painter Giuseppe Arcimboldo. The murals
prompted a burst of aesthetic innovation that has continued to the
present day. While the Tate works contain a more subtle farcicality,
however, his more recent "robot" graffiti, which could be described as a
form of sci-fi photorealism, has brought this penchant back to the fore. As
with the casual indolence of his robot self-portrait from Zaragoza, carrying
home his lunchtime bread while under "attack" from a falling satellite
(see image 1)—NASA's rogue UARS satellite featured heavily in the news
at the time—or his cackling, train-eating cyborg from Turin (with his
purloined train keys on his belt and fractured manacles on his leg), Spok
never allows profundity to outweigh the obvious joy and exuberance he
takes from graffiti. As a pleasurable hobby first and foremost, all his
artistic projects function as an expression of this original graffiti spirit—
the excitement, delight, and *jouissance* that it contains.

1 *Self-portrait*, Zaragoza, Spain, 2011
2 *Tono's Portrait*, London, UK, 2008
3 *Nano's Portrait*, London, UK, 2008

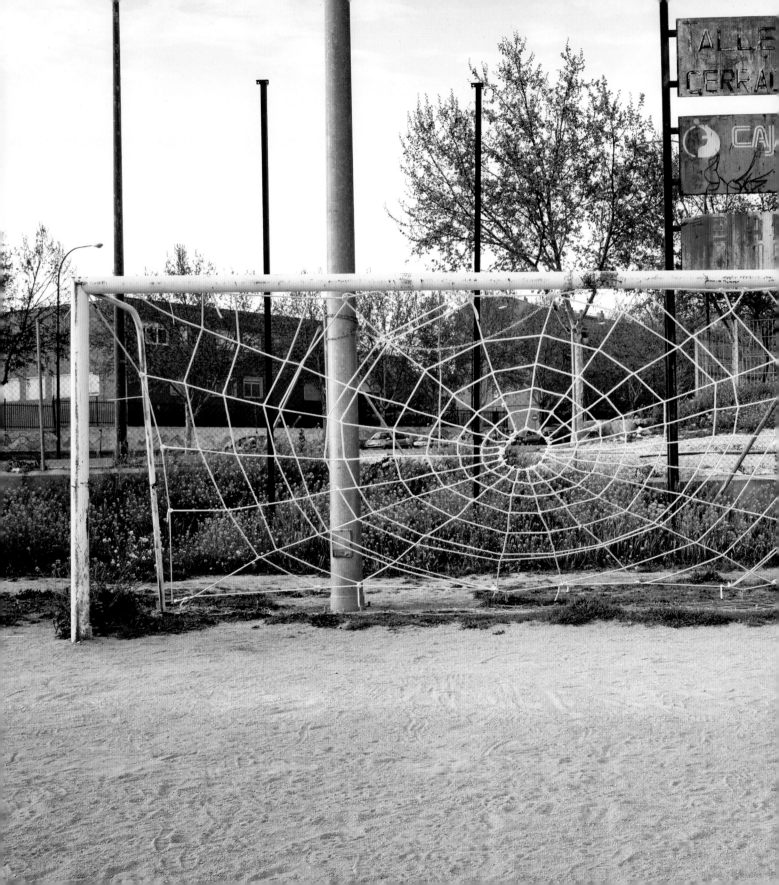

BORN Madrid, Spain MEDIUM Sculpture, spray paint, installation
STYLE Urban intervention THEMES Public space, rules and regulations, sport
and play, decontextualization CREW Los Reyes del Mambo (The Mambo Kings)

SPY
JABO

One of Spain's foremost proponents of Independent Public Art, SpY
produces interventions that create a sense of romance, mystique, and
charm in the city through their upturning of spatial norms. In a body of
work that is both aesthetically and playfully rich, SpY transforms everyday
objects and sites—from fountains and tennis courts, to road signs and
police cars—embracing a childish pleasure in the urban world's unending
potential and striving to bring laughter to the city. He uses irony and
humor to create a dialogue with viewers, who through their laughter
become SpY's "accomplices," as he attempts to impress multiple readings
onto a space and to re-present it as a "frame of endless possibilities." He
breaks prescribed rules to emphasize their innately illusory nature and to
remind us that the world is still one in the making, forever in a multiple,
heterogeneous, incomplete state.

Like many other proponents of what is known as urban intervention,
SpY's first contact with street art was through graffiti, a culture that he
became deeply embedded within from the late 1980s. Attracted to the
images he saw in the streets around him as a youth, he dedicated his
spare time to the discipline and by the 1990s had established himself as
one of the leading graffiti artists in Spain. Painting under the name Jabo
as well as SpY, he was active in every area of the graffiti discourse, painting
trains with other *Madrileño* pioneers, such as Koas (the writer and lecturer
Javier Abarca) and Suso33 (see pp.296–7), as well as opening the first
(albeit illegal) graffiti supply store in Madrid.

By the mid-1990s, however, SpY had entered a phase closer to the one
he currently occupies and begun to experiment with graffiti in a more
formal style. Without any knowledge of the post-graffiti scene emerging
around the world (in an era before the internet), he started to promote his
identity using non-traditional graffiti methods: He produced big posters
with his name in sans-serif letters, changed the messages on billboard
advertisements, and replaced the names of subway stations with his own
name. In what he describes as a "natural evolution" of his practice, SpY
believed that this artistic move was shaped by his understanding of the
city as an "artistic base" and the "sharpened sense" toward space he
had developed during his years of graffiti practice. Although the aesthetic

1 *Web*, Madrid, Spain, 2008

1 *Caution*, New York, USA, 2009
2 *Leaves*, Madrid, Spain, 2009
3 *Water*, Madrid, Spain, 2011
4 *Lines*, Madrid, Spain, 2008

may have been modified, however, the intent was the same, a way of utilizing the street to its maximum, interacting with the city, and recontextualizing space.

SpY's more contemporary urban installations have taken a multitude of different forms: He has refashioned street signage (often using the name of his graffiti collective, The Mambo Kings), modified traditional public art (through placing items such as balaclavas, LEDs, or gas masks on classical bronze sculptures), and even created graffiti for the blind from a portable braille embosser. However, it is his interest in the world of sport in particular, in adapting, reworking, and "decontextualizing" sports stadiums or sports equipment that most clearly brings his theoretical foundation to the fore. This has included transforming the net of a football goal into a huge spider's web (see image 1, pp.292–3), placing a brick wall inside the boundaries of the goal posts themselves, turning a tennis court into a complex matrix of entirely non-symmetrical lines (see image 4), and placing the markings of a soccer pitch onto the curvilinear dimensions of a half-pipe. SpY's works dramatically renegotiate the set rules of the sport in question, as he puts it "provoking disorder and chaos through context and content." They therefore form a literal example of what the French theorist Jean-François Lyotard termed a "differend," a state of total disjunction, a sign of true otherness, a provocation that art is duty bound to reveal (and, equally, a concept that Lyotard illustrates through a sporting example, a moment when a partner begins using tennis balls in the manner of chess pieces and their competitor exclaims "that's not how you play the game"). Adapting and reshaping these spaces provides the viewer with a conceptually and visually delightful image, the spark of pleasure derived from the cognitive and aesthetic dissonance they elicit. These images also extend out of their arenas to embrace play rather than game, a space where one participates not to win but for the pure pleasure of invention, a state where changing the (literal) field of play can demonstrate the infinite possibilities of urban life that we so often become closed off from.

SpY's use of games, sports, and play, and his depiction of their crucial differences, therefore attempts to show how wrapped up we, as well as the city itself, have become with the norm, with the "right" way of doing things, and with the "correct" use of urban space. The amusement and laughter that is triggered through his work is therefore the nervous laughter caused by the possibility of difference and by different ways of seeing the city or the world. It is this transformation of expectations that SpY attempts to ferment in his various practices; his autonomous interventions function not simply to invert or subvert their spaces, but to playfully distort them, to "misuse" them, and thereby reveal the latent possibilities that lie within.

MADRID
BORN Unknown MEDIUM Spray paint, acrylic paint STYLE Performance art, figurative graffiti THEMES Movement, shadows, drama, spectacle
INFLUENCES Action art, dance CREW Los Reyes del Mambo (The Mambo Kings)

SUSO33

Suso333 is a pioneer of the early graffiti movement in Madrid and a progenitor of the European post-graffiti and street art movements, as well as one of the most celebrated contemporary Spanish proponents of a action art. His multifaceted, dynamic talents have kept him center stage in the Independent Public Arts scene for more than twenty years. He is as famous for his iconographic paint-splatter eyeball icon ("la plasta") as for his shadow paintings and single-line, sketch-like motion portraits. Suso's progression into the world of performance and theater—initially as a muralist and painter of scenery for institutions such as the Teatro Real and the Centro Dramático Nacional, and more recently through his live work with classical and contemporary dance groups—reflects his ability to create a performance that unites text and image in one dramatic display. He has also proved himself capable of moving seamlessly between legal and illegal sites, between the public space of the street and the institutional realm of the theater or gallery space, with equal comfort.

Suso's work has always been strongly performative, as is evident from his numerous videos (such as *CRASH!*), which demonstrate his fluent ambidexterity—most astonishingly seen in the execution of his tag. In his shadow paintings—the silhouetted outlines that he places in the hidden corners of the street and on partially demolished ruins—he creates a trace of previous existence, an eerily beautiful record of life in the city. By contrast, the more freestyle approach seen in his series of dancing figures and scrawled, brooding faces, offers a spirling, whirling kinesis, a visual residue of the artist's balletic actions and gestures. A more recent work, entitled *Pintura Escénica de Acción* ("Scene Painting in Action," see image 5), takes the performance element of his work to its natural conclusion. This ninety-minute theatrical presentation sees Suso lead a troupe of dancers and muscians through his images, his paintings acting as the choreographic design, his body the rhythmic lead. For this artist, as he revealed in an interview in 2011, "[the] body acts as a plastic element in which the work is an action in itself," a performance, wherever it takes place, in which "the quality of the final result is almost on a second plane."

This is graffiti as drama; graffiti as spectacle, as something done, rather than something formed; an energy that emerges not through the meaning of a completed work, but through the evanescent actions of its creation.

1		5
2	4	6
3		7

1 Madrid, Spain, 2004 2 Tudela, Spain, 2011
3-4 Logroño, Spain, 2008 5 Gijón, Spain, 2008
6 Madrid, Spain, 2010 7 Madrid, Spain, 2009

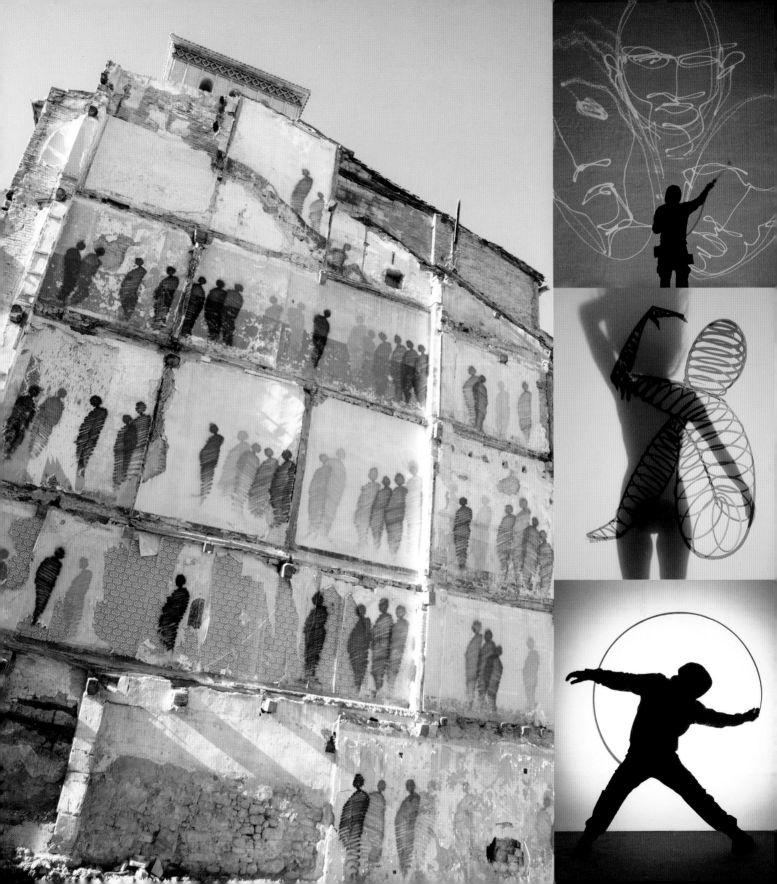

BARCELONA

Barcelona's hip-hop graffiti scene started in about 1983, although it initially focused on break dancing. Youngsters who watched *Style Wars* (1983) and *Beat Street* (1984) fell in love with the culture and began to copy it. Writers from the United States, such as Lee Quiñones and Futura 2000, and graffiti photographer Henry Chalfant visited the city for shows, which significantly influenced the local scene. In 1986 the first graffiti began to appear on Barcelona's subways and trains. The crews of this generation included SN, DFR, M2, 3RL, and GOLDEN. During the 1980s the

scene was truly underground and wild, with writers fighting for their spots and crossing pieces from other crews to open up new spaces to paint.

The second boom period came at the beginning of the 1990s and was influenced by the skateboard scene and the availability of more spray colors and information. Fanzines were printed in color, new shops opened, fat caps appeared, worldwide contacts were made, and travel to other cities began to take place. Writers in Barcelona began to meet every Sunday at the Universitat subway station, where they exchanged 'zines, prepared for jams, and hooked up with writers from other areas. The crews of this period included BZK, SAP, AAA, PH, CFC, 7MS, BTS, STG, among others, whereas the more active writers were Fase, Inupie, Zeus, Biz, Dam, Krash, Telz, Sutil, Sendys, Save, Heiz, and many others. During this period many writers started to hit the *cercanias* (commuter trains), painting hundreds of panels and whole cars running along the lines. Some districts began to look like halls of fame as their abandoned buildings

Crews such as Finders Keepers organized happenings that drew international artists to the city, attracted by its good weather, non-stop partying, and freedom for street painting. These were the golden years of Barcelona's street art, with artists hitting the streets such as Kenor (pp.304–5) & Kode, Lolo, Flan, Tofu Pax, Eledu & J. Loca, and Mr. Kern. However, with the increase in tourism and as many bombers had saturated the historic areas with tags covering old wooden doors and monuments, in 2006 the city's authorities adopted a zero tolerance policy to all forms of artistic expression on the streets.

Today, despite demonstrations against the stringent policy by artists, skaters, and activists, it is forbidden to paint murals, drink alcohol, or play music on the streets of Barcelona. This has led many writers to hit shop shutters or go to the suburbs, rivers, or abandoned factories to paint. However, a new generation of writers, such as Aryz (see pp.300–1) and Grito, continue painting large-scale walls in other cities close to Barcelona. **ZB**

and industrial zones became covered in murals. The neighborhoods of Poblenou and Glories were particular hot spots.

Montana Colors, founded in Barcelona by Jordi Rubio, created their first spray cans soley for graffiti writers in 1994, which together with the Game Over videogame shop supported the local scene—the shop became the new meeting point for writers from all over. Although many new writers began to paint in the suburbs, some stopped painting and instead became immersed in the *bakalao* (Spanish electronic dance music) scene. By the end of the 1990s, there was a mixture of writers emerging out of different backgrounds and Barcelona's graffiti style was evolving into something new and fresh, as writers such as Sixeart (see pp.306–9) experimented with collage and mixed media.

By the start of the new millennium, and with the arrival of "post-graffiti" and the growing influence of the internet, the streets of Barcelona were packed with colorful walls. This period saw famous logo-tags by La Mano, El Pez, Chanoir from Paris, and Xupet Negre, who bombed everywhere. A new collective called Ovejas Negras (Black Sheep) started experimenting on the streets: pasting objects on walls, doing performances, painting in neighborhoods in the city center, and transforming advertisements. They represented an "anti-graffiti" crew because they cared less about how the murals turned out and more about raising political awareness and encouraging people to participate. Members included Zosen (see pp.312–13), Oldie, Debens (see pp.302–3), Kafre, and Maze. At this time Barcelona became a mecca for international graffiti and street art, with many artists from around the world traveling there to make their mark. Others relocated to the city, such as Miss Van (see image 4), Boris Hoppek, and Jorge Rodríguez-Gerada (see image 5).

BARCELONA

BORN 1989, Palo Alto, California, USA **MEDIUM** Spray paint
STYLE Contemporary muralism **THEMES** Exoskeletons, cigarettes,
anthropomorphic animals **CREW** Mixed Media Crew

ARYZ

The youngest and probably the most naturally talented artist featured within these pages, Aryz creates huge, elegiac, romantic murals that show an enormous range of techniques and ideas. He uses a recurring set of iconographic motifs, including his omnipresent cigarettes, anthropomorphic animals, and ubiquitous exoskeletons, as well as a formal approach that often features the transparent, luminous hue of watercolors and the techniques of staining and granulation that this medium is so susceptible to. In just a few short years, he has created a dramatic and graceful aesthetic that is unmistakably his own.

Aryz's first experience of painting on walls proved to have major ramifications on his future output. Although he spent years studying the various "gestures, movements, and colors" of the graffiti he passed daily on his way to school, his first attempt at putting this learning into practice was distinctively humbling: He produced what could only be considered an unmitigated mess that he tried in vain to fix the following day. The feeling of inadequacy this introduction induced instilled a deep drive within Aryz to push and develop his practice. He started to paint more with his friends, producing the backgrounds and characters in his collaborators more classical graffiti pieces, and his self-professed limitations in producing letters soon guided him toward a more illustrative, figurative approach. Although an injury to his finger forced him to start using brushes as well as sprays (leading to his being ostracized by many of the people he then worked with), Aryz's street interventions began to take on a more refined style. They increased both in size and in scope, eventually embracing many of the themes he is now known for. These themes provided Aryz's work with many evocative leitmotifs, although for him the foundation of his work is not any brute "message" but simply their basic form and shape and the "excuse to put colors in one place or another." He still experiences the "same sensation of failure" he had on painting his first wall on almost every occasion he paints. However, the melancholy darkness and intensity of Aryz's work can be seen as a consequence of this sensibility and his insatiable desire for perfection. Aryz continues to take his atmospheric pieces into ever more surreal, unorthodox territory, reveling in his theatrical, elegant aesthetic.

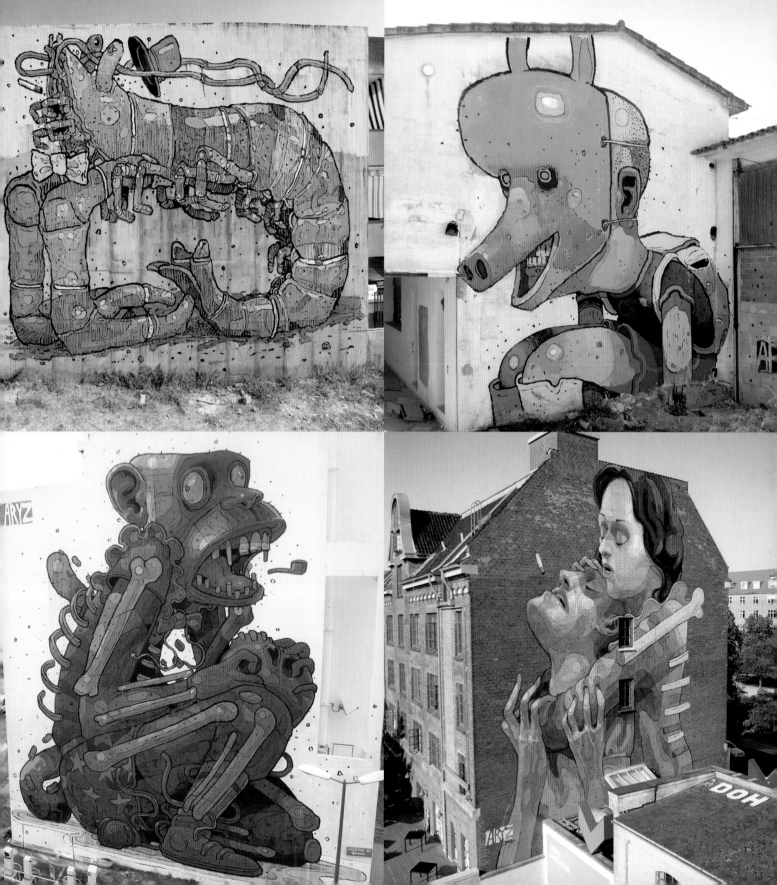

BARCELONA

BORN 1980, Barcelona, Spain MEDIUM Spray paint, photography, sculpture, performance STYLE Neo-Expressionist, collagist THEMES The chair, anti-aesthetic
INFLUENCES Rauschenberg, Cy Twombly COLLECTIVES ONG (Ovejas Negras), 1980

1 *Chair*, Barcelona, Spain, 2001
2 *Droga Cara*, Mollet del Vallès, Spain, 2008
3 *Lovesaver*, Barcelona, Spain, 2012

DEBENS

Born in 1980, Debens first became involved in Independent Public Art in 1994, during the early days of the Barcelona graffiti scene. After spending five years within this artistic milieu, he broke with it, and went on to develop a naive, often ostensibly unsophisticated style. From 1999, he adopted the image of a chair as a central icon, began depicting geometric forms, and incorporated elements of collage and assemblage into his work. Combined with his experiments in performance art, sculpture, painting, and photography, Debens evolved an anti-aesthetic that ran contrary to the prevalent style of street art in Barcelona at that time.

As a key member of the highly influential collectives ONG (Ovejas Negras, or "Black Sheep")—alongside artists Pez, Skum, Sae, and Zosen (see pp.312–13)—and 1980—with Oyes, Ibon Apezteguia, Mister, and Chanoir—Debens has been at the forefront of the developments within the Barcelona Independent Public Art scene during the early twenty-first century. From the more outward-looking, colorful aesthetic of ONG to the less animated, perhaps purer aesthetic of 1980, he has embraced a broad range of aesthetic techniques, though his wit and keen eye for popular culture remain a constant.

From 2005, Debens returned to a more independent form of output, heralding a fruitful period of studio-based activity. His street art directly influenced this work, and vice versa—a "relationship," he says, that "informs all my ideas, skills, forms, and concepts." Debens's enthusiasm for experimentation saw him evolve a new visual language, that revealed more personal thoughts and opinions and engaged more directly with the general public in the street. To that end, his works branched out from traditional graffiti, taking a distinctly Neo-Expressionist turn with a rough, often violent use of color, and a frantic, furious technique. Since 2007, Debens's work has mutated further. Whether working on his graffiti "installations"—site-specific sculptures merging graffiti with trash, cloth, or wood (see image 1 and 2)—his stickers and billboard modifications (another nod to Neo-Expressionism), or his more recent, large-scale collages using found imagery (see image 3), Debens persistently reinvents himself, improvising, taking advantage of chance events, refusing to be limited by any one style or technique.

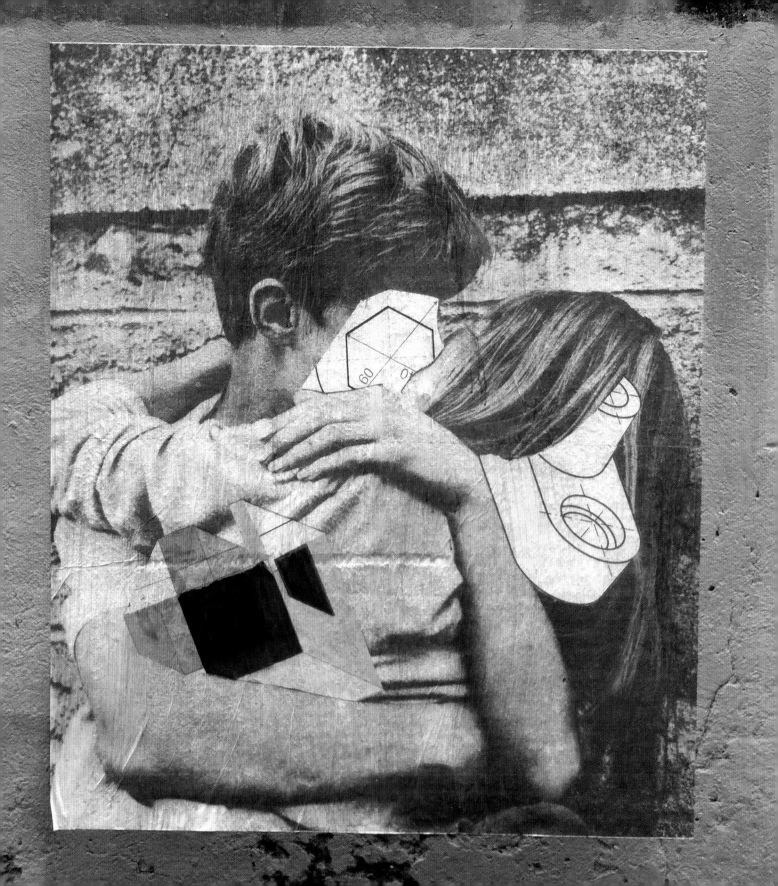

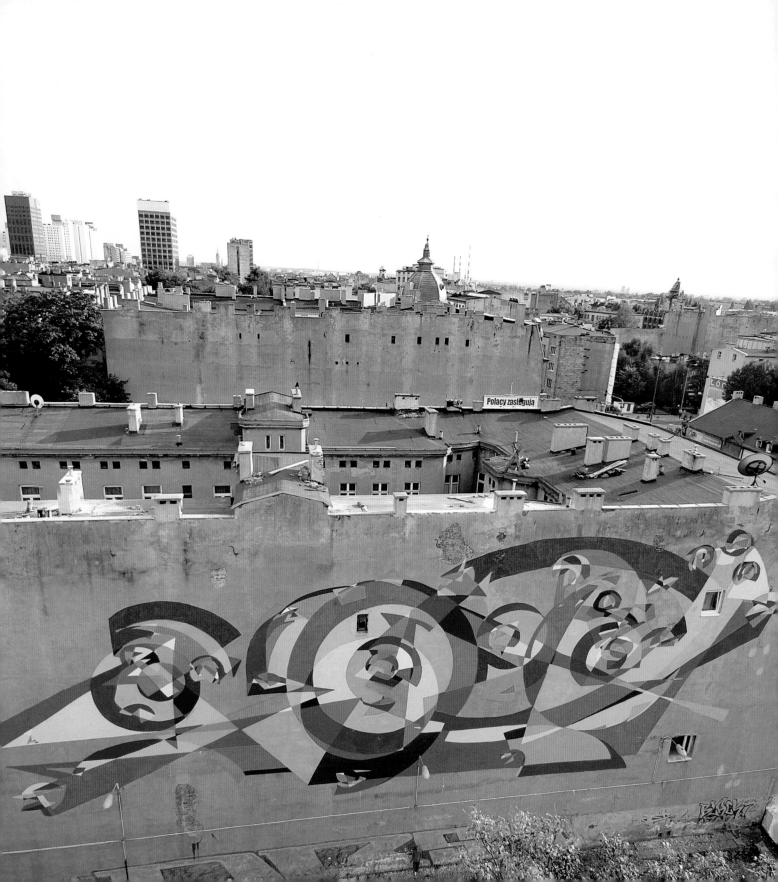

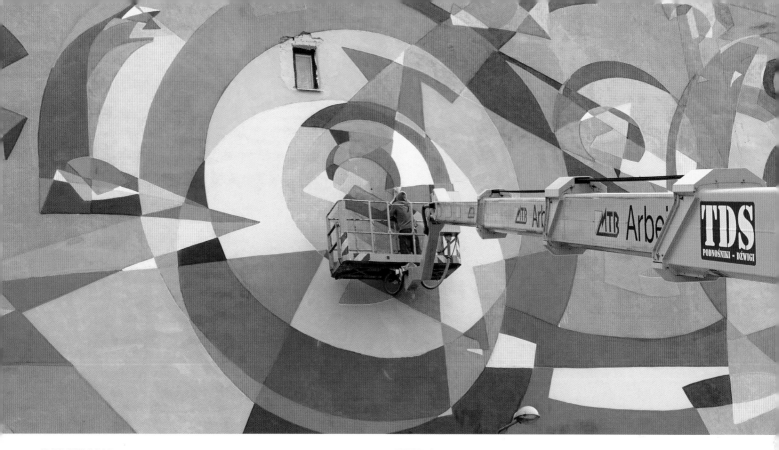

BARCELONA

BORN 1976 **MEDIUM** Spray paint, performance **STYLE** Abstract graffiti, performance art **THEMES** Geometry, color, light, kaleidoscopic patterns
INFLUENCES Gaudí, Miro, hieroglyphics

1-2 Lodz, Poland, 2011

KENOR

Not many graffiti artists like to paint the streets in the nude, but Kenor is not just any graffiti artist. A self-proclaimed extraterrestrial, and a born performer, Kenor's organic, kaleidoscopic productions are geometric representations of sound and movement, visual interpretations of music and dance in two-dimensional form. Their multicolored, effervescent hues and fluid, protean contours force us to enter his paintings, to travel within what he terms his "abstract architecture."

Until 2000, Kenor was focused on more traditional urban art, obsessed with typography, logos, and textual experimentation. Yet as the Barcelona movement gathered pace, Kenor found himself wrapped up within the changes, forming designs that functioned, in his own words, as "parallel worlds, dreams, hopes, illusions, questions, options, and exits." He is driven to transform the city, to counteract the encroaching gray with a wealth of color, to "decorate the dead cities"—in his memorable phrase— to open up the street as a public gallery for everyone. He is moved by the

texture of the city, the broken and tired parts, the boundaries. Such sites call to him—they necessitate repair, resuscitation, reanimation.

Through both his words and images, Kenor has become something of a spokesperson against the increasing commodification of Barcelona's street culture, railing against the new laws that have begun to repress so much of the city's previously vibrant urban life. From skateboarding to performance art, break dancing to busking, street practices have been curtailed—though the city still identifies itself with a liberal, cultural heritage: "They support for a day the same people they punish, to win the sympathy of the young people," Kenor complains.

He strives to keep his work constantly evolving, "recreating spaces of freedom," in another of his vivid analogies. Now working on a monumental scale, covering walls all over the world, Kenor has also moved into new realms—not only installations and sculptures, but a deeper progression into video and performance art. Films such as *Dentro de Mi* and *Cualquier Lugar, un Dia Cualquiera* in particular display the connection between dance and inscription, the choreography of the image. Metamorphosing his art like a living organism, his works grow into ever new dimensions, captured by the infinite possibilities of the movement that surrounds us.

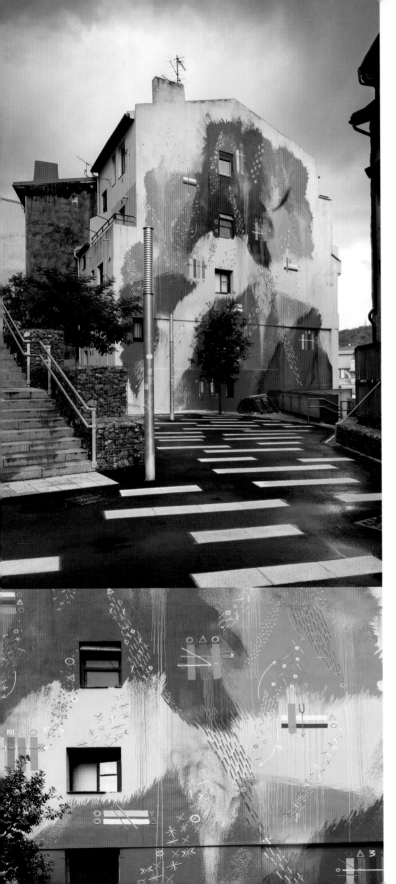

BARCELONA

BORN 1975, Barcelona, Spain MEDIUM Spray paint, sculpture STYLE Primitive futurism THEMES Primal world, color, line INFLUENCES Natural world, architecture, indigeneity, primitive art COLLECTIVE Equipo Plastico

SIXEART
SIXE • SERGIO HIDALGO PAREDES

The artist Sixeart, who is also known as Sixe or Sergio Hidalgo Paredes, is synonymous with his hometown of Barcelona. At the forefront of the Independent Public Art scene in that city, his work has developed from the street into the gallery with great success, while still maintaining its deeply urban roots. Fascinated with depicting the primordial—whether animal life, adolescents, or ancestors—Sixe has developed a form of art that he terms "primitive futurism." It is one with its own language and symbols, its own styles and techniques—a dualist system embracing darkness and light, as well as the madness and wisdom of existence.

An autodidactic artist, Sixe was unschooled in the language of fine or classical art, and instead learned his trade and developed his style solely on the street. He has remarked that his greatest influence was "the [natural] world and the architecture of the city where I used to live," although he was also inspired by the much-loved cartoons and comics of his childhood. These various aesthetic influences are evident in two of his early and most famous projects, *Animales mutantes* ("Mutant Animals") and *Niños malos con flequillo* ("Bad Children with Fringes"). These surreal, vivid, and inherently playful works—both of which appeared initially on the street, but later enjoyed a second life in the gallery—demonstrated a warped and uninhibited aesthetic that shifted the viewer into a parallel, somewhat extraordinary dimension. Like a "tragicomedy," as he describes it, they displayed both "the side of happiness, the child-like one" and the "dark, psychedelic side" of humanity. *Animales mutantes* can therefore be regarded as lighthearted, if slightly eccentric, family portraits. Although the animals are often quite chimerical and surreal, they commonly take the form of pigeons, identifiable by their idiosyncratic four-pronged tufts of feathers. Taking on an outsider art quality, much like the painted Barcelonan homing pigeons that he has been strongly influenced by, Sixe's *Animales mutantes* contain a vibrancy and color that seems to bring them to life, a carefree, if somewhat unhinged quality. *Niños malos con flequillo* (see image 3, p.309) assumed a more melancholic, diabolical tone, however, which he sums up as "drama, love, and madness." These characters were born out of the people he would see wandering during wild Barcelona nights; a group of

1-2 *Futurismo primitivo*, Bilbao, Spain, 2012
3-5 Lima, Peru, 2012 (with Valentino)

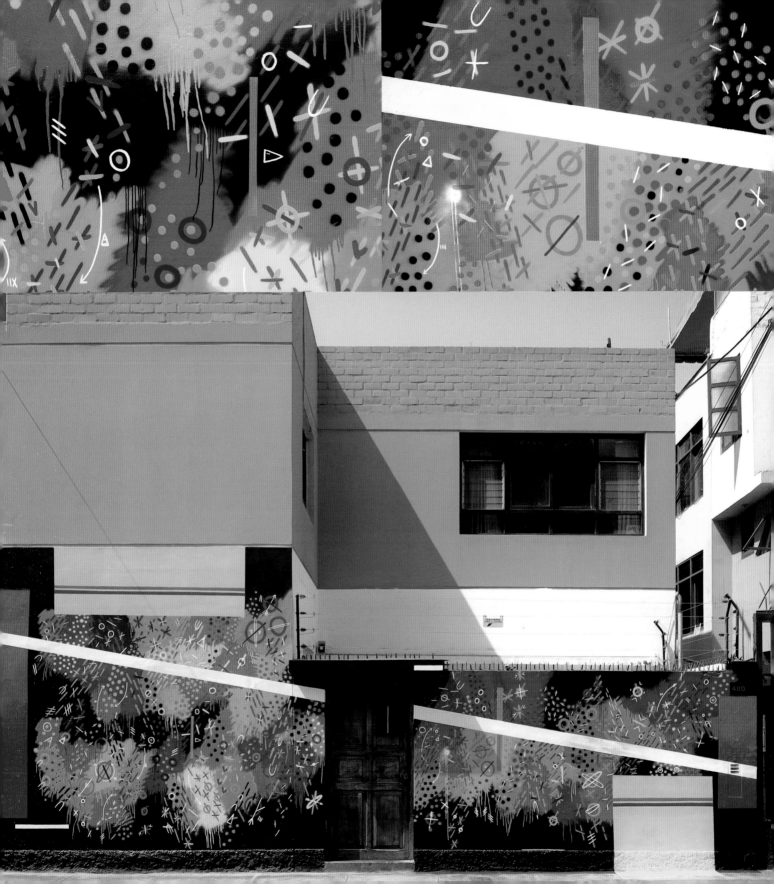

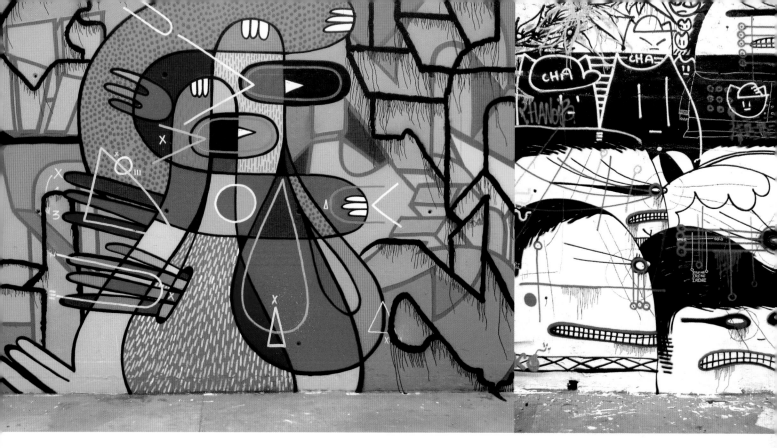

1 *Tolerancia 0*, Barcelona, Spain, 2011
2 Barcelona, Spain, 2009 (with Dios)
3 *Niños malos con flequillo*, Barcelona, Spain, 2005

red-eyed, fierce, yet somewhat sorrowful creatures, these figures represent a balance to his more lighthearted, happy-go-lucky characters, and are a constant reminder of the duality we all have to accommodate in life. Both came to utilize a secondary layer that Sixe terms "circuits," however, an attendant cryptogrammic dimension to the paintings' primary visual layer (and a style that can be more clearly seen in Sixe's map of Barcelona, see pp.310–11). Containing links to variant parts of the same images as well as featuring what Sixe has termed "proto-writing" or "ephemeral typographies," they act as a "diary of symbols," a way of displaying his secrets in a very public form of therapy.

More recently, however, Sixe has become interested in ancient cultures and primitive art that link his obsession with graffiti to more historical, parietal writings. Commencing with his series *Warriors*, which was influenced by the art of ancient Greece, his latest work has focused on Andean and Mesoamerican cultures, taking inspiration from their color, mysticism, myths, and legends. As a method of revisiting the values of the past and creating an ancestral reconnection through the use of symbols and iconography, the pre-Columbian direction in Sixe's work attempts to transport us to the ancient Mayan and Inca cities, sites that

were painted in bright colors, a world away from the gray conurbations in which we live today. As such, there is always a link back to the present, a link back to his *graffitero* roots and to the work that led him into the studio in the first place. However, it is in popular rather than high art that Sixe's aesthetic finds its true companion—in the textiles of the Paracas, the pottery of the Moche, and in the visions and energy generated through the sacred plants *ayahuasca* and the San Pedro cactus.

With his latest project *Futurismo primitivo* ("Primitive futurism"), together with his work in Peru with local artist Radio, Sixe has started to work on a series that encompasses an almost pure abstraction, producing huge swathes of color—like gargantuan paint bombs—and which seeks to re-establish a spiritual connection to a primal visual essence. He continues to refine his work while refusing to relinquish its quintessentially child-like constitution, and the deep joy and innocence it contains. Sixe has never lost his innate necessity to paint in the street, his desire, and his commitment to this locale. Although he is still producing ever more complex canvases, sculptures, and installations, the beautiful purity of a tag is never far away: Sincere and joyous, his work displays a merging of simplicity and complexity, and a harmony of color and line.

BARCELONA
BY
SIXEART

Sixeart's map of Barcelona is not only a prime example of his distinctive, self-named style of *Futurismo primitivo* ("primitive futurism"), but a perfect exemplar of his use of what he terms "circuits" in his work. These purely geometric and textual elements, comprising arrow-like lines, numbers, and letters in strange algebraic formations, initially emerged as a secondary layer to the more primary figurative dimension of Sixeart's work, providing a hidden code that would explain the "everyday encounters between myself and the characters in the painting." As these circuits began to develop, however, they soon found themselves propelled to the very forefront of Sixeart's paintings, overtaking their previously dominant characters, and creating what he terms "compositions without forms," a "never-ending story" of numbers, lines, crossings, and circles. Reminiscent of his earlier, purely textual work, the circuits cut directly to the core of Sixeart's production, harking back to the origins of his work on the street, yet doing so with all the additional knowledge and information he had acquired throughout his practice.

Sixeart's map of his hometown Barcelona consists of a giant diptych with each image measuring 39 x 28 inches (100 x 72 cm). Beautifully illustrated, it provides a richly ornate depiction of the city that clearly delineates many of its key streets and plazas, such as the famous Av Diagonal that almost perfectly dissects the image or the solitary horizontal line that represents Gran Via. It also contains hidden messages and numerical symbolism that are key to Sixeart's life itself—the various "dates where things happened to me, or the numbers, which I think are magical," a whole vocabulary of symbols, numbers, and shapes that for Sixeart act as a personal style of cuneiform writing (the earliest known writing system that emerged in Mesopotamia, Persia, and Ugarit). This dualist, dramatic depiction of Barcelona functions both through intimate and dispassionate lenses, being abstractly subjective and representationally objective at the same time. Sixeart's map provides us with a multilayered understanding of his city, as well as displaying the clarity, intricacy, and balance of color and line he expresses in his oeuvre as a whole.

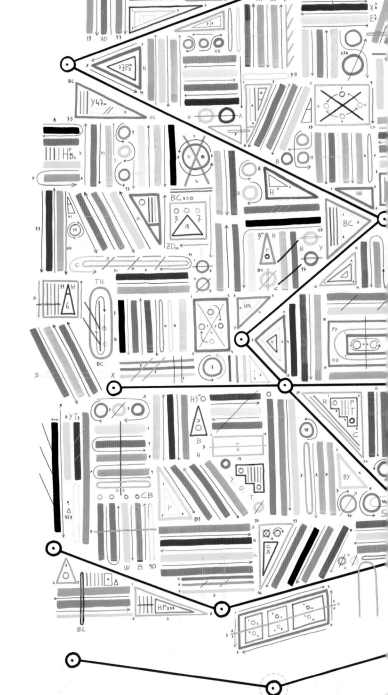

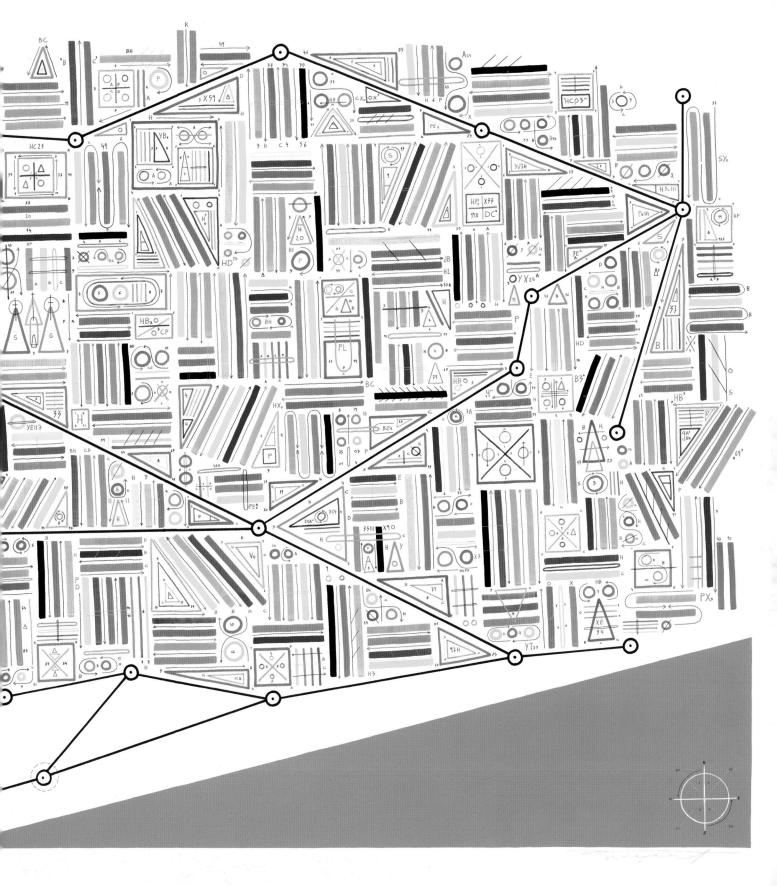

BARCELONA
BORN 1978, Buenos Aires, Argentina MEDIUM Spray paint STYLE Anarcho-primitivist graffiti, punk graffiti THEMES DIY movement, veganism, anarchism, animal liberation INFLUENCES Hip-hop, punk CREW ONG (Ovejas Negras)

ZOSEN
ZOSEN BANDIDO • TOFU PAX
TOFU LIBRE • 1984 NOW

Zosen comes from a background of skate culture, punk, and the DIY movement (as does his collaborator 3TTMan, see pp.312–13), and became an authority on the history of European graffiti from his years spent working within its traditions. His unmistakable psychedelic style, with its vividly rich colors, tribal symbolism, and child-like imagery, is accompanied by serious political intent, however, and he has added a passionate activism to the highly colorful, naive aesthetic for which Barcelona is famous.

Born in 1978, Zosen wrote his first tags on the streets of his hometown Buenos Aires when he was just eleven years old. Moving to Barcelona with his parents a year later to escape the legacy of the dictatorship (a period that he believes had a strong impact on his later artistic output), he continued painting graffiti, growing more closely involved with the distinctly European strain of hip-hop culture, which fed into his love of thrash and punk. He became a key figure in the Barcelona graffiti scene during the 1990s, when the defiantly political attitude of his work became evident—not only in the deviant characters and images of his pieces, but also through the textual messages they featured (such as *Dejame salir de vuestro consumismo de mierda*—"Let me out of your shitty consumerism" and *Ningun ejercito defiende la paz*—"No army defends peace").

By the end of the decade, Zosen's work had become more experimental, now tending toward imagery alone and a more acute sense of color. He became part of the renowned ONG (Ovejas Negras, or "Black Sheep") collective, alongside artists such as Debens (see pp.302–3), Kafre, Maze, Oldie, Pez, Sae, and Skum. The collaborative energy of the group pushed him to new heights, enabling him to find his true voice.

Built on his own idiosyncratic visual language—a primitivist, carnivalesque compendium—Zosen's work continues to tackle the themes that had previously preoccupied him, such as anarchism, animal liberation, and veganism, but now via a more potent technique. Whether he is working with primordial imagery, which combines ostensibly naive symbolism with real meaning and purpose, or utilizing quotations from figures such as anti-civilization philosopher John Zernan, Zosen's productions embody a unique anarcho-primitivist aesthetic.

1 Wroclaw, Poland, 2010 2 Barcelona, Spain, 2011 (with Mina Hamada) 3 San Francisco, USA, 2009 (with Doodles and Luke Ramsey) 4 Tokyo, Japan, 2012 5 Barcelona, Spain, 2011 (with Pez) 6 Barcelona, Spain, 2007 (with Miss Van)

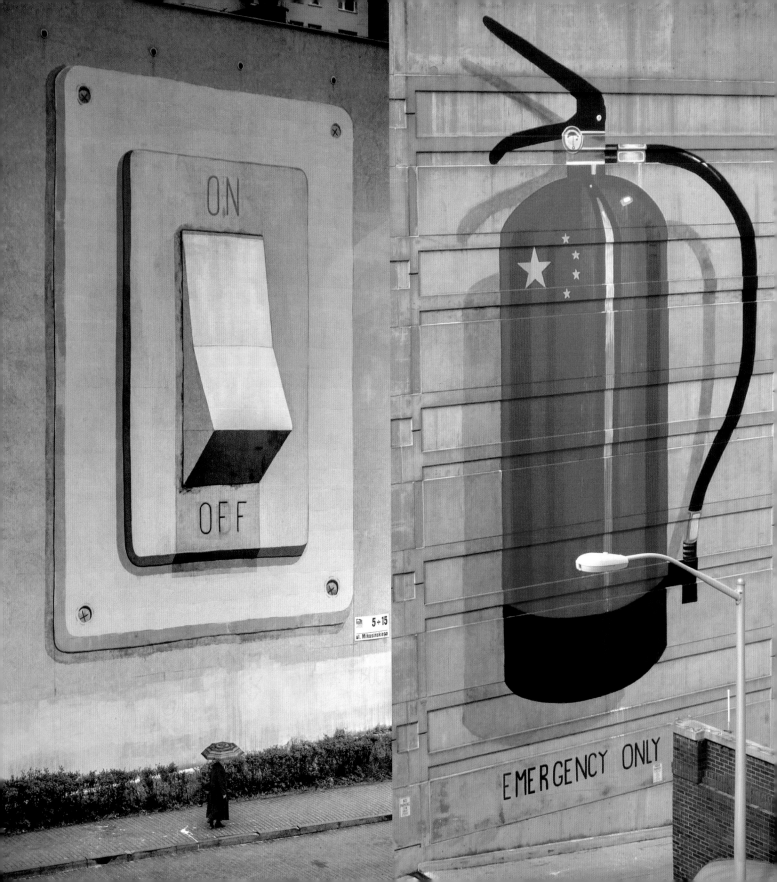

VALENCIA

BORN Unknown **MEDIUM** Spray/acrylic paint **STYLE** Satirical cartoons, murals
THEMES Politics, history, society, the ladder, the fence **INFLUENCES** Os Gêmeos,
Herber, San, Muritzio Cattelan, Santiago Sierra, Teresa Margolles

ESCIF

Escif's understated but profound style has challenged many of the
preconceptions about Independent Public Art, and represents a
distinctively intellectual but instantly accessible approach. Intended
to provoke and question the viewer, his images function in two basic
modalities: either as a form of meta-graffiti—interrogating the various
meanings, motivations, and issues that emerge from the very act of
making graffiti—or as a form of contemporary urban editorial cartoon,
a satirical sketch (appearing on a public wall rather than in a newspaper)
relating to a socio-political issue that Escif wishes to problematize. In both
contexts, his paintings work as an "exercise of reflection that can be shared
with people," an ongoing process by which he strives to develop a range of
ideas and highlight particular concerns. They are a means of research and
exploration, a speech-act transferred to the communal space of the street.

Escif's "meta-graffiti" is evident in his frequent use of two key motifs:
The fence and the ladder. While the former usually serves as a boundary,
and the latter a channel or means of access, both may also be seen as
symbols that enable and disable, permit and resist, and as such are
pivotal to the practice of Independent Public Art. Alongside his ever-
present images of walls—a "strong symbol inside the street art
movement"—Escif tries to assess the many dichotomies that the practice
of graffiti introduces, pointing out that walls "are designed to handle life
in the cities, but not to be handled by the city life," that they are seen as
limits rather than "open channels of communication through which you
can reach thousands of people." While urban images are regularly
denigrated in favor of plain concrete, Escif constantly tests this state of
affairs by undertaking a visual and sociological examination of issues,
asking: "Why paint on the street? What are the walls and to whom do
they belong? Why does graffiti bother people so much, when advertising
is much more abrasive? Where does the freedom of each person begin and
end?" Some of his works are openly explicit—for example, *Apología al
sedentarismo* ("Apologies to Sedentariness," see image 2, p.317), a wall
as a barrier, or *Sin trucos ni tracas* ("Without Tricks or Tracks"), a wall as an
entrance. Others are more esoteric, such as *The Black Wall*, *Rise and Fall*, or
the superb *Sold Out!* (a commentary both on the commercialization of
graffiti culture and the overbearing weight of its history). Both approaches

1 *On/Off*, Katowice, Poland, 2012
2 *Emergency Only*, Atlanta, USA, 2011
3 *Chihuahua*, Mexico City, Mexico, 2012

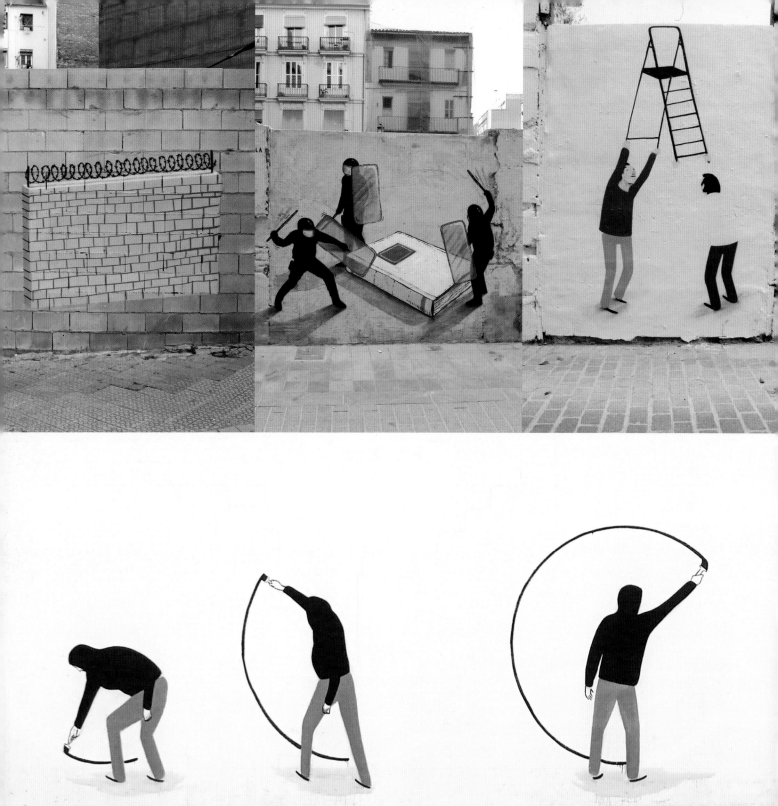

1 *Apología al sedentarismo*, Bilbao, Spain, 2011
2 *Educación para la ciudadania*, Valencia, Spain, 2012
3 *Abusar sexualmente de una escalera*, Valencia, Spain 2010
4 *Art vs. Capitalism*, Grottaglie, Italy, 2011

experiment with and investigate graffiti culture in the same breath. He may have been inspired by this culture, but in Escif's more socio-political commentaries he attempts to escape the movement's stereotypes, and the predilections that he himself has developed, to stimulate the viewer into thinking and provoke some thought in the city at large. He uses imagery to disseminate an idea rather than simply to please the eye, to highlight an issue rather than his own skill.

Much like a political cartoonist, Escif utilizes satire, juxtaposition, hyperbole, and metaphor to question the norm, to query hegemonic attitudes. Rather than using the public platform of a newspaper, however, he chooses the wall and the street, which have become the most visible site in the modern public sphere (along with the internet) and therefore the most effective space for his often caustic messages. Indeed, the role of the political cartoonist bears close comparison with that of the graffiti artist. Both may face physical and judicial dangers—infamous examples include the imprisonment of Honoré Daumier by King Louis Philippe in 1832 and the assassination of the Palestinian cartoonist Naji al-Ali in 1987.

Both artists choose to instruct through parody, through drama and suggestion. Escif's works such as *Art vs. Capitalism* (a comment on the collapse of the Euro, see image 1), *Educación para la ciudadania* ("Education for citizenship," see image 3)—a critique of recent large education cuts in Valencia—and his recent *Chihuahua* (see image 3, p.315) mural in Mexico City (confronting the Tlatelolco massacre in 1968), all point to an issue without being explicit, and have both innately playful and unexpectedly sardonic undertones. To Escif, they work, like his meta-graffiti, not through "revolution, but in the small insurrections that begin with the self," forming interventions that ferment a "dialogue with the city, with the streets, with the walls, and with the passers-by." The subdued palette of his paintings seem to belie their true intention—to offer a piercing indictment of contemporary culture.

Escif's work provides small moments of autonomy in the city, moments which he feels expose the "cracks in the heart of the city," the possibilities of the other. In place of the synthetic happiness of the advertising industry, he offers the "reality of the world with its gray and its nuances."

ELCHE
BORN 1979, Elche, Spain MEDIUM Spray paint STYLE Contemporary
graffiti, graphic design THEMES Futuristic aesthetic INFLUENCES Jack Kirby,
breakdancing, rap culture CREWS Ultra Boys, Porno Stars

DEMS333

One of a new breed of internationally esteemed style writers, Dems333
is a Spanish artist who has formulated a futuristic, free-flowing graffiti
aesthetic that rivals any other being produced today. He has put his
hometown of Elche, a city that despite its small size has produced a
wealth of talent, firmly on the international graffiti radar. Year after year,
Dems's relentless work ethic has resulted in the production of hundreds
of works that have saturated his hometown and progressed far beyond
the borders of Spain itself. He constantly searches for innovative ways of
producing his name and undertaking the endless, limitless task of writing.
Graffiti is not merely something he works at but something he lives
for—an addiction to which he happily yields.

The break dancing and rap culture that arrived in Elche in the early
1990s greatly inspired Dems. He had already been taught the basics of
drawing by his grandfather, but he had never known how to take these
skills further. Although the graffiti in Elche at this time was extremely
limited, when Dems saw a graffiti work for the first time it resulted in a
huge visual awakening, opening his eyes to the vast possibilities of the
form. Although nearby Alicante had a more extensive graffiti scene that
Dems often explored, it was not until 1997 that he had the means to travel
more widely, it being "hard enough to get paint, let alone travel" during
those early years. Journeys to Barcelona, Seville, and Madrid introduced
him to a new network of artists, as well as a world of different techniques
and styles. Yet, despite traveling and working outside Spain, Dems never
sought to move away from Elche but endeavored instead to create a
vibrant community of writers in his home city. Instead of becoming
disheartened at the apparent isolation of his location, he set out to
continually stretch himself by working to produce every color and shape
combination that he could imagine possible.

Dems completely rejects graffiti's assignation as art and makes a
clear separation between his commercial graphic design and his graffiti,
regarding the latter as an inalienable aesthetic undertaken solely for the
purity, joy, and honesty of the act itself. He ensures that his illicit work is
kept sacrosanct—a "gift we give to the city [of our] time, money, and work
for nothing." Dems continues to produce his work obsessively and at an
ever-increasing rate, giving his life to the world of graffiti.

1 Santa Magnetica, Spain, 2011 2-3 Elche, Spain, 2011
4 Santa Magnetica, Spain, 2012 5 Santa Pola, Spain, 2005
6 Santa Magnetica, Spain, 2011 7 Munich, Germany, 2010
(with Satone) 8 Valencia, Spain, 2011

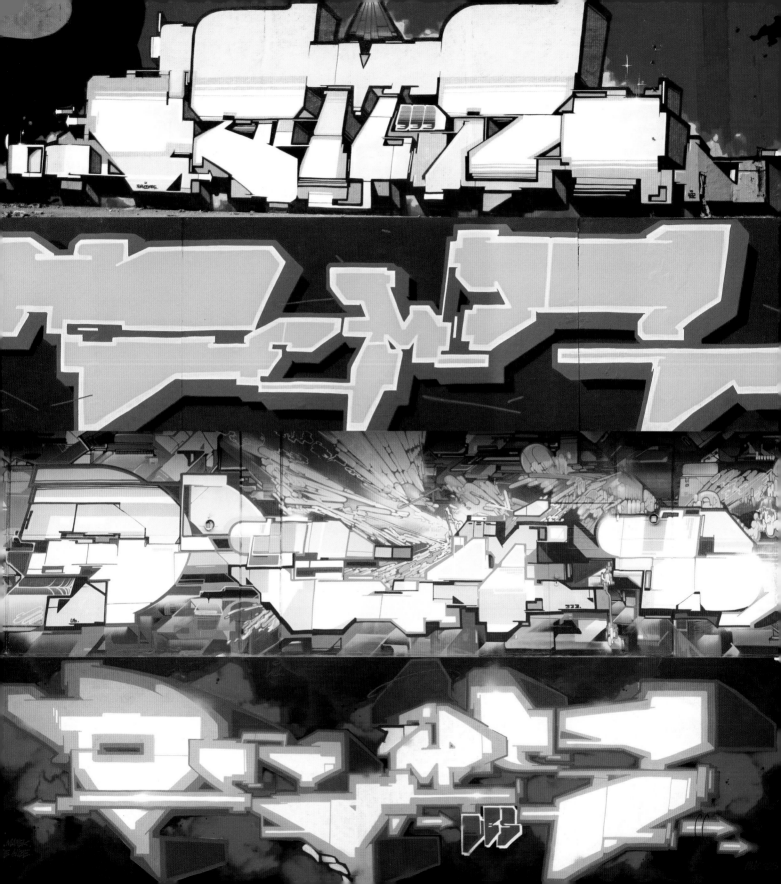

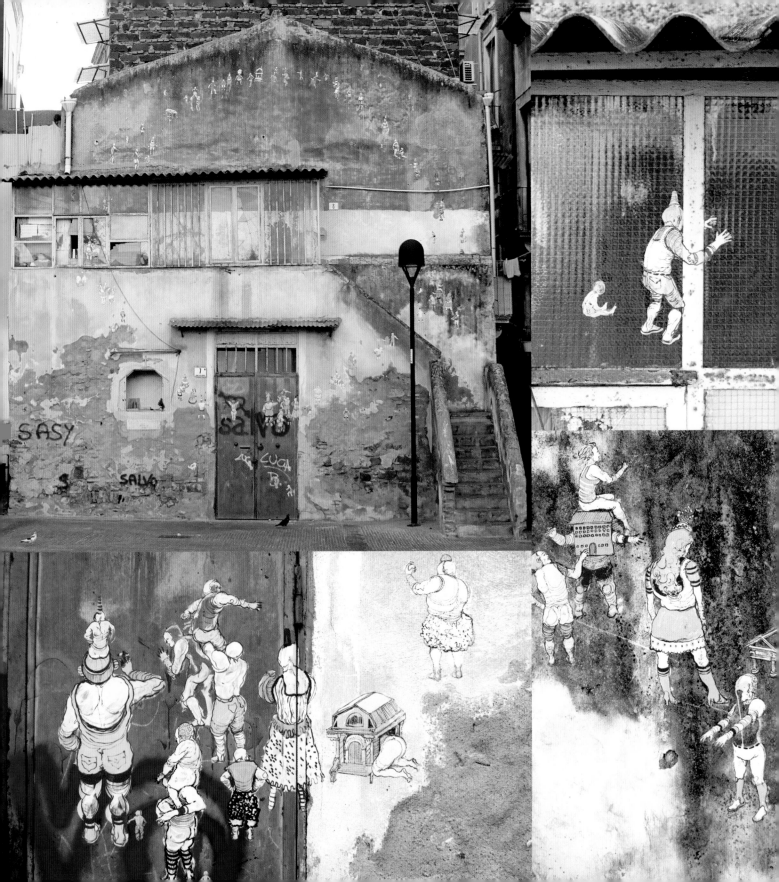

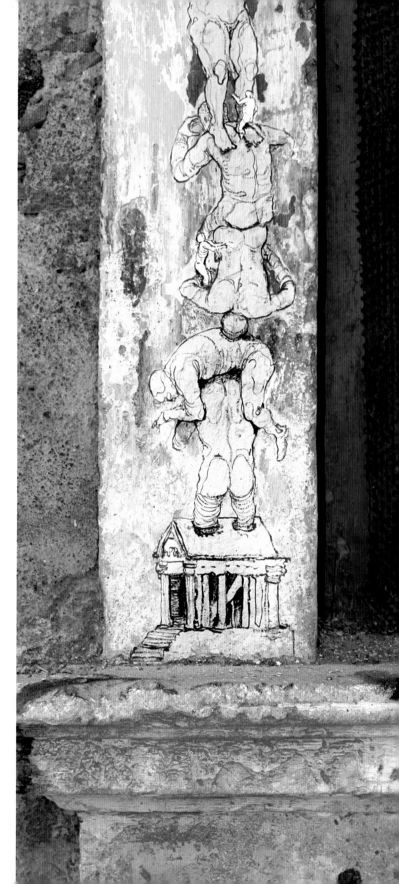

MORALEJA
BORN 1980, Cáceres, Spain **MEDIUM** Painting, drawing, murals
STYLE Contemporary muralism **THEMES** Kafkaesque world, desolation, solemnity, scale **INFLUENCES** Paul Noble, Peter Doig, Michael Borremans, Hieronymus Bosch

SAN
DANIEL MUÑOZ

An artist who combines intense technical skill with a rarely matched symbolic intricacy, San (also known as Daniel Muñoz) is a Spanish artist whose figurative panoramas possess a markedly classical character. Their classicism, however, is injected with a strong, often biting assessment of contemporary moral sensibilities. Growing up in the village of Moraleja in the heart of Extremadura (a region whose name literally means "extremely hard"), San was influenced by the province's dramatic and desolate landscape, its bleakly romantic splendor and status as a tough land producing tough characters. Reflecting this in a body of work as exquisite as it is somber, an oeuvre united through its strangely haunting elegance, San imbues his images with a criticality and solemnity seldom seen in Independent Public Art, one that focuses on the more indeterminate, amorphous quandaries that contemporary urban life throws up. His images have a strongly Kafkaesque bent that articulates the indescribable feelings of senselessness or disorientation we all encounter. San's work therefore functions within an unyielding borderland (much like his birthplace itself), a darkly beautiful arena in which he externalizes his internal conflicts and brings his penetrating vision of the world into physical form.

Although there was little graffiti in Extremadura when he was growing up, San's annual excursions to Madrid to visit his father (who was working there) ensured that he was exposed to the discourse from an early age; the legendary Mambo Kings in particular (a collective including the artist SpY, see pp.292–5) and Suso33 (see pp.296–7) were a strong presence in the Cuatro Caminos barrio where he stayed every summer. Slowly building up a small but stable community of writers back home, however, San trod many of the traditional paths of a young graffiti artist, eventually ending up at art school in Cáceres, before finally moving to Madrid on a more permanent basis in 2000 to continue his studies at the Faculty of Fine Arts. As his technical skills began to develop through his institutional education, however, San became increasingly motivated by the bombing culture. He was highly active in this field for several years; although he would never call himself a "superescritor," he "tasted the pleasure of graffiti." Never interested in its posturing or egotistical elements, San reveled simply in the opportunities graffiti gave him to

1-5 Catania, Sicily, Italy, 2010

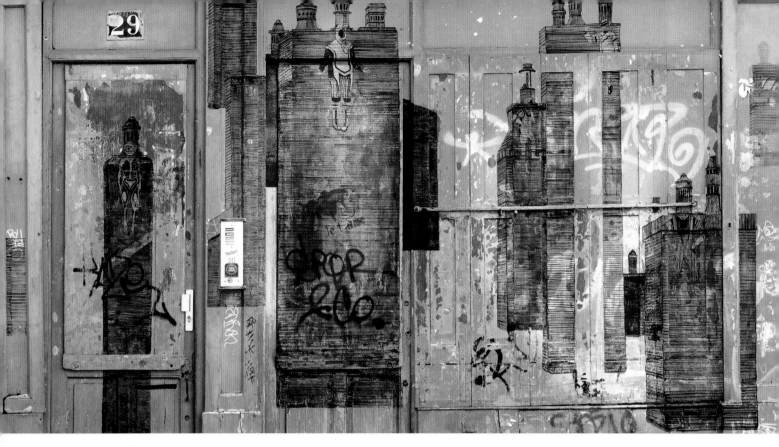

1-5 Besançon, France, 2011

1		2	3
		4	5

experiment with form, color, scale, and movement, as well as the chance for travel it provided him with. His work in the public sphere became increasingly representational and influenced by the world of fine art (in particular contemporary artists, such as Paul Noble, Peter Doig, and Michael Borremans, as well as classical Renaissance Masters such as Bosch and Velázquez). By around 2009 San realized that the work he was producing on the street could no longer be defined by the (very elusive) term of "graffiti": Having dedicated himself more to studio work, not simply using the studio to produce sketches for his outside paintings as he had previously, he therefore found new ways to develop and extend his murals, abandoning his use of the spray can and forming a more subtle and delicate aesthetic.

Since returning to Extremadura, San's intense work ethic and drive has only increased and resulted in a growing collection of superb works on paper and canvas, as well as two notable developments in his public work. He has produced a new series of murals that function on a more diminutive scale, as well as utilized a diaphanous, almost translucent color technique. These developments have seen him focus more on "pure drawing," not wanting to become trapped within the color palette (the

distinct reddish hues) he was becoming most renowned for. Furthermore, San has also challenged the increasing focus on magnitude within Independent Public Art and critiqued the potential of these "grand" paintings to simply subjugate their spectators through their domineering proportions. With his scaled-down works, therefore, he hopes to form a more direct, emotive relationship with the viewer, by producing something that must be studied and contemplated rather than simply glanced at. What San appears to be striving for is a more subdued yet stirring modification of his environment. This is notable in particular in his recent untitled work produced in Besançon, a mural scratched (in a literal enaction of the term "graffiti" from the Italian word *graffiare* meaning to scratch) directly onto the surface of a door (see images 2–5). San is always trying to master the creative challenges that he continually sets himself, overcoming the urge to simply repeat an already successful technique. With a passionate desire to expose the inauthenticity and deception of the world around him, he constructs a narrative that seeks to question "many of the 'truths' that we use to defend ourselves," and which aims to confront that which we so often evade, producing a difficult, yet evocative and elegiac aesthetic.

VIGO

BORN 1980, Vigo, Spain **MEDIUM** Spray paint **STYLE** Contemporary muralism **THEMES** Political critique, monochromes, ethics, satire **COLLECTIVE** Los Niños Especiales

LIQEN

1 *Wall Street Labyrinth*, Miami, USA, 2011
2 *Kalashnikov Brush*, Ukraine, 2012

Like conjoined twins, Liqen and his twin brother Pelucas (see pp.326–7) will always remain attached even as they willfully set out to remain independent. Their work is quite radically different, however, in an almost perfect example of the yin-yang dynamic, what often appears to be mutually incompatible can in fact be understood as each twin exploring the part of their shared brain the other is not using. Functioning as two separate hemispheres of a shared scopic world—a polychromatic versus monochromatic cleavage—their division can be seen as a simple bisection of the whole; they represent ostensibly antithetical forces that are in reality deeply intertwined and interdependent.

While Pelucas's work displays an obsession with carnival, in Liqen's visual world there is a more strongly critical intent and an overt darkness. Liqen has an illustrative, finely graphic style of production that tackles themes such as the immorality endemic in contemporary politics and the power of corporate multinationals. Using satirical distortion

and mythological reinvention, he creates an apocalyptic, often violent visuality that is marked by a deep anxiety about the state of the world. In contrast to Pelucas's nihilism, Liqen is more interested in spiritualism and his aesthetic is driven by an overt consciousness of our contemporary state. Although he can deliver bold, turbulent imagery if and when desired, Liqen explores a more classical visual realm.

His breakout work *Wall Street Labyrinth* (see image 1) is a perfect example of Liqen's intricate drawing style and his uncanny depiction of modern life. In the nightmare world he creates we see metamorphosed human and insect forms, depression, malaise, and the iron cage that traps society within its bureaucratic rationality. With its minute detailing and yet broad narrative scope, it perfectly illustrates the type of critical surrealism Liqen has formulated. Like his common collaborators Interesni Kazki (see pp.254–7), however, Liqen always suggests a glimmer of hope, the possibility of escape or redemption (as perhaps seen by his rogue rat in the system, wearing a natty jacket in image 1). Transforming his subconscious reality into the visible world, he is driven by a desire to share his ideas about the environment with others, creating a fantastical aesthetic that is also a stringent critique of contemporary life.

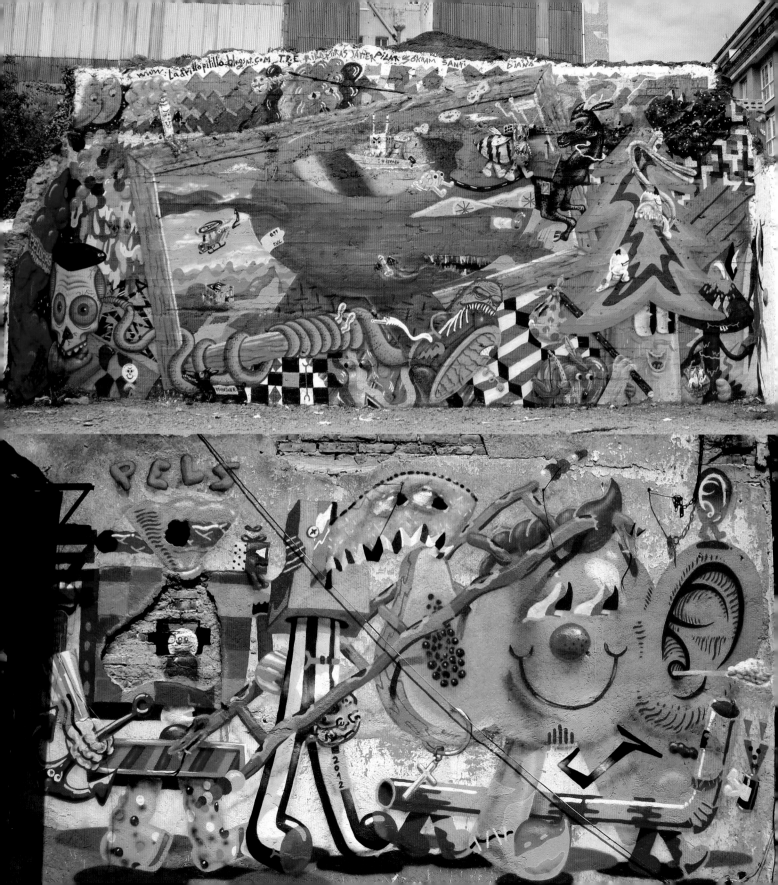

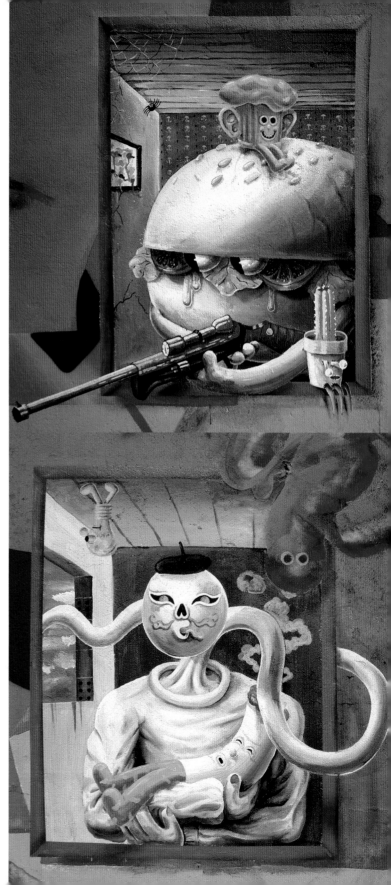

VIGO

BORN 1980, Vigo, Spain **MEDIUM** Spray paint, installation **STYLE** Absurdist graffiti **THEMES** Wild color, humor, excess, carnival, anthropomorphism **INFLUENCES** Kenny Scharf **COLLECTIVE** Los Niños Especiales

PELUCAS

PELS • PILAS

Unlike the work of his twin brother Liqen (see pp.324–5), which displays a cautious, studied, measured aesthetic, Pelucas's oeuvre demonstrates what he has described as "a more personal madness." Shunning Liqen's monochrome for a wild compendium of pigments, a lavish, brash, frenzied coloration, Pelucas creates a world of carnival, licentious play, and bawdy humor. Embracing the sense of transgression, humor, excess, and risk that this picaresque world elicits, Pelucas examines the same corrupt, desiccated world as his brother, but rejects it in a radically different way: Rebuffing it through the lunacy of the Dionysian, Pelucas creates an absurdist aesthetic that uncovers what lies behind the cracks in the concrete and brings forth his tropical madness into the everyday.

Pelucas's images depict a world of garish, psychedelic, acid-infused hedonism. Although he is capable of delicate refinement, as shown by his accomplished control of shade and nuance, Pelucas rejects this in favor of a brash, punk aesthetic in which the toy is king. He utilizes a recurring group of characters, who appear like Mr. Men on hallucinogens (as seen in the papaya-eared character in image 2, for example); however, his simple figures reflect a much deeper complexity than at first appears, their apparent happiness belying the subtlety of their darker edges. Like melting plastic, his characters—who appear in a multitude of forms, whether a pencil, cigarette, beer mug, or a wide variety of fruit and vegetable—seem to dissolve and fuse into their surroundings, their crazed, mutant luminescence infecting their very sites. Taking inspiration from artists such as Kenny Scharf, to which he adds a dirtier, psychotropic, more delinquent edge, Pelucas produces a phantasmagorical assemblage of colors and objects, a Day-Glo kingdom in which the usual values of life are upturned.

Although their work seems diametrically opposed, Pelucas and Liqen's varying approaches can be perceived, as Liqen himself has suggested, simply as "different paths that bind together in the end [...] and then re-differentiate again." Their differences can be seen in terms of light and dark, as seemingly opposite forces that are in fact inherently complementary. What clearly links their work, however, is their interminable commitment to their art, their urge to express themselves at whatever cost, and their identical need to pour their thoughts out into the world.

1 *Puticlub del lago artificial*, Ordes, Galicia, Spain, 2010
2 *Serpiente escalera*, Mexico City, Mexico, 2012
3-4 *Camada encerrada*, Ordes, Galicia, Spain, 2011 (with Raigal)

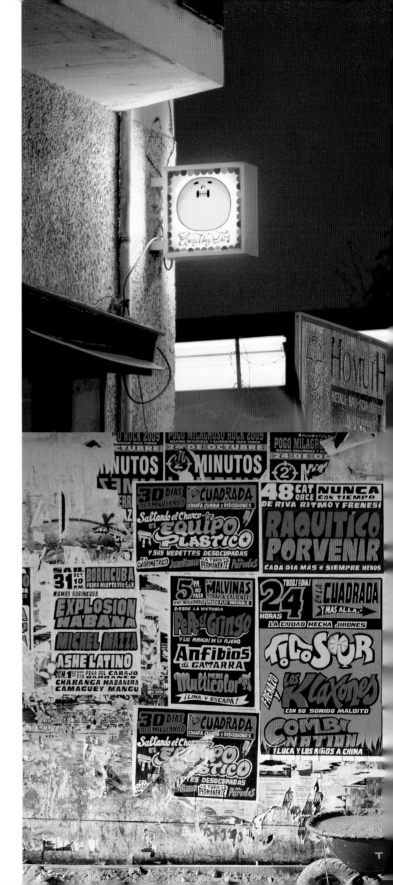

VIGO

BORN 1978, Vigo, Spain **MEDIUM** Spray paint, sculpture, installation
STYLE Contemporary muralism, esoteric installations **THEMES** Abstract
figuration, characters, urban life **INFLUENCES** Cost, Revs, Twist

NANO4814

Although elusive, Nano4814 is an artist of outstanding multidisciplinary
ability, who just loves to make things. Street signs, paintings, sculptures,
throw-ups, 'zines, tags, collages. The list goes on. Whatever material form
his works take, they typically contain an element that is off-center, slightly
warped, uncanny, or unexpected. Initially, we may recognize them and
think we have seen them before, until we take that vital second glance.

Nano's early connection to the street developed through
skateboarding, an activity that—with its physical appropriation of the
city, its bodily performance, and its latent ephemerality—has a strong
relationship with the urban arts. Nano collected early skate 'zines and was
influenced by the first years of *Slap* magazine in particular. However, he
gradually became more interested in the artistic look of the magazines—
posters by Cost and Revs, and early images by Twist and Obey (see
pp.86–9), for example—than he was in the actual images of the skating
itself. He started to experiment with a more traditional graffiti aesthetic
from around 1994; this eventually led Nano to art school (a ten-year
odyssey), although he continued to paint in the streets during this period.

By 1998 Nano had formulated several iconic characters, including
his famous ink-spurting squid, *el choquito*, which he adopted as his
regular throw-up or tag. While he continued to work on more large-scale
murals and joint productions as part of the collective, Los Niños Especiales
(a group including fellow Vigo artists Liqen and Pelucas, see pp.324–7), his
City-Lights project became Nano's most pivotal early work. A venture first
produced in 2003 that has since been re-created in Vigo, Madrid, Berlin,
and London, it took his illustratively strong aesthetic into a more
conceptual dynamic. Noticing the number of disused, light box signs
hanging forlornly on the city walls, Nano decided to reclaim these
objects from the street; he refurbished and repaired them before printing
images and unusual poetic messages on them, such as *Brilla y Desaparece*
("It Shines and Disappears"), "Easy Way Out" (see image 1), or *Elijo Irme*
("I Choose to Leave"). Nano then took them back to the street and illicitly
installed them onto disused or derelict buildings, connecting them to the
live current of the street lamps to ensure that they would be illuminated
at night. Giving life to dead space, the renegade shop signs advertised
not a product or a location of commerce, but a simple idea, showing that

1 *Easy Way Out*, Berlin, Germany, 2007
2 *Raquitico Porvenir/Equipo Plastico Posters*, Lima, 2009
3 *Fiasco*, Vilagarcía de Arousa, Galicia, Spain, 2010

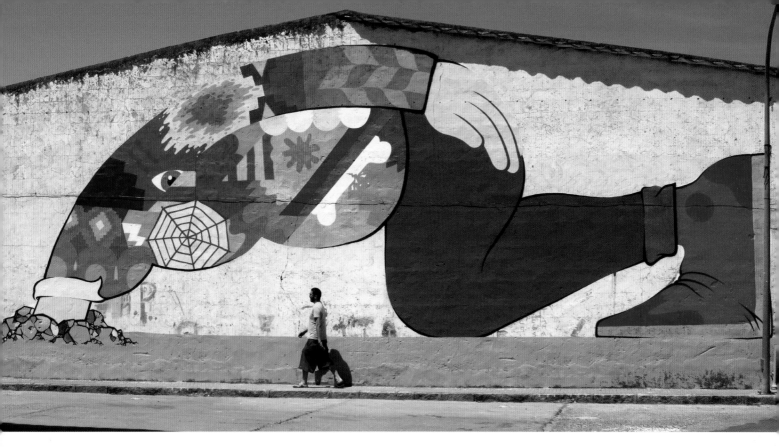

1 Miajadas, Extremadura, Spain, 2010
2 Mexico City, Mexico, 2010

these city sites had not been abandoned. Characterized by the unsettling, often elegiac quality present in all of Nano's work, *City-Lights* represents a perfect harmony of the strange and the beautiful, a blend of the familiar and the uncanny.

Although his *City-Lights* project is ongoing, Nano has recently focused more on his gallery-based work. Producing drawings and paintings, as well as highly complex, impressive installations, these works frequently gravitate around his love/hate relationship with the creative act itself. Equally, his work as part of the collective Equipo Plastico (along with artists Eltono, see pp.280–3, Sixeart, see pp.306–11, and Nuria Mora, see pp.284–5), has both taken inspiration from, as well as worked directly with the urban context. Their recent exhibition in Lima in 2009, for example, produced a plethora of street-based projects, including *Carteles Chicha*, which utilized the widespread fluorescent colored street posters advertising cumbia and chicha music parties that have become a mainstay of international contemporary visual culture since Equipo Plastico's first demonstration. As with his light box signs, Nano's poster placed an enigmatic, rhythmical yet nonsensical slogan (*Raquitico por venir* or "Skinny Future"—see image 2, p.328) into a medium normally

used for promotion, once more transplanting a familar everyday object into a more uncertain realm. Turning the seemingly banal into the searingly esoteric, he aimed to transform a command into a question and point beyond the boundaries of the everyday.

Alongside this work, Nano has more recently returned to the production of large-scale murals, a series of half-abstract, half-figurative works that have steadily progressed the strangely discomfiting and surreal, yet visually arresting style he is perfecting. Frequently focusing on the apprehension he experiences in his own work, his characters (or perhaps his self-portraits) display a palpable fear of the act of painting itself—an angst that is reinforced by their compressed captivity within their sites (see images 1 and 2). They therefore not only represent an enigmatic addition to the street, but are bound together by the element of uncanniness that is present throughout his oeuvre. Like the signature brick walls and barriers, the characteristic wooden shards seen cropping up all over Nano's designs, they both suggest and occlude a veiled truth, hinting while hiding, implying yet escaping. Nano takes the mundane and the obvious, and transports it to a space on the edge, to a space where anxiety and beauty coincide.

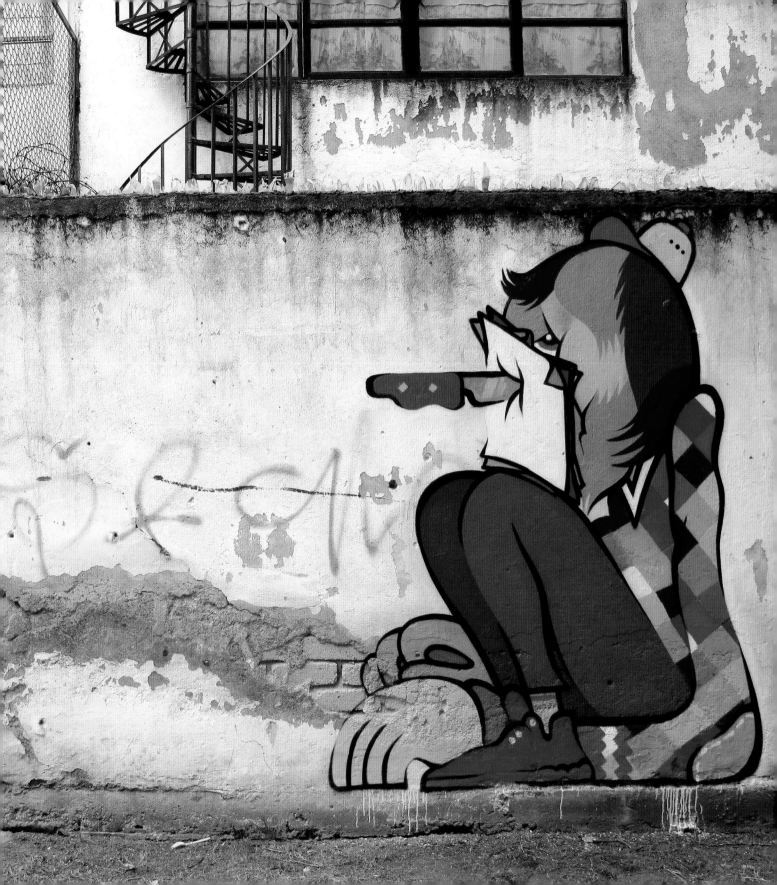

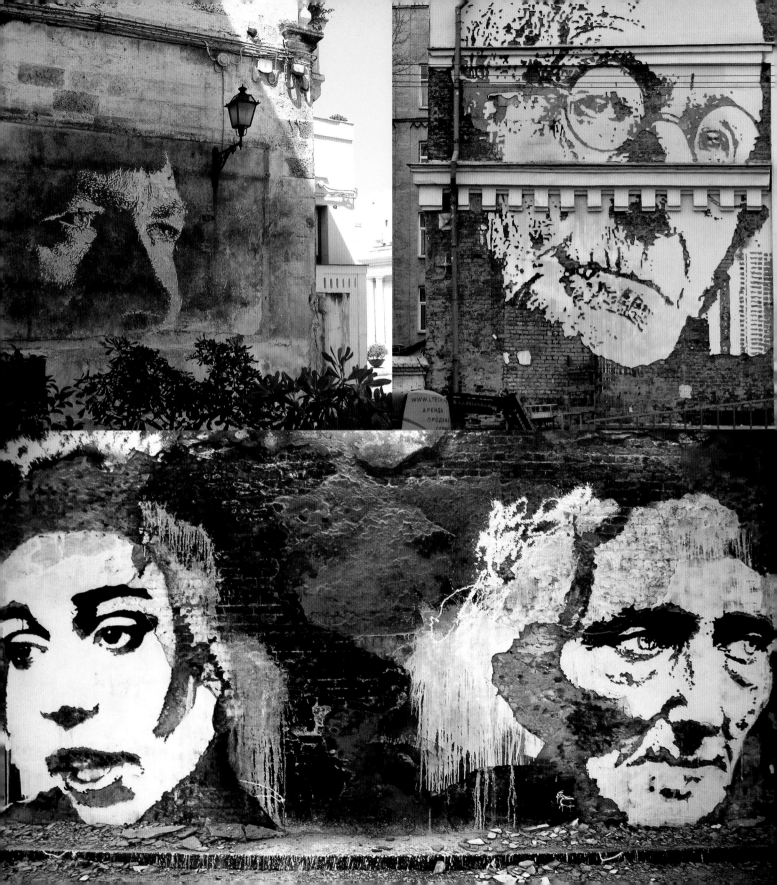

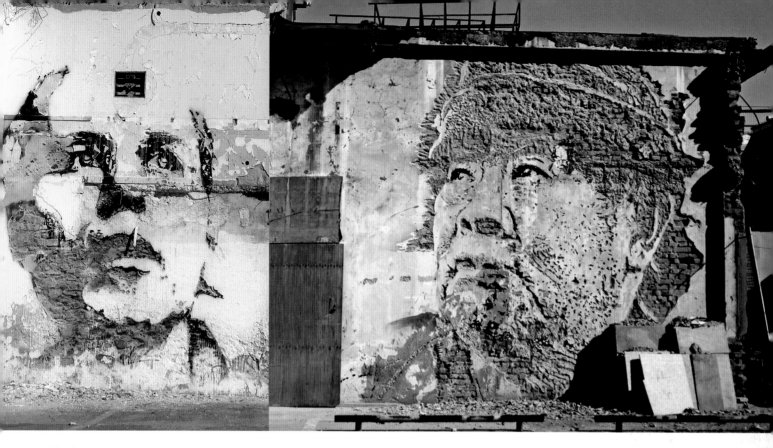

LISBON
BORN 1987, Lisbon, Portugal **MEDIUM** Reverse stenciling
STYLE Archaeological graffiti **THEMES** Creative destruction,
portraiture, decay, deformation **INFLUENCES** Popular muralism

VHILS
ALEXANDRE FARTO

1 Fame Festival, Grottaglie, Italy, 2010 2 *Scratching the Surface*, Moscow, Russia, 2010 3 *Scratching the Surface*, Torres Vedras, Portugal, 2009 4 *Visceral*, Shanghai, China, 2012 5 Cans Festival, London, UK, 2008

More formally known as Alexandre Farto, Vhils is a Portuguese artist who has developed an archaeological style of portraiture, an inversive stenciling that uses the city walls both as his medium and palette. Focusing on the notion of "creative destruction"—a concept that links his earlier graffiti career to his current practice (and which has issues of ephemerality and transmutation at its core)—Vhils presents an aesthetic that is delicate yet rugged, intricate but austere.

Graffiti is key to appreciating Vhils's practice. Born in 1987 in Seixal, an industrialized suburb of Lisbon, he began writing illicitly at the unusually young age of ten and by his mid-teens had become heavily involved in the train bombing scene throughout Portugal. Although graffiti led him to study art in school, the city of Lisbon itself also had a fundamental effect on his later practice. In the aftermath of the Carnation Revolution of 1974, Seixal, a distinctly leftist area of the city, became home to a remarkable style of popular muralism that is more closely linked to a South American aesthetic discourse than a European one. Growing up amid the decaying presence of these murals, images that contrasted starkly with the increasingly prevalent consumer culture, Vhils says that he was affected both by what he terms the "poetic value of decay" as well as the utopian aesthetic these murals proffered. In 2007 Vhils moved to London to study at Central Saint Martins College, where he sought a new way of exploring these influences and pushing his artistic trajectory by exploring the notions of vandalism and destruction so commonly linked to graffiti. The series *Scratching the Surface* (see images 2 and 3), which he started the same year, ingeniously brought together many of the key issues related to this proscribed aesthetic practice, creating form through deformation and iconic figuration through material disfigurement. Revealing images that appear as if locked within the layers of our city walls, stuck between the sediments of time, Vhils undertakes an "act of excavation" that aims to exhibit a "permanent state of transformation." Exposing visions that may have "been forgotten or discarded," revealing the "lost memories [that] compose who we are today," he uses nothing but the already present environment to produce expressive, yet physically brutal works of art.

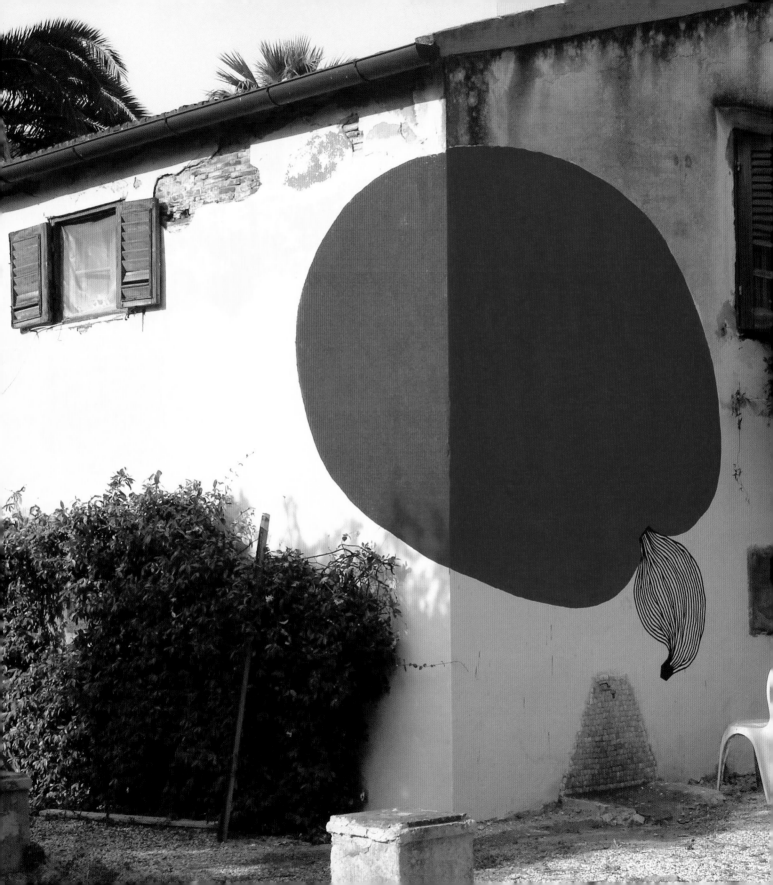

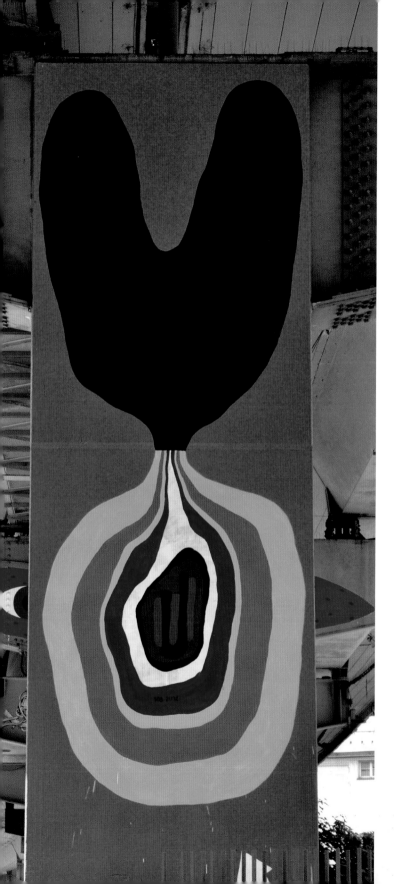

BORN 1978, Alessandria, Italy MEDIUM Paint, stickers STYLE Abstract graffiti, monochromes THEMES Urban/rural divide, labyrinths, ritual INFLUENCES Kazimir Malevich, Suprematism, Brutalism, post-industrialism, non-monotheistic sacred art

108

The dramatic, brooding, often monochromatic artworks by 108 present us with a unique example of what can be termed "abstract graffiti." Strongly influenced by both a post-industrial and post-punk aesthetic, the work of 108 is deeply indebted to the Ukrainian/Russian artist Kazimir Malevich, and the Suprematist tradition of geometric, non-representational compositions.

Born in 1978, in Alessandria—a small, highly industrialized city in northern Italy—108 was greatly influenced by the dichotomies that his local surroundings presented. The intensely harsh, austere, urban environment (Alessandria is perhaps most famous in Italy for its annual fog), along with the untouched beauty of the Piedmontese countryside to which he would regularly escape, presented him with two competing, sometimes conflicting, worlds—worlds that would later coalesce in his artwork. During the late 1980s and 1990s, the post-punk scene was booming in the city, together with a strong underground movement of experimental art and music. Greatly affected by both, and by the graffiti that he had first encountered when he traveled to Geneva in 1990 to visit members of his family, 108 promptly embarked on an experimental, letter-based form of design, a direction that he maintained for the rest of the decade. A move to Milan in 1997 to study industrial design gave rise to a new avenue in his artistic development, however. The influence of the German school of industrial design, the Bauhaus, together with the work of other early twentieth-century avant-garde artists, such as Egon Schiele, Lucio Fontana, and Richard Long, began to seep into 108's work, opening him up to more investigational aesthetic techniques.

While all these influences were significant, however, it was the experimental graffiti of French artist Olivier Kosta-Théfaine (also known as "Stak") that proved to be the primary inspiration for 108's stylistic (and pseudonymic) transformation. He was almost shocked by the absolute Europeanness of Stak's work, its near-total severance from the New York archetype of graffiti, and the urgent movement that it seemed to express toward something innovative and extraordinary. Stak's art was something to which 108 felt he needed to respond, and he did so by producing a series of yellow, minimalist, plastic adhesive stickers,

1 Livorno, Italy, 2009
2 Genoa, Italy, 2012

over 3,000 of which he put up at various sites worldwide from 1999 to 2002. These simple designs, cut in an explicitly spontaneous and intuitive manner (each emerged as a unique pattern as a result), hinted at 108's later practice—a public art that sought to achieve an elemental, primitive effect.

As the street art boom gained momentum during the early years of the twenty-first century, however, 108 found himself becoming increasingly dismayed by the often banal route it appeared to be taking. In opposition, he started to re-explore the abandoned buildings and factories in Alessandria that he had frequented during his youth. The combination of stark concrete walls and rationalist architecture he encountered there, together with the practical necessity of producing something both cheaply and quickly (a factor that had also inspired his use of adhesive stickers), led to the next stage in his artistic journey— what we might call 108's "black period."

Searching for a more universal form of communication, one that utilized neither figures nor alphabets (an idea that is replicated in Remed's work, see pp.286–9, although with remarkably different results), 108 started to evolve a style that incorporated distorted geometrical shapes (triangles, squares, circles) along with a set of labyrinth-like designs for which he has become most famous (see image 2, p.335).

Increasingly influenced by megalithic and non-monotheistic sacred art, 108's work transformed to become almost entirely intuitive and non-mechanically formed. He regarded the process of artistic production as a shamanic one, a spiritual act beyond any of the usual processes of understanding and as far from any scientific laws as it is possible to get. His choice of the color black was intended to suggest introspection, rather than darkness, while with his designs he sought to disturb his viewers, to take them away from the everyday world and into the realm of the "other." Combining raw urban brutalism with the shapes and geometry of the natural environment, 108 reinstituted a style of parietal writing stretching back thousands upon thousands of years, giving rise to a form of contemporary wall painting that attempts to function in total harmony with its surroundings.

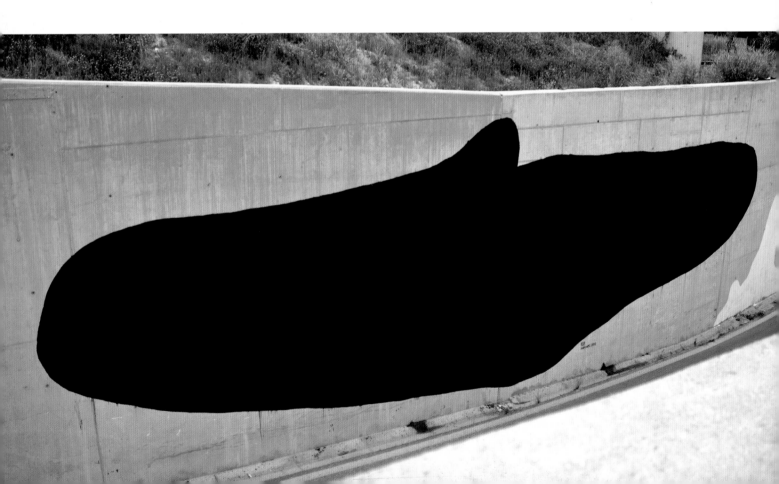

MILAN

BORN 1980, Milan, Italy **MEDIUM** String, rope, wire, spray paint, acrylic paint
STYLE Geometric installations, environmental art **THEMES** Salvaged materials,
anti-consumerism **INFLUENCES** Arte Povera

MONEYLESS
TEO PIRISI

The Milanese artist Teo Pirisi, better known as Moneyless, has pioneered a
form of Independent Public Art that he terms "Flying Graffiti." Using only
rope and fishing wire, he produces complex geometrical installations that
seem to hang unaided in the air, forming complex angles and shapes.
Operating in both urban and rural settings with equal success, his
self-styled "floating solids" beguile us and seem to challenge our eyes.

Having started out painting trains and tagging as a youngster, Pirisi
went on to study fine arts in Carrara and Florence. By 2004, he had begun
to adopt a more geometric style in his street art, moving away from what
he considered to be the constrictions of the traditional graffiti writing
system, and its increasingly close relationship to commercial advertising.
Soon, however, lettering itself became to feel like a restriction for him, so
he began to adapt it: Letters morphed into shapes; shapes vanished into
pure geometry—points, lines, surfaces, and solids.

Although he continued to work in two dimensions—on walls, paper,
wood, and canvas—Pirisi's images became increasingly attenuated, his lines
growing so thin so as to appear diaphanous. He also began to use string in
his compositions, which now extended beyond two dimensions, protruding
into the spectators' space. The transformation became more evident still in
his use of rope, and what were once images now turned into sculptures.
Significantly, however, he sees his lattice-like pieces as outlines of geometric
forms in the world around us, not as abstractions.

As Pirisi's use of materials, his site specificity, and use of both urban
and rural settings might suggest, his work consciously draws on the legacy
of Arte Povera. This avant-garde Italian artistic movement of the 1960s
embraced "impoverished" [povera] materials and the use of non-traditional
locales; in so doing, it implicitly critiqued fine art, its more hierarchical,
elite cousin. Indeed, Pirisi has revealed that the name "Moneyless" was
inspired by the "concept-statement of making art without any budget,
starting from raw, salvaged, and poor materials . . . a kind of rejection of the
consumerist world." Merging a neo-Arte Povera aesthetic with the spatial
awareness of a graffiti artist, Pirisi establishes a unique form of intimacy
with his viewers; his is a destitute art that enriches all those who witness it.

BRESCIA

BORN 1983 MEDIUM Various STYLE Conceptual graffiti, environmental art
THEMES Geopolitics, borders, branding, non-spaces, verbal and non-verbal
language, Web 2.0 brands

FILIPPO MINELLI

Filippo Minelli works at the meeting point of performance and photography, word and image. He has declared his affection for surrealism and paradox, for signs of beauty or elements of controversy in everyday life, and the possibilities offered by such juxtapositions are fundamental to his artistic practice. Minelli's always witty, revelatory work intervenes between the public and virtual worlds, between borders and nations, playing on the fine balance between what he describes as the superficial "simplicity of reality" and the vast "complexity of its nuances."

One constant throughout Minelli's artistic journey to date has been his deep fascination with the concepts of "speech" and "silence"—key dualisms that emerge again and again in his oeuvre. As well as investigating the effect that language can have at the fundamental level of vocabulary, he is also interested in the non-verbal means of communication that are made through physical gestures (expressive features), intonation, tone, stress (prosodic markers), or by critical omissions that require conscious effort on the part of us as listeners to discern (elliptical phenomena).

The Italian-born artist was initially drawn toward what he labels the "aesthetical impact of words in public space"—the power of graffiti, advertising, and every form of text in between to strongly impact on the lives of their viewers. He regarded these messages on the street as distinct speech-acts. Minelli was not simply interested in the surface significance of these lexical communiqués on their own, though—what the words themselves literally meant. Rather, he was intrigued by the ability they had to make suggestions, their ability to give the "first note of a song," to "open up new imaginary spaces." In short, it was the potential that these messages contained, their flexibility, the multiplicity of meanings that lay within them, that Minelli set out to examine within his numerous text-based projects.

Works such as *Ctrl+Alt+Delete* (produced on the euphemistically termed "Security Fence" at the Qalandiya Checkpoint in the West Bank

1 *Line*, Brescia, Italy, 2009
2 *Flickr*, Phnom Penh, Cambodia, 2007
3 *Myspace*, Phnom Penh, Cambodia, 2007
4 *Second Life*, Phnom Penh, Cambodia, 2007

in 2007) and *Democracy* (created on a rusted and abandoned boat at the Nouadhibou ship graveyard in Mauritania—interestingly, on the very day before the latest political coup in 2008), show Minelli's consummate ability to convey elaborate ideas with only the sparest use of the written word. His ongoing project *Contradictions* (see images 2–4) perhaps most usefully demonstrates his approach to practicing "speech," and the way he understands the latent capacity of language. At first, *Contradictions* seems to be just an incongruous, frequently humorous fusion of the simulated world of "Web 2.0" (a term describing the interactive revolution of the internet, one most often connected with the evolution of social media websites) with the everyday reality of life in the developing world. Minelli has spoken of its purpose as being to "point out the gap between the reality we live in and the ephemeral world of technologies," deconstructing the corporations and the marketing behind these new media forms. By inscribing the names of now famous 2.0 brands (such as Facebook, Twitter, FlickR, Myspace, YouTube, and Second Life) in a somewhat rough-and-ready manner upon factories and dilapidated buildings in Cambodia, Vietnam, Mali, and China, Minelli sought to criticize the irrational, semi-religious reverence with which such new technologies are often held by Western societies and the unrealistic expectations that have been raised concerning their benefits for humanity.

By connecting these seemingly location-less corporations with the developing regions of the world—the spaces where most of the physical tools and hardware that these platforms need to function are actually manufactured—Minelli is exposing the new systems of colonialism that are being set up today, and the new inequitable systems of relations that they are contributing to. As is evident in some of his other projects—such as *NonPlace Branding* (2012), *Listen* (2010), and *Nonsense* (2008)—these simple words quickly begin to take on implications much greater than the sum of their parts, relating to issues far beyond the reach of their literal meanings.

As Minelli observed in 2011, however, "Language is only complete when words are mixed with silence." The artist realized that he was failing to address the quietude that exists between utterances, and so with his projects *Lines* (see image 1) and *Shapes*—both of which are ongoing—he sought to prove that he could make an impact without writing anything, by making purely figural incursions in space. In *Lines*, he used spray cans—a tool customarily associated with words and letters—to draw intransigent horizontal lines, stretching across walls, crops, rubble, or snow, dividing the urban and rural, the sky and the land, a "separation and unity at the same time," in his own words. Whether passing across windows or doors, glass or stone, the lines continue on

1 *Democracy*, Nouadhibou, Mauritania, 2008
2 *Sound*, Brescia, Italy, 2006 3 Tudela, Spain, 2011
4 Milan, Italy, 2010 5, 7 Trento, Italy, 2010
6 Brescia, Italy, 2011

irrepressibly. These deliberate, man-made markings seem to interrupt and break up the peace of their natural surroundings, their sheer strangeness in the natural environment making them stand out. Their presence creates uncertainty and ambiguity: We know someone created them, but we don't know why, or what they are for. Like Robert Rauschenberg's *Automobile Tire Print* (1953)—the direct recording of a particular movement instigated by the artist—Minelli's photographs record his performance, his physical intervention in the landscape, while at the same time producing an interaction that privileges form and texture, celebrating the ritual act of demarcation as much as its material appearance.

In *Shapes* (see images 4–7), Minelli's artistic statement takes the form of an eerie, gaseous hue captured for a split second hovering in the air. To create this effect, he employed smoke bombs, having been inspired by watching videos of political demonstrations with the sound muted (he saw the smoke bombs as the fundamental aesthetic factor linking the "people to their messages"). He transported these explosive vapors into rural, picturesque, eerily peopleless settings, juxtaposing a "medium traditionally devoted to create chaos with the romantic beauty of natural landscape," as he said in 2011. Minelli finds something beautiful in this meeting of two very different worlds, which he terms a "clashing of visions," a clash emphasizing the grandeur and power of nature. Quite apart from their aesthetic appeal, all the works in *Lines* and *Shapes* express a need to distance ourselves from the ever-growing onslaught of data and information that we have access to today—the vast noise disseminated through what Minelli refers to as our "era of communication"—to be aware of, and seek out, silence. Both projects strike a balance between performance and sculpture, between the inherent violence of their tools (the spray can and the paint bomb) and the ephemeral beauty of their final state. These works do not transmit a direct (linguistic) message; instead, they convey a nonlexical, corporeal sensation to the viewer.

Minelli has produced numerous other projects on the twin themes of silence and speech, including *Flags*, the hilarious film *You Might Call it Crisis But it's Silence to Me*, auto-destructive land art in *Future*, and what might perhaps be termed "Culinary Art" in *Future 2*. All of these works are informed by the dichotomy between text and image, and express Minelli's desire to explore the conventions and the idiosyncrasies of language, to investigate both its literal and figurative forms, the potential and elasticity of words alongside the power of non-linguistic means of expression. By "writing, building, photographing, and filming words and silence," in his own words, he continues to develop new ways of rigorously reworking our understanding of both concepts.

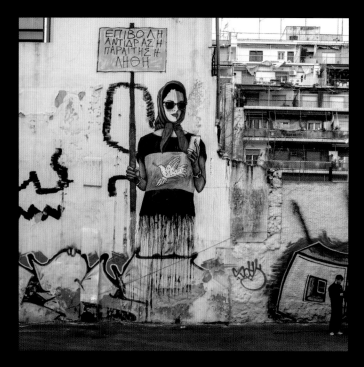

ATHENS

Greece has a long tradition rooted in its socio-political past of catchwords and signs being written in the streets. During the Nazi invasion and occupation in World War II, any sign or word inscribed on the walls was associated with resistance. As time went by, the most populated Greek cities, Athens and Thessaloniki, have become filled with signs, stencils, and images that could either display loyalties to political parties, sports teams, and gangs, or even (on a lighter note) depict love letters.

The graffiti movement in Greece started slowly in the mid- to late 1980s, with just a few writers "bombing" the city streets and using random colors, while trying to experiment with personal styles. Some of these included Dee71 in Kavala, Jasone in Thessaloniki, and Paladin in Athens. In the early 1990s, Woozy, Mavros, and Art (see image 3) emerged in Athens. A group of Greek-French writers, among them Ane, Ante, Tare, Kerts, Mers, and Kenzo, were also active in the city, mainly making tags and silver pieces on the trains and around the streets.

However, the mid-1990s marked the real starting point of the graffiti scene in Athens and northern Greece. It was initiated primarily by the rapid exposure of Greek youth to the American hip-hop culture through magazines, movies, books, documentaries, and later the internet. The movies that shook the minds of young writers were *Wild Style* (1983), *Beat Street* (1984) and the documentary *Style Wars* (1983). Under this influence, a crew called TXC formed in Athens, which encompassed the four elements—MCing, DJing, break dancing, and writing—and a wildstyle graffiti. Their counterpart in Thessaloniki was the SGB crew.

In the mid- to late 1990s, trains, rooftops, bridges, walls, and abandoned houses were filled with all types of graffiti from various writers, such as Nato, Dimer, Spark, Ioye (Greek-French), Suke (German), Roots, Sake, Arlo, Senor, Zap, Spike 69, and crews including FIX, SR (Greek-French), TBD (Greek-French), NBW (Athens and Thessaloniki), UDK, 114 (Athens and Thessaloniki), DFP, CMK, among others. The frequent chasing and constant pressure from the police became a continual playful game, which prolonged the excitement. During this time, the first fines were given to graffiti artists who "hit" the trains.

In 1994, without any sponsorship, various crews and writers created the first "wall of fame" at the racecourse in Athens. A few years later, in 1998, the Greek-American Union and the railway company organized the Ermou graffiti festival in the Thiseio neighborhood of downtown Athens (see image 2). Many world-famous writers, such as Bez, Seen, Ces, Loomit, and Daim, who strongly inspired the Greek graffiti scene, were invited. Meanwhile, books such as *The Color of the City—Graffiti in Greece Vol. 1* (1997) and magazines such as *Tsusu* (1998) and *Carpe Diem* (1999) were published. During this period, graffiti entered into a more "formal" context, in which the first private and public commissions began.

From the early to mid-2000s a new generation of graffiti crews came along—LIFO, HIT, OFK, FROGS, HEROS, SKIDS—while street art and muralism were on the ascendant with B., Alexandros Vasmoulakis (see pp.346–7), the Carpe Diem team, and Stelios Faitakis. In 2002, as preparation for the 2004 Olympic Games, Carpe Diem and Oxy Publications organized the Chromopolis Project, one of the biggest mural art festivals in Europe. Ten murals in ten different cities were produced by Greek and other artists, including Loomit, Besok, Stormie, and Os Gêmeos (see pp.120–3). More festivals, exhibitions, and public events started happening all over Greece, mainly by the members of Carpe Diem. Athens became an urban art center with a collage of tags, full productions, murals, quick pieces, and so on.

|1| |3|
| | |4|
|2|

1 *Imposition Reaction Resignation Oblivion*, Bleeps, 2013 2 First International Graffiti Festival, Ermou Street, Athens, 1998 3 Art, 1996 4 Same84 (from Carpe Diem), "School Mural Program," 500 Primary School, Athens, Greece, 2012

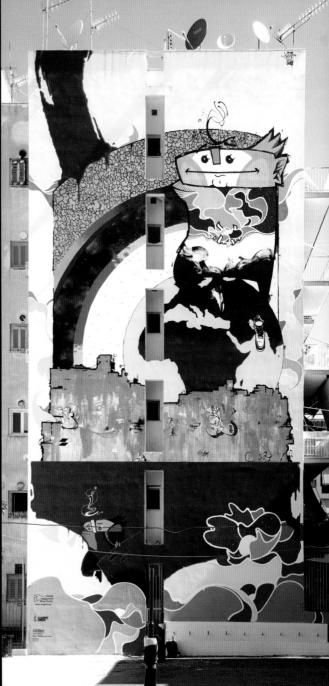

Another unique crew was established in the mid-2000s—GPO (see pp.350–3). Tired of the aesthetic and technical refinement of graffiti styles, they focused on naive, spontaneous, sloppy-style drawings, which appeared in empty advertisement billboards in 2010. Furthermore, Blaqk (see pp.348–9), a duo of designers Greg Papagrigoriou and Simek, began to re-appropriate the ancient tradition of typography-calligraphy, combining it with geometrical shapes.

In 2011, during the 15th Biennal of Young Artists from Europe and the Mediterranean, another large urban mural art project called FaceArt was organized by Kyriakos Iosifidis (from Carpe Diem) in Thessaloniki, Greece's second biggest city. It resulted in eight murals by Blu, Faith47, Dal East (pp.392–3), along with a number of Greek urban artists. Carpe Diem were also involved in the "School Mural Program" in Athens (see image 4).

The global financial crisis has provided fertile ground for new urban art emerging in the public sphere. People have been exposed to a rich visual language and imagery that they feel more open to reflect upon. For example, Bleeps (see image 1) creates a space for common action between people by stimulating the viewer to raise questions concerning the financial crisis, urban poverty, political exclusion, unemployment, and poor health services. He does not provide solutions to these problems, however, and, most importantly, he does not approach the political discourse in moral terms.

Walking in the streets of Athens today, you cannot help but notice the abundance of imagery—tags are intermingled with anarchist signs, while stencils cover a half-ripped poster announcing an upcoming strike. Mainly through its urban art, you get the sense that contemporary Athens is a city that suffers, fights, and screams for its redemption. **EP**

ATHENS

BORN 1980, Athens, Greece **MEDIUM** Found objects, spray paint, paper, sequins, canvas **STYLE** Collage, muralism, sculpture **THEMES** Pseudo-advertisements, uncertainty, ambiguity, juxtaposition

ALEXANDROS VASMOULAKIS

The uncannily beautiful, eerily exotic work of Alexandros Vasmoulakis sits at the border of familiarity and peculiarity. Although he has worked both on large-scale murals (alongside Paris Koutsikos, see images 4–6) and bewildering, often temporary street sculptures (with Christina Theisen, see images 2 and 3, and Stacey Hatfield, see image 1), as well as figurative painting and studio productions, Vasmoulakis can be considered a collagist at heart. All his works share an assemblagist's love of contrast and correlation, an affection for the metamorphoses that emerge through seemingly eccentric combinations of colors, objects, and shapes.

Vasmoulakis first attracted wider public notice with the murals known as *The Pseudo-Advertising Series* (see images 4–7). Mixing conventional painting techniques with pasted paper, sequins, and rhinestones, and omnipresent aerosol paints, he utilized many of the practices traditionally related to illustration and advertising—a heightened sense of color, faux joyfulness, the domination of space—elements that he had mastered through years working as an illustrator and muralist for advertising companies in Athens. His images often have unsettling arrangements: The faces, in particular, are a deeply disturbing constituent of his pieces. Featuring unrepressed, almost hysterical expressions, they reveal (and revel in) a sense of mania that so often seems to lurk behind the images from contemporary marketing campaigns. As he explained in 2009, after "ripping pages from magazines, collecting fragments of other faces, mostly from glamorous ads," Vasmoulakis remodels these fragments, mixing them with his own drawings. He embraces the ambiguity and doubt in the resulting images that brings them, he feels, "one step closer to poetry." Although they are aesthetically quite distinct, the installations that form an important part of Vasmoulakis's oeuvre are strongly related to his mural work. By putting together found objects, by introducing an air of uncertainty, by juxtaposing "ugly" and "beautiful" elements, he continues to search for oddness in the ordinary and everyday, to turn low into high, creating an uncanny but always enchanting spectacle.

BORN 1986, Athens, Greece (Papagrigoriou); 1985, Chalkida, Greece (Tzaferos) MEDIUM Paint STYLE Abstract geometrical typography THEMES Typography, geometry INFLUENCES Classical calligraphy

BLAQK

A recently formed partnership consisting of artists Greg Papagrigoriou and Simek (Chris Tzaferos), Blaqk are an Athens-based duo who have amalgamated typography, calligraphy, abstraction, and muralism into a cohesive, strongly urban aesthetic. Forming a style that appears to be both modern and traditional, and which successfully integrates into the cracks and fissures of the city where it appears, Blaqk take their location of practice—the decaying environment of Athens—as a prime constituent of their work. They use the city not as a blank canvas, but as a multilayered surface they can mold and reshape, incorporating its many textures and subtleties to create an aesthetic that intertwines itself perfectly within the habitat in which it exists.

Previously a keen student of typography and graphic design, Papagrigoriou only recently started to use the city as an artistic medium, whereas Simek has been experimenting in the street since the early 2000s. Intrigued both by the abandoned spots of the city that graffiti introduced him to, as well as the "adrenaline rush coming from doing something fast and illegal," Simek reveled in the freedom of movement that this illicit public work allowed and the potential of the larger surfaces that he was able to work upon. Having moved from his hometown of Chalkida to Athens (where Papagrigoriou was born and raised) in 2004, the pair first began to paint together around 2010, when they initially worked together without attempting to link their specific styles. They fully interlaced their approaches in around 2011, however. This fusion of techniques took Blaqk's work to a new level; Papagrigoriou's background in calligraphy and Simek's experiences in graffiti gave their work an authentic edge and a decorative, typographic fluency.

Regarding their work as a public form of psychotherapy—a practice that keeps Blaqk "feeling active in these strange days"—the team use their highly contextual, site-specific works to try and make a "true connection" with the people around them. Through assimilating with rather than merely coating their surroundings, they have developed an ornamental aesthetic in the truest sense of the term, a simultaneously ancient and avant-garde style that follows in a tradition of parietal writing that has been present in Athenian visual culture for more than 2,000 years.

1		4
		5
		6
2	3	7

1 Athens, Greece, 2012
2 Athens, Greece, 2011
3 *Momentum*, Athens, Greece, 2012
4-7 Athens, Greece, 2012

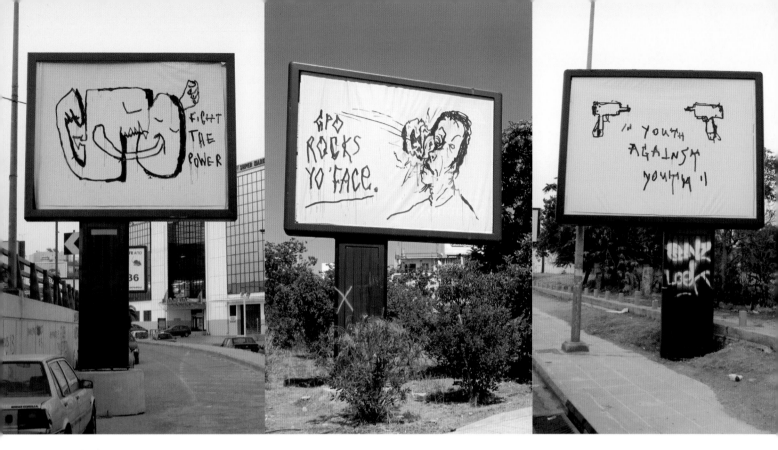

ATHENS

BORN Various **MEDIUM** Various **STYLE** Naive graffiti, "toy graffiti,"
billboard modification **THEMES** Solutions, improvisation, spontaneity
INFLUENCES Early 1980s New York graffiti (Blade)

GPO

GPO is neither an artist nor a collective, but a movement open to anyone who may wish to join. Refreshingly, rather than pandering to the competitiveness that is so prevalent in graffiti culture—the inexorable battle over who is smarter, who is quicker, who has more connections—GPO is purely about the group, about cohesion and solidity. It represents the formation of an "organism that lives without questioning, that lives without multiple personalities," an organism attempting to communicate in new ways both in the city and beyond.

Containing roughly between ten and twenty members (Hard, Taxis, Tales, New, Palms, Ironwolf, Stupid Greg, Ners, and Ejay being some of the principal contributors), GPO comprises illustrators, tattoo artists, graphic designers, and students—a plethora of individuals from different ages and different backgrounds. Its defining feature, however, is that the work comes from the group in its entirety, that it emerges without boundaries set by individuals. In this way, GPO aims to make "one writer out of many,

one artist out of many," eschewing the personal and promoting collectivity, its members supporting one another through a tight bond of friendship. As Athenians living within extremely tough socio-economic times, they aim to provide an example to their surroundings rather than focusing on themselves as individuals or on their own careers. They are concerned not with abstract theory but with concrete action, solutions, models, and outcomes.

The common factor uniting GPO in terms of formal methodology is spontaneity, a desire for immediacy, and a direct link to the world around them. This impulsive, uninhibited way of working functions not only in relation to their material environment, however, but also to the way they operate together: "We like to improvise and play with the city but also to react to one another. Somebody will start something, then someone else changes it, then the next one continues from that. It's about communication, about instinct, about that moment alone." For their billboard project *GPO IS THE LAW*, every site was painted in situ. Occasionally the sites related to the surrounding area, but more often they were simply utilized as an available space for free expression. (As such, *GPO IS THE LAW* is the polar opposite of the work produced by fellow

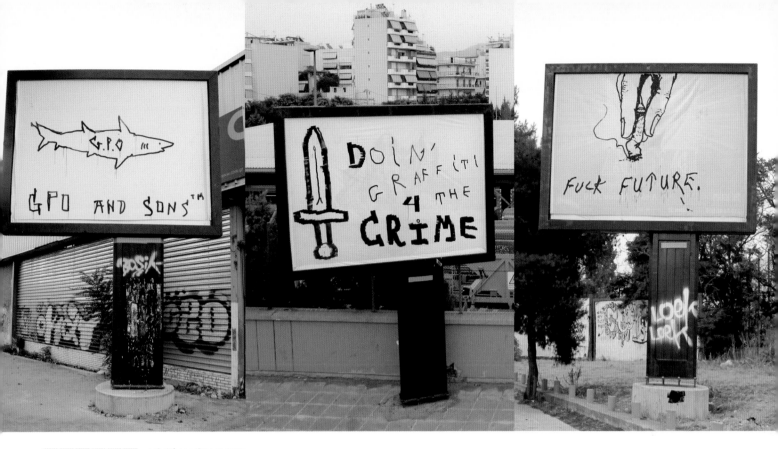

1-6 Athens, Greece, 2010

billboard devotee OX, whose work is never produced at the site itself, yet always works with the direct environment around it, see pp.174–7). With these sites, GPO had been fortunate indeed. Bizarrely, the billboards had been illegally installed; a court ruled that the advertisements on them must be removed, but the billboards themselves remained. GPO were able to improvise with their environment—taking advantage of these empty "canvases" all over Athens—while also improvising upon the boards themselves, never planning what they aimed to produce, simply extemporizing and ad-libbing.

The billboard project also showcased GPO's common love for what they term "toy graffiti," an affection not for its naivety—as is often thought to be the case—but for its inherent creativity. The toy aesthetic ("toy," of course, being the term graffiti artists apply to unsophisticated, primitive work, a term of denigration often scrawled over supposedly substandard pieces) contains the dirt, the haphazardness, the "sloppiness" that GPO believe all graffiti should have. Rather than being well organized and pleasing to the eye, it is an aesthetic that they consider should be "rich in terms of drawing but not in terms of color or 'skills,'" superfluous elements that they argue serve solely to discipline

creativity, expunging its vitality. Sharing a love of the early 1980s New York era (Blade is one practitioner they often mention), GPO attempt to merge this style with that of a young teenager who has just started making graffiti, a neophyte still in the process of learning and therefore open to improvising and experimentation. They operate at a meeting point between genius and naivety, brilliance and innocence. As they observe, "It was never the skills that made someone a toy or a king: It was their creativity."

GPO also have a passion for self-publication—for fanzines, books, and independent printing in general. This chimes with their appetite for spontaneity—for a form that could be designed, printed, and distributed in just a matter of days—but it also allows them to share their thoughts in a less ephemeral medium, albeit one that demonstrates the same rough, irrepressibly playful aesthetic as their graffiti. The political aspect of GPO's work emerges not via a clichéd, overt message, but through their championing of amateurism—the spirit of the artist who works for love, not gain, who works for the pure joy of the act. GPO aim to return graffiti to its original *art brut* status, to an improvisational rather than innovational form of creativity.

ATHENS
BY
GPO

GPO's map of Athens is perhaps the most mechanically, scientifically accurate of all those included in this book. It is one of a series of maps illustrating the actions of the most dominant graffiti crews in Athens between 2000 and 2012 (including 420, OFK, LIFO, TBD, GELO, SCAR, as well as GPO themselves). They were produced to research the patterns of movement and expansion within the city landscape by each group; exploring their physical gestures on a grand scale, it depicts the various tendencies and developments of each collective, transforming their actions in the city into a technical topography.

The data for each map was collected by a number of methods, including a series of "scans" on foot in the center of Athens; the everyday experiences of people who live, work, and study in the city; and extensive interviews with the crews involved. Produced by a member of GPO who

was at the time studying architecture at the National Technical University of Athens, the maps further examine the relationship being built between graffiti writers and urban space. They explore how the material actions of practitioners affect their personal understanding of the city and how that affects their spatial orientation. The maps therefore not only reveal the changes made to public space itself, but the changes that transpire within each collective and within the body of each artist themselves.

The colors on the map signify a specific location or action: The blue circles indicate legal graffiti locations and "halls of fame"; the magenta lines show the routes taken on foot by the writers along their favored bombing courses; the mauve circles represent the writers' local neighborhoods; the yellow dots represent the train stations and subway entrances for each crew; and the black lines signify both the subway and railway routes.

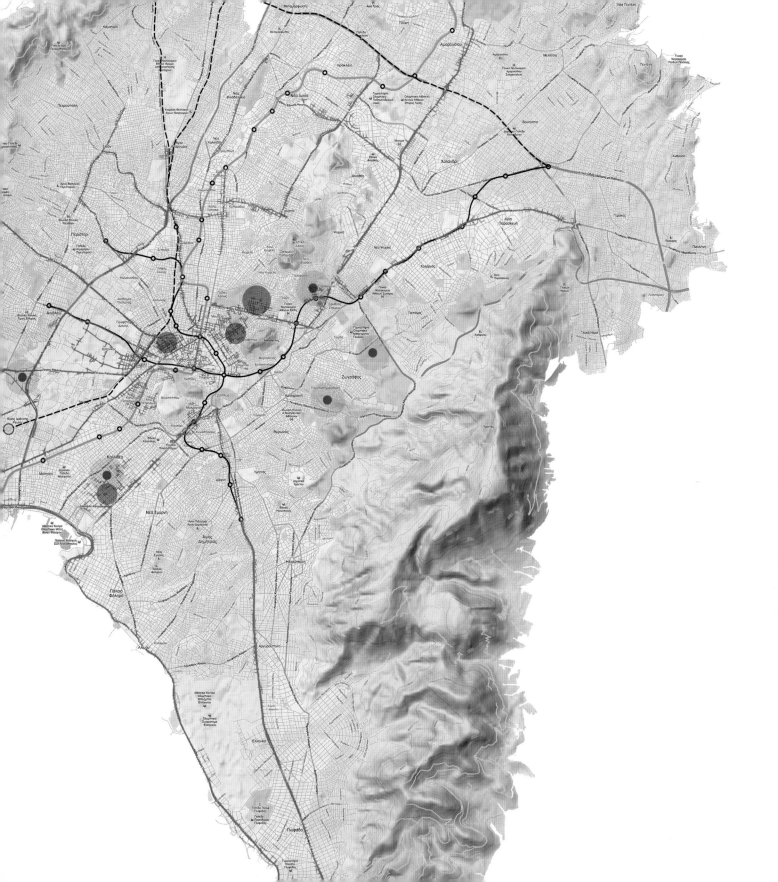

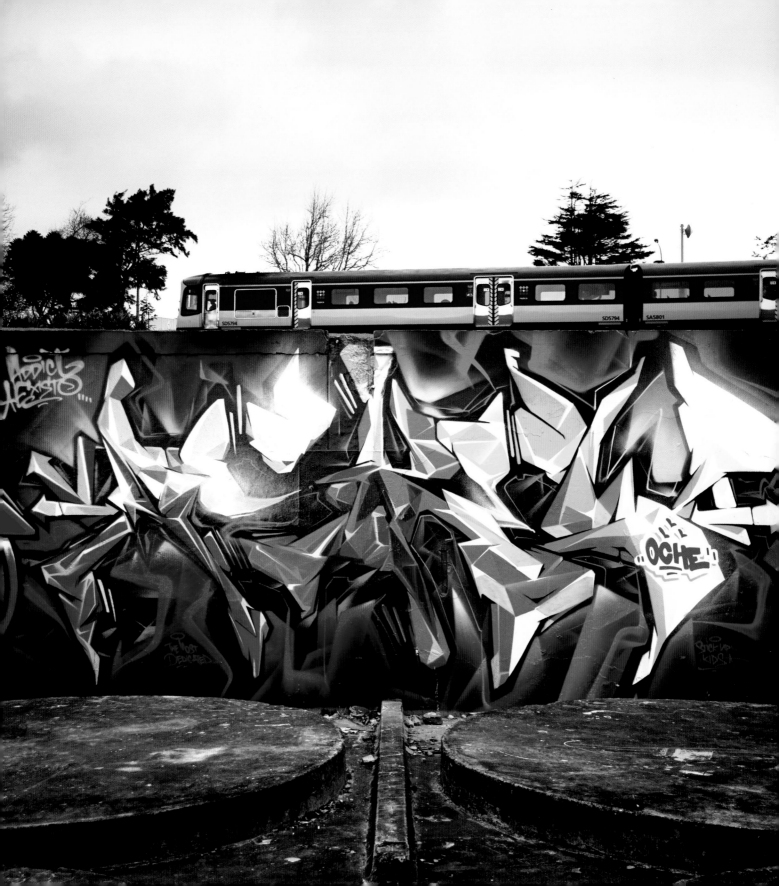

1

REST OF THE WORLD

MELBOURNE SYDNEY TOKYO

ANTHONY LISTER MEGGS RONE IAN STRANGE ESSU BEN FROST
BUFF DISS LUSH DABS MYLA DAL EAST BMD DMOTE ASKEW ONE

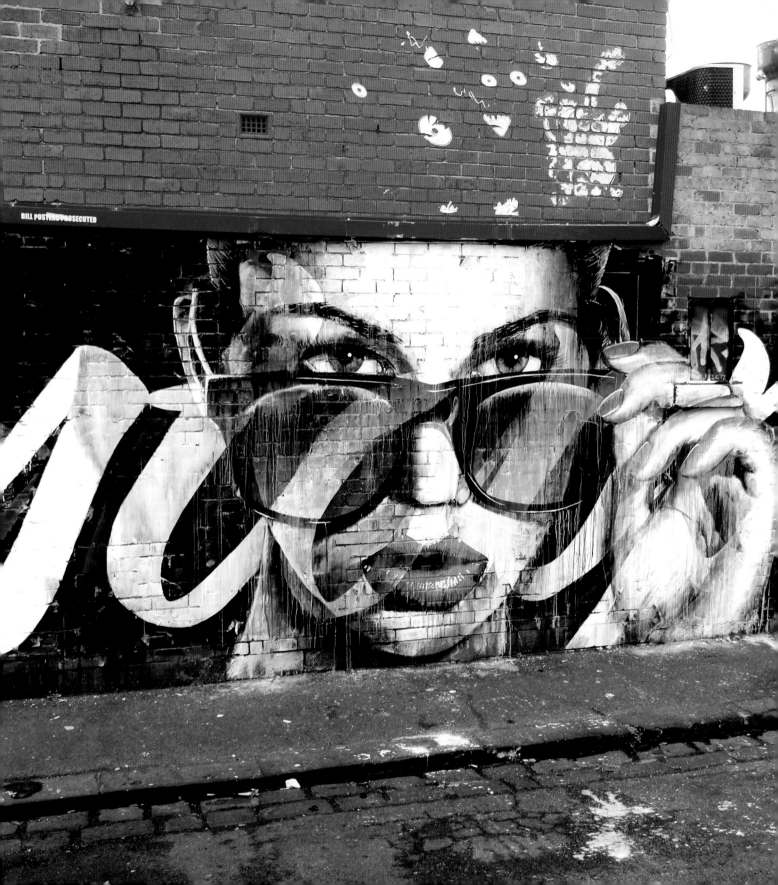

Although the term "Rest of the World" is unsatisfactory, it does usefully bring together a band of disparate artists from equally disparate locations that make up the final chapter of this book. Focusing on individuals from Australasia (Australia and New Zealand) as well as East Asia (China and Japan), the inherent heterogeneity of this group means that a cohesive definition of style is impossible to make. Nevertheless, the artists from these regions represent an exciting group of practitioners who are all making significant progress in the global Independent Public Art arena.

Australia has an established graffiti and street art scene that stretches back to the early 1980s. Melbourne (see pp.358–9) in particular—like Barcelona (see pp.298–9) and London (see pp.150–1)—became one of the most revered world locations for street art during the heady days of the mid-2000s, a site synonymous with the development of stencil art (made famous in particular by artists such as HA-HA and Sync). Meggs (see pp.368–9) and Rone (see pp.370–1) from Melbourne's infamous Everfresh Crew (along with Phibs, Reka, Wonderlust, Prizm, Makatron, and The Tooth) first began working with stencils, but have since moved away from the performative restrictions that stencils often confer, taking their work in more varied and looser directions. Although many native artists have moved away from Australia, Buff Diss (see pp.360–1) now living in Berlin and Dabs and Myla (see pp.362–3) in Los Angeles, the equally cosmopolitan Lush (see pp.364–5) continues to produce his grotesque, acerbic, riotous graffiti in Melbourne and beyond. Sydney (see pp.372–3) has had a somewhat lower profile than its perennial rival Melbourne, yet it can still boast artists such as the BUGA UP collective from the late 1970s, the classic stylings of Dmote (see pp.376–7), and the collagist, anti-pop of Ben Frost (see pp.374–5). Furthermore, it was also the location of practice of perhaps Australia's most famous proponent of urban art, the outsider artist Arthur Stace (as explained by Lachlan MacDowall on pp.372–3). Together with locations such as Brisbane, the home of Anthony Lister (see pp.378–9), Perth, the home of Kid Zoom (see pp.382–3), and along with New Zealand residents Askew One (see pp.384–5) and BMD (see pp.386–7), Australasia presents itself as an internationally important location for contemporary Independent Public Art.

Although Tokyo (see pp.388–9) is a key location on the world graffiti map, with artists such as Barry McGee and BNE (see pp.60–1) having made a significant impact on the local scene, the Independent Public Art movement in the city (and Japan as a whole) is smaller than one might imagine. While there are numerous artists replicating a broadly New York style of graffiti, only a handful have pushed out into visual arenas of their own. Essu (see pp.390–1) and Querencia Peligroso (QP), however, have bucked this trend to produce a fascinating group of works, forming a monochromatic, idiosyncratic, and clearly Japanese style of practice. While the scene in Tokyo goes back to the 1980s, however, China's Independent Public Art movement ranks as one of the youngest in the world. While artists such as Dal East (see pp.392–3), the collective Chirp, and IDT (Industry Definition Transfer) have started to put their aesthetics firmly on the map, the infancy of the scene, as well as the innate difficulty and expense of getting hold of the materials necessary to production, has naturally stymied its wider development. As in Africa, the lack of practitioners in China is not due to there being a lack of an art culture generally in these locations. There is a naturally thriving local art scene in both regions (even if Western art historians or social theorists might designate/denigrate many of the objects that are produced as "ritual artifacts" or "tourist art").However, there is no easy access to tools such as spray cans and it is access to this instrument in itself that enabled the advancement of Independent Public Art in the locations where it originated. It was a device that not only made possible the high speed distribution of paint onto a surface and whose innate portability meant artists could work in unusual locations, but whose ease of use and permanency made it the primary tool in the history of street art and graffiti.

Of course, if one looks hard enough, one can find Independent Public Art in nearly every country around the world: With the Arab Spring that began in 2010, for example, the public forms of protest that took to the walls (as well as the streets) became prominent all over the global media. Egyptian street artist Ganzeer quickly became one of its most celebrated figures, while the tragic murder of the Libyan Kais al-Hilali (shot only minutes after he had finished painting an image of Colonel Gaddafi) became an ignition point for a plethora of new images around the world. Where there is repression and anger, one will always find public, illicit images. However, these forms of popular protest art, while fascinating and fearless in equal measure, present us with a quite different dynamic to the works presented in this book (although groups such as Voina, see pp.268–9, stand much closer to this category). Like gang graffiti, protest art demonstrates issues of an almost purely political rather than an aesthetic nature (if the differences between the two can ever truly be separated) and acts almost as an exact visual reflection of a social set of circumstances. While only a very thin line separates these practices, of course, it is those that function through the lens of art rather than politics that are included in this text, actions which may (and often do) broach socio-political themes, yet do so through the power of figure rather than discourse. It is the forms of communicative practice that function through affect rather than reason that we discuss here, those that function through the passionate intensity of figuration rather than the rational restrictions of dialogue and debate.

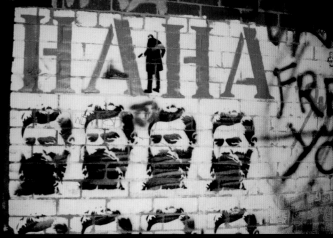

MELBOURNE

Melbourne—or Melburn, as locals have proudly dubbed their city—has a rich history of graffiti and street art. Its roots sprawl out in many directions, from the postwar slogans of indigenous land rights and feminism to the public markings left by local subcultures, such as punks, anarchists, and the suburban gangs of Sharps (or Sharpies) that emerged in the 1960s. However, since the mid-1980s, Melbourne's streets and train system have been dominated by a local form of New York-style, hip-hop graffiti. The city eventually developed a distinctive set of local styles, based on the competitive saturation bombing of train lines, but also a futuristic, elegant series of wildstyles that reanimated letterforms into living creatures, tapping into the anthropomorphic base from which the alphabet was derived. Pioneers of Melbourne graffiti include GS38, DSKYZ, Merda, Duel, Paris, Peril, Tame, NEW2, and Puzle, and later, Nasty, Reach, Denim, and Didle.

In 2010, a trio of graffiti writers collaborated on the landmark book, *Kings Way: The Beginnings of Australian Graffiti—Melbourne 1983–1993*, which documented the golden age of the art form. Since then, Melbourne graffiti has been reanimated by the rise of custom spray paint, the archiving of images on the internet, and strings of national and international visitors. Alongside those painting in a mature New York style, refining elaborate wildstyles or collaborating on large-scale, themed production walls, Melbourne has also seen bursts of anti-style. Renks, Bonez, and others deployed deliberately unrefined letters and color combinations that responded both to the naive, messiness of the New York pioneers and the increasing acceptability of graffiti murals in mainstream Melbourne.

Distinct from Melbourne's graffiti scene has been the development of an active street art movement, which coincided with big political protests in the city, such as those against the World Economic Forum in 2000 and the Iraq war in 2003. For globally literate activists of the time, graffiti had little to do with art: Instead it was a way to send coded messages to the public and each other. A loose network of artists grew out of this period, who over the next five years honed their experimental work into iconic forms, often in the context of crews, studios, and galleries. Among the most visible practitioners were HA-HA (see image 2), Sync, Dlux, Civil, Vexta, and Everfresh crew members Phibs, Meggs (see pp.368–9), and Rone (see pp.370–1), who took advantage of Melbourne's abandoned industrial sites and zones of small service laneways that were yet to become bars and boutique shops.

Street artists of this period raided Australia's national icons, such as Civil's satirical refashioning of colonial and sporting scenes; others reviewed the available models of being an artist in Australia, referencing ex-patriate entertainer Rolf Harris; Mr. Squiggle (see image 1), a puppet who improvised drawings on a long-running children's TV show; or the

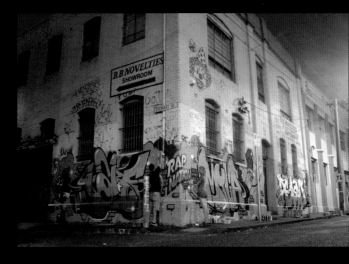

artist as outlaw, as imagined by HA-HA in a series of stencils of nineteenth-century bushranger Ned Kelly in his distinctive hand-made armor. Among the most popular examples of street art were the Crate Men, towering figures fashioned out of colored plastic milk crates and installed around the city by the mysterious Cornelius Brown collective. Many artists experimented with new materials, such as Junky's figures constructed of rubbish (see image 4), Mal Function's cast heads (see image 5), or Buff Diss's masking tape creations (see pp.360–1).

By 2010, street art had become highly self-conscious, with the most energetic artists fusing the dueling trajectories of graffiti and street art, such as Lush's pointedly obscene cartoon slogans. It has produced its own system of galleries and studios and a broad appeal beyond a small subculture. The epicenter of street art has moved from the Central Business District to the surrounding suburbs, where it is packed with high-impact production walls, such as Dabs and Myla's lollipop-retro murals (see image 3 and pp.362–3). Street art is now as likely to exist on the walls of a specialist gallery, auction house, luxury hotel, or behind a sheet of protective plexiglass, as it is on the street.

Melbourne's street art captured the public's imagination and has become an integral part of the city's identity, thanks to landmark sites such as Hosier Lane and Andy Mac's Until Never Gallery, and a frequently cited survey in which tourists rated street art ahead of the National Gallery and Kakadu National Park as reasons for visiting. When large areas of the city were painted in preparation for the Commonwealth Games in 2008, Banksy himself published a ringing endorsement in *The Guardian*: "Melbourne is the proud capital of street painting with stencils. Its large, colonial-era walls and labyrinth of back-alleys drip with graffiti that is more diverse and original than any other city in the world. . . . Melbourne's graffiti scene is a key factor in its status as the continent's hothouse of creativity and wilful individualism." **LM**

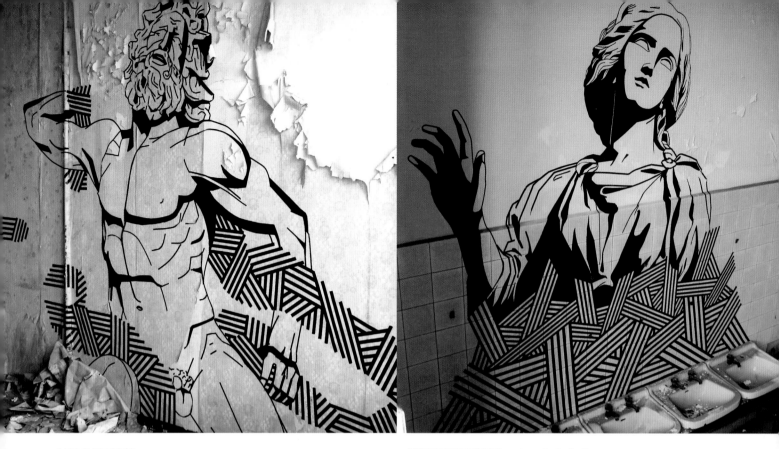

MELBOURNE

BORN Melbourne, Australia MEDIUM Tape STYLE Tape art, architectural interaction THEMES Hands, classicism, Greek mythology INFLUENCES Dskyz, Merda, Puzle, Renks, Bones, SDM Crew

BUFF DISS

The Melbourne-raised but Berlin-based artist Buff Diss has created a unique brand of Independent Public Art, eschewing the use of paint to work solely through the medium of tape. Although his polished, dexterous designs can be appreciated as entities in themselves, the way in which they interplay with the environment shifts them onto a more thought-provoking and distinctive level. His clean images contrast with their often defaced, grubby surroundings in an unexpectedly congruous manner. Using the city environment not as a blank canvas but as a living location with a deeply embedded history, Buff Diss attempts, as he puts it, to develop a "relationship with space" and a "conversation with the architecture." Using his signature giant taped hands (see images 3 and 4), he revels in making a materially tactile intervention in his environment.

Buff Diss initially worked with spray paint but began to use tape in around 2005. He believes he has a graffiti mentality and that this illicit form of production gave him a particular way of seeing and relating to the

1 *Laocoön*, Berlin, Germany, 2010
2 *Conjure a Storm*, Berlin, Germany, 2010
3 *Aftermatch*, Melbourne, Australia, 2007
4 *Plucking Pennies*, Adelaide, Australia, 2011

environment that has proved impossible to abandon: "Graffiti artists are blessed, they get to see under the skin of the city, all the skeletons that exist in the city, all the stories it contains. That's what I find so fascinating." However, the medium of tape appealed to him because of its lack of precedent in street art and the freedom that its novelty allowed. Its practicality (available to work with anywhere) and its linearity (relatively speedy to work with) also convinced him to make it his medium. Furthermore, the fact that tape is not permanent and can be easily detached means that his work has operated in a legally gray area, much to the wrath of local authorities keen to prosecute him.

Aside from his trademark taped hands, Buff Diss has more recently completed a series inspired by the Greek myth of Dido and Aeneas (see images 1 and 2), as well as undertaking a successful collaboration with Berlin-based artist Clemens Behr (see pp.214–15). Nevertheless, whatever the project, each piece Buff Diss produces is a unique artifact and the character of the surface he works upon is always a key presence in the work. With his unique designs, he reinterprets and transforms the urban environment; while continuing to acknowledge its presence, he remodels it in imaginative and remarkable ways.

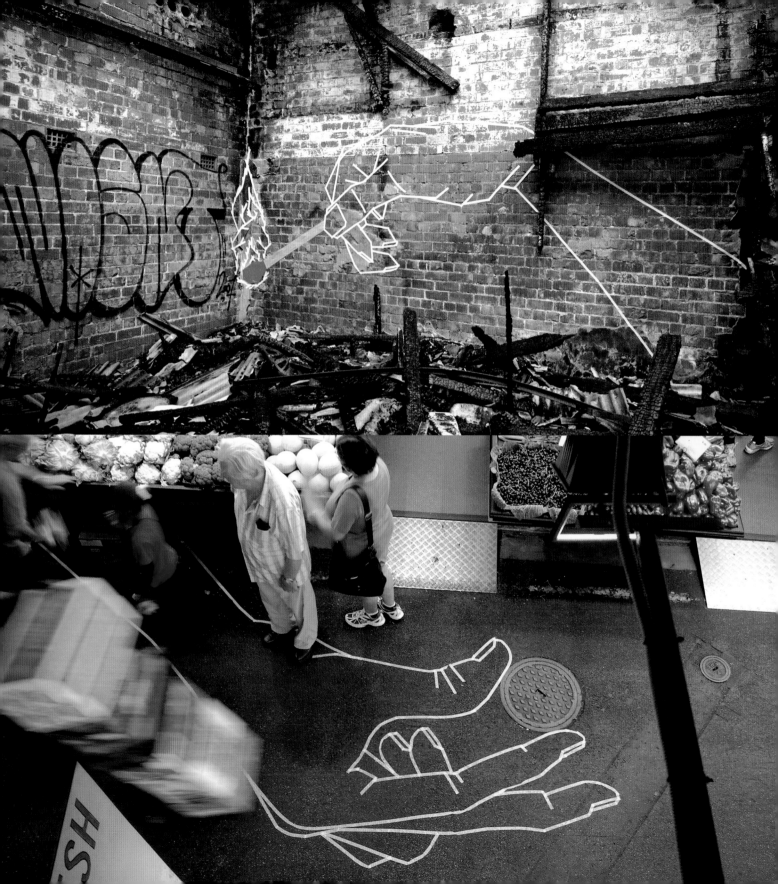

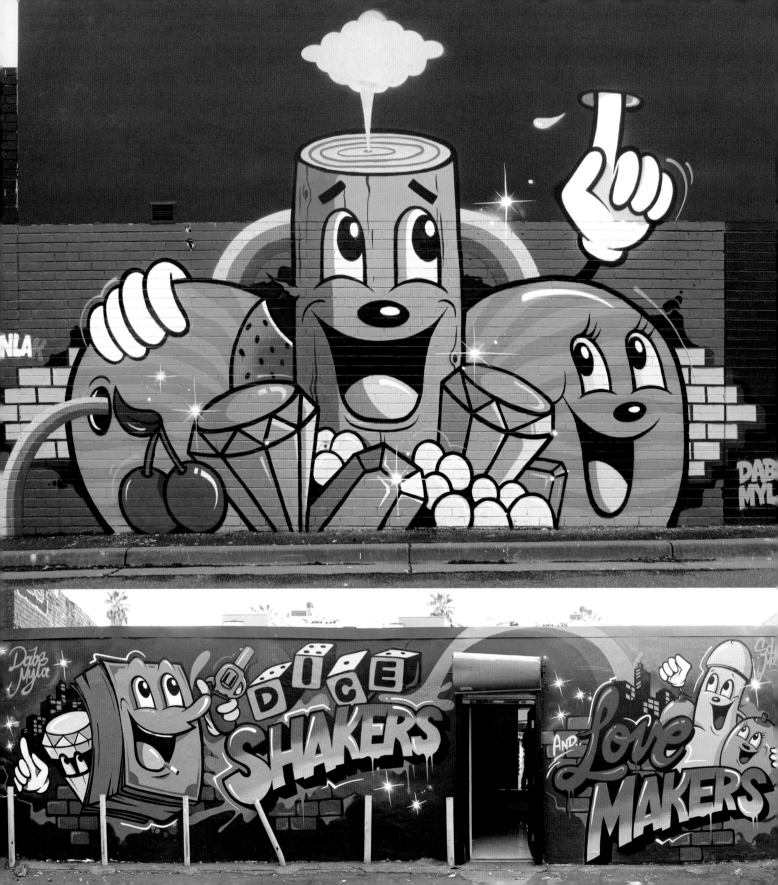

MELBOURNE

BORN Unknown MEDIUM Spray paint STYLE Contemporary graffiti
THEMES Brightly colored, manically happy characters INFLUENCES Classic
animation CREW MSK

DABS MYLA

Born and raised in Melbourne, although currently based in Los Angeles, Dabs Myla are an artistic partnership, as well as an almost absurdly enamored couple, whose creative collaboration commenced from almost the first moment they met. Painting both inside and outside, they are as assured with a spray can as they are with a brush. Influenced both by classic illustration and animation, the pair have developed a comic, bold, often salacious aesthetic that forces an instantaneous reaction from viewers. What is most characteristic about Dabs Myla's images, however, is their ability to transmit the joy experienced in their production directly into the works themselves: There is an omnipresent exuberance permeating all their compositions. Their mirthful, ebullient characters (whether manifested in the form of milk bottles, stacks of cash, certain human appendages, or comical self-portraits) emerge, therefore, not just from the hand but from the very spirit of their makers, their positivity and buoyancy a pleasure to behold.

1 Melbourne, Australia, 2013
2 *Dice Shakers and Love Makers*, Los Angeles, USA, 2011
3 Detroit, USA, 2012

Dabs started to paint graffiti in 1995 and had been a key member of the Melbourne graffiti scene before he decided to return to art school in the mid-2000s. Myla had never previously touched a spray can and had painted mainly with acrylics (the technique that Dabs returned to school to study). Their meeting therefore dramatically changed their artistic (and romantic) paths. As they began to collaborate, Dabs taught Myla the basic techniques of painting with spray cans and of graffiti generally, whereas Myla introduced him to acrylics and photorealism, each of them learning, developing, and pushing the other to improve.

They continued their solo work after they began collaborating, but by 2007 they decided to concentrate solely on their joint production as Dabs Myla, both in terms of their gallery and street production. Their individual characters and content (the only detectible difference being the varying boldness of the colors and the heaviness of the lines) have formed a perfect amalgam of the two. With an impressively diligent work ethic ("the harder you work, the luckier you get!") and an entrenched desire to push their work to its limits, Dabs Myla present us with an exquisite, always cheerful body of work that captivates us with its rapturous, convivial presence.

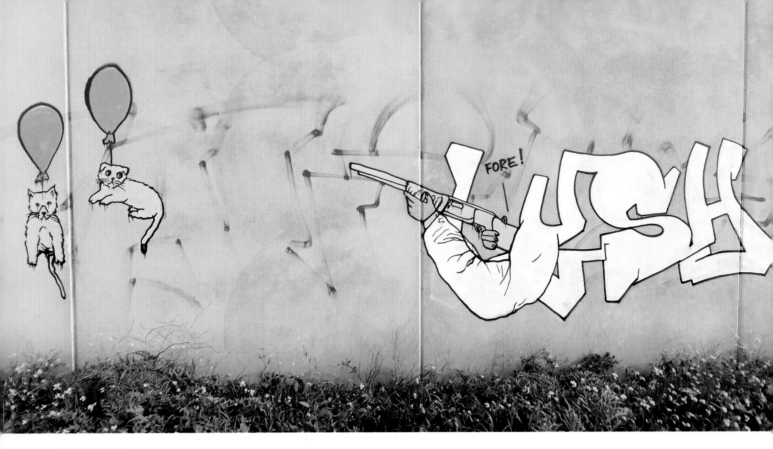

MELBOURNE

BORN Melbourne, Australia **MEDIUM** Spray paint, video, fanzines
STYLE Grotesque graffiti, meta-graffiti **THEMES** Pornography, misogyny,
ethnography **INFLUENCES** Robert Crumb, Raymond Pettibon

LUSH

Described variously as pornographic, misogynistic, tasteless, disrespectful,
and offensive, Lush's work functions as a brutal visual ethnography of the
world of graffiti. It dissects the form's codes and history, as well as its
practitioners themselves, tracing out idiocy and insight in equal measure.
Mocking conventional codes of decency as well as the often dour,
humorless nature of contemporary graffiti, Lush's highly sardonic and
acerbic style pushes the boundaries of acceptability in both mainstream
and graffiti culture, highlighting the often conservative nature of this
purportedly liberal, rebellious discourse. A pariah in both the institutional
and illicit art worlds, Lush enthusiastically holds onto this status, burning
every idol and rejecting any form of fundamentalism whether religious,
political, or aesthetic. Although he repudiates any implication of his
work's seriousness (wisecracking his way through any formal interview
he undertakes: "I'm as serious as a serious legitimate graffiti Grandmaster
can be"), his work must be understood to emerge from a deeply

Rabelaisian standpoint—characterized by the grotesque, the bawdy,
and the licentious—that embraces the world of graffiti while cruelly
lambasting it at the same time.

Born and raised in Melbourne, Australia, a city that despite its strongly
conservative streak became a famous site for the production of street art
in the early 2000s, Lush's work is a product of its environment, a reaction
to both the perceived weakening of the graffiti aesthetic through its
former position and to the provocations set against it by local authorities
in the latter. However, while firmly located within classical graffiti—his
images, for example, almost always contain his name within them,
whether in the form of the bloodstained patterning of a suicide victim,
a dangerously elongated penis, or a possibly matching set of oversized
female breasts—his work can also be seen as refuting the understanding
of graffiti as part of a distinctly hip-hop oriented framework. The
obsession with b-boy culture for the "Kangol-wearing" fraternity of graffiti
is seen by Lush as just another "fetish" that needs to be challenged and
eradicated to show the innately heterogeneous nature of graffiti. Similar
to Escif (see pp.314–17)—although they take radically different aesthetic
approaches—Lush's work functions as a form of meta-graffiti that is set

1 *Target Practice*, Melbourne, Australia, 2012
2 USA, 2012

within the genre while at the same time analyzing and taking a critical perspective of the discourse. His 'zines in particular demonstrate this element of his oeuvre: With inserts such as *A Quick Lil' Course in Etiquette*, *What Do Writers and Serial Killers Have in Common*, and *Should You Do Street Art?*, these highly comedic, penetratingly astute pieces reveal the many hidden aspects of graffiti culture—the various traits of the artists themselves as well as the do's and don'ts of the trade, the excuses for your parents, or the things not to say to the police. They illustrate the common truths within graffiti that are alien to outsiders, the ethnographic realities that turn mainstream "deviance" into subcultural norms. Although much of Lush's work seems to simply stretch the aesthetic limits of perversity and sexuality (work that is unprintable in this book but can be found online), even this can be seen as a boundary-testing activity, an aesthetic of shock—similar to that used by cartoonists Robert Crumb and Raymond Pettibon—that sets out to deliberately unsettle the status quo.

While continuing to work on his dramatically debauched and ardently self-referential graffiti, Lush has more recently started to explore the possibilities of film and has worked on a number of highly parodic, comedic sketches that ridicule various popular styles of internet videos, as well, of course, as the cheerless aspect of the graffiti culture itself. With titles such as *Lush's Lethal Beef-Defence System*, *Toy Vision Graffiti Sponsorship Appeal*, *How to do a Graffiti Masterpiece*, and *Pimp My Piece*, Lush simultaneously mocks and treasures these now hackneyed genres (the self-defense video, the charity appeal, the makeover show) creating mutant breeds and farcical combinations of styles. Much like his collective body of work, these film sketches take some of the ego out of the heritage, traditions, and values of graffiti, by pushing absurdity and farce into the face of the rule-makers. However, by lampooning graffiti's conventions and customs, Lush can also be seen as enriching and championing the very thing he is deriding. Like many forms of satire, from the jesters of medieval society to contemporary political cartoonists, his is a satire that upholds the purity of its target. It seeks not to displace that which it derides but to remind it of its rightful place and to protect it through a subversion and perversion of the norm.

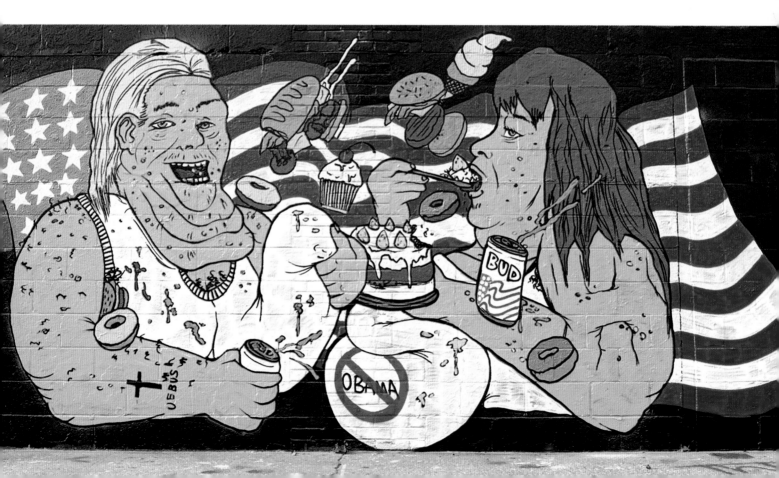

MELBOURNE BY LUSH

Lush's map of Melbourne follows the diagrammatic style that he adopts in many of his drawings. Most commonly working as an almost ethnographic examination of the graffiti culture—a postmodern, parodic examination of the various characters, regulations, and conventions that it contains—these satirical, often caustic illustrations reveal Lush's simultaneous love and hate for the discourse in which he is engaged: With his map of Melbourne (as he suggests, officially pronounced as "Mel-bin or Mel-burn"), Lush appears to be exalting and degrading his hometown in the same moment, glorifying its ingloriousness and demonstrating an understanding of the city that (like his understanding of graffiti) emerges from the lifelong intimacy of a true insider.

Lush's map marks out places of interest (such as "My Home," "Good Fishing," "Shit Hole," "Staby Cunts"), but also presents an educative guide to the various districts and suburbs of Melbourne: "Places to Die" are therefore listed as "Footscray, Melton, Dandenong, Broadmeadows, Frankston, and the CBD [Central Business District]"; locations to "Score Drugs" as "Footscray [once again], Springvale, Collingwood, Melton [now starting to gain a reputation], Sunshine, and Frankston"; while "Slut Habitats" are to be found in "St. Kilda, Rockbank, Melton [appearing for the third time], Werribee, Fabkston, Dandy, and Sunbury." Armed with this information, as well as Lush's guide to the best places to paint in the city ("pretty much anywhere"), the recipient of this map can gain a knowledge of its districts that, while naturally comedic, still acts as a beginners' guide to the city and an underground tourist travelogue. As with Lush's work as a whole, the map displays his infamous crudity, harshness, and parody, but also presents us with the established truths that are so exotic to outsiders, the observational comedy of the Independent Public Art world.

MELBOURNE

BORN Unknown **MEDIUM** Spray paint, stencils **STYLE** Classic graffiti, pop art
THEMES Mythology, order and chaos, tormented heroes **INFLUENCES** Cartoons,
science fiction, skateboarding, Asian art **COLLECTIVE** Everfresh

MEGGS
HOUSE OF MEGGS

1 *St. Alis Laneway*, Melbourne, Australia, 2010
2 *American Phoenix*, Los Angeles, USA, 2012
3 *Cold Front*, Vancouver, Canada, 2011
4 *Owl*, Wollongong, Australia, 2012

A founding member of Melbourne's notorious Everfresh collective, Meggs's dualistic, visually confrontational art fuses diverse graffiti techniques (from stencil art to classical freehand), abstract and figurative designs, as well as fine art and lowbrow aesthetics into a cultural patchwork of variant influences. More recently inspired by classical mythology and Asian art, his work has become increasingly multi-layered in physical and conceptual terms, and has evolved into a strongly expressive, self-reflective form of production.

Named after the iconic Australian comic-book character Ginger Meggs (created by Jimmy Bancks in the 1920s), Meggs was born and raised in the eastern suburbs of Melbourne. He spent his youth obsessing more about skating than art, exploring the city through his skateboard rather than with the aid of a spray can. Although he was interested in drawing, cartoons, and science fiction, his entrance to Independent Public Art came fairly late, after he had graduated from university with a design degree in 2000.

As if making up for lost time, however, Meggs quickly bombarded the Melbourne streets with his stencil and poster art. It soon became clear, though, that his work was pervaded by a duality of balance and chaos. Although he incorporated heroic characters into his designs, Meggs depicted them in moments of great torment or trouble. After the foundation of Everfresh (with fellow members Sync, Phibs, Reka, Rone, Wonderlust, Prizm, Makatron, and The Tooth) in 2004, Meggs's work began to develop materially as he moved from stencils to a more all-embracing aesthetic approach. Concurrently his interest in the conflict between the benevolent and the malignant morphed into its present focus on mythology. Attempting to form a harmony, as he puts it, "out of a chaotic or abstracted form," and to find the "balance of order and chaos," Meggs's work developed its distinctive symbolic style, producing what is a classically Melburnian urban aesthetic.

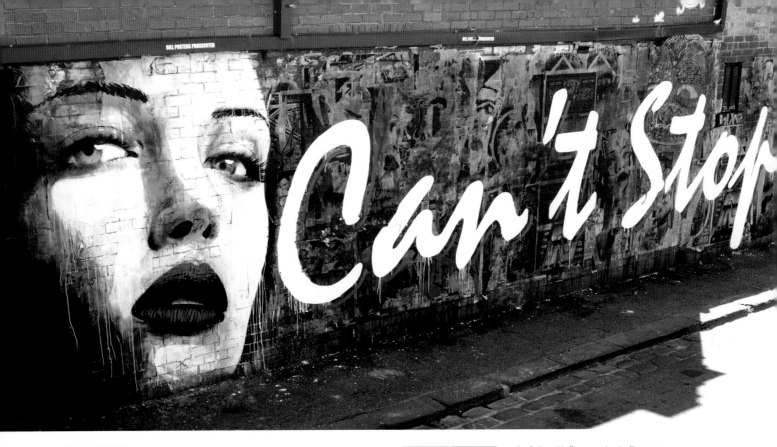

MELBOURNE

BORN 1980, Geelong, Australia **MEDIUM** Stencil, spray paint
STYLE Stencil art **THEMES** Cinematic icons, Jane Doe, beauty vs. decay
INFLUENCES HA-HA, Sync, Psalm **COLLECTIVE** Everfresh

RONE

Rone is a key individual on the Melbourne street art scene, who is famous for his sumptuous paintings of glamorous women, in particular a recurring image of his so-called Jane Doe. He attempts to locate the friction point between beauty and decay, creating an iconic form of urban art with a strongly emotional bent. Having produced many early works by stenciling or screen-printing, like fellow Everfresh member Meggs (see pp.368–9), Rone's movement toward a more freehand style enabled a degree of openness to seep into his images, resulting in a rawness that enhanced their affective quality. His images have not only appeared all over his adopted city, but have increasingly begun to be seen all around the world, too. His trademark figures—his heroic, alluring, cinematic icons—manifest themselves in ever larger, more elaborate, and emotive forms.

After moving to Melbourne in 2000 to study graphic design, Rone became fascinated with the newly emerged stencil art scene that was dominating the walls and border areas of the metropolis. The work of early practitioners, such as HA-HA, Sync, and Psalm in particular, was a huge influence on his decision to adopt the technique himself. Initally confining his painting to the places where he and his friends went to skate, his early experimentation was boosted by his friendship with Everfresh member Reka. Rone's painting soon developed from a personal hobby to a group activity and into a virtual way of life. Although Rone's more recent work has clearly matured in terms of its visual complexity, his early exploits, which harnessed the iconic power of his Jane Doe design, were focused more explicitly on their quantity and mass distribution, with their ability to dominate the environment as their principal rationale. Rone says that he preferred to spend "five minutes knocking out as many images" rather than wasting "days painting something perfectly." This approach lent a strange sort of prestige to his images, a visual notoriety that meant they were immediately recognizable as his. Adopting a classical graffiti mentality, an urge to get up at any cost, Rone's work swiftly became an unmistakable part of the Melburnian cityscape. Their "calming beauty" provides an innate contrast to the walls that they grace; they fuse its dirt with decorativeness to form an ephemeral elegance and transient beauty amid the chaos of the street.

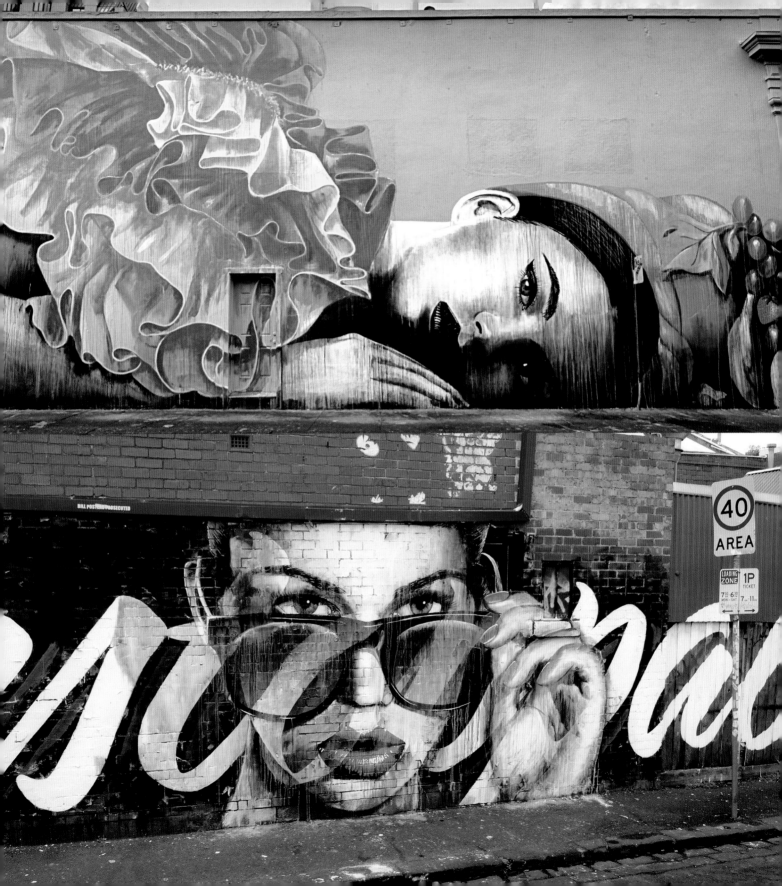

SYDNEY

With a reputation as a brash, rough, party town, Sydney's cultural life is often compared unfavorably with that of Melbourne's, particularly when it comes to graffiti and street art. There are many theories about this supposed malaise and its causes: Sydney's sprawling geography that leads to disconnected suburbs; the constant cleaning of graffiti; rigid licensing laws that prevent the growth of laneway bars and associated street art; and self-interested creatives who do little to change the wasteland of the inner city, once described as a "cultural Chernobyl." However, it is thanks to the perseverance of its artists and activists that Sydney has more than its fair share of graffiti pioneers, while the city's icons, the Opera House, the Harbor Bridge, and Bondi Beach—have each been the canvas for some startling forms of street art.

In the late 1970s, Sydney gave birth to a distinctively Australian movement, the collective BUGA UP (Billboard Utilizing Graffitists Against Unhealthy Promotions, see image 1). Before the invention of the term "culture jamming," members engaged in direct action, using spray paint to alter the meaning of billboards, especially those advertising cigarettes. With a few short bursts from a spray can, the cigarette brand "John Player Special" became "Lung Slayer Special," while billboards out of reach were hit with paint bombs. BUGA UP spread around Australia, later inspiring other activists such as Greenpeace and Sydney's the Lonely Station

collective, who perpetrated audacious, large-scale actions, using climbing gear to scale towers and unfurl protest banners.

From the mid-1980s, Sydney was caught up in the global spread of hip-hop graffiti. Despite a concerted effort to paint out graffiti on walls and trains, a thriving scene developed producing a generation of talented painters, among them Unique, Kidm, Mistery, Atome, Kade, Taven, Spice, Prins, Sach, Gane2, Phibs (see image 5), and Dmote (see pp.376–7). Graffiti pieces spread across the city, often on abandoned buildings, rooftops, and, supported by activist and patron Tony Spanos, in the parking lot of his family's meatworks. The massive wall along Bondi Beach also saw the development of themed pieces and memorial murals, and inspired the next generation of Sydney writers. From the late 1980s, large murals were painted around the inner suburb of Newtown by Mistery (see image 3), Andrew Aitken, and others, often supported by Spanos. Many of these murals commemorate civil rights activism and Sydney's indigenous heritage. Murals such as *I Have A Dream,* featuring Martin Luther King, and *Three Proud People*, commemorating the Black Power salute at the 1968 Olympics, remain intact and have become part of the city's fabric.

In March 2003, activists Will Saunders and David Burgess painted the slogan "No War" on the highest sail of the Sydney Opera House (see image 2)

1 BUGA UP, 2010 2 The Lonely Station collective, 2003 3 Mistery, 2005 4 *Eternity*, Arthur Stace,
c. 1950s 5 Phibs, May Street, St. Peters, 2008 6 *Work*, Will Coles, 2011

1		3	4
2		5	6

to protest against the looming invasion of Iraq by coalition forces: "Our Prime Minister is about to go in and maliciously damage an entire nation," one said, when asked about his own arrest. Protests against the war also stimulated the emerging street art scene, as sloganeering mixed with stencils, stickers, and the street sculpture of Will Coles, whose distinctive re-castings of everyday objects in concrete or bronze are strewn across the city (see image 6). Artists such as Ben Frost (see pp.374–5) also pioneered large-scale postering using wheat glue as an adhesive. Street art was celebrated and formalized through exhibitions, such as the Paste-Modernism shows initiated by Frost and the Mays Lane project, an outdoor gallery space curated by Tugi Balong, with its rotating billboards that traveled to exhibitions around the country. In 2011, Sydney hosted a major international show of street art on Cockatoo Island in the harbor. The Outpost project included local artists such as Beastman and Andy Uprock, alongside street art superstars Banksy and ROA.

The most famous example of urban art in Sydney remains the work of Arthur Stace, a reformed alcoholic who wrote the word "eternity" across Sydney from the 1930s, in response to his own religious awakening (see image 4). Nearly illiterate, Stace chalked the word in neat copperplate nearly 500,000 times over the next thirty-five years. His exploits have been memorialized in an opera and film, while a giant "Eternity" fireworks display adorned the Harbor Bridge to mark New Year's Day 2000 and the opening of the Sydney Olympic Games. While the achievements of many of Sydney's writers and street artists go unrecognized, Stace's graffiti has become an unlikely touchstone for the city itself. According to Ignatius Jones, director of the Olympic celebrations, Stace's "eternity" is "incredibly Sydney" and symbolized "the madness, mystery, and magic of the city." **LM**

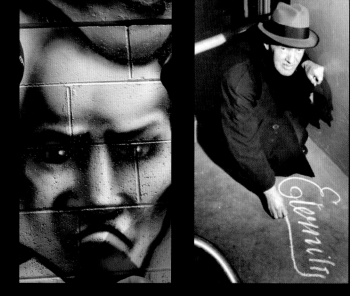

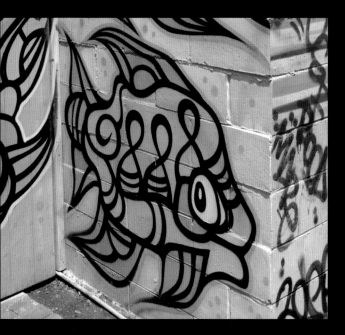

SYDNEY

BORN Brisbane, Australia **MEDIUM** Wheat paste **STYLE** Kaleidoscopic pop art **THEMES** Détournement, contemporary trash culture
COLLECTIVE Stupid Krap Studios

BEN FROST

With an inescapably cynical, confrontational aesthetic, Ben Frost uses a collagist technique to reflect and juxtapose Western popular visual culture. His anti-pop style forms a material representation of hysteria that conveys a love/hate relationship with the contemporary world. He détournés classic icons, such as Hello Kitty, *The Simpsons*, and even model Kate Moss, in images that simultaneously uphold and reject them. Fully aware of the contradictory and pessimistic nature of his practice, which can be seen to simply sustain the objects of his hatred, Frost prefers, in his words, to "dance" rather than "sleep" with the devil, to make images with "blood on his hands," satisfied that at least this paradoxical option exists.

Frost originally rejected traditional painting as a retroactive, inappropriate technique in an age of total image saturation; however, after completing his fine art degree he relocated away from his hometown of Brisbane and his work underwent a total transformation of style. Although he has mainly focused on performance and installation,

his move to Melbourne, where he shared a studio with Regan Tamanui (better known as HA-HA), pushed him toward a more classic, linear style of production. The difficulty he had communicating with his peers through his conceptual work persuaded him to adopt a more legible aesthetic. When HA-HA and Frost were introduced to stencils by Adelaide artist Dlux, everything changed once again, however. The ability to produce images in a photographic style with the power to relate immediately to the street offered Frost of way of combining his performative and painterly impulses and this style began to dominate his work. What eventually emerged was a form of culture jamming that set out to imitate the endless advertising imagery we are constantly bombarded with. Arguing that art had became more like a form of entertainment, in which consumers (rather than viewers) were desensitized to the obsessively violent, pornographic nature of their culture, Frost attempted to bring us face to face with the horror, the inevitable outcome of our capitalist culture. Creating "surreal dialogues that bring to the surface darker consumerist motivations," not trying to answer the problem but shoving the question right back in the viewer's face, he constructs a portrait of society that does not try to hide his defeatist, despondent condition.

1 *World War 3?*, Brisbane, Australia, 2011
2 *Bleeding Hands Goofy*, San Francisco, USA, 2011
3 *Letting Go*, Sydney, Australia, 2009
4 *Popeye Death Machine*, Brisbane, Australia, 2011

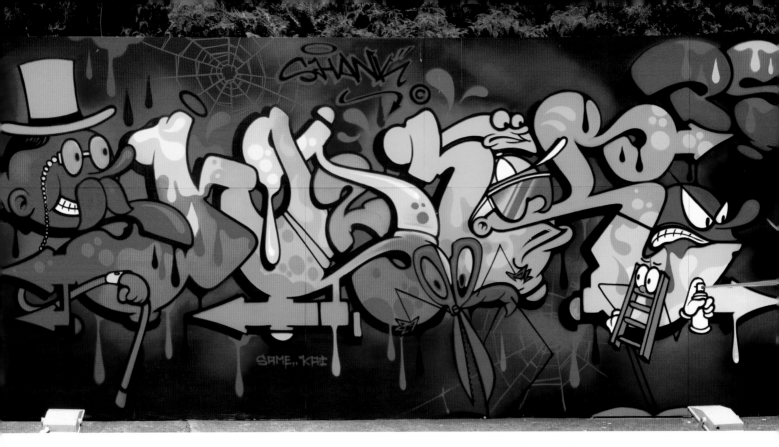

SYDNEY

BORN 1970, Sydney, Australia **MEDIUM** Spray paint **STYLE** Contemporary classic graffiti, classic letter types, hand-drawn lettering **THEMES** Typography **INFLUENCES** Phase 2, Dondi, Reas, Shame Lee **CREW** Prime Suspects

1 Sydney, Australia, 2011
2 Bridgeport, Connecticut, USA, 2012

DMOTE
SHANK

A Sydney native (although he currently lives in the United States), DMOTE is one of Australia's finest, classic graffiti writers. Highly influenced by the New York school, in particular the era from the mid- to late 1980s, he has forged a style that aims to interpret and enrich these roots without straying too far from its fundamental techniques. Although he has become an established figure in the fashion world (where he works in creative direction for a number of renowned brands), as well as more recently finding success with his fine art, DMOTE remains highly active in the streets, keeping his commercial and classic output firmly separate.

Heavily into the b-boy movement as a youth, DMOTE was first attracted to breakdancing through music videos, such as Malcolm McLaren's "Buffalo Gals," and a *60 Minutes* TV feature on the Floor Lords. The first serious writer he encountered was PRINS, his long-time graffiti partner, whom he met at high school. DMOTE soon began writing himself,

building on his knowledge of the graphic background of hip-hop. Although he continued to paint in Sydney throughout his youth, it was his strong desire to travel that pushed him stylistically. Journeying all over Europe, and spending time in Germany particularly, DMOTE became close friends with artists including Daim, Loomit, and Can2, bonds that established him as a key reference point when such artists visited his native Australia.

Graffiti provided DMOTE with a gateway to the world and a training that he believes most conventional designers and artists lack—credentials that come through doggedly working for free over many years. Although he had no formal fashion training, DMOTE's street education encouraged him to start designing clothes for various labels in Australia, work that led him to eventually relocate to the United States. However, it was a more recent move, from California to New York, that boosted his presence back on the street. Since 2011 he has produced a huge selection of new work—particularly that with Bronx-based muralists TATS CRU—that remains true to his graffiti origins. Obsessed by typography and by hand-drawn (rather than computer-generated) lettering, he continues his search for the perfect flow, the perfect arrangement of letters in a contemporary yet always classic aesthetic.

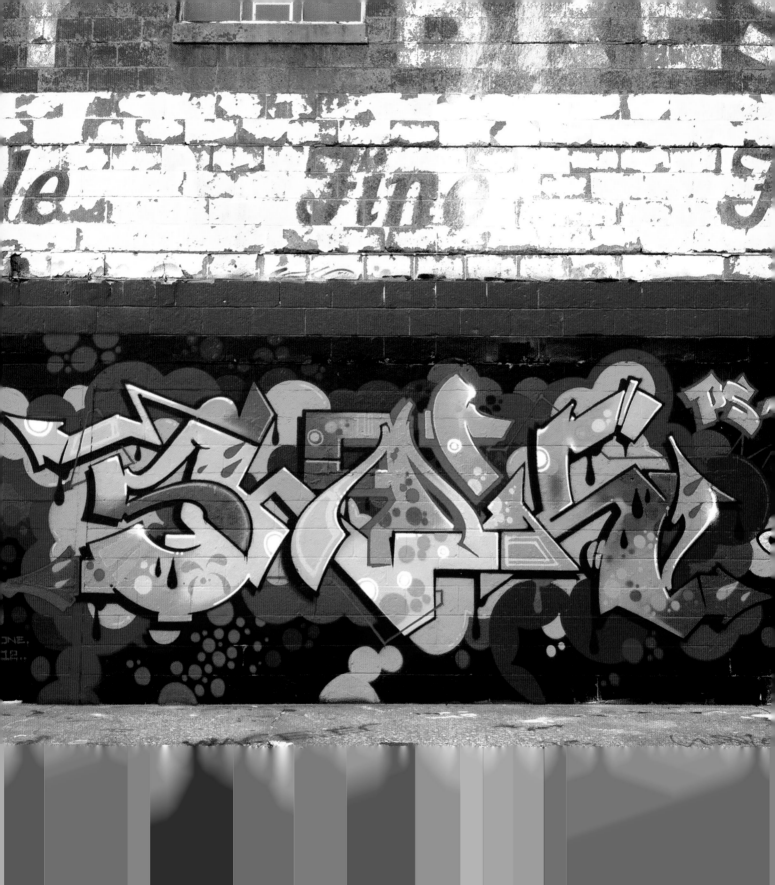

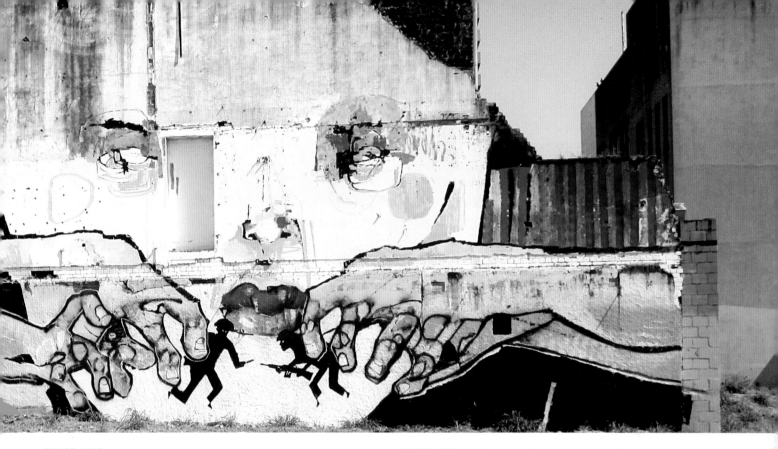

BRISBANE

BORN 1979, Brisbane, Australia MEDIUM Spray paint, acrylic, charcoal, sculpture
STYLE Lowbrow, figurative INFLUENCES "Bad" Painting, pop art, popular culture
THEMES Romance, decadence, hedonism, superheroes, ballerinas

1 *New Year's Party Balloon*, Brisbane, Australia, 2011
2 *The Gift that was Buffed*, Brisbane, Australia, 2011

ANTHONY LISTER

The work of Anthony Lister, one of Australia's most renowned contemporary artists, represents a grimy fusion of high and low art. He combines technical mastery with an entrenched affection for mass appeal, forming an aesthetic with a turbulent, barely controlled energy at its core. In a style influenced by the dirty, rough techniques of "Bad" Painting but merged with the spirit and performative dynamism of graffiti, Lister has embraced a highly stylized, hand-drawn mode of production. Whether working on the street or on canvas, he creates a scratchy, explosive form of figurative art, which could be described as part of the second wave of pop art.

Born in 1979 and raised in Brisbane, Australia, Lister initially began to paint through the influence of his grandmother, a hobbyist with her own art studio. Entranced by the magical nature of this site, the young Lister was given an awareness of the world of art from a young age and was also strongly encouraged to draw himself. By the time he started to become interested in graffiti, first painting on the suburban streets of Brisbane from around the age of seventeen, he already had a strong foundation in drawing and therefore a seemingly innate ability to paint figures. Intrigued by the hand-drawn line and comics in particular—a theme that later came to dominate his work—this non-institutional training eventually led him to the Queensland College of Art where he graduated with a degree in fine art in 2001. Moving to New York soon after to continue his studies (where he was mentored by the famed New Zealand artist Max Gimblett), the street continued to endure as a central part of his artistic practice during this time, a primal need he was unable to shake off. It provided a space where he could take pleasure in his "hobby" of producing art rather than the "craft" of studio work and where he could pursue art in its most spontaneous and loose form.

What Lister most famously came to develop in the street was his series of unique faces—the pink-lipped, often red-nosed characters

1

2

in particular—which continue to proliferate wherever he works and represents his practice in its purest form. Undertaken for the sheer joy of the act, Lister's visages express an unadulterated form of liberty—an outright rejection of the diligent, assiduous work he produces in the studio. As he himself has said, "For me a face on the street represents freedom. When I'm painting on the street I don't want to sweat over problems that I don't feel comfortable solving in the public world or in front of an audience, because that's often what painting in public turns into. I do faces because emotion is interesting to me. I can be free with all that street face thing." Seeing the street as a place of action rather than reflection, a place where he can experiment through flow, Lister thus uses this site as a place where he can be spontaneous and loose, where he can work while having no expectations of either a positive or negative outcome.

Although his work in the street is normally undertaken as "Lister," his contrasting studio work is completed under his full name. Within this realm, Lister takes a more considered and careful approach in a practice that is "almost opposite (in principle)" to his outside productions. Working in the studio Lister therefore aims to use his

materials in a more "quenchable and tangible way," working in a concentrated manner with only "moments of violation" rather than violation as a base: "I'm thinking conceptually and aesthetically, reflecting about anti-beauty, adventure painting, and problem-solving . . . and I will be scrutinizing and really slaughtering my practice in the eyes of giants such as Egon Schiele and Francis Bacon." Focusing mainly on a range of loutish superheroes and vampish ballerinas—characters that perfectly portray his obsession with both the highbrow and the lowbrow—Lister uses these characters to try and make sense of the world around him, turning them into the mythological figures of our current epoch.

In whichever realm Lister practices, however, the reaction that each work provokes and its emotional veracity remain key. He has said the way he works springs from a drive to "make something beautiful" while "constantly being mindful of the opportunity to violate it," a desire for both transgression and acclamation that binds his practice together. Reveling in the "heritage" of popular culture, Lister takes this joint inheritance and remolds it into something both alluring and grotesque, a perfect representation of the society he seeks to depict.

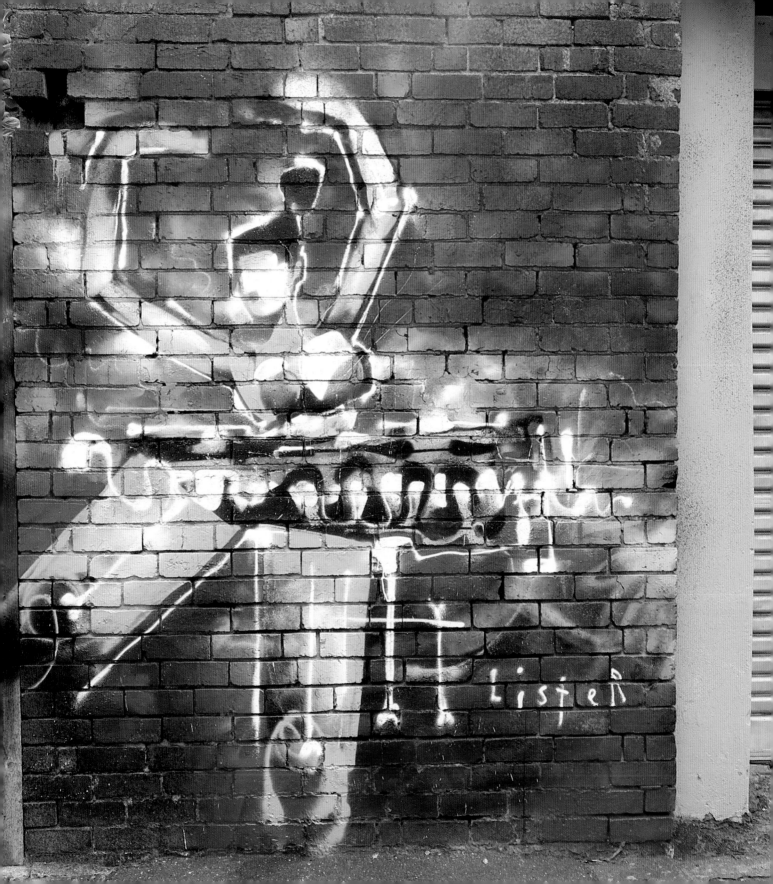

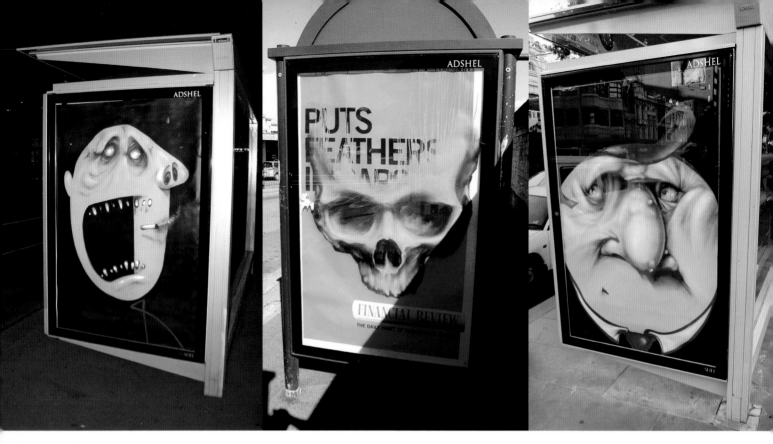

PERTH

BORN Perth, Australia **MEDIUM** Spray paint **STYLE** Photo-realistic graffiti, demonic caricatures **THEMES** Skulls, claustrophobia **INFLUENCES** Stormie, Shime

1 Melbourne, Australia, 2010
2 Sydney, Australia, 2009 3 Melbourne, Australia, 2010
4 *Home*, Cockatoo Island, Sydney, Australia, 2011
5 London, UK, 2011

IAN STRANGE
KID ZOOM

Perth-born and raised, although now residing in Brooklyn, New York, Ian Strange's twisted, hyperrealist blend of fine art and graffiti has taken him to the forefront of the international Independent Public Art scene in only a few years. Famously described by Ron English (see pp.38–9) as "Rembrandt with a Spray Can," Strange (aka Kid Zoom) is equally comfortable producing lifelike representations as demonic caricatures. He has developed a distinctly aggressive, visceral, contorted aesthetic that is characterized by an exquisite painterly technique.

Strange began painting graffiti in the late 1990s and his early style was hugely indebted to local artists, such as Stormie and Shime, both through their own work, as well as that of the international artists they attracted to Perth. The young Strange was hugely inspired by seeing the work of these artists and was also strongly encouraged by his parents who "always told me to do what I love," even though he was regularly being

picked up by the police for painting. After making the move across the Nullarbor to Sydney, Strange's first success came with his work on bus shelters (see images 1–3 for more recent examples), when he removed the adverts from their hoardings and replaced them with his own designs (a classic graffiti technique developed by the New York-based artist Kaws). In his efforts to outwit the "increasingly savvy advertisers" who used these sites, however, Strange's work became increasingly combative, as he was forced to "make sure that [it] couldn't be mistaken for some sort of cynical marketing campaign." Although the prevailing darkness in his oeuvre has stemmed partly from necessity, it also sprang from his background as a child of the suburbs. The angst and anger that this often claustrophobic urban existence can provoke was what he believed originally led him into art in the first place. Although these feelings have now been "channeled into a different place"—into his modified *Playboy* covers, his installations (such as *Home*, a full-scale replica of his childhood house), or his large-scale, photorealistic murals—Strange continues to pursue a warped, uneasy style. Using the same "emotional catalyst and perspective" that he found in graffiti, it is a style that sets out to bring contradictions and conflicts to the surface in his brooding, strangely bewitching aesthetic.

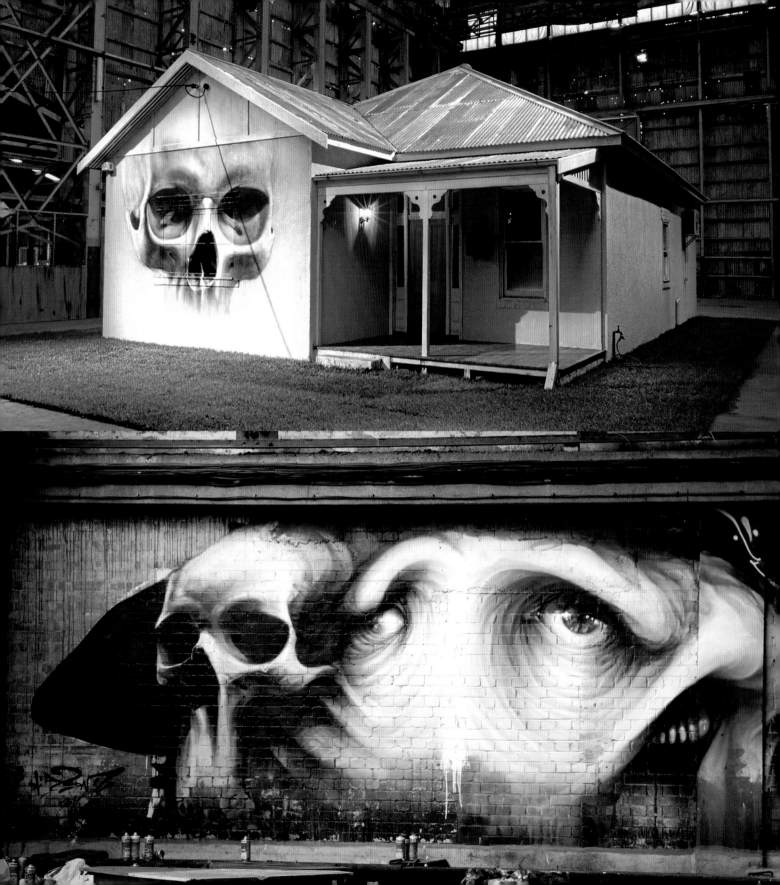

AUCKLAND
BORN 1979, Palmerston North, New Zealand MEDIUM Spray paint
STYLE Contemporary graffiti, "Diamondism," "netching"
INFLUENCES Tank, DAF Crew, Can2, Atom, Wow CREWS SUK, TMD, MSK

ASKEW ONE

As self-reflective and complex in his words as in his images, Askew One is New Zealand's most established and successful graffiti artist. A recognized director and designer in his own right, as well as a conceptually astute historian of graffiti culture, his work in the street has continually transcended the restrictions of what is often perceived as "real" graffiti. His technically rich, diverse production has broken away from its geographic isolation to inspire others on a worldwide scale.

Born in a small city on New Zealand's North Island, Askew's family moved to Auckland when he was only five years old, an event that proved crucial in determining his later artistic path: Having been attracted to drawing from an early age, and being neither particularly sporty nor particularly tough, graffiti became the perfect outlet for him; the presence of many of the local artists and crews in his surrounding area pushed him even further into the culture. He had begun to take the craft more seriously by the time he entered high school, settling upon the name Askew in 1995—partly for its literal meaning of "off-kilter," but mainly due to the symmetry and structural balance of the letters in the word.

Askew has moved through different styles and approaches at an insanely impressive rate, although he admits that such multidimensionality can be a hindrance. His more recent, geometric style of construction, "Diamondism" (see image 3), has propelled him to new heights. Inspired by examining crystal rock formations on a macro level, and observing how these natural elements "throw the most erratic array of colors together in seamless harmony," as he noted in 2011, Askew realized that the rules he had learned on the street were dwarfed by the infinite possibilities of the natural world.

Struck down with Call–Fleming syndrome in 2011, even this potentially debilitating illness failed to halt Askew's passion for evolution. Indeed, the frustrating months spent trying to regain his painting ability brought forth another change in direction—a group of slogans that he terms both "cynical" and "patriotic" called *Smoke Signals* (see image 4). Shifting his focus from style and form to more overt messages about meaning and communication, Askew has pushed his work to the very edge once more, placing New Zealand firmly upon the global graffiti map. His work continues to push at the foundations of the graffiti community, his vivid, elaborate smoldering messages dispersing themselves all over the globe.

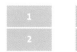

1, 3 Auckland, New Zealand, 2010 2 *TMDEES*, Auckland, New Zealand, 2011 4 *Help Stuck On This Crazy Island*, Auckland, New Zealand, 2011

WELLINGTON

BORN New Zealand **MEDIUM** Spray paint **STYLE** Psychedelic contemporary muralism **THEMES** Monsters, knots, dissection **INFLUENCES** Surrealism, anatomy

BMD

BMD are a duo from New Zealand who produce a maniacal, psychedelic form of contemporary muralism. Their oeuvre includes a huge range of phantasmagorical animal icons that they twist into Gordian knots and anatomically dissect; these warped, comical monsters often sport 1980s wraparound, mirrored sunglasses. Unpretentious and fun, their form of public art joyfully pursues an aesthetic of absurdity and optimism.

Raised in a small town outside Wellington, BMD bonded from a young age through their mutual antipathy toward the parochial creative milieu around them. Their early, small-scale works (stickers and posters, "our feeble attempt at changing the mundane" as they put it) encountered only animosity—from the graffiti community, their parents, and their girlfriends. Yet, this initial negativity had a significant impact on their style and work ethic. BMD started painting as high up as possible on the city walls (dragging a ladder with them on their nightly missions), a technique that enabled them to both respect the work that was already present,

while putting their own out of reach and ensuring it would survive potential erasure from the hands of the authorities and their peers alike. They soon progressed to the production of legal works, however, convincing local businesses that their buildings would be vastly improved "with the addition of a sliced up, anatomically incorrect animal on the side of it." The pair were able to take more time and care over these now mammoth productions and their work evolved both in terms of scale and by incorporating influences from the cartoons and children's books they loved. Although the symbolism of dissection first stemmed from their rejection of "lovey dovey street art"—an urge to start "killing our characters, cutting them up, and getting inside them"—BMD also saw these anatomical works as perfect for public art both "graphically and spatially" as it allowed them to cover more for less by "chopping it and spreading it around." Incorporating the outlandish and the surreal into the heart of the everyday, BMD see their work as an important constituent of city life and a way of breaking its monotony. Hating the idea of art simply being something that "gathers dust on a hallway wall" or "breaks up the trip to the toilet," their arresting, intentionally ludicrous visual regime injects a simple moment of lightheartedness into people's daily lives.

TOKYO

Japanese styles and perceptions of graffiti and street art have been significantly influenced and molded by two of North American contemporary art's best-known exponents of graffiti-informed visual expression: Keith Haring and Barry McGee. Keith Haring's solo exhibition in 1983 at the former Galerie Watari in Tokyo (and his concurrent scribbling across every available public surface) inspired the first peppering of graffiti aficionados and practitioners in the Japanese capital. These homegrown activities solidified into projects such as *Kaze Magazine*, Japan's longest-running graffiti magazine.

The proliferation of exhibitions, clothing design, and Japanese market-specific publications dedicated to graffiti artists such as Futura 2000—reinforced by cultural tastemakers of the 1990s such as Nigo, the former head of the Bathing Ape clothing line—created a widespread and nuanced awareness and appreciation of street art that preceded the street art explosion of the mid-2000s in the United States.

The "Street Market" exhibition created by Barry McGee, Todd James, and Steve Powers (see pp.18–21) at the Parco Gallery in Shibuya in 2000 further strengthened public perceptions of street art. The trio's mix of vernacular sign painting, appropriation of Japanese caricature (notably James's riffs on Suntory Whiskey mainstay artist Yanagihara Ryohei), sexploitative imagery, and bodega aesthetics, alongside traditional graffiti iconography, lit the flame that eventually exploded contemporary Japanese street art. McGee's follow-up solo show at Gaienmae's Watari

Museum further cemented this influence, while simultaneously acknowledging Haring's previous efforts through a side-by-side, outdoor mural adjacent to the museum.

On the streets, echoes of the work of the international MSK (Mad Society Kings) graffiti crew is evident throughout Tokyo. MSK writers broke new ground in the assault on public space in the United States; they coated freeway overpasses stories high, scaled buildings, and painted the sides of ocean liners, while slowly expanding membership from their hometown of Los Angeles to other cities across the United States before hopping oceans to recruit crew members internationally.

The graffiti of the Tokyo branch of MSK set the visual stage in the city. They are among the most prolific vandals: Their stickers, tags, and paintings outshine their graffiti peers in both quantity and placement. The Tokyo members take the crew ethos seriously and they spend a lot of time ensuring that the MSK name is all over town via paint, marker, sticker, and other methods.

Graffiti writer Wanto has giant geometric block letter pieces painted in nearly every ward in Tokyo (see image 1). Having appeared along most major train lines and on top of buildings seen from the highway driving in and out of Tokyo, these pieces have a scale and frequency that is staggering. The same can be said of writer Sect's treatment of huge portions of much of the city (see image 2). His hastily spray-painted strokes loop from side to side, the overspray doing half of the work from the can being held back half a foot from the wall and finished off with a few quick outline strokes.

Ekys's mixed upper and lowercase tag adorns vending machines and outdoor air conditioners across the city (see images 4–6). Using sloped, leaning-back, straight Roman letter forms in ink and spray paint, Ekys is potentially the most visible writer in Tokyo due to mere frequency.

These writers focus on tagging and throw-ups—the less "painterly" aspects of graffiti. They lean more toward vandalism than art as objects of beauty, per se. Their work offers a potentially different variant of graffiti. It is a form of communication that has yet to be recognized—one of syntax. Through spatial repetition and placement, these writers deploy written language of the most minimal sort throughout Tokyo. There is a focus on what is being said, but as with other forms of language, speech, and writing, how and where the statement is conveyed carries just as much meaning. Where writers choose to paint their names takes on meaning, repetition forcing cognizance, and particularly risky placement heightens the work's social relevance.

Perhaps the most interesting of the errant decorators is QP (see images 3–5). His oddball, hybrid letterform and characters break with the highly readable norms of his compatriots. Preferring a monochromatic palette, QP's tags demonstrate a unique approach via non-formulaic placement and sheer idiosyncrasy.

The common characteristic shared by all of these writers is that they ultimately define themselves and their practices by being "up." What is important is having as many pieces on the street as possible, not creating something subjectively "beautiful."

The work of these writers on the street is art's potential third sex: It is about neither concept nor beauty, instead it relies on application, context, and frequency to communicate their desire. **IL**

TOKYO

BORN Tokyo, Japan **MEDIUM** Stickers, spray paint, sculpture
STYLE Monochromatic typographic figuration, *kanji* calligraphy
THEMES Uiko character **INFLUENCES** Zen

1 *Hotel Essu*, Izu, Japan, 2011 2 Yotsuya, Tokyo, Japan, 2007
3 Shinjuku, Tokyo, Japan, 2009 4 Akihabara, Tokyo, Japan,
2006 5 Yoyogi, Tokyo, Japan, 2008 6 Shinjuku, Tokyo,
Japan, 2007 7 Harajuku, Tokyo, 2008

ESSU

Saturating the streets of Tokyo, Essu's detailed, elaborate style of Independent Public Art with its monochromatic, *kanji*-fueled form of figuration displays a quintessentially Japanese aesthetic. (*Kanji* is a system of Japanese writing using Chinese characters.) Essu follows the classical confrontation of the humorous and the grotesque, utilizing motifs such as the lotus flower and tiered constructions reminiscent of pagodas in a fusion of calligraphy and imagery that is prevalent in Japanese art. With the aid of his idiosyncratic, frequently recurring character, Uiko, also known as the "Promising Child," Essu tries to bring the "wisdom" of this "perfect being" into the public sphere, using Uiko's power to "transcend dimensions" and bring the invisible world into the visible realm.

Essu's first obsession was with skateboard stickers rather than graffiti or street art, and he was addicted to collecting them from an early age. He was also inspired by the influential but short-lived Ghetto art space in Shinjuku, a West Coast style, alternative arts center where graffiti writers and skateboarders regularly converged. Essu began making his own hand-printed stickers to promote his burgeoning T-shirt brand and feverishly put them up in Tokyo's streets. As his work became more complex, influenced by the lowbrow art world yet twisted into a more intricate, Japanese modality, his calligraphic portraiture was naturally drawn toward using spray as well as stickers. Connecting the physical performance of graffiti to *shuuji*—the delicate balance and fluidity that must be present in each *kanji* stroke—as well as the Zen mentality and clearness of mind that is crucial to this balance, Essu started to evolve his practice into the "single dimension" of spray against wall rather than the "twofold dimension" of the sticker and focused more on "mentality and action" rather than the image in itself.

More recently he has also taken his works into the third dimension, but what still remains constant in Essu's practice—whether in sculptural or painted form—is his character Uiko, who aims to both infect and interrogate all those who encounter him. Forming a type of "serious laughter," as Essu puts it, his work aims to provide both *satori* (awakening) and *mujun* (contradiction) whichever medium he works in, enlightening the gray Tokyo streets with a dose of laughter and mystery in equal measure.

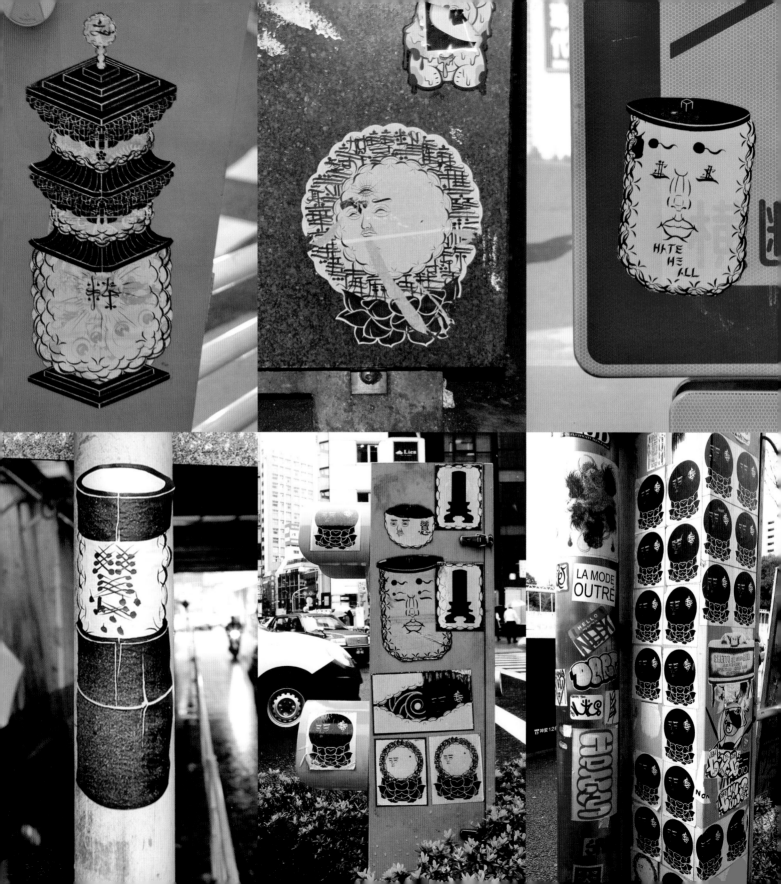

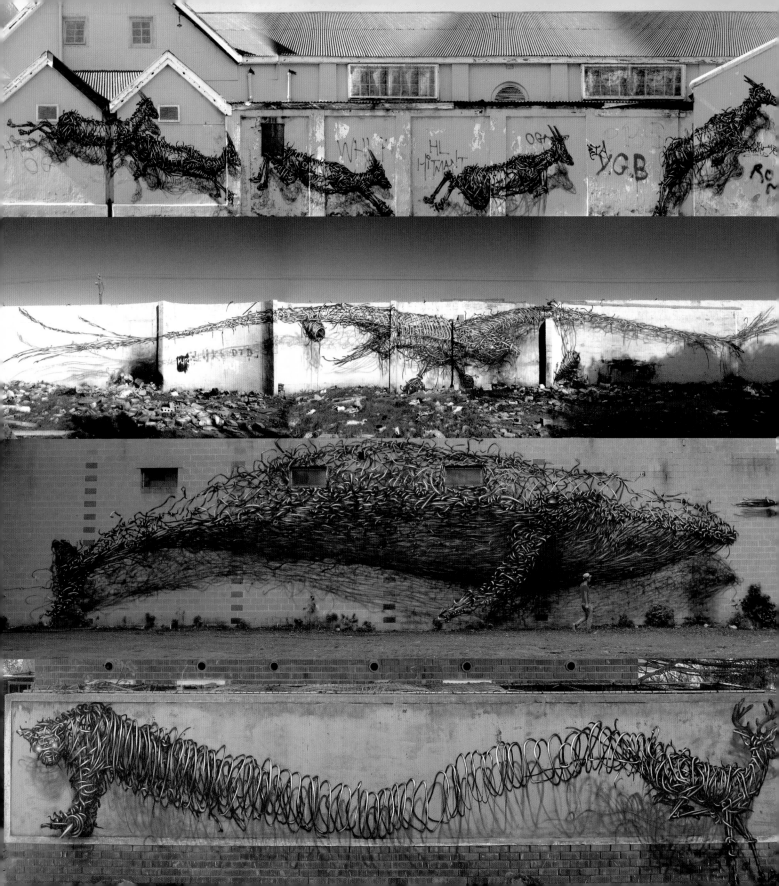

WUHAN

BORN 1984, Wuhan, China MEDIUM Acrylic paint, spray paint STYLE Large-scale murals depicting metallic wire figures THEMES Nature/culture, animals/machines INFLUENCES Eastern philosophy COLLECTIVE Chirp

DAL EAST

Hailing from Wuhan, central China's most populous city, Dal East is an artist who depicts the tense relationship between contrasting worlds—the natural and artificial, the organic and the synthetic. His aesthetic strives to bring these seemingly irreconcilable binaries into beautiful coalescence. Although his trademark style—metallic, monochromatic, sculptural figures—can now be experienced all over the world, his practice remains strongly influenced by Eastern philosophy and by the spirit and energy embued in the natural world. Inspired both by the internal immateriality of dreams and emotions and the external physicality of material and form, Dal's skeletal, spiraled imagery attempts to bring his part-animal, part-machines to life, endowing them with an emotion and spirit that surpasses their purely illustrative qualities.

Dal is a founding member of the Wuhan-based artist collective Chirp—one of the earliest groups in China to merge public art and graffiti—and he has been highly active in the burgeoning Chinese graffiti scene since 2004. He studied sculpture at the Institute of Fine Arts in his hometown, but quit the year before completing his degree because he disagreed with the school's teaching methods. Dal continued his graffiti practice after moving to Beijing in 2009, before eventually settling in Cape Town, South Africa, where he is married to Faith47—a highly respected and renowned artist in the international Independent Public Art movement.

Dal's current work clearly demonstrates the fusion of these illicit and institutional educations, which naturally converges in his three-dimensional, wire-like artworks. Half-robotic and half-biotic, the contorted, large-scale metal sculptures he produces reveal what lies beneath the surface and highlight the foundational frameworks that hold the physical world together. Dal's love for the vitality of the animal world is clearly apparent in his creations: He evokes a fantasy in which the natural and the synthetic become one, resulting in mongrel creatures that illustrate the beauty rather than the horror that can spring from such a union. Putting his art into public space so as to share his "experience and emotion with people," not to tell them "about right or wrong," Dal attempts to confront the viewer on conceptual (as well as spectacular) levels, forming a unique pictorial synthesis of a half-mechanized, half-organic world.

1 *The Williams Brothers*, Cape Town, South Africa, 2012
2 *Milestone*, Cape Town, South Africa, 2012 3 *Discount Evolution*, Rochester, USA, 2012 4 *Deer Park*, Cape Town, South Africa, 2012 5 *C*, Melun, France, 2012

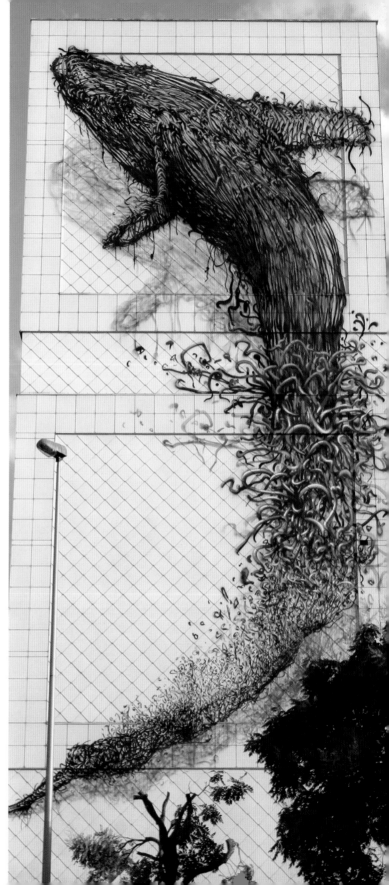

GLOSSARY

AGONISTIC
An approach in which conflict and disputation rather than harmony is sought.

ALL-CITY
The status of being known for one's graffiti writing throughout a city. Originally, the term referred to being known across the five boroughs of New York City through writing upon subway cars.

BACKJUMP
A piece produced on either a train or bus while the vehicle is still in service.

BOMB
To paint prolifically over numerous surfaces in an area. Bombers often use tags or throw-ups rather than more complex pieces because they can be executed faster.

BOXCAR GRAFFITI
Graffiti that first proliferated on railroad boxcars in North America during the Great Depression of the 1930s. Hobos—migratory workers who traveled the railroads—developed a system of markings that conveyed specific messages.

BUFFING
To remove painted graffiti with chemicals or to paint over it with a flat color.

CHARACTER
A cartoon figure taken from comic books, television, or popular culture. A character can take the place of a letter in a word.

CONSENSUAL
An approach in which agreement and accord, rather than dissensus, is sought.

CREW (KREW OR CRU)
A group of associated writers or artists who often work collaboratively and tag the crew's initials along with their own name. Crew names are often a collection of three letters and have numerous, frequently amusing referents.

DUMPSTER DIVING (OR SKIPPING)
The practice of foraging through commercial waste to find items that have been discarded but that may prove useful to the dumpster diver. Items range from food and clothing to paint and materials.

FAT CAP
Specially invented for graffiti, a nozzle attached to a can of spray paint that gives wider coverage and is generally used for bombing and to fill pieces. Also referred to as "tips."

GET UP
To get your work on any surface. Originally, the term meant to successfully hit a train.

GOING OVER
To paint over the top of a piece of graffiti. Also known as "crossing out." Most writers respect each other's work but to intentionally go over another's work is considered an act of violence.

HANDSTYLE
A signature or tag unique to each writer.

HIP-HOP
An urban youth culture starting in the late 1970s associated with rap music, break dancing, and African-American fashion.

INDEPENDENT PUBLIC ART
A term used to describe uncommissioned, unofficial art that takes place in the public realm, outside the gallery or the museum space.

INTERVENTION
An action by an artist that adds elements to, or modifies, the existing physical and social landscape.

KING
Kings are the best and most highly respected writers. Self-pronounced kings often incorporate crowns into their pieces.

LETTERFORM
Term used in typography and calligraphy to describe a letter's shape.

META-GRAFFITI
A form of graffiti that examines the graffiti discourse in itself as its own topic. Like painting about painting, meta-graffiti is a form of conceptual art.

MURAL
A large-scale piece or painting executed directly upon a wall.

OLD SCHOOL
Term generally referring to the early days of writing in the mid-1970s and early 1980s. Old-school writers are respected for their contributions to the early beginnings of graffiti.

ONE-LINER
A tag written in one continual motion. The tip of the writing implement does not lift from the surface until the tag is complete.

PIECE
A graffiti painting, short for masterpiece.

PIXAÇÃO
A unique style of graffiti native to Brazil and characterized by its distinctive cryptic tagging. Many *pixação* artists paint in high and inaccessible places.

SCRIBING
Scratching a tag that is hard to remove onto a surface often using a key, knife, or drill bit.

STICKERS
A form of tagging that can range from using simple computer-generated blank stickers with a writer's name to more elaborate labels incorporating characters. Stickers can be put up quicker than other forms of graffiti.

SUBWAY ART (1984)
Seminal study of the New York City graffiti subculture during the 1970s and 1980s by photographers Martha Cooper and Henry Chalfant.

TAG
A writer's personal logo or signature in marker or paint. The most elemental form of graffiti. While often disparaged by those from outside the graffiti discourse, for the practitioners themselves, tagging is examined in much the same way as classic calligraphy.

THROW-UP
Pieces that are quick and easy to paint, generally only in one or two colors. Bubble shapes often form the letters

TOY
An adjective to describe poorly executed work, or an incompetent or inexperienced writer.

WHEAT PASTE
A liquid adhesive used to glue posters and images to walls on the street.

WHITE CUBE
Refers to the conventional modern art gallery space.

WHOLE TRAIN
The feat of covering a whole train with graffiti pieces.

WILDSTYLE
Graffiti text so stylized and complicated that it is difficult to read. It often features interlocking letters.

WRITER
A practitioner of the art of graffiti.

'ZINE
A small circulation, self-published work of specialized, sometimes unconventional, subject matter usually produced on a photocopier.

READ UP!

JOE AUSTIN *Taking the Train: How Graffiti Art Became an Urban Crisis in New York City* (Columbia University Press, 2001)

JEAN BAUDRILLARD "Kool Killer, or The Insurrection of Signs," in *Symbolic Change and Death* (London: Sage, 1993)

NICOLAS BOURRIAUD *Postproduction: Culture as Screenplay: How Art Reprograms the World* (New York: Lukas & Sternberg, 2002)

BRASSAÏ (GYULA HALÁSZ) *Graffiti (of Paris)* (Stuttgart: Christian Belser Verlag, 1960)

DUMAR BROWN *Nov York: Written by a Slave* (New York: Xlibris, 2002)

CRAIG CASTLEMAN *Getting Up: Subway Graffiti in New York* (Cambridge, Massachusetts: MIT Press, 1982)

MICHEL DE CERTEAU *The Practice of Everyday Life* (Berkeley: University of California Press, 1984)

HENRY CHALFANT & MARTHA COOPER *Subway Art* (New York: Henry Holt & Co., 1984; rev. ed. 1995)

HENRY CHALFANT & JAMES PRIGOFF *Spraycan Art* (London: Thames & Hudson, 1987)

GUY DEBORD *Society of the Spectacle* (Detroit: Black & Red, 1983)

JEFF FERRELL *Crimes of Style: Urban Graffiti and the Politics of Criminality* (New York: Garland, 1993)

JULIET FLEMING *Graffiti and the Writing Arts of Early Modern England* (London: Reaktion, 2001)

DAVID FREEDBERG *The Power of Images: Studies in the History and Theory of Response* (Chicago: University of Chicago Press, 1989)

ROGER GASTMAN & CALEB NEELON *The History of American Graffiti* (New York: Harper Design/ HarperCollins, 2010)

ROGER GASTMAN & DARIN ROWLAND *Freight Train Graffiti* (London: Thames & Hudson, 2006)

ALFRED GELL *Art and Agency: An Anthropological Theory* (Oxford: Clarendon Press, 1998)

KEITH HARING *Art in Transit: Subway Drawings* (New York: Crown, 1984)

JONATHAN HILL *The Illegal Architect* (London: Black Dog Publishing, 1998)

TAKA KAWACHI *Street Market: Barry McGee, Stephen Powers, Todd James* (Tokyo: Little More, 2000)

MERVYN KURLANSKY, JON NAAR, & NORMAN MAILER *Watching My Name Go By* (London: Mathews, Miller, Dunbar, 1974)

CEDAR LEWISOHN *Street Art* (London: Tate Publishing, 2009)

NANCY MACDONALD *The Graffiti Subculture: Youth, Masculinity, and Identity in London and New York* (New York: Palgrave, 2001)

NORMAN MAILER & JON NAAR *The Faith of Graffiti* (New York: It Books, 2009)

W. J. T. MITCHELL *What Do Pictures Want? The Lives and Loves of Images* (Chicago: University of Chicago Press, 2005)

CHRISTOPHER PINNEY & NICHOLAS THOMAS *Beyond Aesthetics: Art and the Technologies of Enchantment* (Oxford: Berg, 2001)

STEPHEN POWERS *The Art of Getting Over: Graffiti at the Millennium* (New York: St. Martin's Press, 1999)

RAFAEL SCHACTER *Ornament and Order: An Ethnography of Street Art and Graffiti* (Farnham: Ashgate, 2013)

PATRICIA SPYER *Border Fetishisms: Material Objects in Unstable Spaces* (New York: Routledge, 1998)

WILLIAM UPSKI WIMSATT *Bomb the Suburbs: Graffiti, Freight-hopping, Race and the Search for Hip-Hop's Moral Center* (Berkeley: Soft Skull Press, 2001)

ARTIST WEBSITES

AKAY akayism.org AFFEX VENTURA janshansen.com ALEXANDROS VASMOULAKIS vasmou.com ANTHONY LISTER anthonylister.com ARAM BARTHOLL datenform.de ARYZ aryz.es ASKEW ONE askew1.com AUGUSTINE KOFIE keepdrafting.com BASCO VAZKO bascovazko.com BEN FROST benfrostisdead.com BLAQK blaqk2.tumblr.com BMD bmdisyourfriend.com BNE bnewater.org BUFF DISS buffdiss.com CALEB NEELON calebneelon.com CEPT spradio.com CHU studiochu.tv CLEMENS BEHR clemensbehr.com CRIPTA DJAN flickr.com/photos/criptadjan DABS MYLA dabsmyla.com DAL EAST daleast.com DEBENS deliriumdebens.com DEMS333 javi333.blogspot.co.uk DHEAR dhear.tumblr.com DMOTE dmote1.wordpress.com DOMA doma.tv EGS oldhelsinki.tumblr.com EINE einesigns.co.uk EKTA ekta.nu EROSIE erosie.net ESPO firstandfifteenth.net EL MAC elmac.net ELTONO eltono.com EPOS 257 epos257.cz ESCIF streetagainst.com EVAN ROTH evan-roth.com FAILE faile.net FASE mundofase.com FILIPPO MINELLI filippominelli.com GPO gpocrew.com HERBERT BAGLIONE herbertbaglione.blogspot.co.uk HOMER sashakurmaz.com HONET aventuresextraordinaires.fr HOW & NOSM howandnosm.com HUSKMITNAVN huskmitnavn.dk IAN STRANGE kid-zoom.com INFLUENZA fluo1.com INTERESNI KAZKI interesnikazki.blogspot.co.uk INTI CASTRO inticastro.com INVADER space-invaders.com JETSONORAMA speakingloudandsayingnothing.blogspot.co.uk JIEM lesiropdelarue.eu JURNE science-ism.com KATSU fffff.at/author/katsu KENOR elkenor.com KR krink.com LES FRÈRES RIPOULAIN lesfreresripoulain.eu LIQEN liqen.org LOS CONTRATISTAS loscontratistas.org LUSH lushsux.tumblr.com MARK JENKINS xmarkjenkinsx.com MEGGS houseofmeggs.com MOMO momoshowpalace.com MONEYLESS moneyless.it NANO4814 nano4814.com NAZZA STENCIL flickr.com/photos/nazza_stncl NEUZZ neuzz.blogspot.co.uk NUNCA lost.art.br/nunca.htm NURIA MORA nuriamora.com OS GÊMEOS osgemeos.com.br OX ox.com.fr PELUCAS ladrillopitillo.blogspot.co.uk PETRO theallotment2011.tumblr.com POINT onepoint.cz RADYA t-radya.com REMED remed.es REMIO remiovts.com REVOK revok1.com REYES reyes78.com RON ENGLISH popaganda.com RONE r-o-n-e.com SAN eseaene.com SANER saner-dsr.blogspot.co.uk SEGO Y OVBAL segoyovbal.blogspot.co.uk SEVER toprotectandsever.com SHEPARD FAIREY obeygiant.com SIXEART sixeart.net SPOK spok.es SPY spy.org.es SUSO33 suso33.com TEC tecalbum.com TURBO hartos.tumblr.com VHILS alexandrefarto.com VITCHÉ vitche.com.br VLOK 12ozprophet.comvlok VOINA en.free-voina.org VOVA VOROTNIOV vovavorotniov.tumblr.com WERMKE & LEINKAUF stopmakingsense.de ZBIOK flickr.com/photos/zbiokosky ZEDZ zedz.org ZEVS gzzglz.com ZOSEN animalbandido.com 108 108nero.com 3TTMAN 3ttman.com

INDEX

Page numbers in **bold** indicate illustrations.

CONTRIBUTORS

(ZB) Zosen Bandido has been an active member of the Barcelona graffiti scene since the early 1990s. A respected folk historian of the local graffiti scene, his repertoire has expanded to canvas, performance art, printmaking, illustration, and fashion design.

(JK) Jacob Kimvall is a Swedish art critic and lecturer. He was a graffiti writer in the 1980s and in 1992 he cofounded the world graffiti magazine *Underground Productions* (UP) in Sweden. He is currently working for a PhD on the historiography of graffiti and street art at Stockholm University.

(IL) Ian Lynam is a graphic designer and writer who lives in Tokyo. An Asia Pacific Design Award winner, he is the co-founder of the Néojaponisme website and is an editor at *Idea Magazine*. His most recent book is *Design of Manga, Anime and Light Novels*.

(LM) Dr. Lachlan MacDowall has published widely on the history and aesthetics of graffiti and street art, including as a contributor to *Uncommissioned Art and Kings Way: The Beginnings of Australian Graffiti (1983–93)*. He lectures at the University of Melbourne, Australia.

(CN) Caleb Neelon's bright, folksy works can be seen in gallery and museum exhibitions and on walls around the world. His work ranges from cultural diplomacy projects and curatorial museum work to public art projects in more than thirty countries around the globe. He is a contributing editor at *Juxtapoz* and the author of several books, including *The History of American Graffiti* (2011), which he coauthored with Roger Gastman.

(RP) Rod Palmer is the author of *Street Art Chile* (8 Books, London, 2008) and its enlarged Chilean edition (Ocho Libros, 2011), for whom he is currently completing *Murals in the Southern Cone of the Americas*. With Thomas Frangenberg, Rod edited *The Rise of the Image* (Ashgate, London, 2003) and *The Lives of Leonardo* (Warburg Institute, London, 2013).

(EP) Elli Paxinou was born in Athens, Greece. She studied fine arts at the University for the Creative Arts, Canterbury, UK, and completed a Master's at Goldsmiths, University of London. She was a curator for the second Athens Biennale, "Heaven," in 2009. Since 2010 she has worked at the Qbox gallery in Athens, but she continues to work as a freelance curator, writer, and critic.

(JS) Je Spurloser was born and raised in East Berlin. He is a member of the artist collective Graffitimuseum Berlin (www.graffitimuseum.de), which examines graffiti as an international phenomenon, as well as a local, site-specific expression of society. Among other projects they produce performances, lectures, and installations. He is currently conducting research on ephemeral aspects and persistent traces in the contemporary city.

(LS) Luciano Spinelli's academic work focuses on street art and urban communication, life in interstitial zones, and postmodern society. He has a PhD in sociology from the Université Paris Descartes Sorbonne in Paris. He is currently a researcher at the Sorbonne's Centre d'Etude sur l'Actuel et le Quotidien (CEAQ). His photographic work has been published in various international magazines and has featured in solo exhibitions.

(MS/DB) Stolen from a scrapyard in *c.* 2008 and raised on chicken drumsticks and white rice in Hackney Wick, east London, **Margarita Skeeta** has many accomplishments including nearly getting a swan and turning into a bat. She lives in Stoke-on-Trent, UK, and **Donal Blarney** lives in Mexico.

ACKNOWLEDGMENTS

Thanks firstly to Jane and Mark, Fiona and Tom (T:roids), without whom this project would never have emerged: I have learned a great deal from you all and remain hugely indebted. Thanks, of course, to all the artists who agreed to participate with the project and to every individual I harassed for their years of commitment to the public sphere and for that you have my humble and profound thanks. Thanks to my doctoral supervisors (and mentors)—Professor Christopher Pinney, Professor Susanne Küchler, and Professor Michael Rowlands. Not only would I have been unable to commence my research into Independent Public Art without your backing, I have been inspired and enriched by your knowledge and passion. A thanks beyond measurement to Feli, Guillo, Louis, Nanito, and Xavier. You know why and you know how much. Thanks to Mama Sara y Hermana Sierra, thanks to American Dave and Sergio de Barna, thanks to Rafa and Lupe, thanks to mi prima Paz, mi tia Nuri, and the beautiful Belen. Thanks to Duncan (let's get coffee at Monk's) and Margarita Skeeta. Thanks to all the city profile contributors and to everyone who kindly bestowed their images upon us. Thanks to D.K. (LDN) for putting up with me. Just saying "thanks" to my parents seems both insufficient and insipid. Your constant faith and belief in me has been more valuable than I could ever ask for and could ever expect. Thanks to Rachel and Steven, Josie and Julius, Rocky and Zips. Thanks to Sunday night Sollys. Thanks to Alan, Blanco, Char, DomP, Jules, Lols, Plotsman, Ritchy Rich, Sanj, Seamus, Seems, Six Sausages, Urps, and Zayz. Thanks to Drogs (and the lads) for the best night of my life in Munich. RAFAEL SCHACTER

Quintessence would like to thank Robert Dimery and Donna Gregory for their editorial work, and Helen Snaith for the index.

PICTURE CREDITS

Published in association with
Yale University Press
P.O. Box 209040
New Haven, CT 06520-9040
yalebooks.com/art

This book was designed and produced by
Quintessence
230 City Road
London EC1V 2TT

Project Editor Fiona Plowman
Designer Tom Howey
Picture Researcher Sara di Girolamo
Production Manager Anna Pauletti
Editorial Director Jane Laing
Publisher Mark Fletcher

This book is a documentary record and critique of graffiti as a form of artistic
expression. Neither the author nor the publisher in any way endorses vandalism
or the use of graffiti for the defacement of private or state-owned property.

Printed in China

ISBN 978-0-300-19942-0

Library of Congress Control Number: 2013935855

10 9 8 7 6 5 4 3 2 1